Camera Trapping for Wildlife Research

Camera Trapping for Wildlife Research

Edited by
Francesco Rovero and Fridolin Zimmermann

DATA IN THE WILD

Pelagic Publishing | www.pelagicpublishing.com

Published by Pelagic Publishing
www.pelagicpublishing.com
PO Box 725, Exeter EX1 9QU, UK

Camera Trapping for Wildlife Research
ISBN 978-1-78427-048-3 (Pbk)
ISBN 978-1-78427-063-6 (Hbk)
ISBN 978-1-78427-064-3 (ePub)
ISBN 978-1-78427-065-0 (Mobi)
ISBN 978-1-78427-066-7 (PDF)

British Library Cataloguing in Publication Data
A catalogue record for this book is available from the British Library.

The data in this book belong to the authors of the corresponding chapters and any further analyses or publications should not be undertaken without the approval of the authors.

RECONYX and Hyperfire are trademarks of RECONYX Inc., for more information visit www.reconyx.com. Cuddeback is a trademark of Non Typical, Inc., for more information visit www.http://cuddeback.com. ArcGis is a trademark of Esri Inc., for more information visit http://www.esri.com. Excel is a trademark of the Microsoft Corporation, for more information visit www.microsoft.com.

Cover image: Leopard (*Panthera pardus*) camera trapped in lowland rainforest in the Udzungwa Mountains of Tanzania (Rasmus Gren Havmøller and Francesco Rovero).

Contents

7. Capture–recapture methods for density estimation 95

Fridolin Zimmermann and Danilo Foresti

8. Behavioural studies 142

Fridolin Zimmermann, Danilo Foresti and Francesco Rovero

9. Community-level occupancy analysis 168

Simone Tenan

10. Camera trapping as a monitoring tool at national and global levels 196

Jorge A. Ahumada, Timothy G. O'Brien, Badru Mugerwa and
Johanna Hurtado

11. Camera traps and public engagement 219

Paul Meek and Fridolin Zimmermann

About the editors

Francesco Rovero (francesco.rovero@muse.it) is an ecologist and conservation scientist with a PhD in animal ecology. He is currently the Curator for Tropical Biodiversity at MUSE – Science Museum in Trento, Italy. He has conducted ecological research since the early 2000s on tropical rainforest mammals and made extensive use of camera trapping for his research, with focus on ecological modelling and applications of this tool to the long-term monitoring of species and communities. In 2005 he discovered, using camera traps, a new species of mammal, the grey-faced sengi or elephant shrew, in the remote forests of the Udzungwa Mountains in Tanzania. He has also been involved in camera trapping studies on large mammals in the eastern Alps, the Amazon and Mongolia.

Fridolin Zimmermann (f.zimmermann@kora.ch) is a carnivore conservation scientist with a PhD on Eurasian lynx conservation and ecology. He is currently coordinator of the large carnivore monitoring in Switzerland at Carnivore Ecology and Wildlife Management (KORA). He made extensive use of camera trapping for his research, since 2002 focusing mainly on abundance and density estimations of Eurasian lynx in different reference areas across Switzerland. He provided his expertise in several Eurasian lynx camera trapping projects abroad, including the Bavarian forest, Scandinavia, the Balkans, the Carpathian Mountains, southwestern Asia and the Himalayas. He has also been involved in Eurasian lynx radiotelemetry projects in the Jura Mountains and northwestern Swiss Alps and live captures of animals for translocation programmes.

About the contributors

Jorge A. Ahumada, Tropical Ecology, Assessment & Monitoring Network, Conservation International, 2011 Crystal Drive, Suite 500, Arlington, VA 22202 USA (jahumada@ conservation.org). Jorge is an ecologist by training and the Executive Director of the Tropical Ecology Assessment and Monitoring Network (TEAM) at Conservation International.

Eric Fegraus, Tropical Ecology, Assessment & Monitoring Network, Conservation International, 2011 Crystal Drive, Suite 500, Arlington, VA 22202 USA (efegraus@ conservation.org). Eric has a hybrid environmental and IT background and is interested in the design and development of technical tools and products relevant to the natural and social sciences.

Danilo Foresti, Ufficio della caccia e della pesca, Repubblica e Canton Ticino, Via F. Zorzi 13, 6500 Bellinzona, Switzerland; KORA, Thunstrasse 31, 3074 Muri bei Bern, Switzerland (danilo.foresti@gmail.com). Danilo is a research assistant in the public administration of Ticino, Switzerland. His professional activity includes the management of fishery resources, the restoration of aquatic habitats and the monitoring of terrestrial wildlife.

Johanna Hurtado Astaiza, Organization for Tropical Studies, La Selva Biological Station, 676-2050 Puerto Viejo de Sarapiqui, Costa Rica (johanna.hurtado@tropicalstudies.org). Johanna is a conservation biologist and the TEAM Costa Rican Site manager. Her research focus is on terrestrial vertebrate monitoring and management.

James MacCarthy, Tropical Ecology, Assessment & Monitoring Network, Conservation International, 2011 Crystal Drive, Suite 500, Arlington, VA 22202 USA (jmaccarthy@ conservation.org). Jimmy is a conservation biologist and data manager that is interested in improving conservation decisions through the use of science and technology.

Paul Meek, New South Wales Department of Primary Industries, University of New England, Suite 5, Level 1, Coffs Harbour, NSW, Australia. (paul.meek@dpi.nsw.gov.au). Paul is a terrestrial ecologist with an interest in vertebrate pest management, his research focus is on Australian predator ecology and population monitoring techniques.

Badru Mugerwa, Institute of Tropical Forest Conservation (ITFC), Mbarara University of Science and Technology (MUST), Mbarara, Uganda, PO Box. 44, Kabale, Uganda; Department of Biology, Western University, 1151 Richmond Street, London, Ontario, Canada, N6A 5B7; Wildlife Conservation Research Unit (WildCRU), University of Oxford, UK. The Recanati-Kaplan Center, Tubney House, Abingdon Road, Tubney, Abingdon OX13 5QL, UK (bmugerwa@gmail.com). Badru is a conservation biologist whose research investigates the role of human presence/activity on wildlife behavior and their conservation in human-dominated landscapes.

Timothy G. O'Brien, Wildlife Conservation Society, Bronx, NY 10460 (tobrien@wcs.org). Tim is an ecologist and statistician with a wide range of interests, including hornbills, large cats, and monitoring of mammal communities.

Daniel Spitale, Tropical Biodiversity Section, MUSE – Museo delle Scienze, Corso del Lavoro e della Scienza 3, 38122 Trento Italy (daniel.spitale@muse.it). Daniel is an ecologist with broad interests including statistic, bryology, limnology, biogeography and community ecology. He is both a freelance researcher working for different institutions and an environmental consultant.

Simone Tenan, Vertebrate Zoology Section, MUSE – Museo delle Scienze, Corso del Lavoro e della Scienza 3, 38122 Trento Italy (simone.tenan@muse.it). Simone is a quantitative ecologist focused on ecological applications in the general areas of population dynamics, community ecology, and conservation biology.

Foreword

Whether you are trying to assess the population abundance of an elusive mammal or you are chasing evidence of the presence of a very rare species, it is likely that the level of frustration will run high as you try to read the environment for signs, tracks, sounds and other clues of the species' presence. No matter how good we are as field biologists or trackers, our capacity to read the environment is often extremely limited. Even when we manage to infer the presence of a species, we are likely to remain frustrated by the weakness of the indirect evidence provided by a sign and its sporadic occurrence. Clearly, it is difficult to build a robust sampling scheme on this sort of scanty information. Reading animal signs in the field is an art built with experience and practice. The hunters of traditional societies such as the pygmies of the Congo basin or the Yanomami in the Orinoco/Amazon region can often 'see' an animal (age, sex, behaviour) from insignificant signs as if the real animal had been observed and photographed. Even if we were good trackers like those hunters, we would remain unable to design a scientifically sound sampling scheme.

Camera traps are the new tools available to field biologists providing eyes wherever we wish to have them, for any time and under any condition. They give us access to a wealth of information that was largely inaccessible using the old invasive and non-invasive techniques of species detection. Camera traps have dramatically revolutionised field biology. We need to go back to the history of radiotelemetry, its first attempts in the 1960s and its recent technological flourishing, to find a parallel of discovery and development. Radiotelemetry suddenly enabled the study of animal movements that had remained inaccessible to other field techniques and provided biologists with a simple method to track elusive animals in any habitat type and under any climatic conditions. Camera trapping is equally revolutionary and field biology will no longer be the same as this method gains in technical improvements and is supported by a wealth of analytical tools.

This book is exactly what all field biologists need to have to learn about the current state of development of the technique, its main applications and the type of data that can be obtained. Not all applications are straightforward; some are very complex and need to be used with much attention to the underlying assumptions and caveats, especially those aimed at assessing abundance and occupancy. The eruption in the number of scientific papers based on camera traps is the best evidence of the refreshing flow of datasets and hypotheses that biologists have been able to build using this tool.

However, there is more than science that is benefiting from camera traps. Probably the most important outcome of the use of this new technique is the enormous contribution to biodiversity conservation. From searching for rare species, to assessing population trends and sizes, to long-term monitoring of population status, camera traps are a precious tool that has allowed us to collect a new wealth of data critical for conservation assessment and planning. In this book, there are many examples of new species and rare species

found using camera traps, an invaluable support to the efforts to identify critical areas for conservation.

The authors are among the foremost world authorities in using camera trapping both for scientific research and for conservation applications. They have produced a book planned and written to explain the details of the technique to novices and experts. It is not a textbook but a real handbook that guides users through all the steps, from choosing the right camera to designing a sampling scheme depending on the objective, to collecting, organising and analysing data. I expect this book to be a primary source of inspiration and guide to the correct use of camera trapping. As such, it is a precious contribution to conservation.

Prof. Luigi Boitani
University of Rome Sapienza

Preface

It is widely acknowledged that scientific progress has relied on new technology as much as on new ideas to observe nature in the attempt to understand its processes. In the context of the study of wildlife, it is not an exaggeration to consider the subject of this book – camera trapping, the use of automatic cameras taking images of passing animals – as a milestone technology that has advanced the field. Indeed, the use of camera traps has introduced a completely new way to detect wildlife and has led to major discoveries, among which are the discoveries of new species of mammals. An added value of camera trapping is represented by the powerful communicative message of the images themselves: striking 'moments' of elusive and rare fauna from anywhere in the planet that can be used to boost conservation awareness worldwide. Indeed several NGOs and conservation agencies have adopted this tool for outreach programmes via the Web and social media. Similarly, camera trapping is emerging as a powerful tool in citizen science, encouraging participation by community members and groups to contribute to the collection of ecological data in their landscapes.

The wide application of camera trapping in science, along with its popularity, has concomitantly raised the need for guidance on the sound use of this tool, from selecting the right camera type among the vast and diverse range of models available on the market, to determine the sampling design, and analysing data potentially using inferential approaches. The importance of such guidance is enhanced by the fact that camera trapping became a very attractive and perhaps even trendy tool; however, it is not obviously always the best method for studying wildlife. As with any other research tools, a clear vision of the research question must precede the choice of the most adequate methodology that enables the scientific question to be answered. Moreover, there is growing integration of camera trapping with different, complementary methodologies (genetic sampling, telemetry, etc.).

On these grounds, this book aims to address comprehensively the multitude of phases involved in the use of camera trapping for scientific research and ecological inference, hence it covers topics from choosing the suitable camera trap model to defining the sampling design, and from the field deployment of camera traps to data management and data analysis for a selection of major types of studies. These latter two steps, and especially data management, are particularly overlooked in the current literature and yet are very relevant given the impressive growth in data collected by modern, digital camera traps. It is precisely the combination of these various and equally important topics into one volume that makes this book unique in the current literature.

The book addresses in great detail the key and most common ecological applications to wildlife research (species' inventory, occupancy, capture–recapture, community assessment, behavioural studies). While it deliberately does not attempt to present the full array of applications of camera trapping, we believe the knowledge provided to implement these major applications will provide researchers with the fundamental skills for a broader range of uses.

The target spectrum of readers is accordingly comprehensive: students, scientists and professionals involved in wildlife research and management.

Francesco Rovero and Fridolin Zimmermann

Acknowledgements

The editors are sincerely grateful to all contributors who joined this project with such enthusiasm and devoted their time to make the book as comprehensive and advanced as possible. They are also grateful to the external reviewers for their valuable comments on selected chapters, and to Professor Luigi Boitani for the foreword.

Francesco Rovero wishes to thank Nigel Massen of Pelagic Publishing, who proposed the book project to him in the first place, and to Fridolin Zimmermann for accepting with enthusiasm to co-edit it, hence embarking on a very fruitful, friendly and enlightening collaboration. He is also grateful to several colleagues who over the years have collaborated on camera trapping projects in Tanzania and elsewhere on the planet, from South America to Mongolia. Among these are Duccio Berzi and Gianluca Serra, 'pioneers' of camera trapping in Italy; Jim Sanderson for his visit in 2002 to the Udzungwa Mountains that triggered years of camera trapping to come, and Trevor Jones for collaborating since the very first camera traps in those forests were set; and Sandy Andelman and Jorge Ahumada for their support in establishing and running a TEAM Network site in the Udzungwa. A big thanks also goes to several collaborators and field technicians who worked on camera trapping projects in Tanzania for more than a decade, especially Emanuel Martin, Arafat Mtui and Ruben Mwakisoma. The making of the book occupied many working hours and Francesco wishes to thank the Director of MUSE – Museo delle Scienze (Trento, Italy), Michele Lanzinger, for being always supportive of his work; this project also took a lot of evenings of family time, and for these much gratitude goes to Claudia.

Fridolin Zimmermann is very grateful to Francesco Rovero for inviting him on this co-editing and writing adventure, as well as for his friendship, availability, great efficiency and competence. All this has contributed to a very enriching experience. He is also beholden to Francesco and Claudio Augugliaro for giving him the opportunity to spend two weeks in Mongolia to set camera traps for snow leopards, which gave him fresh (Mongolian) air and new motivation for the last stage of book writing. Special thanks to Urs and Christine Breitenmoser, heads of Carnivore Ecology and Wildlife Management (KORA), for their trust over the years, and to all members of the KORA team, game-wardens and volunteers involved in lynx monitoring in Switzerland over the years. He is indebted to several colleagues for stimulating ideas and discussions during camera trapping projects, meetings and workshops, especially Paul Meek, André Pittet, Stefan Suter and Kirsten Weingarth. He is grateful to the Federal Office for the Environment (FOEN), especially Reinhard Schnidrig and Caroline Nienhuis, and the cantonal hunting administrations for supporting lynx monitoring over the years. Finally, Fridolin thanks his family and friends, and especially his wife Laure, for support of all kinds and understanding, and for bearing the burden of this book for too many months.

Online resources

Free resources are available online to support your use of this book. Please visit:

http://www.pelagicpublishing.com/camera-trapping-for-wildlife-research-resources.html

1. Introduction

Francesco Rovero and Fridolin Zimmermann

Camera trapping is the use of remotely triggered cameras that automatically take images and/or videos of animals or other subjects passing in front of them. This technology is changing rapidly, largely driven by market demands in the northern hemisphere, with a large proportion of the buyers being recreational hunters. The majority of commercially available camera trap models are passive infrared digital cameras triggered by an infrared sensor detecting a differential in heat and motion between the background temperature and a moving subject, such as animals, people, or even a vehicle, passing in front of them (see Chapter 2). Camera trapping as a scientific tool is widely used across the globe especially to study medium-to-large terrestrial mammals and birds, but is increasingly being also applied to other faunal targets, for example arboreal mammals (e.g. Goldingay *et al.* 2011), semi-aquatic mammals (e.g. river otter *Lontra canadensis*; Stevens *et al.* 2004), small mammals (e.g. Oliveira-Santos *et al.* 2008) and herpetofauna (e.g. Pagnucco *et al.* 2011). Moreover, a new type of underwater camera trap was recently designed (Williams *et al.* 2014) using stereo-cameras, which greatly increase the amount of quantitative data that can be extracted from images (i.e. fish size, position and orientation). The first underwater tests have successfully illustrated the potential of this technology to reveal new insights into marine organisms.

Over the last 15 years, and in particular since 2006, there has been an exponential increase in the number of published scientific studies that used camera trapping. The number of publications per year that used camera trapping increased from less than 50 during 1993–2003 to more than 200 during 2004–2014 with a relative peak of 234 in 2012 (Figure 1.1). This vast and impressive increment in the use of this tool has been accompanied by the widening of wildlife research applications, from basic faunal inventories to focal species studies, from behavioural studies to advanced, inferential studies in numerical ecology (Rovero *et al.* 2010; O'Connell *et al.* 2011; Meek *et al.* 2012; McCallum 2013; reviews in Rovero *et al.* 2013; Royle *et al.* 2013a).

1.1 A brief history of camera trapping

We briefly review the key steps in the advent of camera trapping since its first applications; more detailed accounts of the history of camera trapping can be found elsewhere (Sanderson and Trolle 2005; Kucera and Barrett 2011).

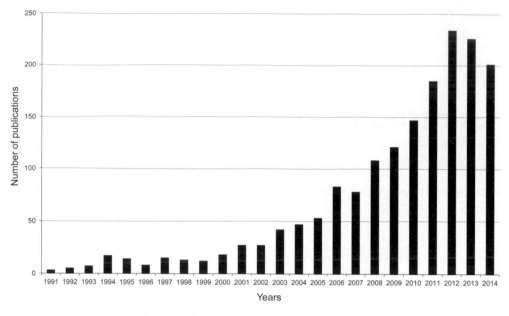

Figure 1.1 The number of camera trap articles published per year according to Web of Science queries for research domains 'sciences technology' and research areas 'zoology' and topics 'camera trap', 'infrared triggered camera', 'trail camera', 'automatic camera', 'photo trap', 'remotely triggered camera' and 'remote camera'.

Camera trapping was invented in the late 1890s by George Shiras III, a lawyer and passionate naturalist who perfected a way of photographing wildlife at night with a large-format camera and a hand-operated flash. Shiras soon gained considerable acclaim for his stunning night photographs of deer and other animals (Sanderson and Trolle 2005). The first camera trap photos were taken when Shiras set up his camera so that he could take a picture remotely by pulling on a long trip-wire. Eventually, he arranged the trip-wire so that an animal triggered the camera, hence taking its own pictures. His articles in the *National Geographic Magazine* from 1906 to 1921 created considerable interest in wildlife photography (Shiras 1913). Subsequently, in the late 1920s, Shiras taught Frank M. Chapman (then Curator of Ornithology at the American Museum of Natural History in New York) how to use camera traps for his research work in the tropical rainforest of Barro Colorado Island in Panama. Chapman used Shiras's camera traps to capture images of the diverse and, at that time, poorly known fauna, including tapirs (*Tapirus bairdii*), ocelots (*Leopardus pardalis*) and pumas (*Puma concolor*). For many years, Chapman was one of the few researchers to use camera traps.

Several decades passed before researchers rediscovered camera traps as a tool, and Seydack (1984) was probably the first to use automatic camera traps to study rainforest mammals. He collected data for inventorying species as well as to estimate bushbuck abundance and identify individual leopards in Africa. Griffiths and van Schaik (1993) used camera traps to study rainforest mammals in Indonesia, and realised the potential of this method to detect species' presence and to study the behaviour, activity patterns and abundance of elusive mammals (Griffiths and van Schaik 1993; van Schaik and Griffiths 1996). Meanwhile, Karanth begun to use camera traps to identify individual tigers in Nagarahole National Park, India (Karanth 1995). His success with applying

capture–recapture models to estimate population density from camera trap data (Karanth and Nichols 1998) led the way for camera trapping coupled with inferential statistics to become a powerful methodology for wildlife research.

Hunters, especially in the USA, began using camera traps in the late 1980s to search for trophy deer and other big-game species. This created a small industry resulting in an increasing range of camera trap models spanning a range of prices. At the same time, technology advanced quickly and modern camera traps soon became relatively small, waterproof plastic enclosures integrating all essential parts into one system (infrared sensor, digital camera, and flash).

1.2 Efficiency of camera trapping and advantages over other wildlife detection methods

Camera trapping is considered a non-invasive method that generally causes a minimum of disturbance to the study animals. While the presence of camera traps, the noise in the ultra-infrasonic range emitted by some models (Rovero et al. 2013; Meek et al. 2014), the smell signature of humans on the unit (Muñoz et al. 2014) and the flash (see below and Chapter 2 for details) could potentially modify the behaviour of passing animals, these potential sources of disturbance are clearly not comparable to those from faunal detection methods that require trapping and handling of animals. The majority of camera models and study types deploy LED flashes, which produce a red glow that is more or less visible to animals depending on the camera model (but see Chapter 2 for details); xenon white flashes, in contrast, produce an instantaneous and intense white light. The potential disturbance to animals of these types of flashes is discussed in the specific study designs (Chapters 5–9).

Camera traps work day and night and can be left unattended in the field for several weeks and even months. Such automatism not only allows for intensive and prolonged data collection over large and potentially remote areas, but makes the traps suited to study animals that are rare, elusive, and only live in remote areas. Camera trapping has also proved more efficient at detecting diurnal species compared to line transects as sighting rates with the latter may be too low, making robust assessments difficult and/or not cost efficient (e.g. Rovero and Marshall 2009).

The vital advantage of camera trapping in comparison to indirect methods used to record the presence of medium-sized to large terrestrial mammals (e.g. dung and track counts) is that photographs provide objective records ('hard fact'), or evidence, of an animal's presence and enable identification of the species. In addition, camera trapping provides information on activity pattern (from the day and time imprinted in the image) and species coexistence (Monterroso et al. 2014), on behaviour, and on the pelage characteristics that in turn can enable individual identification (see Chapter 7).

Taken together, these aspects make camera trapping a cost-efficient method for faunal detection in spite of the initial capital investment needed to purchase the equipment (e.g. Silveira et al. 2003; Rovero and Marshall 2009; De Bondi et al. 2010). Importantly, moreover, they make camera trapping relatively easy to deploy, and hence highly suitable to standardisation, as shown, for example, by the Tropical Ecology, Assessment and Monitoring (TEAM) network (http://www.teamnetwork.org), which implements a protocol of intensive sampling of terrestrial vertebrates simultaneously in (currently) 17 sites across the tropics.

De Luca, D.W. and Mpunga, N.E. (2005) *Carnivores of the Udzungwa Mountains: Presence, Distributions and Threats.* Unpublished report, Wildlife Conservation Society.

De Luca, D.W. and Rovero, F. (2006) First records in Tanzania of the vulnerable Jackson's mongoose *Bdeogale jacksoni* (Herpestidae). *Oryx* 40: 468–471.

Gil-Sánchez, J.M., Moral, M., Bueno, J., Rodríguez-Siles, J., Lillo, S., Pérez, J., Martín, J. M., Valenzuela, G., Garrote, G. and Torralba, B. (2011) The use of camera trapping for estimating Iberian lynx (*Lynx pardinus*) home ranges. *European Journal of Wildlife Research* 57: 1203–1211.

Goldingay, R.L., Taylor, B.D. and Ball, T. (2011) Wooden poles can provide habitat connectivity for a gliding mammal. *Australian Mammalogy* 33: 36–43.

Griffiths, M. and van Schaik, C.P. (1993) Camera trapping: a new tool for the study of elusive rain forest animals. *Tropical Biodiversity* 1: 131–135.

Janecka, J.E., Munkhtsog, B., Jackson, R.M., Naranbaatar, G., Mallon, D.P. and Murphy, W. J. (2011) Comparison of non-invasive genetic and camera trapping techniques for surveying snow leopards. *Journal of Mammalogy* 92: 771–783.

Karanth, K.U. (1995) Estimating tiger *Panthera tigris* population from camera trap data using capture–recapture models. *Biological Conservation* 71: 333–338.

Karanth, K.U. and Nichols, J.D. (1998) Estimation of tiger densities in India using photographic captures and recaptures. *Ecology* 79: 2852–2862.

Kucera, T.E. and Barrett, R.H. (2011) A history of camera trapping. In A.F. O'Connell, J.D. Nichols and K.U. Karanth (eds), *Camera Traps in Animal Ecology Methods and Analyses.* New York: Springer. pp. 9–26.

McCallum, J. (2013) Changing use of camera traps in mammalian field research: habitats, taxa and study types. *Mammal Review* 43: 196–206.

Meek, P.D., Ballard, A.G. and Fleming P.J.S. (2012) *An Introduction to Camera trapping for Wildlife Surveys in Australia.* Invasive Animals Cooperative Research Centre. Canberra, Australia. Accessed at: http://www.feral.org.au/camera trapping-for-wildlife-surveys (22 September 2014).

Meek, P.D., Ballard, G.-A., Fleming, P.J.S., Schaefer, M., Williams, W. and Falzon, G. (2014) Camera traps can be heard and seen by animals. *PLoS ONE* 9: e110832.

Monterroso, P., Alves, P.C. and Ferreras, P. (2014) Plasticity in circadian activity patterns of mesocarnivores in Southwestern Europe: implications for species coexistence. *Behavioral Ecology and Sociobiology* 68: 1403–1417.

Muñoz, D., Kapfer, J. and Olfenbuttel, C. (2014) Do available products to mask human scent influence camera trap survey results? *Wildlife Biology* 20: 246–252.

O'Connell, A.F., Nichols, J.D. and Karanth, K.U. (2011) *Camera Traps in Animal Ecology Methods and Analyses.* New York: Springer.

Oliveira-Santos, L.G.R., Tortato, M.A. and Graipel, M.E. (2008) Activity pattern of Atlantic Forest small arboreal mammals as revealed by camera traps. *Journal of Tropical Ecology* 24: 563–567.

Pagnucco, K.S., Paszkowski, C.A. and Scrimgeour, G.J. (2011) Using cameras to monitor tunnel use by long-toed salamanders (*Ambystoma macrdactylum*): an informative, costefficient technique. *Herpetological Conservation and Biology* 6: 277–286.

Rovero, F. and Marshall, A.R. (2009) Camera trapping photographic rate as an index of density in forest ungulates. *Journal of Applied Ecology* 46: 1011–1017.

Rovero, F. and Rathbun, G.B. (2006) A potentially new giant sengi (elephant-shrew) from the Udzungwa Mountains, Tanzania. *Journal of East African Natural History* 95: 111–115.

Rovero, F., Jones, T. and Sanderson, J. (2005) Notes on Abbott's duiker (*Cephalophus spadix* True 1890) and other forest antelopes of Mwanihana Forest, Udzungwa Mountains, Tanzania, as revealed by camera-trapping and direct observations. *Tropical Zoology* 18: 13–23.

Rovero, F., Tobler, M. and Sanderson J. (2010) Camera trapping for inventorying terrestrial vertebrates. In: J. Eymann, J. Degreef, C. Häuser, J.C. Monje, Y. Samyn, and D. Vanden-

Spiegel (eds), *Manual on Field Recording Techniques and Protocols for All Taxa Biodiversity Inventories and Monitoring*. Abc Taxa, Vol. 8 (Part 1). pp 100–128.

Rovero, F., Zimmermann, F., Berzi, D. and Meek, P. (2013) "Which camera trap type and how many do I need?" A review of camera features and study designs for a range of wildlife research applications. *Hystrix* 24: 148–156.

Rovero, F., Martin, E., Rosa, M., Ahumada, J.A. and Spitale, D. (2014) Estimating species richness and modelling habitat preferences of tropical forest mammals from camera trap data. *PLoS ONE* 9(7): e103300.

Royle, J.A., Chandler, R.B., Sollmann, R. and Gardner, B. (2013a) *Spatial Capture–Recapture*. New York: Academic Press.

Royle, J.A., Chandler, R.B., Sun C.C. and Fuller A.K. (2013b) Integrating resource selection information with spatial capture–recapture. *Methods in Ecology and Evolution* 4: 520–530.

Rutz, C. and Hays, G.C. (2009) New frontiers in biologging science. *Biology Letters* 5: 289–292.

Sanderson, J.G. and Trolle, M. (2005) Monitoring elusive mammals. *American Scientist* 93: 148–156.

Seydack, A.H.W. (1984) Application of a photo-recording device in the census of larger rainforest mammals. *South African Journal of Wildlife Research* 14: 10–14.

Shiras, G. (1913) Wild animals that took their own pictures by day and night. *National Geographic Magazine* XVII: 763–834.

Silveira, L., Jacomo, A.T.A. and Diniz-Filho, J.A.F. (2003) Camera trap, line transect census and track surveys: a comparative evaluation. *Biological Conservation* 114: 351–355.

Sollmann, R., Gardner, B., Parsons, A.W., Stocking, J.J., McClintock, B.T., Simons, T.R., Pollock, K.H. and O'Connell A.F. (2013a) A spatial mark–resight model augmented with telemetry data. *Ecology* 94: 553–559.

Sollmann, R., Gardner, B., Chandler, R.B., Shindle, D.B., Onorato, D.P., Royle, J.A. and O'Connell, A.F. (2013b). Using multiple data sources provides density estimates for endangered Florida panther. *Journal of Applied Ecology* 50: 961–968.

Sollmann, R., Tôrres, N.M., Furtado, M.M., de Almeida Jácomo, A.T., Palomares, F., Roques, S. and Silveira, L. (2013c) Combining camera trapping and noninvasive genetic data in a spatial capture–recapture framework improves density estimates for the jaguar. *Biological Conservation* 167: 242–247.

Stevens, S.S., Cordes, R.C. and Serfass, T.L. (2004) Use of remote cameras in riparian areas: challenges and solutions. *IUCN Otter Specialist Group Bulletin* A 21.

van Schaik, C.P. and Griffiths, M. (1996) Activity periods of Indonesian rain forest mammals. *Biotropica* 28: 105–112.

Williams, K., De Robertis, A., Berkowitz, Z., Rooper Ch., and Towler, R. (2014). An underwater stereo-camera trap. *Methods in Oceanography* 11: 1–12

Zimmermann, F., Breitenmoser-Würsten, Ch., Molinari-Jobin, A. and Breitenmoser U. (2013) Optimizing the size of the area surveyed for monitoring a Eurasian lynx (*Lynx lynx*) population in the Swiss Alps by means of photographic capture–recapture. *Integrative Zoology* 8: 232–243.

2. Camera features related to specific ecological applications

Francesco Rovero and Fridolin Zimmermann

2.1 Introduction

Camera trap functioning is complex and has changed vastly from its early origins (Shiras 1906; Shiras 1913; Guiler 1985) to current-day models. The first commercially available camera traps in the 1980s were xenon white flash systems connected via circuitry to a separate camera, which was often an off-the-shelf camera wired to respond to a break in an infrared beam (active infrared (AIR), see below). Over the last 20 years, technological advances have led to sophisticated units comprising a self-contained package that includes sensors and camera.

The range of camera trap brands and models currently on the market is vast, with new functions being introduced each year. Camera brands and models can vary greatly in features and specifications (Cutler and Swann 1999; Swann *et al.* 2011), however they have consistent features and components to function, the main ones being shown in Figure 2.1. In this chapter, we (1) briefly describe the camera trap components and camera systems, (2) describe the key technological features to be evaluated when choosing a camera trap system, and (3) outline the optimal interactions of these features in relation to the study designs described in section 2.4 and Chapters 5–9.

2.2 Camera trap systems

The majority of modern-day camera traps rely on a passive infrared sensor (PIR, also called a 'pyroelectric sensor') to detect a differential in heat and motion between a subject and the background temperature,[1] and on an infrared/LED flash array to illuminate the

[1] Most if not all PIR detection systems use just one PIR element that has two sensors (two vertical bands). They generate a signal linked to the difference in infrared radiation received by each sensor when the image of the animal passes from one vertical sensor to the other, provided that there is a difference in temperature between the animal and the background. With a single flat Fresnel lens, there is normally just one trigger as there is only one image formed by the lens. Many manufacturers use curved Fresnel lens arrays, which are nothing but a combination of a number of small lenses on the same support. These arrays generate multiple images of the target animal, one per 'zone'. A trigger signal will be generated whenever the animal enters or exit any of the zones (A. Pittet personal communication 2015).

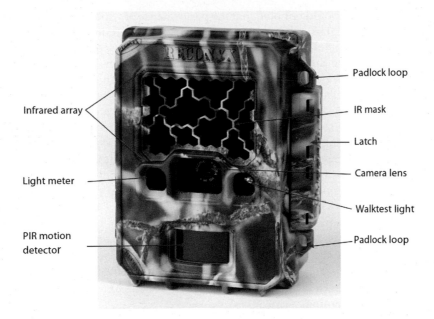

Infrared array

Light meter

PIR motion
detector

Padlock loop

IR mask

Latch

Camera lens

Walktest light

Padlock loop

Figure 2.1 Diagram of a Reconyx HC600 depicting the main components of a camera trap. (Reconyx Inc.)

target area. All animals have a heat signature in the infrared spectrum and the PIR detects this difference and triggers the camera (Meek *et al.* 2012). For a comprehensive glossary of technical terms we refer the reader to Meek *et al.* (2014a).

One limitation of PIR sensors is the way they detect differences between the target animal and the background temperature. The optimum condition for camera trapping is where the temperature differential between the target and the background is greater than 2.7°C (see Meek *et al.* 2012). PIR camera traps can therefore prove unreliable when the ambient temperature falls within the body temperature range of most mammals (31.5–36.5°C, with recorded peaks of 42.5°C). A second limitation of PIR sensors is that they can be triggered by the movement of pockets of hot air or by the motion of vegetation in the detection zone. This problem can be limited by avoiding pointing the camera directly at a background that is directly exposed to solar radiation. Another limitation of the PIR systems is that the field of view of the camera lens is rarely, with the exception of Reconyx cameras, equal to the detection zone of the PIR as will be explained in section 2.3.

Based on both sensor and flash technology, there are three main categories of camera traps, the first two being the most common ones:

1. *PIR with infrared flash*: the majority of camera traps on the market today use PIR sensors, despite the aforementioned shortcomings, coupled to an infrared LED flash, and take monochrome images at night.
2. *PIR with white flash*: two types of white flash cameras are available on the market: xenon and white LED. Xenon gas based flash systems were amongst some of the earliest of camera trap designs but faded into the background once infrared technology started to be used. In recent times, however, the demand for white flash camera traps has been reignited and, in 2012, Reconyx and Scoutguard models (see Appendix 2.1 for websites of camera trap producers) equipped with white LED flashes were released

onto the market. It should be noted that the performance of white LED flashes does not match that of xenon flashes when optimal picture clarity is required (see section 2.2).

3. *Active infrared with infrared flash*: these cameras usually have separate components (i.e. camera, transmitting unit, and receiving unit). These systems have not been widely used in recent times although at a recent colloquium their advantages over PIR were reiterated (Meek *et al.* 2014b) and steps have been taken to rekindle interest in this form of triggering system. These advantages relate to the greater flexibility in camera positioning relative to the target, as the infrared bean can be set in such a way that the camera trap is only triggered when the animal passes a very precise point in the field of view, the height of which can be adjusted, hence avoiding smaller, non-target species. This in turn may lead to higher photographic quality. Faunatech Australia and PhotoTrap are among the few remaining companies that still market this type of camera trap and provide wireless connection as an option. The major disadvantage relative to PIR cameras is that if any part fails (e.g. cable failure or damage in non-wireless connections resulting from pulling or chewing animals, misalignment, battery failure of the camera or sensor), the entire system fails. Also, since the camera trap comprises separate components, the equipment becomes heavier and more cumbersome to use. Finally, setting the separate units is logistically more complex and thus time consuming.

2.3 Camera features to consider when choosing models

A clear vision of the research question and hence adequate sampling design must precede the choice of camera trap features (see Nichols *et al.* 2011). A number of practical and local environmental factors will also affect the choice of camera type, notably target species, site accessibility, climate, target site (i.e. trails or focal points such as ponds or baited stations), and habitat (open vs. densely covered in vegetation). This is because the various camera trap features will result in varying performance depending on these factors. For example, the PIR sensitivity should be suited to the body size of the target species and to the local temperature; flash intensity will give different results depending on the target site (e.g. a narrow trail or a wider zone); camera trap dimensions and weight can be important, for example when travelling into very remote areas; the housing will be important especially where extreme weather conditions are experienced; and power autonomy will be relevant for studies where cameras cannot be checked regularly.

Since there is currently no 'ultimate' camera trap (see Meek and Pittet 2012 for details) on the market that can be used for all kinds of studies, in agreement with Rovero *et al.* (2013) we propose the following 10 camera features be evaluated when choosing camera trap type and models. We do not explicitly consider cost here, although it is obviously one of the most influential factors when researchers choose a camera model (Meek and Pittet 2012). However, cost is mainly a function of camera performance—for example, cameras that are resilient to tropical climates and offer a fast trigger speed, weather-resistant case and high-quality images will likely cost more than less robust cameras with slow trigger speeds.

1. *Trigger speed*: this is a fundamental feature of cameras, if not *the* critical one. It is the rapidity with which the camera captures an image relative to when the sensor detects the passing target. A 'fast' trigger speed (usually < 1 s) increases the probability of a target being recorded; a 'slow' trigger speed may result in missing targets. This feature

should be more correctly called 'trigger delay', with low delays corresponding to fast trigger speed, however we retain the commonly used term 'trigger speed'. Trigger speed and detection zones are interacting parameters, because a slow trigger speed can be compensated for by a wide detection zone.

2. *Flash type (white or infrared)*: cameras with white flash are fundamental when sharp and/or colour pictures are needed at night as well as in daytime, as is the case with capture–recapture studies that require individual recognition (see below), or for faunal inventories, as colour pictures will increase the chance of identifying species. Currently, classic xenon flashes outperform white LED flashes in terms of image sharpness, because the xenon flash is more powerful and its duration is short enough (of the order of 10^{-3} s) to freeze moving animals. Recently moreover, no-glow (also called 'black') infrared flashes have been introduced to minimise the red glow emitted by standard infrared LEDs, which can be seen by animals (Meek *et al.* 2014c). These no-glow flashes should minimise trap-shyness by animals and limit the risk of damage or theft by humans. However, while no-glow flashes may be invisible to humans, there is evidence that they can still be seen by animals; moreover, any camera trap can be heard by animals, because they emit noise in the infra-ultrasonic range (Meek *et al.* 2014c), and they can even be smelled by animals (Muñoz *et al.* 2014). A limited number of PIR camera trap models have dual (xenon and infrared flash; e.g. Spypoint, Bolymedia) or triple (xenon, infrared and black LEDs flashes; e.g. Cuddeback C123) flashes. With this option the user can choose the optimal flash according to the study aim.

3. *Detection zone*: this is a critical, albeit often overlooked feature. It is the area in which a camera trap is able to detect the target through its sensor. The detection zone is not necessarily equal to the camera's field of view, i.e. the area included in the actual photograph. Detection zone area varies widely among current models (15–324 m², data in Meek *et al.* 2012), and for some, only a small proportion of the field of view actually corresponds to the camera's detection zone. Today many commercial camera traps are equipped with curved-array Fresnel lenses, resulting in a wide detection angle and triggering the PIR sensor even before the animal is in the camera's field of view; this compensates for a relatively slow triggering system (Meek and Pittet 2012). On the contrary, depending on the technical specifications of the PIR sensor a few models sense through a single lens, resulting in a relatively narrow, conical shaped detection zone, and a few others through a combination of horizontal bands and vertical axis zones (e.g. Reconyx). Generally, camera traps with a narrow detection zone, i.e. smaller than the camera's field of view, have fast trigger speeds and will take the photo when the animal is well within the field of view. The detection zone and the field of view can both be increased to some extent by moving the camera further away from the target, and this will compensate for slow trigger speeds.

4. *Number of photos taken, recovery time, and video*: a number of infrared flash cameras are capable of taking bursts of images in rapid sequence,[2] which may be important for a

[2] For multiple shots triggered by the same event, the minimum time between pictures is technically limited on one side by the time taken to transfer a frame from the sensor to the storage device, and on the other side, for night photographs, by the time needed to recharge the flash. The limitation due to transfer rate could be partly overcome by having an intermediate storage in RAM before writing to the memory card. The limitation due to the need to recharge the flash is valid for xenon flashes that discharge a high voltage capacitor into a xenon tube. This limitation usually does not exist for white or IR LED flashes as they use much less energy and do not require energy accumulation in capacitor followed by discharges (A. Pittet, personal communication 2015).

number of purposes, e.g. better animal identification (as the chances of obtaining a good image within a burst will be increased, especially when animals are not moving too fast) and recording individuals within family groups and packs. At night, xenon white flash cameras are not capable of taking photo bursts or videos due to the flash recharge time being ≥10 s; however, the recently proposed white LED flash cameras do not suffer from this limitation. Rapid image sequences and videos can be useful for behavioural and monitoring studies (e.g. to determine the minimum number of wolves in a pack) or for specific research needs (e.g. in northeastern Italy, videos are used to study the use of rubbing trees by brown bears; Tattoni *et al.* 2015). However, data handling is more time consuming, memory cards are filled up faster and power consumption is greater, hence videos are not recommended when photographs alone provide the data required. In this book the data management and core analytical approaches (Chapters 4–7 and 9) are based on the use of images, while we recommend the use of videos for specific examples of behavioural studies (Chapter 8).

5. *Sensitivity*: a setting, often adjustable, that regulates the sensor responsiveness to the target by changing the heat sensitivity threshold. In general, high sensitivity is better for detecting small-sized animals; however, high sensitivity will increase the chance of misfiring when the sun hits the target site, and a highly sensitive sensor is more likely to be triggered by moving vegetation.

6. *Flash intensity*: a number of digital camera models can adjust the flash intensity automatically according to the distance of the subject from the camera. Some models offer the option to adjust the amount of light generated for two to three distance settings (e.g. UVision UV565HD), while in the majority of models the flash is programmed for maximum distance and illumination. A number of camera models have a setting that adjusts the ISO, hence adjusting the image sensor sensitivity to light. The white flash LED Reconyx PC850 and HC550 adjust the intensity according to the distance an animal is from the device. The Scoutguard 860C uses white LED illumination and with a firmware upgrade[3] can be adjusted for close settings. We expect to see in the future more systems offering automatic adjustment of the flash intensity as is the case for all hand-held digital cameras.

7. *Power autonomy*: studies in remote areas or deploying intense sampling often require high power autonomy; generally, cameras with xenon white flash consume more battery power than those with infrared flash. The three most common battery types used by camera traps are lithium, nickel–metal hydride (NiMH) and alkaline. Lithium batteries are generally preferred for their high power output and resilience, but are also the most expensive. Although rechargeable batteries have a higher initial cost, they can prove more economical in the longer run over alkaline and other non-rechargeable batteries as they can be reused multiple times. Importantly, moreover, they produce less toxic waste in landfill, and can be recycled. However, the voltage of NiMH batteries is lower than those of alkaline and lithium batteries, and therefore some systems may not work reliably. Although nowadays most camera traps are designed to work with NiMH batteries, it is recommended that camera trap functionality be checked prior to setting up in the field. Moreover, rechargeable batteries require greater maintenance: they need to be recharged from an electrical source not only during fieldwork but also immediately afterwards because they

[3] Some camera trap manufacturers propose firmware updates, which allow the camera to be improved with enhanced performance and new features. We recommend visiting their website prior to camera deployment to check for firmware updates.

should be stored at a level of charge that depends on the battery type to maximise their life span. Alkaline batteries are the most common battery type and are widely used in camera traps even though they discharge quicker than lithium batteries. A number of camera models (e.g. Spypoint, Uway, Buckeyecam, Cuddeback C123; see Appendix 2.1) mount an input jack for external batteries or small solar panels, and thus higher-capacity lead–acid batteries can be used to prolong deployment. Despite the higher initial costs, we highly recommend using rechargeable batteries as long as the camera trap performance is not compromised. Most modern camera traps currently use AA size batteries. As the availability of batteries on the market changes quickly, we encourage users to regularly check for new batteries and to test the most promising one in a field or controlled trial. In this regard, the newly released NiZn rechargeable batteries have a voltage comparable to non-rechargeable batteries and seem, therefore, very useful for camera traps.

8. *Image resolution, sharpness and clarity*: the majority of camera traps on the market take medium- to high-resolution pictures and videos; however, a more critical feature is the sharpness and clarity of colour images, needed for identification of individuals and in some cases to identify species. For night pictures, only those images taken with a white xenon flash are clear and sharp enough to allow identification of individuals of naturally marked species. Moreover, the resolution and clarity of images is often critical when using camera traps for small animals, especially where sympatric species coexist and morphological features can be similar. However, researchers should be aware that the number of pixels declared in camera trap specifications is often larger than actually achieved due to pixel interpolation. In addition, a higher pixel number is often accompanied by an increase in digital noise and chromatic aberrations. On the other hand, the higher the (true) image resolution, the slower the shutter speed, which can result in blurred images in low-light conditions; therefore, a compromise between resolution and shutter speed is needed to produce the sharpest images. Some infrared camera trap models have a 'night mode' option that maximises clarity at night by reducing the illumination power and increasing the speed of the shutter, thus reducing the chance of obtaining blurry images.

9. *Camera housing and sealing*: the housing, camouflage, and water- and insect-proof qualities of camera traps is extremely important in wildlife research (Swann et al. 2011; Meek and Pittet 2012). This is especially so where extreme weather conditions are experienced (snow, rainfall and humidity). The housing should allow easy attachment of the unit to the tree or support used, and it should be possible to replace batteries and memory cards without needing to move the camera from its support. Cameras should ideally have a screw thread on the underside of the housing for attaching positioning brackets (Meek and Pittet 2012). The weight and size of the camera trap can also be important in many contexts. In addition, the ability to protect cameras with metal cases and lock them is critical against theft, human vandalism, and disturbance/damage by organisms (including large and small animals, insects, plants and fungi). Protection cases are available for most commercial camera traps to protect them against large mammals such as elephants and bears.

10. *Camera programming and setting*: these should be as simple as possible, to allow for field workers with varying degrees of experience to set camera traps without errors. In addition, most cameras have the option of programming the operation schedule to avoid unnecessary images, which may be useful, for example, when only nocturnal species are targeted. Customisation features that allow normal PIR sensing images to be taken in combination with a time-lapse mode enable researchers to confirm that

the camera trap was operational throughout the duration of the deployment, which is especially important when no photos have been taken. In areas with a high risk of theft, a password can be set to make the system unusable if stolen.

Through a survey of 154 researchers using camera traps around the world, Meek and Pittet (2012) summarised some of the important features of the 'ultimate camera trap', which included: 2 photos taken within 1 s with 0.5 s latency to first trigger, ≥5 megapixel resolution, 1–100 images per trigger, video length programmable to continue until the motion stops to prevent long-lasting empty video sequences filling the memory cards, time-lapse function, aperture controls for close up and distant detection, dual-flash systems, flash intensity control, high-definition video with sound. They also highlighted some additional requirements such as remote viewers with detection zone water marks, wide-angle PIR detection sensors, and battery meters, as well as a range of suggested housing and locking systems to improve field deployment. Whilst packaging all of these sometimes conflicting features into one device would be challenging and prohibitively expensive, all of these suggestions are well founded and desirable. The challenge is in keeping the cost affordable so that researchers can still purchase the number of units needed for robust scientific research.

2.4 Camera performance in relation to study designs

Chapters 5–9 focus on study designs; here we detail which camera features are best suited to different study designs (Table 2.1).

Table 2.1 Summary of sampling designs and camera features for key study types based on camera trapping

Study type	Camera features
Faunal inventories	White flash, high sensitivity if small species are targeted, large detection zone, fast trigger speed.
Occupancy	Infrared flash, sensitivity tuned to species size.
Density estimation through capture–recapture	Xenon white flash, short delay between consecutive pictures, high sensitivity if small target species, fast trigger speed, either two xenon white flash camera traps per site or one xenon white flash combined with an infrared or white LED camera trap which allows multiple photos per trigger.
Behavioural studies	Burst of images or video (with sound), time-lapse mode, fast shutter speed or high-resolution video, high sensitivity and fast trigger speed; no glow flash (to reduce disturbance).

2.4.1 Faunal inventories

To detect animals when conducting a general faunal inventory by camera trapping (see Chapter 5), one needs to maximise the chances of capturing clear images of the greatest number of species possible. Accordingly, the ideal camera should have high sensitivity, a fast trigger speed, a wide detection zone (especially if the trigger speed is low), and appropriate power autonomy to be left for relatively long times (minimum 30 days).

Critically, white flash cameras (particularly those equipped with a xenon flash, which produces images sharper than those taken with white LED flash) produce better colour images both night and day, and hence facilitate identification. In tropical countries, cameras will need to be robust and resistant to moisture, rain, and insect intrusion.

While these indications apply to general inventories of medium to large species (i.e. from approximately 500 g), detection of focal species or groups of species will need specific camera features and designs. For example, if one targets small-bodied species, camera sensitivity will become critical. Likewise, when an animal's coat colour and pattern is of relevance (assessing skin diseases, detecting suspected new species or range records, recording poaching signs on animals, etc.), then obtaining sharp, high-quality colour pictures will be critical; for example, a colour photo from a camera trap was instrumental in identifying a new species of giant sengi, or elephant-shrew, from Tanzania (Rovero and Rathbun 2006).

2.4.2 Occupancy studies (species and community-level)

Occupancy studies are fundamentally based on multiple detections of passing animals triggering camera traps arranged in randomly placed grids of predefined size. Hence, it is critical to use cameras with fast trigger speeds in order not to miss passing animals. Other requirements, such as sensitivity, will depend on target species and communities. For studies in diverse communities, such as in tropical forests, cameras should be tropicalised and of high quality to allow for clear identification of animals. The TEAM programme, which implements the largest network of camera traps in the tropics, uses highly sensitive, professional PIR cameras equipped with infrared flash (TEAM Network 2011).

2.4.3 Capture–recapture

For species with individually distinct fur patterns or artificial marks, data from camera trapping can be analysed with a closed capture–recapture model framework, to estimate abundance and density (Chapter 7). This approach relies on identifying individuals of the study population based on coat patterns or artificial marks.

Camera traps producing high-quality photos in terms of clarity, sharpness (moving objects should not be blurred), and resolution are even more critical for species that do not have easily distinguishable coat patterns (e.g. rosettes in Eurasian lynx *Lynx lynx*) and for those that lack individually identifiable natural markers (e.g. puma *Puma concolor*). Furthermore, high-quality pictures are a prerequisite for pattern recognition software (e.g. Hiby *et al.* 2009; http://www.conservationresearch.co.uk/lynx/lynx.htm [22 September 2014]; Bolger *et al.* 2012; Oscar *et al.* 2015; see also Chapter 7), which are increasingly being used as camera trap studies extend their range of sampling both temporally and spatially. Currently the ideal camera traps for capture–recapture studies are those with PIR sensors and a xenon white flash (that has at least two flash distance settings), with a short delay between consecutive pictures (currently up to 10 s are necessary for the flash of the Cuddeback C123 to recharge), and a high trigger speed. However, because camera traps should be placed in pairs to photograph both flanks of the passing animal, researchers have assessed the opportunity to combine the non-overlapping advantages and disadvantages of xenon flash with infrared LED flash. In particular, the combination of an infrared LED flash camera, which allows multiple photos per trigger or videos, with

a xenon white flash camera has proved to be an efficient system for gathering pictures of sufficient quality to enable individual identification while enabling detection of family groups or individuals following each other within short distances and short times (F. Rovero unpublished data). In addition, multiple photos per trigger and videos can document how animals react to the camera traps.

2.4.4 Behavioural studies

For most activity pattern studies, the use of photography as the recording mode may be adequate; however, if the aim is to make a detailed study of some specific behavioural sequences (e.g. marking behaviour of a lynx at marking site, Vogt *et al.* 2014 or brown bears at rubbing trees; see Chapter 8), camera traps with video mode or camera traps that are capable of taking bursts of images within a short time (0.5–1 s) are essential. It should, however, be taken into account that trigger speeds are generally longer in video recording mode compared to picture recording mode (e.g. it takes up to 6 s for a Bushnell to start the video after it has been triggered). Optimal camera traps for these studies should have high sensitivity (especially if the study is targeting small species), and fast trigger speeds (usually <1 s) so as not to miss animals passing in front of the camera and/ or any phases of a behavioural sequence. In addition, if individuals can be identified based on natural or artificial marks and if individual recognition is important for the aim of the study, cameras with a fast shutter speed to prevent blurring of moving objects on the pictures, or videos with an adequate resolution should be used. Video with sound can also be important in particular if the aim is to study intra- or inter-species communication and/or interactions. The camera functions should make it possible to change the number of pictures per trigger, the video length (10–60 s), the resolution, and the delay after triggering (i.e. the time interval between consecutive photographs when more than one photograph is taken per trigger event) for photos/videos. A camera with a time-lapse mode is appropriate when the event of interest occurs frequently (e.g. recording the migration of salmon, Hatch *et al.* 1994; monitoring of species at a water hole) or when a continuous record is requested. Low-glow or no-glow infrared flash should be used in order to minimise animal disturbance. Moreover, a flash intensity that varies with the distance of the animal to the camera trap or at least a flash with two different distance settings is ideal to prevent over- or under-exposed pictures or videos. If the aim is to study large groups of animals the field of view of the (video) camera should be as large as possible and the infrared LED illumination powerful enough to cover a large portion of the field of view.

2.5 Review of currently available camera trap models and comparative performance tests

Although as mentioned earlier there is a high turnover in the camera traps available on the market, we will try here to provide a selection of models classified by cost range for the currently available, most reliable and most widely used PIR camera traps for wildlife research (Table 2.2). In addition, useful information about current camera trap models can be found on websites with detailed reviews of camera trap models (e.g. http://www. chasingame.com, http://www.trailcampro.com, http://www.cameratrap.co.za), as well as on a camera trapping information exchange group (http://uk.groups.yahoo.com/group/ cameratraps).

Table 2.2 List of currently available and most used passive infrared sensor (PIR) camera traps for wildlife surveys, arranged by cost range. All prices are indicative and subject to change by manufacturers. Manufacturer, model, flash technology, and trigger speed are given for each model (IR = infrared).

Manufacturer	Model	Price	Flash technology	Trigger speed (s)
Buckeye	Cam X7D/X80	$$$	No-glow IR LED	2 triggers in 0.1 s
	Cam Orion	$$$	IR LED	0.2
Bushnell	Trophy Cam HD Aggressor	$$	No-glow IR LED	<0.2
Covert	Extreme HD40	$	IR LED	1.2
Cuddeback	C123	$	Trio Xenon white, IR LED and no-glow IR LED	0.25
Moultrie	M-990i Gen2	$	No-glow IR LED	0.69
	Panoramic 150	$$	IR LED	<1
Pixcontroller	Raptor	$$$	IR LED or no-glow IR LED	1
Reconyx	HC500	$$	IR LED	0.2
	HC550/600	$$$	White LED/no-glow IR LED	0.2
	PC800/850/900	$$$	IR LED/white LED/no-glow IR LED	0.2
	PC900C	$$$	No-glow IR LED	0.2
ScoutGuard	860 C	$	White LED	1.2
	SG565FV	$	Xenon white	1.1
Spypoint	FL-8	$$	Dual xenon white and IR LED	<0.6
UWAY	MB500	$$	No-glow IR LED	1.2
	U150	$	IR LED	1.2
	U250	$	IR LED	1.2
	VH200HD	$	No-glow IR LED	1.2

Price range: $$$, high end (US$500–1,200); $$, mid range (US$250–<500); $, low end (<US$250).

Despite the wide range of camera trap models available on the market, there are very limited data on the strengths and weaknesses of the various models for the purposes of scientific research. An intrinsic limitation is that camera trap models are continuously changing and by the time publications appear, the information therein is dated. In addition, proper assessment of camera traps is potentially expensive and time consuming, requiring laboratory testing and the inclusion of many camera models. Hence, there is a need to develop standard procedures for testing camera traps for scientific research that can be compiled in databases and made widely available through the web.

As notable exceptions, Swann *et al.* (2004) evaluated six models of camera trap to provide guidance on the suitability of certain models for specific studies. More recent field trials of camera trap models (Hughson *et al.* 2010) found greater variation between models than reported by Swann *et al.* (2004). Weingarth *et al.* (2013) attempted to

determine what camera traps were suitable for estimating Eurasian lynx abundance and density using capture–recapture models, and proposed a process for testing new camera trap models with regards to trigger speed and the image quality necessary for visual identification of lynx moving along trails. Recently Wellington *et al.* (2014) conducted head-to-head field trials with two camera traps (Cuddeback Capture IR and Reconyx HC 600 Hyperfire) to evaluate the potential source of sampling bias when several models of camera traps with different attributes that can affect sampling efficiency are used. Reconyx cameras (large detection zone and high-sensitivity motion detector) recorded approximately twice as many independent photographs as did the paired Cuddeback cameras. The performance differences between the two cameras were reduced when the sensitivity of the motion detector on the Reconyx cameras was lowered and a wooden stake with bait was positioned in the centre of the immediate detection zone of both camera traps. They concluded that biologists undertaking camera trapping studies that use more than one model of camera traps consider a testing phase where they can evaluate the differences among cameras. If such differences are disregarded, they could introduce unwanted heterogeneity in species detectability that should either be avoided or accounted for in the analyses.

2.6 Limitations and future developments of camera technology

Camera trap technology has made impressive progress in recent years and manufacturers such as Reconyx, Scoutguard and Cuddeback have started to introduce some of the features for the ultimate camera trap suggested by Meek and Pittet (2012), highlighting the influence users can have in future technological development. However, there are still critical limitations with current technology. These include: (1) Detection of camera traps by animals. Our experience indicates that no camera trap remains completely unnoticed by animals, as even professional Reconyx IR models with 'no glow' flash and the newly released Cuddeback black flash are noticed or heard by the animals. Some species can see the infrared flash and/or hear the noise in the infra-ultrasonic range generated by cameras and/or even smell the camera trap (Muñoz *et al.* 2014) or the odour left by the investigator while checking the camera trap. (2) In many models, both white and infrared LED flashes are not powerful enough to allow a fast shutter speed, resulting in blurred photos. (3) There is a need for all digital camera traps (infrared, xenon and LED white flash) to adjust flash intensity automatically to the subject distance to avoid overexposed photos. (4) Digital infrared camera traps producing high-quality pictures which allow multiple photos per trigger should be developed. (5) Passive motion detectors do not have a 100% detection (when two passive camera traps are set at the same site some animals detected by one camera trap will not be detected by the other camera) and therefore commercial camera traps with active motion detection should be developed in the future. (6) Systems that take one picture with xenon flash before proceeding to capture infrared LED images or even videos should be developed in the future.

A number of camera trap manufacturers have proposed a system were several camera traps (up to 10 in Spypoint) communicate through a black box receiver (e.g. Spypoint Tiny W3). When a picture is taken and written to the SD card of the camera, it is also being wirelessly transmitted in a lower resolution to the SD card of a remote (within 150 m) receiver which can be hidden. The receiver enables to delete/view the photos and to remotely control the camera settings. Such a system can reduce download and

programming time, prevents data losses and provides a useful security feature whereby if the camera is stolen it may capture a picture of the thief and transmit it to the hidden receiver. In addition it prevents the camera trap sites from being disturbed frequently.

Some camera trap models have integrated a GSM module which allows the transmission of basic data (i.e. time of last recording, GPS position) and images via MMS to an email address or a cellphone or through a GPRS system to email addresses only. Like wireless camera trap networks, it is possible to remotely control these camera traps (e.g. switch from photo to video mode, request real-time images or the location of the camera). Future development of GSM devices should include alert messages for when the device has low batteries, or the memory card is full. GSM devices are increasingly being used for animal welfare issues to remotely view live traps (e.g. box-traps) in order to limit the time animals spend in the trap and to allow the whole capture team (perhaps including a veterinarian) to be summoned only when the target species is caught. Such devices are also used to determine what mammals are present and where and when they are active. For this purpose 30 still and video cameras - directly transmitting images and videos to an email account by means of a wireless network covering the area – were installed around the 1,200 acre Jasper Ridge Biological Preserve, Stanford University (Ashe 2012). In a similar but more revolutionary way, the WiSE project (Nazir *et al.* 2013) developed a digital platform for smart internet-enabled video monitoring. This system connects sensors and cameras to a gateway that coordinates the monitoring and also provides backhaul connectivity[4] to the internet. As mentioned for the black-box receiver, these systems too have the advantage of real-time access to imagery, which reduces the time and effort needed for data collection. This may be particularly critical for camera trap sites that are remote or difficult to access (e.g. tree canopies). However, any such transmission facility comes at an energy cost and therefore has an impact on battery life or size.

Appendix

Appendix 2.1 List of camera trap producers' websites

Acknowledgements

We are grateful to André Pittet and Paul Meek for valuable comments on previous versions of this chapter.

References

Ashe, K. (2012, 1 June) Caught on tape: the nightlife of animals at Stanford's Jasper Ridge preserve. *Stanford News*, http://news.stanford.edu/news/2012/june/jasper-ridge-cameras-060112.html (accessed 12 February 2015).

Bolger, D.T., Morrison, T.A., Vance, B., Lee, D. and Farid, H. (2012) A computer-assisted system for photographic mark–recapture analysis. *Methods in Ecology and Evolution* 3: 813–822.

Cutler, T.L. and Swann D.E. (1999) Using remote photography in wildlife ecology: a review. *Wildlife Society Bulletin* 27: 571–581.

[4] Wireless network technology to transmit voice and data traffic from a cell site to a switch, i.e. from a remote site to a central site.

Guiler, E.R. (1985) *Thylacine: The Tragedy of the Tasmanian Tiger*. Melbourne: Oxford University Press.

Hatch, D.R., Schwartzberg, M. and Mundya, P.R. (1994) Estimation of Pacific salmon escapement with a time-lapse video recording technique. *North American Journal of Fisheries Management* 14: 626–635.

Hiby, L., Lovell, P., Patil, N., Kumar, N.S., Gopalaswamy, A.M. and Karanth, K.U. (2009) A tiger cannot change its stripes: using three dimensional model to match images of living tigers and tiger skins. *Biological Letters* 5: 383–386.

Hughson, D.L., Darby, N.W. and Dungan, J.D. (2010) Comparison of motion-activated cameras for wildlife investigations. *Californian Fish and Game* 96: 101–109.

Meek, P.D. and Pittet, A. (2012) User-based design specifications for the ultimate camera trap for wildlife research. *Wildlife Research* 39: 649–660.

Meek, P.D., Ballard, A.G. and Fleming, P.J.S. (2012) *An Introduction to Camera Trapping for Wildlife Surveys in Australia*. Invasive Animals Cooperative Research Centre, Canberra, Australia, http://www.feral.org.au/camera-trapping-for-wildlife-surveys (accessed 5 February 2015).

Meek, P.D., Ballard, G., Claridge, A., Kays, R., Moseby, K., O'Brien, T., O'Connell, A., Sanderson, J., Swann, D.E., Tobler, M. and Townsend, S. (2014a) Recommended guiding principles for reporting on camera trapping research. *Biodiversity and Conservation* 23: 2321–2343.

Meek, P.D., Ballard, A.G., Banks, P.B., Claridge, A.W., Fleming, P.J.S., Sanderson, J.G. and Swann, D.E. (eds) (2014b) *Camera Trapping in Wildlife Research and Management*. Collingwood, Australia: CSIRO Publishing.

Meek, P.D., Ballard, G.-A., Fleming, P.J.S., Schaefer, M., Williams, W. and Falzon, G. (2014c) Camera traps can be heard and seen by animals. *PLoS ONE* 9: e110832.

Muñoz, D., Kapfer, J. and Olfenbuttel, C. (2014) Do available products to mask human scent influence camera trap survey results? *Wildlife Biology* 20: 246–252.

Nazir, S., Fairhurst, G., Verdicchio, F., van der Wal, R. and Newey, S. (2013) Resource monitoring with wireless sensor networks and satellite. Conference paper, Open Digital, Salford, UK, November 2013.

Nichols, J.D., O'Connell, A.F. and Karanth, K.U. (2011) Camera traps in animal ecology and conservation: what's next? In: A.F. O'Connell, J.D. Nichols and K.U. Karanth (eds), *Camera Traps in Animal Ecology. Methods and Analyses*. New York: Springer. pp. 253–263.

Oscar, M., Lluis, M.P., Sergio M., Manuel, I.J., Andreu, R., Antonio, R. and Giacomo, T. (2015) APHIS: a new software for photo-matching in ecological studies. *Ecological Informatics* 24: 64–70.

Rovero, F. and Rathbun, G.B. (2006) A potentially new giant sengi (elephant-shrew) from the Udzungwa Mountains, Tanzania. *Journal of the East African Natural History Society* 95: 111–115.

Rovero, F., Zimmermann, F., Berzi, D. and Meek, P. (2013) "Which camera trap type and how many do I need?" A review of camera features and study designs for a range of wildlife research applications. *Hystrix, the Italian Journal of Zoology* 24: 148–156.

Shiras, G. (1906) Photographing wild game with flash-light and camera. *National Geographic Magazine* XVII: 367–423.

Shiras, G. (1913) Wild animals that took their own pictures by day and night. *National Geographic Magazine* XVII: 763–834.

Swann, D.E., Hass, C.C., Dalton, D.C. and Wolf, S.A. (2004) Infrared-triggered cameras for detecting wildlife: an evaluation and review. *Wildlife Society Bulletin* 32: 357–365.

Swann, D.E., Kawanishi, K. and Palmer, J. (2011) Evaluating types and features of camera traps in ecological studies: guide for researchers. In: A.F. O'Connell, J.D. Nichols and K.U. Karanth (eds), *Camera Traps in Animal Ecology. Methods and Analyses*. New York: Springer. pp. 27–44.

Tattoni, C., Bragalanti, N, Groff, C. and Rovero, F. (2015) Patterns in the use of rub trees

by the Eurasian Brown Bear. *Hystrix: the Italian Journal of Mammalogy* doi:10.4404/hystrix-26.2-11414.

TEAM Network 2011. *Terrestrial Vertebrate Protocol Implementation Manual, v. 3.1.* Tropical Ecology, Assessment and Monitoring Network, Center for Applied Biodiversity Science, Conservation International, Arlington, VA, USA. http://www.teamnetwork.org/files/protocols/terrestrial-vertebrate/TEAMTerrestrialVertebrate-PT-EN-3.1.pdf (accessed 5 February 2015).

Vogt, K., Zimmermann, F., Kölliker, M. and Breitenmoser, U. (2014) Scent-marking behaviour and social dynamics in a wild population of Eurasian lynx *Lynx lynx*. *Behavioural Processes* 106: 98–106.

Weingarth, K., Zimmermann, F., Knauer, F. and Heurich, M. (2013) Evaluation of six digital camera models for the use in capture-recapture sampling of Eurasian lynx (*Lynx lynx*). *Forest Ecology, Landscape Research and Nature Conservation* 13: 87–92.

Wellington, K., Bottom, C., Merrill, C. and Litvaitis, J.A. (2014) Identifying performance differences among trail cameras used to monitor forest mammals. *Wildlife Society Bulletin* 38: 634–638.

3. Field deployment of camera traps

Fridolin Zimmermann and Francesco Rovero

This chapter addresses the general practicalities of deploying camera traps in the field, irrespective of the study design (unless explicitly stated). For additional details we also refer to Rovero *et al*. (2010), Team Network (2011), Ancrenaz *et al*. (2012), Meek *et al*. (2012), Sunarto *et al*. (2013) and van Berkel (2014). The study aim, and consequent sampling design, will determine the type of camera trap, the number of camera stations and cameras per station (single or pairs) to be set, their location and placement, and the season and duration of the sampling (Chapters 5–9). These factors will in turn determine the duration of the fieldwork, and the personnel, transport and infrastructure needed. In general terms, local expertise among the field team and the involvement of local personnel in the field (e.g. rangers, hunters, nature lovers) will be critical for choosing suitable camera trap sites even for studies that target the whole community of medium-to-large terrestrial vertebrates and for which a random sampling is recommended, such as in occupancy studies (Chapter 6).

Under some particular circumstances – e.g a new study area for which very little knowledge is available – a pilot study prior to the survey itself may be critical (Silver 2004; Jackson *et al*. 2005). This will help researchers identify suitable camera trap sites, ensure that a large enough area can be sampled, test the equipment under the specific field conditions, optimise the settings and positioning of the camera traps, train the field staff, and make contact with the local community ahead of the survey. While setting camera traps is relatively easy, trained field personnel are needed at all stages to ensure proper setting and retrieval of cameras and strict adherence to the sampling and camera-setting criteria needed for the particular study.

3.1 Pre-field planning

Once the sampling design has been defined (see Chapters 5–9), we propose that the following key steps are considered before any fieldwork is conducted:

1. Ensure that all requested authorisations are acquired from relevant authorities and local communities.

2. Ensure that means of transport, infrastructure (e.g. field station), and field staff and/ or trained volunteers are available to conduct the survey during the specified period.
3. Make a list of all the equipment needed to conduct the survey including spare material (see below).
4. Prepare and test all equipment, including newly bought devices.
5. Plan in detail the itinerary of field days with a list of all the material needed, for each field team if multiple teams are involved, and for each field day (see below for checklist of material).

We strongly recommend mapping the camera locations (using a global map of the study area showing the field site(s) and a detailed map for each site(s)) and storing them in a GPS unit. This will assist precise navigation in the field (or to the sampling area). As a back-up it is also useful to have a hard copy of the camera site localities in case the GPS-stored locations are lost.

The list of essential equipment includes:

- Camera traps (including extra units), cables or mounting brackets with adjustable mounts (heads) to affix camera traps to trees.
- Security cables with locks,[1] if deemed necessary.
- Cordless electric drill and screws to fix mounting brackets on trees.
- Portable devices to visualise images from cards in the field (e.g. a digital camera, a card reader, a tablet or a smartphone).
- Memory cards (plus spares).
- Charged battery sets to run the camera traps (plus spares).
- Hand-held GPS unit with locations loaded and enough spare batteries.
- Plastic binder containing a checklist of all equipment needed for daily trips to set up cameras, camera field guides, forms for recording metadata (camera trap setting and retrieval data and habitat forms), and printed copies of the map of the entire study area showing the field site(s) and detailed maps for each site(s), and the list of coordinates of all the camera sites.
- Flagging tape or tags for marking camera trap locations, if necessary.
- Umbrella to keep the camera dry in rainy conditions when checking the camera trap.
- Cloth to dry the unit before opening and to clean the lens in case of rain.
- Whiteboard (or blackboard) and marker pen to take 'start' and 'end' images.
- In areas with frequent human presence, laminated information sheets with contact address, aims of the study and information related to the protection of privacy (e.g. disclaimer note stating that images of humans and pet animals will be deleted); see Chapter 11, section 11.5.4.
- Additional useful items are: toolkit with pliers, knife, foldable saw to remove branches, lighter, pins (for posting information sheets), small SD card labels, pencils, opaque tape (to limit the range of the flash or motion detector), battery tester, small boxes for storing SD cards and a compass to avoid directing the camera trap towards the sun.

[1] It should be noted that camera traps can be stolen regardless of locks, therefore in some circumstances frequent relocation of cameras to prevent theft or vandalism may be needed (Karanth and Nichols 2002).

AIR camera traps may also need spare electric cables, cable ties or plastic straps to fix the electric cable to the supports to prevent animals from pulling out the cable plugs, and electrical tape to protect cables from being chewed by animals or to repair damaged cables. Setting the separate elements of AIR camera traps will usually require installing poles (using a pole pounder or heavy axe) as there may not be suitably placed trees to set each element at the right distance and angle from the target area.

While the above is meant to be a detailed list for a general study, the study area and context will determine the precise list or require additional items. In snowy conditions, for example, it may be useful to have a light shovel to remove snow from the camera traps (which are generally set 40–50 cm above ground level) and the area in front of them, and snow shoes or cross-country skis to make a trail of packed snow by walking up and beyond the trap a good distance as this allows animals to be directed through the camera trap site. In a humid climate placing packets of desiccant (reuseable silica gel) inside the camera box helps protect the unit from extreme moisture, but these need to be replaced and dried often.

All settings need to be determined before the fieldwork and will depend on the study design (see Chapter 2). The fundamental settings are: (1) camera settings – date, time, photo and/or video mode and resolution, number of photos taken per trigger or video duration; (2) sensor settings – sensitivity, minimum time between photos; (3) flash intensity if adjustable; and (4) time-lapse mode (on/off). All cameras should be set and tested – including camera software updates – before travelling to the field so that they just need to be activated before use. This in turn implies that batteries need to remain inserted in the devices, to avoid losing camera settings. We also recommend using the correct type of SD card according to the information provided in the camera trap manual.

We recommend the use of rechargeable batteries (see Chapter 2), and it is important to stress that after fieldwork rechargeable batteries should be stored in charged state in a cool (i.e. around 15°C), dry, clean place, away from heat and metal objects, to maximise battery performance. The optimal level of charge for storing batteries depends on the type of batteries themselves, hence users should check the instruction manual provided by the manufacturers. As batteries will self-discharge during storage, before re-use they usually need to be recharged. Hence, it is recommended not to charge the batteries too early because they lose their capacity very quickly and might not be fully charged when used in the field. The time needed to charge the batteries before, during and after deployment needs to be considered in the study plan. This in practice means ensuring that a sufficient number of battery chargers are available; in addition, a supplementary set of batteries will be needed when batteries are replaced in the course of sampling. A battery tester may be useful in the field, especially for checking the charge level when setting/checking camera traps. Moreover, when carrying batteries during fieldwork it is important to ensure that there is no contact between poles of different batteries to prevent unexpected discharge and to store them well away from snow and/or water.

We recommend that each camera trap unit be uniquely numbered, or otherwise coded, for identification purposes. Write the code with a permanent marker or carve/etch it on the housing of each camera trap. Some digital camera traps can print a code automatically at the bottom of each photograph. The code of each camera can also be used as ID in the camera trap and picture databases. When a large number of camera trap units are used, we suggest creating a registry of the units (including a record of the brands, type of motion detector, year of activation, if the camera trap is still functional or not, if it is in the office or loaned to a volunteer, and special remarks). This will enable a quick overview of the devices that are available or in need of repair. Similarly, label the

memory cards with the site and camera trap number; a progressive number can also be added in case multiple memory cards are used in the same camera during the course of the study.

3.2 Setting camera traps in the field

3.2.1 Site selection and placement

Although the choice of specific camera sites will depend on the sampling design, the standard approach is to place the cameras at locations that maximise capture probability of the target species. Hence, knowledge about the signs of wildlife presence is essential. In the absence of animal signs or information from local guides, camera traps are generally set along wildlife trails, existing human trails (e.g. forest roads, hiking trails), or at the intersection of several trails. Other suitable sites are river crossing points (e.g. bridges), ridgelines or valley bottoms, or when a trail is narrowed by features (e.g. rocks) on either side.

3.2.2 Trail settings

With a few exceptions, e.g. capture–recapture studies that need paired camera traps (Chapter 7), usually one camera trap is set per site. It is recommended whenever possible to choose a camera trap site where the ground is relatively flat. Camera traps are most often strapped directly to a suitably located tree (preferably a straight and smooth one), but they can also be mounted on wooden poles (either brought in or made on site) – the latter allow for precise and repeatable placement. Alternatively, the use of mounting brackets with adjustable heads enables a quick setting and the optimal and precise orientation and fixing of the camera on any type of support, even on trees that are inclined and/or gnarled (Figure 3.1).

The most suitable height will be determined by the target species, the objective of the study and the camera trap functionality. For medium-to-large mammals setting camera traps at about 40–50 cm above ground level is standard. Particular habitat settings will need ad-hoc camera positioning; for example, in rocky and treeless landscapes, such as most of the snow leopard habitat, camera traps are mounted on natural-looking cairns made of rocks, which both protect and hide camera traps (e.g. Jackson *et al.* 2005). For a recent study on snow leopards (*Panthera uncia*) in Mongolia, the chapter authors successfully used wooden boards carved so that the base of the camera traps fitted into them, allowing for easier placement of camera traps on rocks.

The position and distance of the support (tree, pole, etc.) relative to the trail centre or passing area, which needs to be centred in the image frame, should be chosen based both on target animal(s) and camera specifications. If the study is targeting a small species the camera will need to be relatively close to the target area so that individuals will not appear too small in the frame. However, camera specifications will also determine the minimum distance; in particular, cameras can be kept close if their trigger speed is fast (see Chapter 2), whereas a greater distance will be required for cameras with slow trigger speeds. The flash intensity will also determine the minimum and maximum distance. In general, we recommend a distance of 3–5 m from the camera to the centre of the trail/ area through which the target animal is assumed to pass. The intensity of the flash can be reduced 'manually' by sticking on opaque tape if the camera trap does not offer the

Figure 3.1 Mounting brackets with adjustable heads enable rapid setting, and offer optimal and precise orientation and fixing of the camera trap on any kind of tree. (Fridolin Zimmermann)

option of adjusting the flash via its settings (Figure 3.2). The same arrangement can be used to adjust the detection zone, by manually limiting the motion detector width.

Camera traps are usually set perpendicular to the trail to obtain a good side image of the passing animal (important for identification of species and individuals); however, they can also be placed slightly off perpendicular to the trail (i.e. about 60° between camera trap aim and trail) to increase the portion of trail covered by the frame and the detection zone, thus increasing the detection rate for PIR camera traps. For specific research aims, such as determining the minimum group size of group-living animals (e.g. wolves), the angle of the camera trap aim may be better placed more parallel to the trail than the standard setting to maximise the number of individuals detected simultaneously. However, we recommend not to orient the camera traps beyond 45° relative to the target trail for two reasons: (1) with increasing orientation the images will be of either the heads or backs of passing animals; and (2) the functionality of the PIR motion detector may be compromised. This is because when an animal walks straight towards the camera trap it hits the two vertical sensors of the PIR simultaneously, and this does not trigger the camera trap as the PIR detector works by sensing the differential between the two sensors (see Chapter 2, section 2.2). Moreover, the smaller the angle between the camera detection axis and the animal trail, the smaller the motion of the animal relative to the sensors, and this in turn lowers the sensitivity of the PIR detector (A. Pittet, personal communication 2015).

Figure 3.2 The intensity of a xenon flash can be reduced 'manually' by sticking opaque tape in the middle of the flash if the flash cannot be modulated via the settings of the camera trap. The same can be done with infrared LED flashes, by covering the first one or two top or bottom rows of LEDs. (Fridolin Zimmermann)

We recommend testing the positioning of the camera trap to determine the detection zone. This can be done using the camera's 'walk test' mode, a red LED lighting when the camera senses a person moving in front of it (effectively acting like a passing animal) and by checking it at different distances and directions relative to the trap. This helps with the initial positioning of the unit, which should then be refined by taking test images. This step is critical to assess the camera's field of view, which may not coincide with the sensor's detection zone (Chapter 2) and enables a check to be made if the pictures are well framed. Viewing test images can be done by using an ordinary digital camera, having previously checked that it can read the specific image format of the camera trap. Alternatively, image viewers, tablets or smartphones can also be used if these are able to read SD cards. Also, a number of camera trap models mount monitors in the unit, but these are very small and consume excessive amounts of battery power.

For sites with steep terrain, when using single camera traps these should be set on the downhill side relative to the target area to ensure that the camera is approximately at the same height as the target (Figure 3.3). In addition, and especially on narrow trails in steep terrain, camera traps can be fixed to the side of a tree via mounting brackets, to

Figure 3.3 Single camera traps in sites with steep terrain should be set on the downhill side relative to the target area (left, camera circled in red). If placed on the uphill side (right), animals, especially smaller ones, will be missed and movement and sunlight in the background can cause false triggers. (Fridolin Zimmermann)

increase the distance from the camera to the centre of the trail while reducing the chance that animals touch the camera trap itself.

Because of the shape of the detection zone of the sensors used in PIR camera traps, a camera trap set on an 'ideal' site (i.e. with a vertical support and flat terrain) will need to be inclined slightly downwards for optimal performance (Meek *et al.* 2012). This ensures that animals passing closer to the camera relative to the target area are not missed; at the same time, it limits the far end of the detection zone, hence preventing animals passing beyond optimal camera range (i.e. more than approximately 8–10 m from the camera) from triggering the camera but not appearing clearly on the image or not being properly illuminated by the flash. Depending on the study, the optimal position of passing animals can be chosen by selecting obligatory passages, for example because of dense vegetation or a rock limiting the far side of the frame (Figure 3.4).

In densely vegetated areas we recommend removing branches in front of the camera and cleaning the ground in front of the camera trap of debris and vegetation that could cover the animal or reflect the flash causing the image to be overexposed. Vegetation moving in the wind can even falsely trigger the camera trap (Figure 3.5). Clearing the area will also avoid plant regeneration when the camera trap is kept unattended in the field. In addition, because PIR camera traps can be triggered by sunlight impinging directly on the sensor or reflected off the ground or vegetation in front of the sensor, camera traps should not be directed towards sunlit areas or large rock faces which may absorb heat and cause false triggering. In cold climates and during winter it is important to account for the variable height of the site targeted due to snowfall and melting. This ideally requires adjusting the camera trap positioning accordingly over the course of the survey. Alternatively, the camera trap can be set higher than normal in anticipation of snowfall or at sites that are less exposed to snowfalls, such as under large trees.

Setting AIR camera traps is more complex as they consist of different elements. The transmitting and receiving units should be set at an appropriate height above ground level, measured at the location of the target species' expected path of travel where it intersects the infrared beam. The target point can be positioned exactly where it is wanted in the frame by directing the infrared beam to the right location. Electric cables should be sheathed to protect them against damage by animals.

Figure 3.4 Obligatory passages such as those created by dense vegetation, large rocks, cliffs or human constructions (e.g. bridges, walls or wood piles) can be used to ensure the animals are centred in the field of view of the camera traps. (Fridolin Zimmermann)

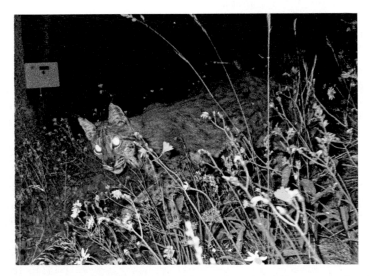

Figure 3.5 Branches and vegetation in front of the camera should be removed and the ground in front of the camera trap cleaned of debris and vegetation, as they could cover the animal or reflect the flash causing the image to be overexposed. Moving grass or branches can even falsely trigger the camera trap. (KORA)

3.2.3 Checklist of actions to activate the camera trap

Once the camera unit is placed, the following sequence should be done to make it ready for use:

- Check the detection range and take a test image to ensure the camera is functioning and is correctly set.
- Ensure date and time, and other settings, are correct.
- Activate the camera and take a 'start' photo of a field team member holding a whiteboard or blackboard with the following information: camera unit ID, start date and time, name of the person holding the board. We recommend making trial 'start' photos as depending on flash type, colour of the board, and inclination of the board relative to the camera, the writing on the board may not be visible.
- Leave the area.

As mentioned earlier, the exact camera trap location should be recorded using a GPS unit and in dense forest the site can be flagged to find it more easily the next time, though this can expose the camera trap to theft. In addition to marking the locality on the GPS itself, the latitude and longitude (and coordinate system) should be recorded on a form (Appendix 3.1) along with other metadata, namely: camera trap ID number, site number, local name (when available), camera model, memory card number, start date and time, camera trap settings (useful if several people check the camera trap sites and later on when the data are analysed). Depending on the study, additional data on the habitat type or any other relevant information can be collected (e.g. presence of roads nearby, particular signs or features such as waterholes found at the site, den sites, animal tracks, etc.).

If information panels for passers-by are used, they should not be set right by the camera trap itself because people will go right up to the camera to read them. This would lead to a high number of non-target pictures.

3.2.4 Checking and retrieving camera traps

Modern camera traps have a long autonomy which will partly depend on the battery type used (Chapter 2) and memory card capacity. Although battery duration and memory card capacity are not limiting factors, camera traps may fail due to water ingress, animal and human inference, or from mud or snow on the lens, fallen branches or fast-growing vegetation blocking the field of view, or for unknown technical problems. Thus camera traps should ideally be visited frequently enough to reduce their down time. In areas with frequent risks of interference (from humans or large mammals) cameras may need to be checked on a weekly or biweekly basis, while in areas with a low risk of disturbance monthly camera trap checks may be sufficient. When surveys are conducted in temperate zones during winter time, it becomes important to check the sites regularly (e.g. once a week) especially after fresh snowfall or periods of thaw.

3.2.5 Checklist of actions when checking and removing the camera trap

- When arriving at the site a picture with a board similar to the 'start' photo should be taken to check if the camera trap is still functioning. The board need only mention date and time in this case.
- Check if date and time, and other settings are correct before switching off the camera trap (if not, report it on the form; see Appendix 3.2).
- Record the date of the control or removal and the number of pictures on the counter on the form. If the camera trap is not functioning, the reason (e.g. batteries out of power, memory card full, camera covered with snow, sabotage, etc.) if known should be recorded on the form; see Appendix 3.2).

The subsequent steps are only needed when checking the camera trap.

- Replace the memory card. Check the battery indicator if the camera trap has one and change the batteries when necessary. If the camera trap has no battery indicator it is advised to use a portable battery checker (otherwise it is necessary to rely on previously testing the camera autonomy with the batteries actually used).
- Visualise the images with a portable device to see if they are well framed, whether there is vegetation in the way, whether there is a problem with sunlight causing blank photos, to detect possible camera trap failure (e.g. black picture because of non-functioning flash) or how well the camera trap is performing in terms of the number of images of animals. For site settings with pairs of camera traps, check if both camera traps have approximately the same number of pictures. If there is a marked discrepancy, check the sensitivity of the motion detector of the camera trap with the lowest number of pictures and if necessary replace the camera.
- Test the camera trap if it did not take any pictures, especially if you have good reasons to assume that animals passed in front of the camera (e.g. fresh tracks), and if needed replace it.
- After checking the camera trap, the orientation of the camera traps should be readjusted and tested following the same procedure as described when the traps were first placed in the field.
- Before leaving the site make sure that the device is switched on with the date and time correctly set, and that the camera trap is well oriented, fixed firmly to its support and locked to avoid damage and theft; finally, take a photograph using the black/whiteboard with the same information as when the camera trap was activated.

Upon retrieving camera traps, an 'end' image should be taken similarly to the 'start' one using the black/whiteboard. Information on camera functioning and any other notes should be recorded on the form.

3.3 After the fieldwork

After completing the fieldwork, all the camera traps should be checked for additional data stored in their internal memory (if they have one); any such data should be recovered on a memory card labelled with the site and camera trap number, and subsequently saved in the appropriate data folder. Finally the internal memory should be formatted to

remove all pictures. The camera traps should subsequently be cleaned carefully, i.e. avoid scratching the lens, with a glass cleaner, especially the glass in front of the camera and the lens of the PIR. The traps should then be tested and if necessary and possible repaired. Upon completion of the study, the traps should ideally be stored in plastic boxes in a cool, dry and clean place. The camera trap units' database should be update with the latest information from the inventory. All batteries and additional accessories (poles, mounting brackets, cables, locks, etc.) should be sorted, maintained (e.g. rechargeable batteries need to be stored charged) and inventoried. All broken or missing material should be replaced right away. Ideally all material should be stored separately in appropriate storage units labelled according to their content so that the material can easily be found by any of the field staff at the beginning of the next survey.

Appendices

Appendix 3.1 Form to record metadata when setting camera traps
Appendix 3.2 Form to check and remove camera traps

Acknowledgements

We thank Paul Meek for valuable comments on an earlier version of this chapter.

References

Ancrenaz, M., Hearn, A.J., Ross, J., Sollmann R. and Witting, A. (2012) *Handbook for Wildlife Monitoring Using Camera-traps*. BBEC II Secretariat, c/o Natural Resources Office, Chief Minister's Department, Kota Kinabalu, Sabah, Malaysia.

Jackson, R.M., Roe, J.D., Wangchuck, R. and Hunter D.O. (2005) *Surveying Snow Leopard Populations with Emphasis on Camera Trapping – A Handbook*. Sonoma, CA: The Snow Leopard Conservancy.

Karanth, K.U. and Nichols, J.D. (2002) *Monitoring Tigers and Their Prey: A Manual for Researchers, Managers and Conservationists in Tropical Asia*. Centre for Wildlife Studies, Karnataka, India.

Meek, P.D., Ballard, A.G. and Fleming, P.J.S. (2012) *An Introduction to Camera Trapping for Wildlife Surveys in Australia*. Invasive Animals Cooperative Research Centre, Canberra, Australia, http://www.feral.org.au/camera-trapping-for-wildlife-surveys (accessed 2 October 2014).

Rovero, F., Tobler, M. and Sanderson J. (2010) Camera trapping for inventorying terrestrial vertebrates. In: J. Eymann, J. Degreef, C. Häuser, J.C. Monje, Y. Samyn, and D. Vanden-Spiegel (eds), *Manual on Field Recording Techniques and Protocols for All Taxa Biodiversity Inventories and Monitoring*. Abc Taxa, Vol. 8 (Part 1). pp. 100–128.

Silver, S. (2004) *Assessing Jaguar Abundance Using Remotely Triggered Cameras*. Jaguar Conservation Program, Wildlife Conservation Society, New York.

Sunarto, Sollmann, R., Mohamed, A. and Kelly, M.J. (2013) Camera trapping for the study and conservation of tropical carnivores. *Raffles Bulletin of Zoology Supplement* 28: 21–42.

TEAM Network (2011) *Terrestrial Vertebrate Protocol Implementation Manual, v. 3.1*. Tropical Ecology, Assessment and Monitoring Network, Center for Applied Biodiversity Science, Conservation International, Arlington, VA, USA. http://www.teamnetwork.org/protocols/bio/terrestrial-vertebrate (accessed 22 April 2015).

van Berkel T. 2014. *Camera Trapping for Wildlife Conservation. Expedition Field Techniques*. Royal Geographical Society: London.

4. Camera trap data management and interoperability

Eric Fegraus and James MacCarthy

4.1 Introduction

These days sensors are everywhere and collect more data than ever before. Scientists and businesses increasingly rely on this data to monitor environmental variables and improve decision-making.

As digital storage capabilities improve, there is a strong incentive to capture as much data as possible and digital camera traps are no exception. Compared to the older 35 mm film camera traps, digital camera traps produce orders of magnitude more images. Modern digital camera traps are generally composed of a digital camera that is connected to a motion and/or heat sensors that determines when to take a picture or series of pictures (i.e. an animal passes within the field of detection and the camera triggers; see Chapter 2 for a detailed description of camera trap technology, systems and features). In addition, modern camera traps also tend to include firmware that stores a wide variety of information about the camera and camera settings as well as environmental information, such as temperature and moon phase. Some camera trap models are also able to store their location via GPS.

Like many other sensors, the cost per unit continues to decrease as technological components and manufacturing costs decrease. As a result, digital camera traps are rapidly becoming the sensor of choice for wildlife biologists, ecologists and conservation practitioners. However, as is the case with most new technology, the successful adoption of new sensors requires the creation of new tools to make efficient use of their functionality. This is certainly the case with digital camera traps since they produce datasets that are often much larger and more complex than the camera trap community has previously experienced. The ability to record video or a sequence of images with camera traps has also contributed to the explosion in camera trap data.

This chapter introduces software tools that are needed to properly collect, manage and archive camera trap data. Data standards are also needed to ensure camera trap data are exchangeable (or shareable) and well documented. Together, these tools and standards provide a foundation from which the camera trap community can accelerate scientific discoveries and use results from camera trap data to inform conservation and natural resource decision-making.

4.2 Camera trap data

Camera trap projects are organised and implemented for a wide variety of different monitoring and conservation goals, from studies of animal behaviour to estimates of abundance and occupancy (see Chapters 5–8). Figure 4.1 identifies a typical camera trap project flow.

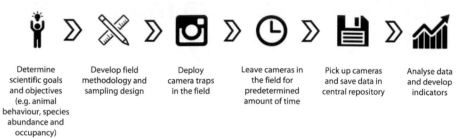

Determine scientific goals and objectives (e.g. animal behaviour, species abundance and occupancy) Develop field methodology and sampling design Deploy camera traps in the field Leave cameras in the field for predetermined amount of time Pick up cameras and save data in central repository Analyse data and develop indicators

Figure 4.1 The typical workflow for a camera trap project.

In the beginning, high-level scientific goals and objectives are identified and field methodologies are developed to accomplish those goals and objectives. Next, a sampling design that identifies where individual camera trap deployments will be located is developed. Once the locations of each camera trap are confirmed in the field, camera traps are deployed and left in the field for a predetermined length of time. After this predetermined time has elapsed, camera traps and/or data storage media (e.g. SD cards) are picked up. Some monitoring protocols call for continuous monitoring and in these situations the camera is permanently running and batteries and SD cards are scheduled for changing and pickup at certain dates. Once the data from the camera trap data are picked up they need to be transferred to a computer, managed, annotated and then analysed for a wide range of uses, including simple statistical analyses, sophisticated analytics dashboards, and as an indicator that is relevant to the goals and objectives of the project.

Camera trap projects can vary tremendously in terms of spatial and temporal extent, field methodologies, sensor configurations and a whole of host of other considerations; however, there are a number of conceptual components that remain true for all camera trap projects irrespective of the specific configurations or settings an individual camera trap project may decide upon. These conceptual components enable software systems to capture the most essential aspects of a camera trap project.

4.2.1 Camera trap conceptual components

Even though the majority of camera trap data comes from a single device (i.e. a 'camera trap'), the data management components are surprisingly complex and become even more complex as more sensors are added to the camera trap. At the core of camera trap data is the image and the species (or several species) in that image. The image represents a physical observation and provides a verifiable record of what was seen, when it was seen and the context in which it was seen. As a result, the image and image properties (filename, file size, file type, etc.) need to be preserved, but much more data needs to be documented as well. This additional data includes information such as the date–time

stamp, latitude, longitude, species name, individual ID (for species with natural or artificial marks, if appropriate), field methodology and custom camera EXIF metadata (i.e. information about the camera that is stored in an image file) (Fegraus *et al.* 2011). All of this information is critical for evaluating whether or not data should be included in an analysis and for identifying data translation activities that need to happen prior to and during analysis. To understand camera trap data more clearly, it is useful to examine individual camera trap data components in greater detail.

Camera trap data conceptual components include:

- Image – image properties and standard image EXIF metadata.
- Animal – taxonomic authority used to determine scientific name, species name, number of species and demographic information, red list status.
- Camera trap – sensor settings such as trigger rate, number of images per sequence, location, custom EXIF data, camera trap manufacturer and model, etc.
- People – what is their role in the project (data collector, taxonomic identifier, etc.), and what is their basic contact information (email, organisation, etc.)?
- Project – general location (at a macro scale), sampling design (e.g., camera density per km^2, number of camera trap points, etc.), field methodologies (single vs. paired camera trap deployments, camera trap mounting instructions, baited vs. non-baited camera traps, etc.) and overall scientific and conservation goals and objectives.

These conceptual components are the building blocks that software data management tools need to address and adequately capture.

4.3 Managing camera trap data: Wild.ID

As described previously, it is important to adequately capture all the camera trap conceptual components when the data is retrieved from each individual camera trap and enters the data management process. The success of DeskTEAM (Fegraus *et al.* 2011) for managing the camera trap data collected by the TEAM Network provides an excellent test-bed to further consider what else is required to manage camera trap data for any scientific or conservation project. This experience led to the creation of Wild.ID, which was created for the camera trap community at large and incorporates many of the key camera trap conceptual components into the software itself. The Wild.ID software and help documentation is available at www.teamnetwork.org/solution and at www.wildlifeinsights.org.

Wild.ID divides the workflow for the camera trap conceptual components into two steps: project setup and data processing. The project setup step stores all the information the software needs to manage camera trap data for a particular project, while the data-processing step includes all the activities associated with uploading and annotating the data for that project.

4.3.1 Setting up a camera trap project

To create a project in Wild.ID, the user enters project-level information on the project setup page, such as the name, latitude, longitude, research objective and whether or not bait was used. Information about the five main components of a camera trap project – camera trap deployments, events, cameras, institutions and people – are then entered

into Wild.ID. These five components capture the majority of the information associated with a project and are described in more detail here.

- Camera trap deployment – A unique placement of a camera trap in space and time. This includes information about the geo-location of the camera, the date range it was observing and specific camera settings (e.g. the use of a quiet period). Each camera trap requires a latitude and longitude and can be added manually or via a batch upload process.
- Camera trap arrays – These are logical groupings of camera traps. An array could have one or more camera traps and are usually used to group camera traps by logistical or thematic reasons (e.g. all the deployments north of the river).
- Sampling events[1] – Camera trap arrays can be grouped into sampling 'events' (not to be confused with events of animal detection by camera traps, see footnote). Common events could be seasons (wet and dry), months, years or other types of logical groupings when field sampling occurs.
- Cameras – This section enables the user to enter relevant information about the cameras that will be used for a project. This includes entering the manufacturer,

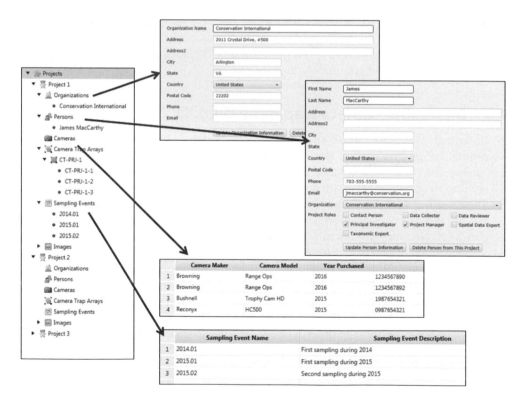

Figure 4.2 Screenshots illustrating how a user enters information related to each of the camera trap project setup components.

[1] This is different from 'independent photographic event' as introduced in Chapter 5. That term refers to the images of a given species obtained by camera traps that are separated by a fixed temporal interval to derive the independent number of species detections.

model number and serial number. All of this information can be entered individually or via a batch upload process.

- Institutions – This section stores information about the institution that is collecting the data in the field. The name and contact information for each institution involved in the project are stored here.
- People – The relevant people associated with a camera trap project are stored in this section. Information such as name, email and role are entered individually. Roles currently available for people are: data collector, project manager and principal investigator.

Each of the main Wild.ID project setup steps are illustrated in Figure 4.2. All the information established in the project setup will be associated with camera trap images and data created by that project. A user can easily manage many projects and, if needed, the project setup information can be easily modified. Importantly, Wild.ID provides batch upload via standardised files to populate all of these components. For large projects this is more efficient and also reduces the potential for error.

4.3.2 Processing camera trap data

Once a camera trap project is created and all of the associated project information is stored in Wild.ID, camera trap data processing may begin (see Figure 4.3 for a typical camera trap workflow[2]). The information entered in the project setup page of Wild.ID is used to populate drop-down menus and facilitate data entry. This process also helps to provide an initial quality control (QC) layer because the user does not have to enter the information manually for each camera as the data is processed and the information can be checked as new data is added. Several other data QC measures are also built into Wild.ID, including an internal taxonomic authority (the IUCN Mammal Red List and the Birdlife International Checklist) which is used to populate the 'genus' and 'species' fields to prevent typographic errors and reduce the time spent typing out the species name.

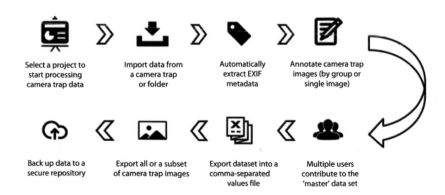

Figure 4.3 A typical workflow for processing camera trap data in Wild.ID.

[2] Occasionally, camera trap data are accidentally erased or files become corrupted. When this happens, an additional 'data recovery' step should be added to the workflow so the data can be recovered prior to annotation. There are several free (e.g. recuva, JPEGsnoop, PhotoRec_FR, PC Inspector) as well as commercial (e.g. Stellar Phoenix, Recover My Files) options for recovering lost or corrupted data.

The camera trap processing page automates part of the annotation process through the use of an EXIF data reader that extracts and stores data (e.g. date, time, temperature, moon phase) directly from the image. If something goes wrong during the sampling event (e.g., the memory card reaches its capacity or the camera trap malfunctions), the EXIF data can also be used to accurately calculate the sampling effort for each camera trap since Wild.ID records the date and time for the first and last image instead of assuming the deployment lasted for a predetermined length of time. There is also an option to annotate an entire group of images, which helps limit the amount of effort required to process and annotate camera trap arrays. All of these features are designed to capture as much information as efficiently as possible, while maintaining the flexibility to accommodate projects with different goals and objectives.

After all of the images have been annotated, the entire data set can be exported to an Excel spreadsheet or comma-separated values (CSV, Figure 4.4) file that can be opened using a number popular statistical programs, such as R (see Chapter 5 for more details on loading this file for analysis in R). *It is important to note that opening the .CSV file in Excel will likely cause modification of the time and date format depending on the user's computer settings.*

Wild.ID also provides the following key features:

- Import data from a memory card or folder.
- Annotate multiple images with the click of a button.
- Supports EXIF data extraction for multiple camera trap models.
- Search annotated images and export a subset of data to CSV.
- Enables multiple users to manage camera trap data independently while being able to combine data when needed

Figure 4.4 Example of CSV output file from Wild.ID, as opened in Excel mantaining the original format for date and time.

See Figure 4.5 for Wild.ID screenshots that take a user from project setup to importing and annotating images to exporting the data to a local computer or backing up to repository.

4.3.3 Retrofitting legacy camera trap data

Many existing camera trap projects have legacy images and data on their file systems that are not currently being managed by Wild.ID. To retrofit legacy data and images into Wild. ID a few key steps need to be accomplished. A hierarchical directory structure should be created for each project. Note that the use of Events and Arrays should be used in the same manner as in the Project Setup process. Each camera deployment folder should

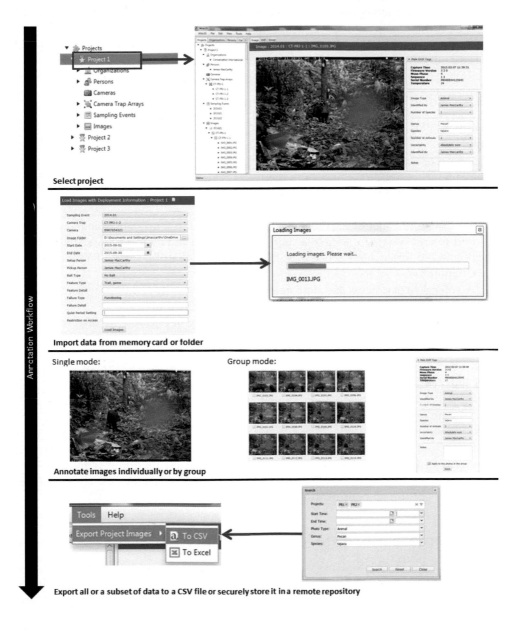

Figure 4.5 Wild.ID screenshots covering all the data-processing steps. Finished data can either be stored locally in Wild.ID, exported to a CSV file for analysis or synchronised with a remote data repository.

contain the images from a specific deployment (per Project/Event/Array/Camera). The only requirement is that every image from a single deployment has a unique filename. Ideally, all images are included in the directory to help ensure the images have not been high-graded or filtered (e.g. for only one species or just the 'nice' pictures). If the images have not been annotated previously, then once they are in the hierarchical directory structure they are ready to be processed by Wild.ID. During the import process, be sure to select 'Import from Folder' (see Figure 4.5). If legacy data have already been annotated (i.e. a file exists that contains what species and how many are in the image), Wild.ID provides an xlsx template to easily batch upload the data. A data transformation process may be necessary to get the data into the Wild.ID xlsx template but will still be more time and cost effective than re-annotating the images from scratch.

4.3.4 Additional camera trap data management tools

Besides Wild.ID a number of other camera trap data-management tools exist. These include:

- CameraBase (http://www.atrium-biodiversity.org/tools/camerabase/) has very nice features for paired camera trap and individual identification. Many analysis tools are also built into the software.
- eMammal (developed by the Smithsonian Institution, http://emammal.si.edu) is an end-to-end system for data collection, management and distribution; such a platform is suitable for citizen science projects on mammal distribution and abundance (see Chapter 11).
- A spreadsheet process and data management tool developed by Harris *et al.* 2010 is also available (http://www.publish.csiro.au/pid/7150.htm).
- Other organisations such as the Zoological Society of London are also working on producing similar tools.

Each of these tools provides varying levels of data management and/or analysis packages. Unfortunately, none of these data-management systems are currently able to take full advantage of the video functionality now offered by camera traps, which has become more widespread in recent years. As researchers increasingly make use of these capabilities, it is essential that new data standards are developed and management tools are built to accommodate video capture. The activity around camera trap data management clearly signals the overall community need for these types of tools in response to the technological advances in camera trap sensors and the uptake of these data into scientific and conservation objectives.

4.4 Camera trap data interoperability

In late 2012 the TEAM Network, in response to the growing and widespread adoption of camera traps for wildlife monitoring, began to explore how to interoperate with other existing camera trap projects. As camera trap projects were identified (mostly from within the core members of the TEAM Network) it became clear that bringing data together would be particularly challenging due to data heterogeneity. For example, there were discrepancies on what organisations called a 'project' or the terminology for where a camera trap was deployed (e.g. camera trap location vs. camera trap point ID

vs. deployment ID). As a result a minimum data standard was established to be able to combine camera trap data from different projects. This standard was established by considering the following questions:

- What information is needed to understand enough about the camera trap and the way in which the data were collected to be potentially relevant for basic analyses?
- Of this information, what is the minimum amount of information needed?
- If more information is required, who is the dataset contact?

The camera trap minimum standard was created with input from a number of the largest camera trap data-collecting organisations in the world. Each organisation's process for managing and storing camera trap data was examined and synthesised. Commonalities were identified and then put together to answer the key questions above. This effort resulted in a camera trap metadata standard (CTMS) that will enable the exchange of camera trap data from one organisation (or individual) to another. The CTMS can be implemented in CSV, XML or JSON and then shared from one organization to another. Where possible, the CTMS also maps into more established metadata standards (e.g., the Geospatial Metadata Standards developed by the Federal Geographic Data Committee, FGDC). The CTDMS standard is available at www.wildlifeinsights.org/minimumstandard.

4.5 Wildlife Insights – the camera trap data network

Wildlife Insights (WI), founded by Conservation International, the Smithsonian Institution, Wildlife Conservation Society and the North Carolina Museum of Natural Sciences, is a cloud-based data-sharing platform for wildlife camera trap images, data and analytics. WI will allow users and organisations to share, store, find and analyse millions of camera trap images and related data from around the world, including interconnecting some of the world's largest camera trap repositories managed by the founding members. The WI platform and tools enable any organisation to share its data with the broader community and provides the community a point of access to camera trap data from around the world. The specific goals of WI are the following:

- Provide web-based tools to discover and explore camera trap data from around the world.
- Provide web-based analytics on camera trap data.
- Provide web services to ancillary datasets (e.g. GIS environmental layers) that can be used with camera trap data for analysis and data products.
- Provide organisations or individuals with the tools and documentation needed to share their camera trap data. Camera trap images and/or metadata can be shared and can be directly uploaded into WI or shared via an application programming interface (API). An API enables organisations that maintain a database or online system to share their data directly via a standard interface.

Hewlett Packard also generously supported much of the platform behind WI. Wild. ID will be able to share data and/or images directly with WI and WI will also have a web-based tool for direct data upload. WI launched in October 2015 and it is envisioned

that it will become a central knowledge and data-sharing centre for the camera trapping community.

4.6 The future: more repositories, better data management and analytical services

We envision a future for camera trapping where there are more and more camera trap repositories and databases being managed by a wide variety of individuals and organisations. As a result the software solutions mentioned here (as well as potentially many others not described here) will provide the community with the tools it needs to manage and analyse camera trap data. The creation of repositories that are shareable with efforts such as WI and other data-discovery solutions (e.g. Global Biodiversity Information Facility, http://www.gbif.org, and DataOne, https://www.dataone.org) will ensure that valuable data is not lost and can be maximally utilised by the broader community.

Video also presents an additional challenge for camera trap tools, both in terms of increased storage demands as well as the transformation of video into data points. Fortunately many camera traps currently enable researchers to take sequences of images (from a camera trap trigger) and the analytical approaches being developed account for these sequences. These approaches will be very relevant to accurately handling video and turning this into actionable data.

As a parallel to the growth of camera trap repositories, we envision better web and data services around camera trap data. For example, data services could provide climate information to complement camera trap data for a specific location. The capability to embed automated image identification and individual identification into camera trap data management tools and/or online repositories can make species/individual identification more efficient and provide an extra layer of quality control (Yu *et al.* 2013).

References

Fegraus, E., Lin, K., Ahumada, J., Baru, C., Chandra, S. and Youn, C. (2011) Data acquisition and management software for camera trap data: a case study from the TEAM Network. *Ecological Informatics* 6: 345–353.

Harris, G., Thompson, R., Childs, J. and Sanderson, J. (2010) Automatic storage and analysis of camera trap data. *Bulletin of the Ecological Society of America* 91: 352–360.

Yu, X., Wang, J., Kays, R., Jansen, P., Wang, T. and Huang, T. (2013) Automated identification of animal species in camera trap images. *EURASIP Journal on Image and Video Processing* 2013: 52.

5. Presence/absence and species inventory

Francesco Rovero and Daniel Spitale

5.1 Introduction

This chapter addresses descriptive analysis from camera trapping surveys aimed at assessing the presence of target species, groups of species, or the whole community of terrestrial vertebrates (hence effectively compiling a faunal inventory for the study area). According to a scheme that will be followed in all the analytical chapters of this book, the first part of the chapter provides the theoretical background. We first introduce the raw metrics that are derived from faunal surveys, namely the observed species richness, the number of photographic events, and the relative abundance index (RAI) for each species. These are useful descriptors for an initial assessment of data obtained from camera trapping surveys. We then provide a detailed overview of sampling design, pointing the reader, in particular, to the fundamental differences between opportunistic and systematic designs. This section includes indications on sampling effort, i.e. number of camera trap stations and survey duration, as well as means to assess sampling completeness.

The second part of the chapter provides a case study with real data whereby the reader is guided step-by-step through data import, data screening and a set of fundamental analytical routines to derive the metrics above and related summaries such as temporal and spatial distribution of trapping events at the species level. As this chapter is the first on data analysis, it also briefly introduces the preparatory steps that are necessary to use R (http://www.r-project.org/), the main analytical software used here (R editor, setting directories, loading libraries, sourcing functions, etc.), and hence this knowledge is taken for granted in subsequent chapters. The analyses proposed assume basic general confidence in the use of R and Excel.

The use of camera trapping for faunal surveys is the simplest and perhaps most common use of this tool, and one that is instrumental to more detailed analysis. Indeed a clear definition of study objectives, beyond inventory compilation, is a prerequisite to define the correct sampling design. If the study is limited to assessing the presence of species, then the sampling design, sampling duration and selection of camera trap sites can be *relatively* flexible. For the purpose of maximising trapping success, it might be possible to use baits placed in front of the camera trap, or targeting particular sites of intense use such as feeding or drinking sites, nests, rubbing trees, etc.

However, we anticipate here that an opportunistic sampling design, i.e. one that does not adhere to the fundamental principles of randomisation and replication of samples, will fail to provide representative observations of the studied population, and as such, cannot be used to *infer* parameters of the whole target population (Williams *et al.* 2002). This means that the data obtained from opportunistic sampling are usually not suited to test hypotheses and make predictions on these populations. However, if the objective of the study is to provide only a species list of a target area, then an array of camera traps arranged in an opportunistic way may represent a reasonable and affordable strategy. It is likely that opportunistic sampling will bias the results towards one or a pool of species that are more likely to use the selected sites relative to other species (i.e. not all species will have the same chances of being detected at all sites), and/or because no consideration is given to the spacing of camera traps in relation to the home range of the target species (see below and Chapter 6). These are only two of the several potential sources of variation, which are unrecognisable, and whose influence is addressed through randomisation and replication (Williams *et al.* 2002).

If, in contrast, the inventory is conducted as a baseline assessment for future studies, for replication to other areas, or for modelling species' distribution, then a systematic sampling design is required. Similarly, such design is recommended for robust assessment of activity pattern (see Chapter 8). Hence, sites should be selected at *random* relative to animal movements and therefore relative to the chances of animals encountering the cameras. In this way we can assume that species have the same chances of being detected across all sites, i.e. there is no bias towards selected species by deploying variable setups (e.g. camera traps on nests or drinking sites at some sites and along wildlife trails at others). In such cases, the study design could follow the one recommended for single-season occupancy studies (Chapter 6) that adopts a regular grid of cameras, or could follow a stratified random design, as well as a full randomisation approach (Rowcliffe *et al.* 2011). Moreover, if the survey targets the whole community of terrestrial vertebrates, a robust sampling for analysis in occupancy framework allows the estimation of true species richness using the Bayesian approach described in Chapter 9.

5.2 Raw descriptors: naïve occupancy and detection rate as a relative abundance index

Besides the checklist, i.e. the list of captured species, data from faunal surveys at the species level can be analysed to derive two basic descriptors of species' presence: (1) naïve occupancy and (2) camera trapping detection rate, often called the RAI.

Naïve (or observed) occupancy is simply the proportion of camera trap stations where the species has been captured relative to the total number of camera stations sampled. It therefore has a value ranging from 0 to 1 that provides an indication of the extent of species' presence across the area sampled. The closer the value is to 1, the larger the proportion of sites where the species occur. This may in turn indicate wider distribution of a species, especially if the camera sites are sufficient in number to cover a representative sample of the target area. These simplistic presence–absence data may be biased by detection error – i.e. a recorded absence of a species at a site may in fact be a non-detection, and not a true absence. Using such data with naïve estimators will thus result in underestimates of true occupancy (MacKenzie *et al* 2002; see Chapter 6 for details). When imperfect detection is not accounted for, the metric we are estimating is not true species occupancy, as occupancy and detection are confounded. Naïve

occupancy provides information on where the species is more or less likely to be detected rather than an estimate of true occupancy. Since detection probability can change even for the same species inhabiting different regions (e.g. as a result of different behaviours or habitat characteristics), comparison of naïve occupancy among different surveys could lead to erroneous conclusions.

The camera trapping rate is the photographic 'event' rate, i.e. the number of photographic events at which a species is trapped during the sampling. It is therefore calculated as the ratio events/sampling effort. Survey effort is typically measured as camera days, i.e. the number of camera traps used multiplied by the number of days they were in operation (taking into account malfunctioning cameras if necessary). Hence, the unit of the camera trapping rate is events per day of sampling.

An interval between consecutive images is typically used to separate out single, passing animal events from repeated images of the same event. Intervals of 30 min to 1 h are common (e.g. O'Brien *et al.* 2003; Bowkett *et al.* 2008; Rovero *et al.* 2014) although Kays and Parsons (2014) found that temporal autocorrelation dropped off after 1 min, and thus chose this as their independence interval. Indeed, Yasuda (2004) addressed this issue by analysing the number of species' appearances with variable intermission lengths and found that 39–52% of all the photographs were taken within a 1 min interval, depending on target species, and the number levelled off at a 30 min intermission length. Hence, beyond this interval, the probability that new images are independent events of passage increases. However, this author used baited camera trap stations, and hence it is doubtful if these results can be generalised.

The camera trapping rate is also called RAI as this metric may provide information on population abundance and indeed be considered an index of relative abundance (O'Brien 2011). On the general concepts of indices of abundance we refer the reader to general essays (e.g. Williams *et al.* 2002) as well as specific applications to camera trapping (O'Brien *et al.* 2003; Rovero and Marshall 2009; O'Brien 2011). While the camera trapping rate will, in principle, be related to true abundance, it remains an index based on observed data (frequency of captures) and does not account for time- and space-related factors that will affect detectability (e.g. Yoccoz *et al.* 2001; Pollock *et al.* 2002). Species-specific factors such as body size (Kelly and Holub 2008; Tobler *et al.* 2008; Anile and Devillard 2015; but see Rowcliffe *et al.* 2011 on how this can be taken into account), trail use (Trolle and Kéry 2003), daily range (Rowcliffe *et al.* 2008; Tobler *et al.* 2008) and behaviour (Steenweg 2012) will also affect detectability. In addition, camera trap model, temperature and moisture (affecting the performance of the sensor, see Chapter 2) and habitat features at the camera site (e.g. vegetation denseness, steepness and other features that affect the camera's field of view) will bias the camera trapping rate according to a species- and site-specific process (Rowcliffe *et al.* 2011; Rovero *et al.* 2014). As a result, comparisons of camera trapping rates between species, and within species over time and space, that do not take these factors into account may to some extent lead to erroneous conclusions (Sollmann *et al.* 2013).

However, a few studies that have calibrated RAI to density estimates (Carbone *et al.* 2001; O'Brien *et al.* 2003; Rovero and Marshall 2009; Rowcliffe *et al.* 2008) show that there may be a robust, linear relationship between density and RAI hence supporting its use as a relative abundance index. Nevertheless, calibrations are difficult, as they require an independently derived density estimate, and would ideally need to be performed at each study area and over time. Therefore, these studies partially support the use of RAI only for comparisons within populations (Rovero and Marshall 2009; Sollmann *et al.* 2013).

In summary, when data are collected opportunistically from faunal surveys they are not suitable for abundance estimation that accounts for detectability (such as occupancy, see Chapter 6). In this case, the use of RAI as a raw index of event rate, and naïve occupancy as an indication of occurrence, will be helpful for descriptive comparisons among populations and hence for making preliminary observations and hypotheses. These in turn will help in designing more robust studies suitable for rigorous analysis and hypothesis testing. In addition to deriving the species' list, species' accumulation and the raw metrics of relative abundance, in the following example we will also show simple, additional descriptive analysis such as plotting the activity pattern of each species, using the RAI at the camera trap sites to plot distribution maps, make simple assessments on habitat associations of focal species and on possible interactions between potentially competing species.

5.3 Sampling design

If the study objective is simply to assess which species are present within a given area, the sampling design implies setting single camera traps across the study area, preferably stratifying according to the habitat types targeted. Tobler *et al.* (2008) indicated that the area covered by the camera traps may have little impact on the number of species detected so long as the sampled area is representative of the general study area and habitat type. There are no strict indications on the number of camera trap stations to be sampled, which will broadly depend on the size of the area. When facing a trade-off between number of sampling sites and sampling days, however, perhaps because only a few camera traps are available, we recommend maximising the number of sites at the expense of sampling days per site, hence moving camera traps around the area (Si *et al.* 2014). This is intuitive to some extent, as the larger the number of camera used and spatial coverage of sampling, the greater the chances of maximising the number of species captured.

As an illustration of this suggestion we created a simulation using the TEAM Network data provided for the case study presented further below. We set a target of 300 camera days to be deployed in the study area, and wanted to assess how many species we would detect with increasing numbers of camera trap sites sampled (and accordingly, decreasing number of days for each). We considered 10, 20, 30, 40 and 50 camera trap sites. We then randomly selected (out of an overall sample of 60 camera trap sites) the camera traps and determined the number of species detected using 10, 20, 30, 40, 50 cameras once 300 camera days had been reached; we repeated this computation 1,000 times for each set of cameras and determined an average number of species detected. We found that the number of species detected increases with the number of camera stations (Figure 5.1). That is, with the same sampling effort, we found more species using more cameras working for less time than using few cameras working longer. This indicates that when the number of camera traps available is small (10 or fewer), it is better to move camera traps around to sample a larger area when the aim is to maximise the number of species. The overall duration needed to carry out a survey will be inversely proportional to the number of camera trap stations sampled. While there may be no strict limits on the duration of a one-off survey, we recommend keeping it within a season, or a year, i.e. within a period that can be assumed closed to changes in species' richness, and species' occupancy state (Rovero *et al.* 2013).

The spatial arrangement of camera traps should reflect the study objective and, in particular, the target species. Spacing will determine the probability of which species will

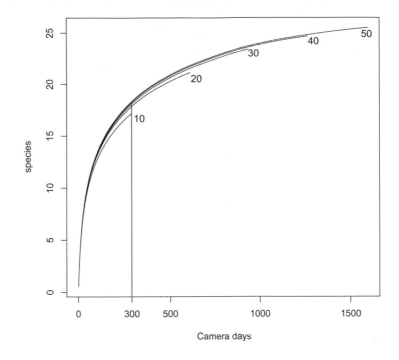

Effort (camera days)	Number of cameras	Average number of species (± SD)
300	10 (working 30 days each)	17.1 ± 2.0
	20 (15 days)	17.8 ± 1.3
	30 (10 days)	18.0 + 1.0
	40 (7.5 days)	18.2 ± 0.7
	50 (6 days)	18.3 ± 0.5
600	20 (30 days)	21.1 ± 1.7
	30 (20 days)	21.5 ± 1.2
	40 (15 days)	21.7 ± 0.9
	50 (12 days)	21.8 ± 0.5
900	30 (30 days)	23.2 ± 1.4
	40 (22.5 days)	23.4 ± 0.9
	50 (18 days)	23.5 ± 0.6
1,200	40 (30 days)	24.5 ± 1.0
	50 (24 days)	24.6 ± 0.6

Figure 5.1 Results of simulations of observed species' richness determined by a constant survey effort of 300 camera days with varying combinations of number of cameras used (10–50) and sampling duration. The number of species detected (values shown on the table) increases with the number of camera sites sampled. See text for details.

be captured based on the species' home range. In general terms, if the spacing between camera stations is larger than a species' home range, this species will have less chance of being detected relative to a species with a home range that is larger than the spacing of camera stations. This is because in the latter case animals will have, on average, more sampling points within their home ranges. An adequate spacing for detecting as many species as possible would therefore be a compromise between missing species with small home ranges by spacing camera traps too far apart, and missing species with large home ranges by spacing camera traps within a very small area (TEAM Network 2011; see also Chapter 6).

Unless researchers can identify prior to the study a set of optimal sites (drinking sites, nests, etc.), the approach generally taken is to design a regular grid (the size of which will depend on the total number of camera stations and the area targeted) and broadly set one camera station at each node. We also recommend the adoption of a consistent criterion to identify the camera trap site at the node, which would simply imply finding a wildlife trail within a given distance from the node, e.g. 50 or 100 m maximum (TEAM Network 2011). Similarly, the actual setting of camera trap units on supports, usually trees, should follow a standardised procedure in terms of camera height and inclination, orientation relative to trails, etc., as described in Chapter 3 (see also TEAM Network 2011). The use of bait at camera sites is not recommended for this systematic approach. Bait increases the chance that animals passing nearby modify their trajectory towards the camera trap detection zone, and will likely bias the results towards certain sites and/or species (see Chapter 7 on the use of baits and lures).

Finally, we recommend not using different camera trap models when undertaking a survey as this will likely introduce a potential source of bias due mainly to varying camera sensitivity (see Chapter 2). We are aware that this may not always be possible as camera units within camera sets may be progressively replaced. In Chapter 6 we mention how this potentially confounding factor can be taken into account in data analysis.

5.4 Sampling completeness

The completeness of sampling effort for a faunal inventory is assessed by building species accumulation curves and looking at the levelling off, as exemplified in detail in the next section. In principle, the more individuals are sampled, the more species will be recorded (Gotelli and Colwell 2001). This sampling curve rises relatively rapidly at first, then much more slowly in later samples as increasingly rare taxa are added. A species accumulation curve records the total number of collected species as additional camera days are added. This has important practical implications, as researchers can use this curve to judge when sampling is adequate and adjust the study design and duration accordingly. For diversified communities of terrestrial vertebrates, such as in tropical forests where up to 40–50 species may occur at one particular area, there is convincing evidence that 1,000–2,000 camera trap days may be enough to detect up to 70–80% of the species (Tobler *et al.* 2008; Ahumada *et al.* 2011; Rovero *et al.* 2014). This of course will partly depend on site-specific features and species-specific detection rates. Nevertheless, many thousand camera trap days may be required to obtain a more complete species list, and the rarest or most elusive species may not be captured even when deploying a very large sampling effort (Srbek-Araujo and Chiarello 2005; Tobler *et al.* 2008). When the species accumulation curve reaches the asymptote, we can be quite confident that the species community has been sampled exhaustively. However, when this is not the case

(either because the community is very species rich, or because the sampling effort was not sufficient), we could be still interested in knowing the 'real' species richness. For this goal, statistical studies have suggested a large number of estimators of the asymptotic number of species (Magurran 2003). Most, if not all the estimators, ignore the imperfect detectability of species. One of the most promising methods to estimate species richness while accounting for imperfect detection of individual species is provided by Dorazio *et al.* (2006). An application of this method is provided in Chapter 9 (see also Rovero *et al.* 2014 for an example).

5.5 Case study

5.5.1 Raw data format (.CSV file)

In this section we provide an example using a data set of mammal images taken in the Udzungwa Mountains of Tanzania by the TEAM Network project during 2009–2013. According to a standardised protocol designed to assess and monitor communities of terrestrial vertebrates in tropical forests (TEAM Network 2011), this project deploys 60 camera stations through three sequential arrays of 20 camera traps each. Camera trapping was conducted from July to November each year from 2009 to 2013, and we use the 2009 data in this example as the baseline sampling of the long-term programme (see Rovero *et al.* 2014 for more details).

Images were entered into Wild.ID (see Chapter 4) and the output data set is a .CSV file for which we report in Figure 5.2 the columns that are relevant to the analysis with the first 10 records (see Chapter 4 for the full format of the output file). Each record is an image stored on the memory card. The complete dataset file can be downloaded as Appendix 5.1.

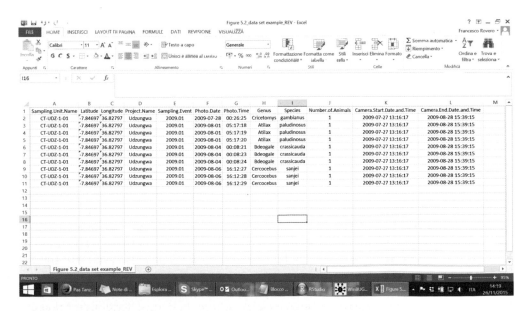

Figure 5.2 Screenshot of the first 10 rows of the data set used for analysis, a .CSV file produced by Wild.ID and opened in Excel.

This is the data format on which all subsequent analysis are based. The columns contain the following information:

- Sampling Unit Name: in this example, the standard TEAM coding of camera trap sites is used (Team Network 2011), whereby CT = Camera Trap, UDZ = Udzungwa, 1 = array 1, i.e. the first array of the three sequential arrays of 20 camera traps that are deployed each year, 01 = the first camera trap of 20 set for each array.
- Longitude, Latitude: coordinates of the sampling unit. The default coordinate system is in decimal degrees (format WGS 84). In the example provided, these are converted into UTM format.
- Sampling Event: the year of sampling (this is especially important for multiple-year studies). As described in Chapter 4, this field can be customised: we recommend the format adopted here (i.e. 2009.01 with the decimals indicating the season, in case there are multiple seasons sampled within the same year).
- Photo Date: the date the image was taken. It is fundamental to maintain the exact output format of Wild.ID which is yyyy-mm-dd. Since spreadsheet software such as Excel will modify this format when the .CSV file is opened depending on the computer settings, we recommend opening the file with a text editor to see the correct format.
- Photo Time: the time the image is taken using the format hh:mm:ss. The same observation as for the Photo Date applies.
- Genus and Species: the scientific binomial species' name (in two columns).
- Number of Animals: the number of individuals captured in the image.
- Camera Start Date and Time, Camera End Date and Time: these are the date of beginning and ending of the sampling, respectively. These are critical information and the .CSV output format is 'yyyy-mm-dd hh:mm:ss' (note the space between the date and time). Here, too, we note that opening the file in Excel is likely to modify these settings.

Note that the first steps described in the analysis will involve adding Class, Order and Family to the dataset using the IUCN database as the reference taxonomy. This will allow, for example, the analysis to be restricted to mammals only.

5.5.2 Importing data in R

To run the analysis, readers should first learn the basics of using the open-source software R (http://www.r-project.org/), for which a wealth of books and online references exist (see http://www.r-project.org/doc/bib/R-books.html, Venables and Smith 2009; Adler 2010; Kabacoff 2011; Crawley 2012). Since R receives instructions through the command line, we can code directly in the R console but often it is more convenient to write scripts in a separate file instead of typing them directly in the console. This requires a text editor. R comes with a default editor (which is accessed from the menu 'File' and then 'New script'), but it is very basic and lacks a lot of useful utilities. Among the available R editors, we recommend RStudio (available at http://www.rstudio.com). A typical screenshot of RStudio is given in Figure 5.3, showing four windows (that can be reduced or arranged as one prefers):

- The R script (top left in the example) which is where the code is written and saved.

Figure 5.3 Example of a screenshot of RStudio.

- The R console (top right) which is the R environment exactly as it would be if one runs analysis in R without using an editor. Here, the lines of the script are run and the outputs are displayed.
- Two additional panels are available, each with different attributes; in the example are shown the 'environment' (bottom left), where data and functions are listed and can be visualised by clicking on the corresponding icon on the right, and the plot(s) generated (bottom right).

Before starting, we need to set the working directory. It is recommended to create a folder where the .CSV data file, all scripts sourced and the R project are saved. This is the directory where all the output files will be saved. The directory can be set by selecting 'Set Working Directory' in the menu 'Session'.

Before importing data in R, we need to source the script called 'TEAM library 1.7' where all the functions needed to prepare and analyse the data are found:

```
source("TEAM library 1.7.R")
```

The sourced script contains many useful functions that can be called directly from this file without any need to report them in the R console. In practice, when we want to perform a specific task, we call the functions stored in that script. These sourced files will remain unchanged.

Next, we need to install several packages needed for the following tasks. There is a large number of available packages, for graphics, for performing statistical tests in most disciplines, etc. (see http://cran.r-project.org/web/packages/ to get a sense of the available packages). To use a package in R, we need to install it into a local library (i.e. a folder on our computer where all packages are stored). Next, we need to load the package into the current working session. Upon installing R for the first time, it comes with a number of different packages depending on the R version, and we can type the following command line to obtain a list of packages available by default in the version installed:

```
packages(all.available=TRUE)
```

The analyses presented in this section will need the following packages (each of them has a reference page on the web from which a manual in .PDF can be freely downloaded, as indicated for the package 'chron'):

- chron (http://cran.r-project.org/web/packages/chron/chron.pdf): handles chronological objects such as dates and times.
- reshape: restructures and aggregates data in a flexible way.
- vegan: a package containing a lot of functions for ecological analyses.
- plotrix: a package to visualize circular data.
- ggplot2: a powerful package for producing graphics.
- maptools: a package for combining spatial data and hence producing maps using GIS layers.

Information on each package (with a manual and examples) can be found on the R website. In order to install these packages type:

```
install.packages(c("chron","reshape", "vegan", "plotrix",
    "ggplot2"))
```

If all went well, the packages are now ready to be loaded in the current session of R.

```
library(chron)
library(reshape)
library (vegan)
library(plotrix)
library(ggplot2)
library(maptools)
```

We are now ready to load the data into R. A simple way is to use the command below that uses the function file.choose() which opens a window to search the data file manually:

```
team_data<-read.csv(file.choose(), sep=",",h=T)
```

Alternatively, if the data file is stored in the working directory where the R script runs, we can use the following command that states the exact name of the .CSV file:

```
team_data<-read.csv(file="teamexample.csv", sep=",",h=T,
    stringsAsFactors=F)
```

In both cases, it is important to make sure that the separator of the .CSV file is correctly identified in the command. In this example we have a comma-separated file, as it can be viewed by opening the data in a text editor (e.g. Notebook). We recommend *not* opening the .CSV file in Excel as the date and time formats will change depending on the local formats; a text editor will always display the correct format of the file. The command includes h=T because the data set contains the headings in the first row.

If we have installed RStudio, we can now observe in our 'Environment' window (bottom left in Figure 5.4) that our `team_data` object is being listed as containing 76,150 observations (`obs.`) of 12 variables. Additional datasets created by the analysis will be progressively stored in this window under the 'Data' heading.

Figure 5.4 Screenshot of RStudio showing the data set object `team_data` loaded in the 'Environment' window (bottom left).

As mentioned above, we now add taxonomic attributes (Class, Order, Family), sourcing these from the IUCN database, which is a .CSV file provided in Appendix 5.5.[1]

```
iucn.full<-read.csv("IUCN.csv", sep=",",h=T)
iucn<-iucn.full[,c("Class","Order","Family","Genus","Species")]
team<-merge(iucn, team_data, all.y=T)
```

We then run a function which elaborates our raw data as imported (object called `team_data`) to derive our 'clean' data ('data' object) ready for analysis:

```
data<-fix.dta(team)
```

By running this, we end up with a database that contains 19 columns from the 12 that were found in the original `team_data`. We had already included the taxonomy attributes (Class, Order, Family), moreover the function `fix.dta` corrects the format of dates (check, for example, the variable `Photo.Time` in `team` and `data`), creates two new time objects (camera start date and time; camera end date and time), an ID for each picture (date and time) and a binomial name of species (`bin`).

Our 'data' object is ultimately the database on which subsequent analysis is done.

5.5.2.1 Checking data

It is good rule first to look at the data to ensure that everything is in order and consistent with the raw data being imported. Hence, we run this command to view the column headings of the 19 columns in the object `data`:

[1] These attributes (Class, Family, Order) may be automatically integrated in future versions of Wild.ID, in such cases the `fix.dta` function can be applied directly to the uploaded data set, and the three script lines needed to source them from the IUCN database will not be required.

```
names(data)
```

R returns in the console the output, which in our case is:

```
[1]  "Genus"                     "Species"
[3]  "Class"                     "Order"
[5]  "Family"                    "Sampling.Unit.Name"
[7]  "Longitude"                 "Latitude"
[9]  "Project.Name"              "Sampling.Event"
[11] "Photo.Date"                "Photo.Time"
[13] "Number.of.Animals"         "Camera.Start.Date.and.Time"
[15] "Camera.End.Date.and.Time"  "Start.Date"
[17] "End.Date"                  "bin"
[19] "td.photo"
```

Next, we extract the first year, 2009, from the whole dataset. We also extract the mammals only:

```
yr2009<-data[data$Sampling.Event =="2009.01" &
    data$Class=="MAMMALIA",]
```

By using the function `unique`, which returns values in a dataset without duplicates, we can then check the content of a number of key columns to simply check if things are in order. For example, we can type:

```
unique(yr2009$bin)
```

This returns the binary name of species contained in the database simply by listing them only once for every name found. We obtain the following list:

```
[1]  Cricetomys gambianus        Atilax paludinosus
[3]  Bdeogale crassicauda        Cercocebus sanjei
[5]  Cephalophus harveyi         Cephalophus spadix
[7]  Panthera pardus             Hystrix africaeaustralis
[9]  Civettictis civetta         Potamochoerus larvatus
[11] Nesotragus moschatus        Homo sapiens
[13] Papio cynocephalus          Loxodonta africana
[15] Colobus angolensis          Nandinia binotata
[17] Paraxerus vexillarius       Genetta servalina
[19] Cercopithecus mitis         Mellivora capensis
[21] Procolobus gordonorum       Dendrohyrax validus
[23] Rhynchocyon cirnei          Mungos mungo
[25] Petrodromus tetradactylus Syncerus caffer
[27] Rhynchocyon udzungwensis
```

This is a quick way to check the species reported in the database, in this case 27 mammals from the TEAM Network site in the Udzungwa Mountains. Since in this case we are not interested in the images of humans, we remove this species from the data:

```
data<- droplevels(yr2009 [data$bin!="Homo sapiens", ])
```

Next, we may want to check the number of camera trap stations for which there are records in the database:

```
unique(yr2009$Sampling.Unit.Name)
```

In our example, we obtain a list of 58 camera stations, which means that out of the 60 camera stations originally sampled two camera stations did not produce any image record that is contained in the database. This could be due to a total malfunction of a camera trap, a camera trap stolen or a camera trap damaged by an animal without any image being recorded in the memory.

Another useful check is on the start and end date of sampling:

```
unique(yr2009$Camera.Start.Date.and.Time)
```

We obtain (see first row below) a list of 58 start dates and times which are useful to check for consistency with the beginning and ending of our sampling as we will know this from the fieldwork:

```
[1] (09-07-27 13:16:17) (09-07-25 15:52:52) (09-07-26 11:46:24)
```

5.5.3 Deriving sampling effort, events and species' list

We derive the survey effort (camera days) by using the function `cam.days` sourced in the libraries. The function needs as arguments the data and the sampling period, or sampling year (in this case `2009.01`) which is in the data column `Sampling.Event`. This is to identify the sampling year in studies that involve repeated sampling in multiple years (see Chapter 6).

This function yields a table with a list of cameras, start and end dates, and the number of days the camera traps have worked. In the case that a camera trap did not work for the all duration of sampling (e.g. because of memory saturation or malfunctioning), Wild.ID adjusts the end date to the last image taken, so that the correct sampling effort can be calculated.

We therefore run the command:

```
camera_days<-cam.days(data,2009.01)
```

The object `camera_days` is now stored in the Environment window of RStudio, and contains 58 observations (the number of camera trap stations sampled) of four variables, namely: `Sampling.Unit.Name`, `Start.Date`, `End.date` and `ndays`.

We then use the function `write.table` if we want to save this object in a text file that we call 'camera_days_2009.txt', saved in the default directory:

```
write.table(camera_days,file="camera_days_2009.txt",quote=F,
    sep="\t")
```

The file can be opened in a text editor (such as Notepad) or in Excel and should appear as in Figure 5.5 (first ten rows):

We can then derive minimum, maximum, median and quartiles of dates and sampling effort:

```
Sampling.Unit.Name    Start.Date      End.Date     ndays
       CT-UDZ-1-01     2009-07-27    2009-08-28        32
       CT-UDZ-1-02     2009-07-25    2009-08-28        34
       CT-UDZ-1-03     2009-07-26    2009-08-28        33
       CT-UDZ-1-04     2009-07-24    2009-08-30        37
       CT-UDZ-1-05     2009-07-27    2009-08-30        34
       CT-UDZ-1-06     2009-07-28    2009-08-31        34
       CT-UDZ-1-07     2009-07-25    2009-08-28        34
       CT-UDZ-1-08     2009-07-25    2009-08-28        34
       CT-UDZ-1-09     2009-07-28    2009-08-31        34
       CT-UDZ-1-10     2009-07-28    2009-08-31        34
```

Figure 5.5 Output table for the calculation of the sampling effort.

```
summary(camera_days[,2:4])

            Start.Date                 End.Date                   ndays
   Min.   :2009-07-24    Min.   :2009-08-06    Min.    : 7.00
   1st Qu.:2009-07-31    1st Qu.:2009-09-02    1st Qu.:30.00
   Median :2009-09-12    Median :2009-10-13    Median :31.00
   Mean   :2009-09-12    Mean   :2009-10-14    Mean   :31.34
   3rd Qu.:2009-10-28    3rd Qu.:2009-11-29    3rd Qu.:33.00
   Max.   :2009-11-03    Max.   :2009-12-04    Max.   :37.00
```

Such simple summaries can of course also easily be done in Excel.

The next step is to derive, for each species and camera trap station, the trapping events according to a user-defined time-interval criterion. We use the function event.sp that has as arguments: a data frame (i.e. the data object produced earlier), the sampling year (year as indicated above), and the time interval expressed in minutes (thresh). This function reshapes the object date, yielding a table with the cameras in rows and the species in columns. The entries of this table are the number of events separated by a specific threshold.

Below we run the commands and store away the results for an interval of 1 hour (thresh=60) and 1 day (thresh=1440), respectively:

```
events_hh<-event.sp(dtaframe=data, year=2009.01, thresh=60)
events_dd<-event.sp(dtaframe=data, year=2009.01, thresh=1440)
```

Comparing the two tables, events_hh and events_dd, we see that most of the species were not captured repeatedly in a day. Only the most detected species, as *Cephalophus harveyi*, passed more times a day in front of the cameras.

We can store away the results (objects events_hh and events_dd) as above:

```
write.table(events_hh, file="events_hh.txt",quote=F, sep="\t")
write.table(events_dd, file="events_dd.txt",quote=F, sep="\t")
```

These tables are 58 × 28 in size, i.e. the number of camera trap stations by the number of species (plus the sampling unit name column). We can also produce a summary table of events by species:

```
events_hh_species<-colSums(events_hh)
```

```
write.table(species, file="events_hh_species.txt", sep="\t",
    quote=F)
```

We now have derived the event scores for each species (and, if needed, by camera trap site), which are used to calculate the RAI. We can first verify the differences between daily and hourly scores, the total number of events being 1,039 and 1,259, respectively.

species	events_hh	events_dd	Survey effort	RAI_hh	RAI_dd
Atilax paludinosus	3	3	1818	0.17	0.17
Bdeogale crassicauda	130	126	1818	7.15	6.93
Cephalophus harveyi	367	281	1818	20.19	15.46
Cephalophus spadix	60	58	1818	3.30	3.19
Cercocebus sanjei	73	71	1818	4.02	3.91
Cercopithecus mitis	22	22	1818	1.21	1.21
Civettictis civetta	1	1	1818	0.06	0.06
Colobus angolensis	1	1	1818	0.06	0.06
Cricetomys gambianus	276	215	1818	15.18	11.83
Dendrohyrax validus	23	23	1818	1.27	1.27
Genetta servalina	18	18	1818	0.99	0.99
Homo sapiens	2	2	1818	0.11	0.11
Hystrix africaeaustralis	11	10	1818	0.61	0.55
Loxodonta africana	11	10	1818	0.61	0.55
Mellivora capensis	7	6	1818	0.39	0.33
Mungos mungo	2	2	1818	0.11	0.11
Nandinia binotata	2	2	1818	0.11	0.11
Nesotragus moschatus	114	97	1818	6.27	5.34
Panthera pardus	8	8	1818	0.44	0.44
Papio cynocephalus	3	3	1818	0.17	0.17
Paraxerus vexillarius	46	46	1818	2.53	2.53
Petrodromus tetradactylus	3	2	1818	0.17	0.11
Potamochoerus larvatus	18	18	1818	0.99	0.99
Procolobus gordonorum	5	5	1818	0.28	0.28
Rhynchocyon cirnei	4	4	1818	0.22	0.22
Rhynchocyon udzungwensis	45	45	1818	2.48	2.48
Syncerus caffer	4	4	1818	0.22	0.22
	1259	1083			

Figure 5.6 List of species detected and calculation of the camera trapping rate, or relative abundance index (RAI).

This step can also be easily done in Excel (Figure 5.6). We simply need to copy into a spreadsheet the species' list and events, and divide the events by the sampling effort (in this case 1,818) to derive the RAI for each species, using both hourly and daily events. Note that we multiply the index by 100 as most values are <0.

An assessment of RAI across camera stations may be useful to explore if there are differences in species' relative abundance with possible environmental gradients (elevation, habitat types, distance to sources of disturbance, etc.) and below we show how to plot species' distribution to produce a descriptive assessment. However, we stress again that proper inference on abundance patterns of the population at large can only be done when using a state variable of abundance that accounts for imperfect detection (Chapter 6).

5.5.4 Naïve occupancy

The calculation of naïve occupancy (camera trap sites positive to presence on the total number of sites, see above) is simple and can easily be done in Excel using the `events_dd` object as derived above (Figure 5.5). For each species, we need to calculate the number of camera trap sites where events are greater than zero and divide the value by 58 (the total number of camera trap sites). The function `COUNT.IF` in Excel does that, with '>0' being the criterion for counting the cells. As with any other function in Excel, we also need to provide the interval of cells to which the function is applied. We will then copy the resulting values somewhere else besides the species' list (see object `events_dd_species`). Note that we will derive the counts of positive camera trap sites arranged on a row while we have the species' list in column, which is more convenient; we therefore opt to transpose the counts using the option 'Paste special' > 'Transpose' under the 'Home' menu of the main Excel bar. Once this is done, we can calculate naïve occupancy (in Figure 5.7 the results are shown for the first five species).

Alternatively, we can run this analysis in R using two functions: `f.matrix.creator` and `naive`. The function `f.matrix.creator` is applied to the main data set (object `data`). This function creates, for each species, a table with cameras on rows and days on columns. The function `naive` in turns yields the naïve occupancy values for each species. As usual, we can save away the results.

```
mat<-f.matrix.creator(yr2009)
naive_occu_2009<-naive(mat)
write.table(naive_occu_2009, file="naive_occu_2009.txt",
    sep="\t", quote=F, row.names = F)
```

Species	Num. positive cameras	Num. sites	RAI
Atilax paludinosus	3	58	0.0517
Bdeogale crassicauda	43	58	0.7414
Cephalophus harveyi	50	58	0.8621
Cephalophus spadix	27	58	0.4655
Cercocebus sanjei	30	58	0.5172

Figure 5.7 Example of calculation of the naïve occupancy for the first five species of the checklist.

5.5.5 Species accumulation

As explained earlier, the completeness of the faunal inventory can be assessed by creating a species accumulation curve and checking if it has reached an asymptote. We build a species accumulation curve by using the function `acc.curve`. The function needs as usual the object `data` and the year we intend to analyse. Then it retains only the class Mammalia (i.e. the other classes, if present, are dropped), and the table is arranged in the correct way as the internal function `specaccum` needs. The function `specaccum` is loaded from the package `vegan` and it is set to count the species richness as camera trap days increase. The function repeats the counts many times (we set it to 100), each time changing the order of days. The output of the function `acc.curve` is the average species richness and its standard deviation.

```
accumulation<-acc.curve(data,2009.01)
```

We then save the output object `accumulation` and observe that it contains three columns: the progressive number of camera days, the richness and the standard deviation of the richness:

```
write.table(accumulation, file="accsp_2009.txt", sep="\t",
    quote=F)
```

Finally, we plot the average species richness, with standard deviation, and the camera trap days to obtain the species' accumulation curve (Figure 5.8):

```
ggplot(accumulation, aes(x=Camera.trap.days, y=species)) +
    geom_line(aes(y=species-sd), colour="grey50",
    linetype="dotted") +
    geom_line(aes(y=species+sd), colour="grey50",
    linetype="dotted") +
    geom_line()
```

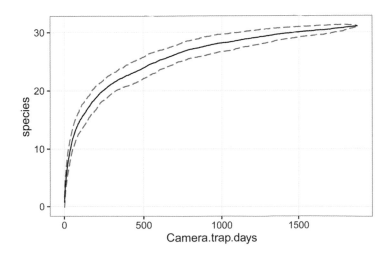

Figure 5.8 Randomized species accumulation curve (solid line), and confidence intervals (dashed line).

5.5.6 Activity pattern

When surveys cumulate a robust survey effort (e.g. >500 camera days) and hence some species are recorded with enough events (>20) for focal analysis, species-specific activity pattern can be assessed by plotting all hour-separated events by the hour of the day.

This is done by the function `events.hours` that is fed, as usual, by the object `year2009`. It yields a table with hours (0–24) and species summing all the events, keeping 1 hour as the interval.

```
activity_24h<-events.hours(year2009)
```

This could also be calculated for all years data, as follows:

```
activity_24h<-events.hours(data)
```

We then save the resulting object `activity_24h`:

```
write.table(activity_24h, file="events_24hour_2009.txt",quote=F,
    sep="\t",row.names = F)
```

An extract of this output file opened in Excel is shown in Figure 5.9 for the first four species and the first five 1 h intervals:

With this, we can make charts of events in the 24 h directly in Excel.

Alternatively, we can use the ad-hoc `clock24.plot` function in R (package `plotrix`, see http://cran.r-project.org/web/packages/plotrix/index.html or type ? `clock24.plot` in the R console). We first define `clock` as a vector of 24 values, and we then build the plot for a focal species, in this example the red cuiker *Cephalophus harveyi*:

```
clock<-c(0:23)
clock24.plot(activity_24h$Cephalophus.harveyi,clock,show.
    grid=T,lwd=2,line.col="blue", main="Cephalophus.harveyi",
    cex.lab=0.5)
```

	Atilax. paludinosus	Bdeogale. crassicauda	Cephalophus. harveyi	Cephalophus. spadix
00:00:00	0	9	8	0
01:00:00	0	13	11	2
02:00:00	0	19	4	1
03:00:00	0	9	5	1
04:00:00	1	9	3	0
05:00:00	1	8	4	4
06:00:00	0	0	32	4
07:00:00	0	0	39	5
08:00:00	0	0	26	9
09:00:00	0	0	16	1
10:00:00	0	0	15	5

Figure 5.9 Hourly counts of events per species, needed to derive charts of activity. The example shows only the first 10 h for four species.

Figure 5.10 Radial plot of activity pattern based on hourly counts of events.

The resulting radial plot is shown in Figure 5.10.

With data from multiple years, such as in our case, the following code derives the hourly events for all available years:

```
activity_24h<-events.hours(data)
```

We refer to Chapter 8 for detailed background and analysis of activity pattern including quantitative assessment of activity overlap between species (see also below for a descriptive comparison of activity patterns).

5.5.7 Presentation and interpretation of results

As the species accumulation gives an indication of sampling completeness, we recommend showing this curve (see Rovero *et al.* 2014 for an example). In our example, the shape of the curve with its steep increase and tendency to reach a plateau indicates that sampling has captured a good portion of species in the community. Curves that do not flatten are generally an indication of insufficient sampling.

Next, we suggest presenting the full inventory results in terms of checklist of species camera trapped group by taxonomic attributes together with the raw indices we derived in the example (Table 5.1).

These results will in turn provide a description of the variation among species in terms of event rates (RAI) and naïve occupancy (the two indices may be broadly concordant) and, for non-systematic surveys where no further analysis is feasible, enable some conclusions to be drawn based on observed metrics about the relative abundance of species.

When the survey covers adequately the target area, and the spatial design is regular enough, it is useful to plot results on a map and inspect the distribution of species. This may also help assessing any potential, mutual distribution among two or more species for which an interaction is postulated. To do this we use the camera trap site coordinates from the Open DeskTEAM output file.

Table 5.1 Checklist of mammals camera trapped in Mwanihana forest, Udzungwa Mountains, Tanzania during the baseline survey of the TEAM programme (adapted from Rovero *et al.* 2014)

Taxonomic group	Common name	Scientific name	Events per hour	RAI	Naïve occupancy
Afrotheria	tree hyrax	*Dendrohyrax arboreus*	23	1.27	0.241
	African elephant	*Loxodonta africana*	11	0.61	0.121
	four-toad sengi	*Petrodromus tetradactylus*	3	0.17	0.017
	chequered sengi	*Rhynchocyon cirnei*	4	0.22	0.052
	grey-faced sengi	*Rhynchocyon udzungwensis*	45	2.48	0.259
Carnivores	marsh mongoose	*Atilax paludinosus*	3	0.17	0.052
	bushy-tailed mongoose	*Bdeogale crassicauda*	130	7.15	0.741
	African civet	*Civettictis civetta*	1	0.06	0.017
	Lowe's servaline genet	*Genetta servalina lowei*	18	0.99	0.259
	honey badger	*Mellivora capensis*	7	0.39	0.103
	banded mongoose	*Mungos mungo*	2	0.11	0.034
	African palm civet	*Nandinia binotata*	2	0.11	0.034
	leopard	*Panthera pardus*	8	0.44	0.052
Primates	Sanje mangabey	*Cercocebus sanjei*	73	4.02	0.517
	Sykes' monkey	*Cercopithecus mitis*	22	1.21	0.241
	yellow baboon	*Papio cynocephalus*	3	0.17	0.052
	Udzungwa red colobus	*Procolobus gordonorum*	5	0.28	0.069
	Angolan colobus	*Colobus angolensis*	1	0.06	0.017
Rodents	giant pouched-rat	*Cricetomys gambianus*	276	15.18	0.534
	Cape porcupine	*Hystrix africaeaustralis*	11	0.61	0.086
	Tanganyika mountain squirrel	*Paraxerus vexillarius*	46	2.53	0.328
Ungulates	Harvey's duiker	*Cephalophus harveyi*	367	20.19	0.862
	Abbott's duiker	*Cephalophus spadix*	60	3.30	0.466
	suni	*Neotragus moschatus*	114	6.27	0.448
	bush pig	*Potamochoerus larvatus*	18	0.99	0.190
	African buffalo	*Syncerus caffer*	4	0.22	0.052

Such maps can be done directly in R, with a basic graphic being simply a plot of geo-referenced camera locations represented as dots of varying colour or size according to the metric used. Ideally, however, we can use any geographical attribute that will help interpreting the map; these geographical 'layers' should be shapefiles, i.e. graphical objects that are geo-referenced so that they can be assembled using, for example, the package `maptools`. In the example below we simply use the shape of the forest, that we have as a shapefile, i.e. a geo-referenced polygon. Additional attributes could be road networks, rivers, digital elevation models, or even a geo-referenced topographical map.

The species' metric used for plotting can be simple presence/absence, number of events, or RAI.

Here, we plot as an example the cumulative daily trapping events scored for the two giant sengis, or elephant-shrew (genus *Rhynchocyon*). Since these species belong to the same genus, are similar in size and have similar diet, we are interested to see if their distributions overlap and whether any sign of competition is evident in the spatial distribution.

We first load in R our forest contour shape (file park.shp):

```
shape <- readShapeSpatial("park.shp", repair=T)
```

We also load the package maptools needed to convert the coordinate format from decimal degrees into UTM:

```
library(maptools)
```

We then create a table with coordinates of the camera traps locations and associated daily events for all species at first:

```
ev.dd.map<-merge(unique(data[,c("Sampling.Unit.Name",
    "Longitude","Latitude")]),events_dd)
```

Because the default format of coordinates is decimal degrees, we transform the coordinates in UTM using the lines below (should the coordinates originally be included in UTM, then the reader can skip these lines). Note that these are referred to the specific UTM zone of the study area (UTM 37S), and therefore this code will need to be customised:

```
coord<-ev.dd.map[,c("Longitude","Latitude")]
xy <- project(as.matrix(coord), "+proj=utm +zone=37
    +south +ellps=clrk80 +units=m +no_defs")
ev.dd.map$Longitude<-xy[,1]
ev.dd.map$Latitude<-xy[,2]
```

We tell R how to arrange the two maps that we are going to create in a panel, and we first just plot the forest contour:

```
par(mfcol=c(1,2), mar=c(0.5,0.5,0.5,0.5), oma=c(1,1,1,1))
plot(shape,axes=F)
```

We then plot the map for *R. cirnei*, specifying the title, font and size; since we want to have dots on a grey scale according to the number of events, we create a vector called Rc, standardising the values to the maximum.

```
mtext("Rhynchocyon cirnei", cex = 1.5,font =3 )
Rc<-ev.dd.map[,c("Rhynchocyon cirnei")]/max(ev.
    dd.map[,c("Rhynchocyon cirnei")])
points(ev.dd.map[,"Longitude"],ev.dd.map[,"Latitude"],
    pch = 21,bg=grey(1-Rc))
plot(shape,axes=F)
```

We do the same for the other species, *R. udzungwensis*:

```
mtext("Rhynchocyon udzungwensis",cex = 1.5, font =3)
Ru<-ev.dd.map[,c("Rhynchocyon udzungwensis")]/max(ev.
    dd.map[,c("Rhynchocyon udzungwensis")])
points(ev.dd.map[,"Longitude"],ev.dd.map[,"Latitude"],
    pch = 21,bg=grey(1-Ru))
```

The resulting panel is shown in Figure 5.11.

This map is very informative as we observe a typical, *parapatric* distribution, whereby the two species have contiguous but non-overlapping distributions across the forest. This may indeed be the result of competitive exclusion shown by species with similar ecological niches. Similar spatial plots of RAIs for target species or group of species can also be done to assess if any likely pattern of habitat associations exist – for example species that may prefer forest edge vs. interior habitat, species that prefer riverine habitats or species that react to sources of disturbance.

Similar inspections of results can be done along the temporal dimension using the results of the activity pattern. For example, we can plot side-by-side the activity pattern plots for species that may be under competition for resources and may therefore adjust their temporal pattern of activity. We can show this for three species of forest antelope (*Cephalophus spadix, C. harveyi* and *Nesotragus moschatus*) in the example below.

We first tell R to arrange the subsequent plots in a panel of 1 row × 3 columns, and then we reload the `clock` object (see above):

Rhynchocyon cirnei *Rhynchocyon udzungwensis*

Figure 5.11 Map of the camera trapping event score for the two species of giant sengi, or elephant-shrew in Mwanihana Forest, Udzungwa Mountains. The grey scale of the symbols represents the cumulative daily events standardised on the maximum number of events for that species.

Figure 5.12 Panel with plots of activity patterns for three species of forest antelope.

```
par(mfrow=c(1,3),cex.lab=0.5, cex.axis-0.5)
clock<-c(0:23)
```

We then make the three plots sequentially using the same command as before and only changing the colour of the line (`line.col=""`):

```
clock24.plot(activity_24h$Cephalophus.spadix,clock,
    show.grid=T,lwd=2,line.col="green", main="Cephalophus.spadix")
clock24.plot(activity_24h$Cephalophus.harveyi,clock,
    show.grid=T,lwd=2,line.col="blue", main="Cephalophus.harveyi")
clock24.plot(activity_24h$Nesotragus.moschatus,clock,
    show.grid=T,lwd=2,line.col="red", main="Nesotragus.moschatus")
```

The resulting panel of plots is shown in Figure 5.12.

5.6 Conclusions

This chapter has addressed the use of camera trapping for faunal surveys. We have emphasised the importance of setting a clear study objective and how the difference between a systematic vs. an opportunistic study design will determine the type and quality of the ensuing analysis, with a systematic approach allowing for inferential analysis on the population at large. We have also cautioned against overreliance on an index such as the event rate (RAI) – which does not account for multiple sources of variation in detectability – for making inferences on abundance in space and time, and for comparison among populations and species. Through a case study, we have provided the essential tools for an analysis that can be generalised and customised to the readers' data. Finally, for an inferential assessment on focal species or communities based on occupancy, i.e. a state variable that accounts for imperfect detection, the reader is referred to Chapter 6.

Appendices

Appendix 5.1 Case study data set: 'teamexample.csv'
Appendix 5.2 R script: 'R script_chapter 5.R'
Appendix 5.3 R library with all functions: 'TEAM library 1.7.R'

Appendix 5.4 Shape file of forest contour: 'park.shp'
Appendix 5.5 IUCN species taxonomy: 'IUCN.csv'

Acknowledgements

We are grateful to Roland Kays and Fridolin Zimmermann for valuable comments on previous versions of this chapter.

References

Adler, J. (2010) *R in a Nutshell*. Sebastopol, CA: O'Reilly Media.

Ahumada, J.A., Silva, C.E.F., Gajapersad, K., Hallam, C., Hurtado, J., Martin, E., McWilliam, A., Mugerwa, B., O'Brien, T., Rovero, F., Sheil, D., Spironello, W.R., Winarni, N. and Andelman, S.J. (2011) Community structure and diversity of tropical forest mammals: data from a global camera trap network. *Philosophical Transactions of the Royal Society B Biological Sciences* 366: 2703–2711.

Anile, S. and Devillard, S. (2015) Study design and body mass influence RAIs from camera trap studies: evidence from the Felidae. *Animal Conservation* 19: 35–45.

Bowkett, A.E., Rovero, F. and Marshall, A.R. (2008) The use of camera-trap data to model habitat use by antelope species in the Udzungwa Mountain forests, Tanzania. *African Journal of Ecology* 46: 479–487.

Carbone, C., Christie, S., Conforti, K., Coulson, T., Franklin, N., Ginsberg, J.R., Griffiths, M., Holden, J., Kawanishi, K., Kinnaird, M., Laidlaw, R., Lynam, A., Macdonald, D.W., Martyr, D., McDougal, C., Nath, L., O'Brien, T., Seidensticker, J., Smith, D.J.L., Sunquist, M., Tilson, R. and Wan Shahruddin W.N. (2001) The use of photographic rates to estimate densities of tigers and other cryptic mammals. *Animal Conservation* 4: 75–79.

Crawley, M. (2012) *The R Book*. New York: Wiley.

Dorazio, R.M., Royle, J.A., Söderström, B. and Glimskär, A. (2006) Estimating species richness and accumulation by modeling species occurrence and detectability. *Ecology* 87: 842–854.

Gotelli, N.J. and Colwell, R.K. (2001) Quantifying biodiversity: procedures and pitfalls in the measurement and comparison of species richness. *Ecology Letters* 4: 379–391.

Kabacoff, R.I. (2011) *R in Action*. Greenwich, CT: Manning Publications Co.

Kays, R. and Parsons, A.W. (2014) Mammals in and around suburban yards, and the attraction of chicken coops. *Urban Ecosystems* 17: 691–705.

Kelly, J.M. and Holub, E.L. (2008) Camera trapping of carnivores: trap success among camera types and across species, and habitat selection by species on Salt Pond Mountain, Giles Country, Virginia. *Northeastern Naturalist* 15: 249–262.

MacKenzie, D.I., Nichols, J.D., Lachman, G.B., Droege, S., Andrew Royle, J. and Langtimm, C.A. (2002) Estimating site occupancy rates when detection probabilities are less than one. *Ecology* 83: 2248–2255.

Magurran, A.E. (2003) *Measuring Biological Diversity*. Oxford: Wiley-Blackwell.

O'Brien, T.G. (2011) Abundance, density and relative abundance: a conceptual framework. In: A.F. O'Connell, J.D. Nichols, U.K. Karanth (eds), *Camera Traps in Animal Ecology. Methods and Analyses*. Springer: New York. pp. 71–96.

O'Brien, T.G., Kinnaird, M.F. and Wibisono, H.T. (2003) Crouching tigers, hidden prey: Sumatran tiger and prey populations in a tropical forest landscape. *Animal Conservation* 6: 131–139.

Pollock, K.H., Nichols, J.D., Simons, T.R., Farnsworth, G.L., Bailey, L.L. and Sauer, J.R. (2002) Large scale wildlife monitoring studies: statistical methods for design and analysis. *Environmetrics* 13: 105–119.

Steenweg, R., Whittington, J. and Hebblewhite, M. (2012) Canadian Rockies Carnivore Monitoring Project: Examining Trends in Carnivore Populations and their Prey Using Remote

Cameras. Year 1 Progress Report, 2011–2012. August 2012. University of Montana. http://www.cfc.umt.edu/Heblab/ParksCamera.html (accessed 5 February 2015).

Rovero, F. and Marshall, A.R. (2009) Camera trapping photographic rate as an index of density in forest ungulates. *Journal of Applied Ecology* 46, 1011–1017.

Rovero, F., Zimmermann, F., Berzi, D. and Meek, P. (2013) "Which camera trap type and how many do I need?" A review of camera features and study designs for a range of wildlife research applications. *Hystrix: the Italian Journal of Mammalogy* 24: 148–156.

Rovero, F., Martin, E., Rosa, M., Ahumada, J.A. and Spitale, D. (2014) Estimating species richness and modelling habitat preferences of tropical forest mammals from camera trap data. *PLoS ONE* 9: e103300.

Rowcliffe, J.M., Field, J., Turvey, S.T. and Carbone, C. (2008) Estimating animal density using camera traps without the need for individual recognition. *Journal of Applied Ecology* 45: 1228–1236.

Rowcliffe, M., J., Carbone, C., Jansen, P.A., Kays, R. and Kranstauber, B. (2011) Quantifying the sensitivity of camera traps: an adapted distance sampling approach. *Methods in Ecology and Evolution* 2: 464–476.

Si, X., Kays, R. and Ding, P. (2014) How long is enough to detect terrestrial animals? Estimating the minimum trapping effort on camera traps. *PeerJ* 2: e374.

Sollmann, R., Mohamed, A., Samejima, H. and Wilting, A. (2013) Risky business or simple solution – relative abundance indices from camera-trapping. *Biological Conservation* 159: 405–412.

Srbek-Araujo, A.C. and Chiarello, A.G. (2005) Is camera-trapping an efficient method for surveying mammals in neotropical forests? A case study in south-eastern Brazil. *Journal of Tropical Ecology* 21: 121–125.

TEAM Network (2011) *Terrestrial Vertebrate Protocol Implementation Manual, v. 3.1.* Tropical Ecology, Assessment and Monitoring Network, Center for Applied Biodiversity Science, Conservation International, Arlington, VA, USA. http://www.teamnetwork.org/files/protocols/terrestrial-vertebrate/TEAMTerrestrialVertebrate-PT-EN-3.1.pdf (accessed 5 February 2015).

Tobler, M.W., Carrillo-Percastegui, S.E., Leite Pitman, R., Mares, R. and Powell, G. (2008) An evaluation of camera traps for inventorying large- and medium-sized terrestrial rainforest mammals. *Animal Conservation* 11: 169–178.

Trolle, M. and Kéry, M. (2003) Estimation of ocelot density in the Pantanal using capture-recapture analysis of camera-trapping data. *Journal of Mammalogy* 84: 607–614.

Venables, W.N. and Smith, D.M. (2009) *An Introduction to R.* Network Theory Limited.

Yasuda, M. (2004) Monitoring diversity and abundance of mammals with camera traps: a case study on Mount Tsukuba, central Japan. *Mammal Study* 29: 37–46.

Yoccoz, N.G., Nichols, J.D. and Boulinier, T. (2001) Monitoring of biological diversity in space and time. *Trends in Ecology & Evolution* 16: 446–453.

Williams B.K., Nichols J.D. and Conroy M.J. (2002) *Analysis and Management of Animal Populations.* New York: Academic Press.

6. Species-level occupancy analysis

Francesco Rovero and Daniel Spitale

6.1 Introduction

This chapter addresses the use of camera trapping to estimate occupancy at the species level. Occupancy is defined as the proportion of area, patches or sites occupied by a species (MacKenzie *et al.*, 2002), and it is fundamentally a function of abundance and the parameters that govern the dynamic process of how animals are distributed in the environment (O'Connell and Bailey 2011). As a state variable of animal occurrence and abundance, occupancy is of great interest in ecology. While its primary use is related to studies on distribution modelling, range size, metapopulation and community dynamics, the value of occupancy as a surrogate for abundance makes this metric of wide use also in studies such as modelling habitat associations, assessing the impact of management actions, multispecies relationships and, critically, monitoring temporal changes of populations and communities (reviews in MacKenzie *et al.* 2006; O'Connell and Bailey 2011; Bailey *et al.* 2014; see also Chapter 9).

Studies on populations are most often interested in measuring abundance, but estimation of this requires substantial efforts because it normally requires the identification of individuals. This may be unfeasible, or too resource demanding, and it may also not be necessary, unless the target population is very threatened and small – hence knowing the number of individuals remaining in the population is of critical conservation relevance – or when determining vital rates (i.e. rates of birth, death and movements in and out of the population) that drive changes in its abundance is essential for the management of the population (MacKenzie *et al.* 2006). Indeed in most cases, an unbiased metric (i.e. one that accounts for imperfect detection, see below), which can be used as a surrogate of abundance, will be equally useful for investigating population trends over time, or spatial variation of population in relation to covariates, so that scientific hypotheses can be tested. In the case of camera trapping as a detection method, Chapter 7 addresses abundance estimation for naturally marked animals, such as most felids, using capture–recapture models. However, for the vast majority of terrestrial vertebrates detected by camera traps this approach is not applicable, while occupancy estimation is very suited for the study of any target species (but see Chandler and Royle 2013; Dénes *et al.* 2015).

The advantage of estimating occupancy instead of abundance is that determining whether a target species is present at a sampling location may be easier, and less costly, than collecting the data needed for estimating the number of individuals. Yet it is intuitive that, at the appropriate scale, occupancy and abundance are related: high density corresponds to more occupied habitat and vice versa (Royle and Dorazio 2008). While the two state variables address different aspects of population dynamics, i.e. the fraction of area occupied by a species (occupancy) vs. the number of individuals in the area (abundance), an appropriate choice of sampling unit will ensure that discrepancies are minimal (MacKenzie and Nichols 2004; see also section 6.3). Indeed, theoretically the two measures could coincide at small spatial scales, if each site is occupied by only one, territorial individual. Hence, occupancy can be used as a surrogate for abundance especially for species with relatively small (<5–10 km^2) and well-defined home ranges, so that a large enough area can be sampled simultaneously by camera traps. In this case, one can assume that each individual can only appear in one camera trap, and the camera trap grid should cover a representative portion of the population (Rovero *et al.* 2013).

We defined naïve occupancy in Chapter 5 as the number of sites occupied relative to the total number of sites sampled and we mentioned the inherent limitation of this metric: it does not account for imperfect detection (i.e. when a species is present but not detected). Here, we introduce true occupancy estimation, which is based on repeated presence–absence surveys of animals at multiple sites, a sampling approach that allows for the estimation of, and correction for, imperfect detection. As detailed further below, the basic repeated sampling scheme implies multiple visits to a randomly selected set of sites within a short interval of time so that sites are closed to changes in occupancy states (present, not present) within the season of sampling (O'Connell and Bailey 2011).

Importantly, occupancy analysis is particularly well suited for camera trapping data, because the sampling period (i.e. the duration for which each camera trap works) is fractioned, during analysis, into a number of multiple, sequential sampling occasions, e.g. 1 day each (but see Guillera-Aroita *et al.* (2011) on modelling detection as a continuous process). Therefore, detection data appear to be effectively collected over a greater number of sampling occasions than is normally feasible with alternative methods such as counts of signs, sightings or captures of animals, where temporal replication of sampling requires actual additional effort (repeated counts of signs, multiple sessions of trapping, etc.).

6.2 Theoretical framework and modelling approach

6.2.1 Basic single-season model

We provide here a description of the basic modelling framework (MacKenzie *et al.* 2002) that is used in the case study. We set as our goal the estimation of occupancy (ψ), the estimation of detection probability (p), and how these vary with potential covariates for a target species, within a single 'season' in the target area. We define detection probability (p) as the probability of detecting the species at a site, given it is present. According to the sampling design principles explained below, we then define a number of sites (s) deemed adequate for inference on the greater area, or collection of sites (S), to be sampled by camera traps. The duration for which each camera trap is deployed (and takes pictures) will determine the number (k) and length of sampling occasions, or repeated surveys, in which the sampling duration is discretised (see section 6.4.2). If detected, a survey

can confirm a species is present at the site s_i and sampling occasion k_i; however, if not detected, we cannot confirm a species is absent. The non-detection may be due either to the species being absent at the site, or to the species being present but undetected during the survey. The sequence made by k sampling occasions of detections (1) and non-detections (0) of the target species at the site i is defined as the site's detection history (\mathbf{h}_i). For example, a detection history for a sampling duration of 30 days could be considered as a sequence of six sampling occasions ($k = 6$) of 5 days each and could be $\mathbf{h}_i = 011001$, i.e. the species was detected at the second, third and sixth sampling occasions but went undetected at the first, fourth and fifth sampling occasions.

Detection–non-detection data are compiled for each site giving a matrix of sites (s) by sampling occasions (k) which represents the input information for estimating, through modelling, the two parameters of interest, ψ and p. For details on modelling approach we refer to MacKenzie *et al.* (2006) and general texts on ecological modelling (Bolker 2008; Soetaert and Herman 2009). It is useful to consider the occurrence of a species as a combination of two processes. The first determines whether a site is occupied or not (ecological process) and the second process (observation) determines whether the species is found or not given its presence (Kéry and Schaub 2012). Once the probability statement for each of the s observed detection histories is formulated, a likelihood equation allows for the estimation of the parameters of interest using maximum likelihood techniques (MacKenzie *et al.* 2006; Royle and Dorazio 2008). Alternatively, the parameters can be estimated in a Bayesian framework (Royle and Dorazio 2008; Kéry and Schaub 2012). Choosing one or the other approach is partly a matter of personal preferences and background, and is partly imposed by the complexity of the analysis. In the case study presented below, we used maximum likelihood (a frequentist estimation method) for the single-season occupancy models, while we propose the Bayesian approach for the multi-season, dynamic models; this is partly because complex multi-season occupancy models are currently poorly resolved in maximum likelihood with available analytical routines in R. A general background to the Bayesian framework is presented in Box 6.1 and we also refer readers to Chapter 9 (community analysis) where the case study is implemented using this analytical approach.

BOX 6.1 The Bayesian paradigm in brief

Simone Tenan

The purpose of this box is to introduce the principles of Bayesian inference in general terms; to learn more about this vast, and sometimes complex, topic readers are referred to some of the main references on which this short description is based (e.g. Gelman *et al.* 2003; Clark and Gelfand 2006; Congdon 2006; McCarthy 2007; Royle and Dorazio 2008; King 2009). The main difference between classical (frequentist) statistics and the Bayesian approach is that the latter considers parameters as random variables that are characterised by a prior distribution, on the same footing as the data. In contrast, in classical statistics, parameters are fixed and unknown constants, whereas data are the result of random processes. Under the Bayesian perspective data are observable quantities, whereas parameters, missing data and predictions are unobservable quantities that can only be estimated probabilistically, i.e. they are considered random variables (that can be

described by a statistical distribution). Bayesian statistics thus works by estimating a distribution for a parameter, differently from a frequentist approach focused on the estimation of a single value for a model parameter. The following example from Kéry (2010: p. 3) helps to clarify the differences between the two approaches:

> For instance, when estimating the annual survival rate in a population of some large bird species such as a condor, we would be rather surprised to find it to be less than, say, 0.9. Values of less than, say, 0.5 would appear downright impossible. However, in classical statistics, by not using any existing information, we effectively say that the survival rate in that population could be just as well 0.1 as 0.9, or even 0 or 1. This is not really a sensible attitude since every population ecologist knows very well a priori that no condor population would ever survive for very long with a survival rate of 0.1. In classical statistics, we always feign total ignorance about the system under study when we analyze it.

In Bayesian inference, before data are collected it is the prior distribution that describes the variation in the parameters. The prior distribution represents an assumption that we make about a model parameter on the basis of what we knew about it before conducting the analysis. Bayes' theorem, on which Bayesian statistics is based, provides the way to combine (or update) our prior belief with new observations (data) to obtain a posterior distribution on which inference is based. An important, practical distinction between frequentist and Bayesian treatments of hierarchical models concerns how latent variables (i.e. random effects) are treated. In classical statistics, random effects are removed from the model by integration. Unlike classical statistics, however, the Bayesian approach defines prior distributions for all unknown quantities and uses probability calculus and simulation methods to yield the posterior distribution of random effects.

The Bayesian approach follows from a simple application of Bayes' theorem that provides a posterior distribution for all of the model parameters jointly. If we are interested in only a particular parameter (or a subset of parameters) we want to estimate the *marginal* posterior distribution for that parameter alone (or for each parameter in the subset). In order to obtain the marginal posterior distribution we have to integrate the *joint* posterior distribution. It is here that the difficulties arise, due to the intractability involved in the calculation of the marginal posterior distribution. The modern approach to this problem is not to try to integrate the joint posterior distribution analytically, but instead to employ special simulation procedures (known as Markov chain Monte Carlo, MCMC; Robert and Casella 2004) that allow samples of the posterior distribution to be derived. Having simulated values from the joint posterior distribution means that one then naturally has simulated values from the marginal posterior distribution of the parameter of interest. Therefore, MCMC methods allow the construction of a sequence of values whose distribution converges to the posterior distribution of interest, given an arbitrarily large sample. This sequence is a dependent sample from the joint posterior distribution, since each realisation depends directly on its predecessor. Once the chain has converged to the stationary distribution we can use the sequence of values of the chain in order to obtain empirical estimates

of any posterior summary of interest, such as the marginal mean, median or standard deviation. The updating procedure remains relatively simple, no matter how complex the posterior distribution can be.

Markov chains are simulated by means of various algorithms already implemented in the so-called 'MCMC black boxes', which are freely available and based on the BUGS language. BUGS stands for 'Bayesian inference Using Gibbs Sampling', reflecting the basic computational technique originally adopted. Currently, there are three BUGS engines in widespread use among ecologists: WinBUGS (Lunn *et al.* 2000), OpenBUGS (Lunn *et al.* 2009) and JAGS (Plummer 2003). For further details about the BUGS language and engines see Lunn *et al.* (2012).

We refer to MacKenzie *et al.* (2002) and other sources (e.g. MacKenzie *et al.* 2006; O'Connell 2011) for a more detailed description of the analytical approach to running a basic single-species model. The basic model assumes that the *k* surveys are conducted over a suitable duration of time so that the *s* sites are closed to change in the state of occupancy. The total length of *k* sampling occasions defines this period of population closure as a *season* (i.e. sites are either occupied or not during the entire season). In addition to the closure assumption within seasons, this model assumes that (1) sites and detections are independent (i.e. detection histories among sites are independent, and species' detections on each occasion at a site are independent of detections during other occasions at the same site); (2) species are not misidentified; and (3) the probability of occupancy and detection are constant across sites, *or* that this variation can be modelled using covariates. The assumption of site independence (1) can be met by deploying a sampling design that has adequate spatial separation between sites, i.e. that minimises the chance that individuals' home ranges extend over multiple sites (see section 6.4 for more details). Similarly, the risk of violating independence of detections at the same site can be partially accommodated during analysis by choosing an appropriate sampling occasion. Independence is violated when the same individual, moving in front of the camera, creates multiple records; to reduce this risk, sampling occasion can be extended so that such multiple detections are considered a single event. This practice will still not guarantee complete independence of detections and increasing the length of sampling occasions carries other implications that need to be considered (see section 6.4.2 for more details). Assumption (2) should be accounted for by the use of the appropriate type of camera traps (see Chapter 2). Assumption (3) implies that site-level environmental covariates can be incorporated into the model; indeed the assumption of constant ψ and p is quite unrealistic, and most commonly the study objective is based on hypotheses about what drives variation in these parameters.

6.2.2 Covariate modeling and assessing model fit

Often the main goals of occupancy models are to test ecological hypotheses by estimating the covariate effects on both detection probability and occupancy. Covariates are included into the models by using appropriate link functions, the most common being the logit link (a logistic equation). Covariates for detection probability can be distinguished

between *site covariates* and *sampling covariates*. Site covariates vary among sites but are constant across the whole survey duration, whereas sampling covariates vary by survey (and can also vary by site). For example, we could hypothesise that the occurrence of a prey species is related to a particular habitat type preference, e.g. deciduous forests, among a suite of habitat types. Consequently, the occurrence-relevant site covariate will be for each site a category of habitat (a categorical variable). Occurrence could also vary in the study area according to some form of human disturbance that can be quantified by the distance of the site to the edge of the protected area, which would be a second site covariate (a numerical one). This latter covariate could also be used to model variation in detectability among sites due, for example, to shyness associated with disturbance near the edges of the area (Rovero *et al.* 2014). A typical site covariate of detection could be the camera trap model deployed at each site when different models are used. In addition, animals could be more elusive under a full moon to avoid predation, and therefore the moon phase of each sampling occasion would be a sampling covariate, rather than a site covariate. Other examples of typical sampling covariates are climate variables, such as temperature or rainfall.

Having the ability to model both occupancy and detection probability as functions of covariates enables many models to be investigated with appropriately collected data. Each model within the set of models formulated can be viewed as a hypothesis in a classical statistical perspective. We may have multiple hypotheses about our ecological system and we need a method to decide which model (or hypothesis) from the pool is the best. The acceptable model is selected with the aid of 'information theory' which defines the costs and benefits of selecting a particular model in favour of others. A popular method is the Akaike Information Criterion (AIC; Burnham and Anderson 2002; Konishi and Kitagawa 2008). The AIC is useful because it explicitly penalises any superfluous parameters in the model. In fact, the key concept at the base of this approach is the 'principle of parsimony' (Occam's razor) which states that simpler models are preferable over more complex models. Small values of AIC represent better overall fits, and adding parameters (e.g. covariates) which have negligible improvement to fit penalises the AIC score. It is important to emphasise that there is no p-value associated with the AIC, so we cannot say that there is a statistically significant difference between models: a model with a lower AIC is better but we should avoid the term 'significant' in conjunction with the AIC. Instead, a common rule of thumb used to compare models suggests the following: models with an AIC that differ by less than 2 (ΔAIC < 2) are more or less equivalent; models with an AIC that differs by more than 4–7 are clearly distinguishable; and models with an AIC that differs by more than 10 are definitely different.

In model selection it sometime happens that several models differ only slightly in their AIC value and as such they are equally supported. When this pool of best models have some common feature (e.g. multiple models containing the same covariate), one approach for determining the level of support for that common feature is to sum the model weights for each of the respective models (Burnham and Anderson 2002). For an example of this approach we refer to the case study (section 6.5). Under the same scenario of similar candidate models with low AIC difference, instead of choosing a single 'best' model to draw inferences from, we may use estimates from multiple models, hence calculating 'model-averaged' estimates. Model averaging produces parameter and error estimates that are not conditional on any one model but instead derive from weighted averages of these values across multiple models. We refer the interested reader to Burnham and Anderson (2002) for more detail.

6.2.3 Multi-season occupancy models

In ecological studies we will probably be interested in determining whether occupancy changed from one season to the next. The concept of 'season' will be *timed* depending on the study objective. We could relate the sampling season to breeding seasons, calendar seasons of the year, consecutive years or even consecutive periods of several years. In general, our objective will be assessing changes in occupancy states due to intervening factors between two or more consecutive seasons.

MacKenzie *et al.* (2003) extended the single-season model to the multi-season, or *dynamic* model by including two parameters: ε (probability of extinction) and γ (probability of colonisation). The first (ε) is the probability that an occupied site in season t becomes unoccupied in season $t + 1$, and the second (γ) is the probability that an unoccupied site in season t becomes occupied in season $t + 1$. The within-season assumptions remain the same as in the single-season model described above.

The basic sampling scheme, likewise, implies the repetition of k surveys in the season $t + 1$ at the same s sites surveyed in season t. Therefore, an example of the detection history for a site i studied across three seasons, and surveyed three times each season, would be $\mathbf{h}_i = 011\ 000\ 010$, i.e. in the first season the site was occupied with the species detected at the second and third surveys; in the second season the species was undetected for all three surveys (i.e. either it was present but undetected, or it went extinct, and recolonised at the third season); in the third season, the site was occupied with the species being detected only at the second survey.

Similar to the single-season model, occupancy, colonisation and extinction can be modelled with season-specific covariates that have a single, constant value for the duration of the season (MacKenzie *et al.* 2006); these can be divided into *site covariates*, i.e. factors vary among sites but are constant among seasons, and *time-dependent covariates*, i.e. factors that vary among seasons (and can vary among sites too). Examples of site covariates are habitat features such as elevation or distance to a disturbance source, as above, while time covariates may be climate variables (mean rainfall during the season, mean temperature during the season, etc.) or the intensity of human disturbance (hunting level during the season, habitat degradation, etc.). Detection probability can be modelled with season-specific and survey-specific, or *observation covariates* (i.e. variables that may change with each survey at a site, such as the observer, temperature or climate variables during the survey).

We do not describe here model designs in which different sites are used in different seasons, e.g. through a 'rotating panel design', whereby rather than surveying sites over the entire area of interest each season, sites are selected from within a smaller sub-area, and each season a different sub-area is selected. We refer the reader to MacKenzie *et al.* (2006; section 7.7) and we caution that while this approach may practically allow sampling a greater area (possibly to overcome logistic limitations) there are important implications for model inference that need to be carefully considered.

6.3 Sampling design

In line with Yoccoz *et al.* (2001), it is important when designing a scientific study to consider three key questions: (1) why the data are being collected (i.e. the study objective); (2) what type of data to collect (i.e. which state variable is most appropriate and what level of this variable are we interested in: individuals, species, communities); and (3) how the data should be collected (i.e. the study design). As for the 'what', we have defined occupancy

at the species level as our state variable of interest. We can then focus on the 'why', the study objective, and the 'how', the sampling design. The two are strictly linked, as the objective determines how the data are collected so that they contain sufficient information to answer the scientific questions (and competing hypotheses of interest) that underline the objective (MacKenzie *et al.* 2006). MacKenzie and Royle (2005) provide an excellent summary of how this reasoning should be approached when designing occupancy studies. They assume that 'two potential objectives for a study might be to: (i) determine the overall level of occupancy for a species in a region; (ii) compare the level of occupancy in two different habitat types within that region'. These objectives will in turn generate scientific questions, in case (i), for example, we may want to resample the region over different years to test if a known source of disturbance will alter occupancy over time. In case (ii), a likely question would be to test if the target species prefers one habitat over the other due to measurable differences in trophic resources (prey availability, habitat suitability, etc.). MacKenzie and Royle (2005) continue with a discussion of an important trade off:

> Two potential designs that could be used are: (a) randomly select sites to survey from throughout the entire region; (b) stratify the region according to habitat type, then randomly select sites only from the two strata of interest. Design (a) could be used for both objectives, although it may be an inefficient design for objective (ii) as some effort will be used to survey sites in habitat types not of interest, effectively reducing the sample size for the comparison. Design (b) would therefore be a much more efficient design for objective (ii) but would not be useful for objective (i) as some areas of the region will be excluded from the sampling.

Whatever study objectives have been set – which therefore define the most appropriate sampling design – the total area surveyed by camera traps will only sample a fraction of the population at large. This is of extreme importance, as the way in which camera trap sites are located – following the principles of randomisation and replication of samples described in Chapter 5 – allows the results of the data analysis to be generalised to the entire population. This aspect cannot be restated enough, but it is often poorly understood. If a non-probabilistic sampling scheme is used (e.g. sites are selected arbitrarily, opportunistically or haphazardly), then generalisation of results from the sample to the greater population is no longer based on any statistical theory (MacKenzie and Royle 2005).

Camera trap sites should therefore not be located based on pre-existing knowledge of occupancy level gained before the study itself. Various spatial configurations of sampling units can be used (simple random sampling, stratified random sampling, cluster sampling, etc.), and we refer the reader to Williams *et al.* (2002) and the literature therein for further details. An approach that we recommend, on which the case study below is based, is to generate a regular grid of locations and then randomly place the grid over the study area based on the study objective (e.g. Rovero *et al.* 2014). Using the example above, a continuous grid over the region would be appropriate for objective (i), while two separate sub-grids would be more appropriate for objective (ii). Alternatively, if there is a strong gradient (increasing elevation, or distance from a major river or road, etc.) and we are interested in estimating the variation in occupancy according to that gradient, then our grid could be aligned with the gradient of interest (TEAM Network 2011).

The distance between camera traps in the grid will, again, depend on the study objective. If the study is focus on a single species or group of similar species, the distance should ideally be slightly larger than the diameter of the average home range of the species

of interest, to avoid spatial autocorrelation (i.e. to avoid detecting the same individual at multiple camera sites) which would violate the assumption of independence of sites. If, however, the home range diameter of a species is much larger than the distance between camera traps, the results should be interpreted as the percentage of area *used* by a species during the survey period rather than the percentage of an area occupied (MacKenzie and Nichols 2004; see also MacKenzie *et al.* 2004a; MacKenzie 2005). This distinction is not irrelevant, because if occupancy is considered a surrogate for abundance, the level of use may not be of interest, and indeed could even be misleading. The inter-camera distance, on the other hand, should not be too much larger than the average home range diameter to avoid missing individual home ranges in between camera traps, as estimated occupancy may similarly become poorly informative of abundance. If the study targets multiple species, camera spacing will need to be spread out enough so that larger species with larger home ranges can be sampled with sufficient detection probability without over-spacing, as this may result in missing species with smaller home ranges. TEAM Network (2011) designed a protocol to sample the communities of medium-to-large terrestrial vertebrates in tropical forests by spacing camera points on a grid with one camera every 2 km^2.

To determine survey effort, we now need to define the number of sites (*s*) and the duration of sampling, hence the number (*k*), and duration, of sampling occasions.

6.4 Survey effort and sampling completeness

6.4.1 Deciding the best number of sites and sampling duration

The closure assumption of the basic single-season occupancy model has implications for the duration of the survey. If species are known to migrate seasonally in and out of the study area, surveys should be conducted outside the migration period. Generally, occupancy studies require a large number of camera traps to produce reliable data, especially when assessing changes in occupancy over time (e.g. the TEAM Network protocol deploys 60–90 camera stations within each study area; TEAM Network, 2011). Because it may be impractical or too expensive to deploy such effort simultaneously, setting camera traps in multiple blocks in sequence is a valid solution as long as the total duration falls within a single, ecologically meaningful season. The TEAM Network protocol allows for deploying three consecutive blocks of 20–30 cameras, each block operating for at least 30 days (TEAM Network 2011).

The feasible survey effort for a study is the result of a trade-off between sufficient spatial replicates (*s*) and sufficient sampling occasions (*k*), i.e. surveying enough sites while maintaining enough sampling occasions. Increasing the number of sites (*s*) will improve the precision of the occupancy estimates (MacKenzie *et al.* 2006); however, decreasing the number of sampling occasions (*k*) may increase the estimated variance in *p*, and potentially negate the benefits of increasing *s*, the number of sites. In general, adequate within-season camera trapping effort largely depends on the detection probability (*p*) of the species of interest. This is because accurate estimation of occupancy rests on the correction of ψ by *p*, but information regarding *p* can only be gathered from occupied sites (MacKenzie and Royle 2005). Hence, when ψ is low, it is better to survey more sites, rather than few sites more often. Expending a lot of survey effort at relatively few sites may yield little information about *p* as most of the sites will be unoccupied.

When ψ is high, a lot of information about p can be gathered by surveying fewer sites more often.

MacKenzie and Royle (2005) and later Guillera-Arroita *et al.* (2010) used simulations to determine how many repeated surveys are ideally required and how many sites should be surveyed. When considering costs for sampling to be equal for initial surveys at new sites as subsequent surveys at current sites, they showed that 2–5 surveys, or sampling occasions, should be enough when $p > 0.5$. In general, as p decreases a larger number of surveys are required. Moreover, and less intuitively, *surveys should increase as the occupancy probability increases*. As an example, let us assume that we want to estimate the occupancy of a rare and of a common species, each surveyed with a standard design with s spatial replicates. The rare species will be truly absent from most of the sites. Hence, it would be a waste of resources increasing the number of surveys at each site because the species will continue to be absent from most of the sites. On the contrary, the common species may be present at most sites, but it may go undetected. In this case, it may be more worthwhile increasing the number of surveys to ascertain its presence and estimate p, rather than moving to another site where the species is also likely to be present. On these grounds, MacKenzie and Royle (2005) suggested a general principle for the design of occupancy studies: for rare species, one should survey more sites less intensively (i.e. with fewer repeated surveys), while for common species, one should survey fewer sites more intensively (i.e. with more repeated surveys).

With preliminary data on captures, one can use the simulation capabilities of software to inspect precision and bias of ψ and p under different combinations of s and k (e.g. Guillera-Arroita *et al.* 2010). When the sample size (s) is large, likelihood theory provides tools for approximating the estimator properties of ψ and p (for small samples the precision may be too low). In this framework, MacKenzie and Royle (2005) derived study design recommendations in which the optimal number of sampling occasions (k) needed until the first species is detected is established under varying combinations of ψ and p (Table 6.1). As mentioned, with camera trapping data the number of days used to discretise the continuous sampling is derived from k (see section 6.4.2). Assuming we set the sampling occasion to 1 day, for example, the camera traps should work 34 days to cover all possible combinations of values of ψ and p (Table 6.1).

Table 6.1 Optimal maximum number of surveys (k) to conduct at each site for a removal design where all sites are surveyed until the species is first detected, for selected values of occupancy (ψ) and detection probabilities (p). From MacKenzie and Royle (2005).

p	ψ								
	0.1	0.2	0.3	0.4	0.5	0.6	0.7	0.8	0.9
0.1	14	15	16	17	18	20	23	26	34
0.2	7	7	8	8	9	10	11	13	16
0.3	5	5	5	5	6	6	7	8	10
0.4	3	4	4	4	4	5	5	6	7
0.5	3	3	3	3	3	3	4	4	5
0.6	2	2	2	2	3	3	3	3	4
0.7	2	2	2	2	2	2	2	3	3
0.8	2	2	2	2	2	2	2	2	2
0.9	2	2	2	2	2	2	2	2	2

When the sample size is not large, and especially dealing with rare (low ψ) and elusive (low p) species, the estimators could be strongly biased. Under these circumstances, one should inspect the quality of estimators (e.g. the standard error of ψ and p) using simulations (choosing design parameters k and s) and given ψ and p (Guillera-Arroita *et al.* 2010).

6.4.2 Post-hoc discretisation of sampling duration in sampling occasions

There is no general recommendation for dividing the sampling period into discrete sampling occasions. There are also criticisms as to whether this procedure is needed at all. This is because discretising data leads to information loss as the detection process is in fact continuous and should theoretically be modelled accordingly (Guillera-Arroita *et al.* 2011). However, for most camera trapping studies it is difficult to model continuous data as animals will move back and forth, resulting in sampling occasions that are almost completely dependent. Moreover, this kind of data may carry little information relevant to the parameters of the model ψ and p, as such closely repeated events do not embed any ecological meaning. This introduces the issue of deciding the time scale on which to discretise the continuous data.

It is commonly assumed that 1 day is a long enough interval to consider captures as independent events. Autocorrelation analysis on the same TEAM data used for the case study presented here has shown that independence can be reached at even shorter time intervals, on the scale of <1 h (J. Ahumada and F. Rovero unpublished data; see also Chapter 5; Kays and Parsons 2014). Thus, 1 day represents a good starting point to inspect the model parameters and fit. Pooling the data over longer times (2, 5, 10 or more days), does not affect occupancy but only detection probability. As the time interval increases, so does p but at the expense of precision in both ψ and p as the total sampling effort decreases (Figure 6.1). However, while most studies are interested in occupancy estimation and consider detectability a nuisance parameter, estimates of p may in fact be of interest, for example, in studies that evaluate the detection process of different camera models, or when detectability varies according to physiological states of the animals, seasons, climate variables, etc. (Guillera-Arroita *et al.* 2010). In summary, we recommend adopting the following rule of thumb: discretise the data into intervals that are as short as possible with a minimum length of 1 day. This practice maximises the amount of information about p, which, in turn, maximises the precision of ψ. It is also useful to note that numerical estimation errors will occur in some analysis methods (e.g. maximum likelihood implemented in the `unmarked` package in R) when the chosen interval is too short. Therefore, multiple interval lengths may need to be tested when trying to maximise the precision of ψ.

As an example, let us assume that our target for the p estimator to be unbiased has a maximum SE of 0.05 (i.e. an approximate 95% confidence interval (SE × 1.962) would be ±0.1) and the study design is one adopted by the TEAM Network (60 camera trap sites sampled for 30 days). The time intervals used to discretise data would commonly be 1, 2, 3, 5, 10 days (i.e. we avoid fraction data and intervals >10 days as this would result in too few events). We used four data sets for species with high, medium (two species) and low ψ, namely *Cephalophus harveyi*, *Cricetomys gambianus*, *Cephalopus spadix* and *Rhynchocyon udzungwensis*. As expected, aggregating time length from 1 to 10 days did not cause significant changes in ψ but led to an increase of p at the expense of precision

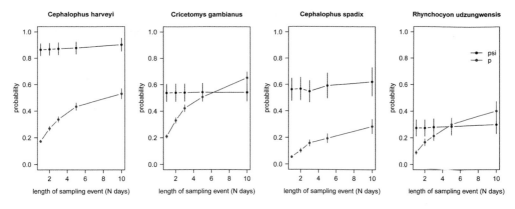

Figure 6.1 Results of estimated occupancy (black line) and detection probability (red line) for four species detected by the TEAM Network project in the Udzungwa Mountains of Tanzania using different intervals of days (1, 2, 3, 5, 8, 10) to discretise the overall sampling effort of 30 days.

in both ψ and p (Figure 6.1). Standard error increased from 3 to 7 times the values but always remained below our target of 0.05, with the exception of *R. udzungwensis* at 10 day intervals when SE increased to 0.072.

6.5 Case study

In this section we provide an example of occupancy analysis using the same data set of mammal images taken in the Udzungwa Mountains of Tanzania by the TEAM Network project between 2009 and 2013 and used, for the baseline year, in Chapter 5. In the first part of this example, we selected the year 2009 to perform the single-season occupancy analysis on a selection of species (Rovero *et al.* 2014). The analytical approach follows the frequentist inference as explained by MacKenzie *et al.* (2006), and used the R package unmarked (Fiske and Chandler 2011). In the second part, we present a multi-season occupancy analysis using the Bayesian framework. In this case, we prefer to adopt this strategy for two reasons: (1) to show an alternative way to test the models, and (2) because for large data sets such those collected by the TEAM Network the Bayesian analysis currently provides more reliable results. With our data, the frequentist approach with the maximum likelihood estimator failed to converge when the models included covariates.

6.5.1 Single season occupancy analysis

First, readers should follow the instructions given in Chapter 5 for setting the working directory, sourcing the script TEAM library 1.7, and loading all packages. We then load the data as the output .CSV file from Wild.ID (see Chapter 4), which is teamexample. csv, and add Class, Order and Family from the IUCN database as described in Chapter 5. We process the file to transform the variables' names and formats so that they are compatible with the functions used for analysis. We finally extract the data from 2009 and for mammals only from the data set:

```
team_data<-read.csv(file="teamexample.csv",
    sep=",",h=T,stringsAsFactors=F)
```

```
iucn.full<-read.csv("IUCN.csv", sep=",",h=T)
iucn<-iucn.full[,c("Class","Order","Family","Genus","Species")]
team<-merge(iucn, team_data, all.y=T)
fd<-fix.dta(team)
yr2009<-fd[fd$Sampling.Event =="2009.01" & fd$Class=="MAMMALIA",]
```

In 2009 a number of camera traps did not work correctly, hence we removed them from the covariate data set.

```
cov<-read.table("covariates.txt", header=TRUE)
workingcam<-which(cov$Sampling.Unit.Name %in%
    unique(yr2009$Sampling.Unit.Name))
```

The models we intend to test include both numerical (distance to forest edge, elevation, etc.) and categorical (habitat type) variables, which we load and correct before the analysis.

```
cov.or<-cov[workingcam, ]
cov.num<-cov[,sapply(cov,is.numeric)]
cov.std<-decostand(cov.num,method="standardize")
cov.fac<-cov[,sapply(cov,is.factor)]  # extract factor variables
covs<-data.frame(cov.std,cov.fac)
```

We now have both data sets (species and covariates) which can be prepared for being processed by the ensuing functions. In particular, the function f.matrix.creator creates a list of tables, each one corresponding to a single species, and arranged with camera trap sites on rows and sampling occasions on columns. Before going through the analysis, we also compute the naïve occupancy for all the species in the data set for 2009 (function naive):

```
mat.udz.09<-f.matrix.creator(yr2009)
names(mat.udz.09)
naivetable<-naive(mat.udz.09)
naivetable
```

The single-season occupancy analysis will be performed on two of the four focal species which are both endemic to the area (see also Rovero *et al.* 2014): Sanje mangabey (*Cercocebus sanjei*), and grey-faced sengi (*Rhynchocyon udzungwensis*).

The default matrix for analysis has 1 day as the sampling occasion. To shrink the matrix to gain the advantages explained in section 6.4.2, we use the function shrink and merge 5 days into one sampling occasion. The following example is done for *C. sanjei*:

```
Cs<-shrink(mat.udz.09[["Cercocebus sanjei"]],5)
```

The matrix and covariate can now be processed using the unmarked package (Fiske and Chandler 2011); first we prepare the object for testing models using the function unmarkedFrameOccu.

```
umCs<-unmarkedFrameOccu(y=Cs,siteCovs= covs)
```

Now we have the data in the correct format to test several models with the function occu in unmarked. This function fits the single-season occupancy model of MacKenzie *et al.*

(2002). The following is a 'null' model formulation, i.e. one without covariates neither of detection ('~1' on the left), nor of occupancy ('~1' on the right).

```
m0<- occu(~1~1,umCs)
```

Instead, the set of models below are fitted using different covariates and combinations according to several hypothesis of their effect on ψ and p as explained in Rovero *et al.* (2014). The first three models (called d1–3) have covariates only on p, the second three (o1–3) only on ψ, and the last seven models (m1–7) have covariates on both ψ and p.

```
d1<- occu(~edge~1,umCs)
d2<- occu(~border~1,umCs)
d3<- occu(~edge+border~1,umCs)
o1<- occu(~1~border,umCs)
o2<- occu(~1~habitat,umCs)
o3<- occu(~1~habitat+border,umCs)
m1<- occu(~edge~border,umCs)
m2<- occu(~border~border,umCs)
m3<- occu(~edge+border~border,umCs)
m4<- occu(~edge~habitat,umCs)
m5<- occu(~border~habitat,umCs)
m6<- occu(~edge+border~habitat,umCs)
m7<- occu(~edge+border~habitat+border,umCs)
```

Each model result should be carefully inspected to check estimates, standard errors and convergence.

For example, let us examine the model m1 with `edge` as covariate of p and `border` as covariate of ψ. The model converged without problems and provided the following estimates: `border` 0.698 (SE = 0.468) and `edge` –0.200 (SE = 0.168). The signs of the parameters suggested that with increasing values of `border`, occupancy increased, whereas detection was inversely related to the distance from the edge of the forest. Since we used standardised data, the estimates should be back-transformed to be interpreted on the original scale. The second thing to note is the large values of SE and the consequent non-significance of terms (p `border` = 0.136; p `edge` = 0.234). Because both the detection and occupancy components were modelled with covariates, covariate coefficients must be specified to back-transform the parameters to the original scale (0, 1). Here, we set the probability of detection given a site is occupied and `border` is set to 0:

```
backTransform(linearComb(m1, coefficients = c(1, 0),
    type = "det"))
```

And similarly for occupancy:

```
backTransform(linearComb(m1, coefficients = c(1, 0),
    type = "state"))
```

Detection probability for m1 was 0.226 (0.035 SE) and occupancy estimate was 0.630 (0.103 SE).

The function `fitList` compares the null model (m0) with the others on the basis of minimizing AIC.

```
dlist<-fitList(Nullo = m0,d1=d1,d2=d2,d3=d3,o2=o2,m4=m4,m5=m5,
    m6=m6)
selmod<-modSel(dlist,nullmod="Nullo")
```

The model selection shows that there is not a single, best model, as ΔAIC increases gradually. As suggested by Burnham and Anderson (2002), all models with AIC differences of less than 2 have a substantial level of empirical support, 4–7 substantially less support, and greater than 10 essentially no support.

Hence in our case, as shown in the R output table pasted below, the first seven models are equally supported. Five of them are concordant in supporting the hypothesis that occupancy varies in relation to `habitat` (deciduous, montane). `edge` and `border` seem to affect similarly the detection probability, as they both appear frequently in the first seven models.

	nPars	AIC	delta	AICwt	cumltvWt	Rsq
m6	5	329.17	0.00	0.16	0.16	0.16
m7	6	329.34	0.17	0.14	0.30	0.19
m4	4	329.34	0.17	0.14	0.44	0.13
o2	3	329.60	0.43	0.13	0.57	0.09
m3	5	329.71	0.54	0.12	0.69	0.15
m5	4	330.85	1.68	0.07	0.76	0.11
m2	4	330.97	1.80	0.06	0.82	0.10
o3	4	331.44	2.27	0.05	0.87	0.10
o1	3	331.74	2.57	0.04	0.92	0.06
m1	4	332.25	3.09	0.03	0.95	0.08
Nul	2	333.31	4.14	0.02	0.97	0.00
d1	3	333.61	4.45	0.02	0.99	0.03
d2	3	335.29	6.12	0.01	0.99	0.00
d3	4	335.30	6.13	0.01	1.00	0.03

A convenient manner to quantify the importance of the covariates is to sum the model weights for the models where they are retained. Thus, for example, `habitat` totalises 0.16+0.14+0.14+0.13+0.07= 0.64 (64%) and `border` 0.14+0.07 +0.02 = 0.27 (27%). That is, `habitat` is the most important variable affecting occupancy. Concerning detection probability, `border` totalizes 0.55 and `edge` 0.56. An additional way to assess the importance of a covariate is to count how many times in the selected models it is statistically significant. Thus, for example, `habitat` appear five times in the best seven models, and in four it is significant. Pasted below is the detailed output of the top-ranked model m6:

```
m6

Call:

occu(formula = ~edge + border ~ habitat, data = umCs)
```

```
Occupancy:

                    Estimate        SE          z      P(>|z|)
(Intercept)          -0.738       0.507     -1.460       0.146
habitatMontane        2.024       0.812      2.490       0.013

Detection:

                    Estimate        SE          z      P(>|z|)
(Intercept)          -1.155       0.187      -6.17       0.000
edge                 -0.326       0.176     -1.860       0.063
border               -0.325       0.212     -1.530       0.127
AIC: 329.2
```

Once the key variables are selected, it is important to plot the prediction of how occupancy or detection probability vary according to single variables. For example, we plot how occupancy varies according to habitat type as follows. First, we create a new data frame with the values of the covariates included in the model o2. In this case, habitat was a categorical covariate and we need only to specify its levels. Then, we can predict the values of ψ on the basis of model o2:

```
newhab<-data.frame(habitat=c("Deciduous","Montane"))
pred<-predict(o2,type="state",newdata=newhab,appendData=T)
```

We then plot the prediction as follows, which provides the chart in Figure 6.2:

```
ggplot(pred,aes(x=habitat,y=Predicted))+
    geom_point(size=4) +
    ylab("Predicted Psi Cercocebus sanjei") +
    theme_bw() +
    geom_errorbar(aes(ymin=Predicted-SE, ymax=Predicted+SE),
    width=.2)
```

Next, we can produce spatially explicit maps of estimated occupancy (or of detection probability) provided that we have values for the covariate(s) that is (are) significantly retained in the models available for the entire study area; hence effectively allowing for inference beyond the sampled sites. This is typically the case for covariates that are derived from GIS, such as, in our case, gross habitat type, edge and border. Hence, we use a raster file, or a grid of points, or a data frame with grid of points with the corresponding covariate values. To do so, we use the .TXT file map which is a table with x and y coordinates (UTM projection, in meters) and the covariate values for each of these points. Each point corresponds to a pixel 100 × 100 m.

```
map<-read.table("covs100x100.txt",h=T)
head(map)

     ID          x          y     edge    border     river       road  habitat
  1 259662.6   9131369    186.99   6116.04    612.36   6392.01   Montane
```

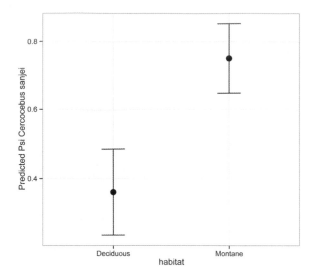

Figure 6.2 Predicted occupancy with SE of Sanje mangabey in the Udzungwa Mountains of Tanzania in relation to the two levels of the `habitat` variable used as covariate for occupancy modelling. See Rovero *et al.* (2014) for more details.

```
2 259762.6  9131369   258.57  6019.64   712.31  6304.52  Montane
3 259862.6  9131369   284.72  5923.37   647.37   6217.4  Montane
4 259962.6  9131369   244.42  5827.22   552.96  6130.68  Montane
5 260062.6  9131369   217.35  5731.21   460.91  6044.37  Montane
6 260162.6  9131369   198.02  5635.33   372.98  5958.49  Montane
```

Because models have been fitted on standardised data, the covariates on the map also need to be standardised using the mean and standard deviation of the object `covs.udz`.

```
mapst<-data.frame(x=map$x,y=map$y, habitat=map$habitat,
    edge=(map$edge-mean(covs$edge))/sd(covs$edge),
    border=(map$border-mean(covs$border))/sd(covs$border),
    river=(map$river-mean(covs$river))/sd(covs$river))
predmap<-predict(o2,type="state",newdata=mapst,appendData=T)
levelplot(predmap$Predicted ~ x + y, map, aspect="iso",
    xlab="Easting (m)", ylab="Northing (m)", col.regions=terrain.
    colors(100))
```

The function `predict` takes a while to fit the model o2 to the data (about 1 min). After that, the function `levelplot` of the package `lattice` (http://cran.r-project.org/web/packages/lattice/lattice.pdf) provides a nice, spatially explicit model of the estimated occupancy of sanje mangabey over the entire study forest (Figure 6.3).

We now examine the example of the grey-faced sengi (*Rhynchocyon udzungwensis*), an Udzungwa-endemic and narrow-range species of giant sengi, or elephant-shrew, described as a new species in 2008 (see Chapter 1 and Figure 1.2 therein). The hypothesis is that `edge` and `border` could influence detection probability as the species could be

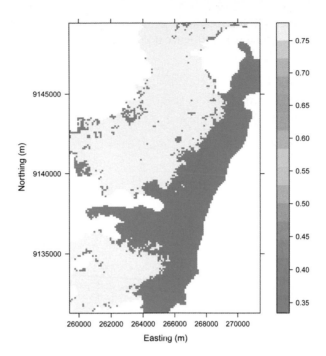

Figure 6.3 Map of estimated occupancy by habitat type (deciduous and montane forest) of Sanje mangabey in the study forest of the Udzungwa Mountains of Tanzania. See text for details.

more elusive near forest edges/park borders. We conduct a more explorative approach to model selection, because of our limited knowledge about the ecology of the species. We consider again `edge` and `border`, but also habitat type and distance to river as covariates for occupancy. In this example, we do not fit all the possible models combining the covariates, but instead we check them step-by-step in order to decide what the next model could be.

```
Ru<-shrink(mat.udz.09[["Rhynchocyon udzungwensis"]],5)
umRu<-unmarkedFrameOccu(y=Ru,siteCovs=covs)
m0<- occu(~1~1,umRu)
d1<- occu(~edge~1,umRu)
d2<- occu(~border~1,umRu)
```

Models including `border` and `edge` in detection suggest that both covariates are of limited importance (in d1, $p(>|z|)$ edge = 0.279; in d2, $p(>|z|)$ border = 0.234). Thus, in the subsequent models we decide to omit both from the detection part of the models.

```
o1<- occu(~1~edge,umRu)
o2<- occu(~1~border,umRu)
o3<- occu(~1~habitat,umRu)
o4<- occu(~1~river,umRu)
```

Now that we have fitted all the covariates for the occupancy part of the models, we see that distance to river is unlikely to influence occupancy. Thus, we create the next models omitting river.

```
o5<- occu(~1~edge+habitat+border,umRu)
o6<- occu(~1~habitat+border,umRu)
o7<- occu(~1~edge+habitat,umRu)

dlist<-fitList(Null=m0,d1=d1,d2=d2,o1=o1,o2=o2,o3=o3,o4=o4,o5=o5,
    o6=o6, o7=o7)
sel<-modSel(dlist, nullmod="Null"))
sel
```

model	nPars	AIC	ΔAIC	AICwt	cumltvWt	R2
o7	4	198.1	0.00	0.35	0.35	0.18
o3	3	198.7	0.70	0.25	0.60	0.14
o5	5	199.2	1.20	0.19	0.79	0.19
o6	4	200.7	2.70	0.09	0.88	0.14
o1	3	201.3	3.23	0.07	0.95	0.10
o2	3	203.7	5.61	0.02	0.97	0.06
Nul	2	204.9	6.87	0.01	0.98	0.00
d2	3	205.4	7.35	0.01	0.99	0.03
d1	3	205.7	7.65	0.01	1.00	0.02
o4	3	206.9	8.84	0.00	1.00	0.00

The top three ranked models are equally supported. Thus, we apply a model-averaging technique to estimate occupancy from these multiple models (Burnham and Anderson 2002).

```
library(MuMIn)
best<-list(o7,o3,o5)
avgmod <- model.avg(best, fit=T)
summary(avgmod)
```

The summary of the `avgmod` function is long and we do not reproduce it here in full. It provides model-averaged coefficients and the relative importance of each variable.

We then proceed to map estimated occupancy across the study forest (Figure 6.4), as done for the sanje mangabey.

```
predmap<-predict(avgmod,type="state",newdata=mapst,appendData=T)
levelplot(predmap$Predicted ~ x + y, map, aspect="iso",
    xlab="Easting (m)", ylab="Northing (m)",col.regions=terrain.
    colors(100))
```

6.5.2 Multi-season occupancy analysis

We here add a level of complexity by adding more than one season in the analysis. We use the same TEAM data set but now consider all four years (2009–2013). For clarity, we load the data again and adjust variables and formats with the function fix.dta.

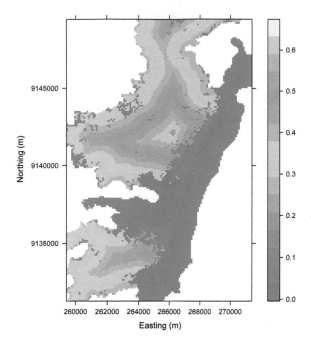

Figure 6.4 Map of estimated occupancy of the grey-faced sengi in the study forest of the Udzungwa Mountains of Tanzania according to an average model that includes distance to edge, distance to border and habitat type. See text for details.

```
teamc<-read.csv(file="team.yr09_13.csv",
    sep=",",h=T,stringsAsFactors=F)
fd<-fix.dta(teamc)
```

Then we have to construct a list containing for each year the list of species with the detection–non-detection observations. We do that with the following code:

```
samp<-unique(fd$Sampling.Event)
res<-numeric()
for(i in 1:length(samp)){
    temp<-which(fd$Sampling.Event==samp[i])
    fd2<-fd[temp,]
    res<-c(res,list(fd2))
    }
data.byYear<-res
names(data.byYear)<-samp
data.byYear<-lapply(X=data.byYear,f.minusBirds)
mats<-sapply(data.byYear,f.matrix.creator)
```

From the object `mats` we extract the Sanjei mangabey to provide an example of the analysis for this species. It can happen that over the four years of sampling not all the camera traps worked properly. Thus, we adjust the data so that all years contain the same number of rows (camera trap sites) and columns (sampling occasion). This is done by the

function `adjMult` following the shrinking of the matrix at 5 day intervals as done for the single-season examples (function `shrink`).

```
spl<-sapply(mats, "[[", "Cercocebus sanjei")
sl<-llply(spl,.fun=function (x) shrink(x,5))
mat.yrs<-adjMult(sl)
```

We are now ready to formulate the Bayesian model as required by JAGS. JAGS (Just Another Gibbs Sampler; Plummer 2003) is a program for analysis of Bayesian hierarchical models using MCMC simulation (see Box 6.1). To download JAGS, visit the 'files' page of the 'mcmc-jags' project at 'sourceforge' (http://sourceforge.net/projects/mcmc-jags/files/). Once JAGS is installed, we need the R package `R2jags` (http://cran.r-project.org/web/packages/R2jags/R2jags.pdf), which provides the interface between the program and R. In practice, we command JAGS through R.

```
library(R2jags)
J<-array(as.matrix(mat.yrs),dim=c(60,25,5))
    #60 sites, 25 det events, 5 years
```

Now we define the model using the JAGS syntax:

```
modJ.bug<- function (){

# Specify priors
    psi1 ~ dunif(0, 1)
    for (k in 1:(nyear-1)){
        phi[k] ~ dunif(0, 1)
        gamma[k] ~ dunif(0, 1)
        p[k] ~ dunif(0, 1)
        }
    p[nyear] ~ dunif(0, 1)

# Ecological submodel: Define state conditional on parameters
    for (i in 1:nsite){
        z[i,1] ~ dbern(psi1)
        for (k in 2:nyear){
            muZ[i,k]<- z[i,k-1]*phi[k-1] + (1-z[i,k-1])*gamma[k-1]
            z[i,k] ~ dbern(muZ[i,k])
            } #k
        } #i

# Observation model
    for (i in 1:nsite){
        for (j in 1:nrep){
            for (k in 1:nyear){
                muy[i,j,k] <- z[i,k]*p[k]
                y[i,j,k] ~ dbern(muy[i,j,k])
                } #k
```

```
        } #j
      } #i

  # Derived parameters: Sample and population occupancy,
      # growth rate and turnover
      psi[1] <- psi1
      n.occ[1]<-sum(z[1:nsite,1])
      for (k in 2:nyear){
          psi[k] <- psi[k-1]*phi[k-1] + (1-psi[k-1])*gamma[k-1]
          n.occ[k] <- sum(z[1:nsite,k])
          growthr[k] <- psi[k]/psi[k-1]
          turnover[k-1] <- (1 - psi[k-1]) * gamma[k-1]/psi[k]
          }
      }
      ",fill = TRUE)
      sink()
```

The model above, with minor modifications, has been sourced from Kéry and Schaub (2012). As initial values we took the observed occurrence:

```
zst <- apply(J, c(1, 3), sum, na.rm=T)
zsti<-ifelse(zst>0,1,0)
jags.inits <- function(){ list(z = zsti)}
jags.params <- c("psi", "phi", "gamma", "p", "n.occ", "turnover")
```

With these objects, the function jags of the package R2jags can now be called, to finally run the model. The function has as argument the data organised as a list, the starting values for the BUGS model (inits=jags.inits), the number of total iterations per chain (n.iter=2000), the number of Markov chains (n.chains=3), and the file containing the model written in BUGS code. The function jags also has other arguments but we leave them as default (see the R2jags package documentation for details).

```
jagsfit<-jags(data=list(y = J, nsite = dim(J)[1], nrep = dim(J)
    [2], nyear = dim(J)[3]), inits=jags.inits, jags.params,
    n.iter=2000, n.chains=3, model.file=modJ.bug)
```

This may take some time depending on the speed of the computer. Once done, we can call the model output:

```
print(jagsfit, dig=2)
```

The object jagsfit is printed to inspect the estimates of the parameters. The inference provides the average and distribution of the following parameters: gamma (colonisation rate), n.occ (number of occupied sites = number of cameras which captured the species among the 60), p (detection probability), phi (survival), psi (occupancy) and turnover (i.e. the probability that an occupied site picked at random is a newly occupied one). Mean and SD are shown in the column under headings mu.vect and sd.vect, respectively. The other headings are for the distribution of parameters.

	mu.vect	sd.vect	2.50%	25%	50%	75%	97.50%	Rhat	n.eff
gamma[1]	0.56	0.15	0.21	0.47	0.58	0.67	0.81	1.01	3000
gamma[2]	0.35	0.2	0.03	0.2	0.34	0.5	0.76	1.01	550
gamma[3]	0.4	0.18	0.09	0.27	0.4	0.53	0.76	1.01	1100
gamma[4]	0.57	0.15	0.26	0.46	0.57	0.67	0.84	1	2400
n.occ[1]	38.28	3.96	32	35	38	41	47	1.01	290
n.occ[2]	49.48	2.47	44	48	50	51	54	1	2900
n.occ[3]	51.07	2.12	47	50	51	52	55	1	740
n.occ[4]	46.85	1.9	44	45	47	48	51	1	2000
n.occ[5]	44.98	2.14	42	43	45	46	50	1.01	240
p[1]	0.22	0.03	0.16	0.2	0.22	0.24	0.29	1.01	370
p[2]	0.24	0.03	0.19	0.22	0.24	0.25	0.29	1	2200
p[3]	0.25	0.02	0.2	0.23	0.25	0.26	0.3	1	3000
p[4]	0.33	0.03	0.28	0.31	0.33	0.35	0.39	1	2400
p[5]	0.32	0.03	0.27	0.3	0.32	0.34	0.38	1	550
phi[1]	0.94	0.06	0.77	0.91	0.96	0.98	1	1	790
phi[2]	0.94	0.05	0.82	0.91	0.95	0.98	1	1	2100
phi[3]	0.83	0.06	0.71	0.8	0.84	0.88	0.94	1.01	450
phi[4]	0.78	0.07	0.63	0.73	0.79	0.83	0.91	1.01	430
psi[1]	0.63	0.09	0.47	0.57	0.63	0.69	0.82	1	650
psi[2]	0.81	0.06	0.67	0.77	0.81	0.85	0.91	1	3000
psi[3]	0.83	0.06	0.7	0.79	0.84	0.87	0.93	1	840
psi[4]	0.76	0.06	0.64	0.73	0.77	0.81	0.87	1	660
psi[5]	0.73	0.06	0.6	0.69	0.73	0.78	0.85	1.01	420
turnover[1]	0.26	0.1	0.06	0.19	0.27	0.33	0.46	1	1300
turnover[2]	0.09	0.06	0	0.04	0.08	0.13	0.24	1.01	630
turnover[3]	0.09	0.06	0.01	0.05	0.08	0.12	0.23	1.01	780
turnover[4]	0.18	0.07	0.07	0.14	0.18	0.23	0.32	1	1000
deviance	1895.9	23.19	1852.51	1879.69	1894.69	1910.89	1942.52	1	1400

With the coda package (http://cran.r-project.org/web/packages/coda/coda.pdf) it is possible to inspect more carefully the results and assess chain convergence.

```
library(coda)
summary(jagsfit)
codaout.jags <- as.mcmc(jagsfit)
plot(codaout.jags , ask=TRUE)
densityplot(codaout.jags)
```

In particular, the trace plots of samples vs. the simulation index can be very useful in assessing convergence. The trace plot indicates whether or not the chains have converged to their stationary distribution, i.e. if they need a longer burn-in period. A trace can also tell us whether chains are mixing well. A chain might have reached stationarity if the distribution of points is not changing as the chain progresses. The aspects of stationarity that are most recognisable from a trace plot are a relatively constant mean and variance.

At this point we can derive naïve occupancy for each year for comparison with the estimated occupancy values from the Bayesian inference.

```
nv<-function (x) sum(ifelse(rowSums(x, na.rm=T)>=1,1,0))/nrow(x)
naive<-aaply(J,3,.fun=nv)  # naive occupancy
```

Finally, we can plot estimated occupancy for the four years, along with the naïve occupancy values (Figure 6.5).

```
meanB<-jagsfit$BUGSoutput$mean$psi
CRI2.5<-jagsfit$BUGSoutput$summary[20:24,3]
CRI97.5<-jagsfit$BUGSoutput$summary[20:24,7]
plot(2009:2013,meanB, type="b",xlab = "Year",
    ylab = "Occupancy Sanje mangabey", ylim = c(0,1))
segments(2009:2013, CRI2.5, 2009:2013,CRI97.5, lwd = 1)
points(2009:2013, naive, type = "b", col = "blue", pch=16)
# add this line to compare real occupancy with naive (blue line)
legend(x=2011, y=0.2, legend=c("estimated occupancy","naïve
    occupancy"), col=c("black","blue"), pch=c(1,16), lty=c(1,1),
    bty="n")
```

The chart allows for a visual assessment – from comparing estimated occupancy and credible intervals among years – as to whether occupancy changed over the study period, according to the above model whereby occupancy was allowed to vary with seasons (years) through potential variations in colonisation and extinction. In this case, however, no significant change occurred. The reader can also refer to Ahumada *et al.* (2013) for an example of dynamic occupancy modelling from another site in the TEAM Network.

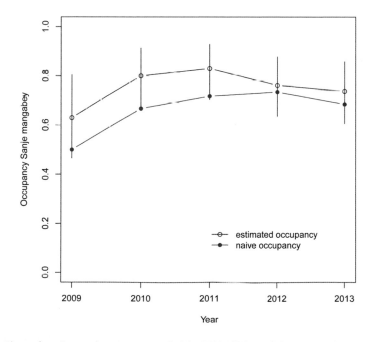

Figure 6.5 Plot of estimated occupancy (with 95% CRI) and (open circle, black line) and naïve occupancy values (filled quadrat and blue line) for Sanje mangabey as derived from the dynamic occupancy model.

6.6 Conclusions

In this chapter we have introduced occupancy analysis at the species level, an inferential analytical approach (also extended to community analysis, see Chapter 9) that is very suited to camera trapping data for a wide range of ecological studies, and has attracted a lot of attention in recent years. We based the chapter on the basic model formulations for both single- and multi-season analysis, and we described how these can be implemented using a frequentist approach or a Bayesian one, with the latter opening the way to more complex analysis that has become the norm for multi-species analysis (Chapter 9). The standard models that we described have been subject to several novel applications and extensions in more recent years (see O'Connell and Bailey 2011; Bailey *et al.* 2014). Among these are species co-occurrence models (MacKenzie *et al.* 2004b), which can indicate whether one species' occupancy and detection probability is influenced by the occurrence of other species at the same sites (e.g. predator–prey interaction or competitive exclusion); and multi-state occupancy models (MacKenzie *et al.* 2009), which provide for the inclusion of different categories of occupancy, such as sites that may be used for reproduction, or sites that species use for different activity states (e.g. territoriality or seasonal migration).

Appendices

For dataset and R script with all functions, see the following appendices to Chapter 5:
 Appendix 5.1 Case study data set: 'teamexample.csv'
 Appendix 5.3 R library with all functions: 'TEAM library 1.7.R'
 Appendix 5.5. IUCN species taxonomy: 'IUCN.csv'

For the code and files for the case studies in this chapter:
 Appendix 6.1 'Chapter 6 R script'
 Appendix 6.2 'covariates.txt' (environmental covariates for modelling)
 Appendix 6.3 'covs100x100.txt' (grid of covariate values for spatially explicit maps)

Acknowledgements

We are grateful to Robin Steenweg and Fridolin Zimmermann for very valuable comments on a previous version of this chapter.

References

Ahumada, J.A., Hurtado, J. and Lizcano, D. (2013) Monitoring the status and trends of tropical forest terrestrial vertebrate communities from camera trap data: a tool for conservation. *PloS ONE* 8: e73707.

Bailey, L.L., MacKenzie, D.I. and Nichols, J.D. (2014) Advances and applications of occupancy models. *Methods in Ecology and Evolution* 5: 1269–1279.

Bolker, B.M. (2008) *Ecological Models and Data in R*. Princeton: Princeton University Press.

Burnham, K. P. and Anderson, D.R. (2002) *Model Selection and Multimodel Inference*. New York: Springer.

Chandler, R.B. and Royle, J.A. (2013) Spatially explicit models for inference about density in unmarked or partially marked populations. *Annals of Applied Statistics* 7: 936–954.

Clark, J.S. and Gelfand, A.E. (2006) *Hierarchical Modelling for the Environmental Sciences: Statistical Methods and Applications*. Oxford: Oxford University Press.

Congdon, P. (2006) *Bayesian Statistical Modelling*. New York: John Wiley.

Dénes, F.V., Silveira L.F. and Bissinger S.R. (2015) Estimating abundance of unmarked animal populations: accounting for imperfect detection and other sources of zero inflation. *Methods in Ecology and Evolution* 6: 543–556.

Gelman, A., Carlin, J.B., Stern, H.S. and Rubin, D.B. (2003) *Bayesian Data Analysis*. Boca Raton, FL: CRC Press.

Guillera-Arroita, G., Ridout, M.S. and Morgan, B.J.T. (2010) Design of occupancy studies with imperfect detection. *Methods in Ecology and Evolution* 1: 131–139.

Guillera-Arroita, G., Morgan, B.J., Ridout, M.S. and Linkie, M. (2011) Species occupancy modeling for detection data collected along a transect. *Journal of Agricultural, Biological, and Environmental Statistics*, 16: 301–317.

Fiske, I. and Chandler, R. (2011) unmarked: an R package for fitting hierarchical models of wildlife occurrence and abundance. *Journal of Statistical Software* 43: 1–23.

Kays, R. and Parsons, A.W. (2014) Mammals in and around suburban yards, and the attraction of chicken coops. *Urban Ecosystems* 17: 691–705.

Kéry, M. (2010) *Introduction to WinBUGS for Ecologists. Bayesian Approach to Regression, ANOVA, Mixed Models and Related Analyses*. New York: Academic Press.

Kéry, M. and Schaub, M. (2012) *Bayesian Population Analysis Using WinBUGS: A Hierarchical Perspective*. New York: Academic Press.

King, R. (2009) *Bayesian Analysis for Population Ecology*. Boca Raton, FL: CRC Press,.

Konishi, S. and Kitagawa, G. (2008) *Information Criteria and Statistical Modeling*. New York: Springer.

Lunn, D.J., Thomas, A., Best, N. and Spiegelhalter, D. (2000) WinBUGS – a Bayesian modelling framework: concepts, structure, and extensibility. *Statistics and Computing* 10: 325–337.

Lunn, D., Spiegelhalter, D., Thomas, A. and Best, N. (2009) The BUGS project: evolution, critique, and future directions. *Statistics in Medicine* 28: 3049–3067.

Lunn, D., Jackson, C., Nicky, B., Thomas, A. and Spiegelhalter, D. (2012) *The BUGS Book*. Boca Raton, FL: CRC Press.

MacKenzie, D.I. (2005) What are the issues with presence-absence data for wildlife managers? *Journal of Wildlife Management* 69: 849–860.

MacKenzie, D.I. and Nichols, J.D. (2004) Occupancy as a surrogate for abundance estimation. *Animal Biodiversity and Conservation* 27: 461–467.

MacKenzie, D.I., Nichols, J.D., Lachman, G.B., Droege, S., Royle, J.A. and Langtimm, C.A. (2002) Estimating site occupancy rates when detection probabilities are less than one. *Ecology* 83: 2248–2255.

MacKenzie, D.I., Nichols, J.D., Hines, J.E., Knutson, M.G. and Franklin, A.B. (2003) Estimating site occupancy, colonization, and local extinction when a species is detected imperfectly. *Ecology* 84: 2200–2207.

MacKenzie, D.I., Royle, J.A., Brown, J.A. and Nichols, J.D. (2004a) Occupancy estimation and modeling for rare and elusive populations. In: Thompson, W.L. (ed.), *Sampling Rare or Elusive Species*. Washington, DC: Island Press. pp. 149–172.

MacKenzie, D.I., Bailey, L.L. and Nichols, J.D. (2004b) Investigating species co-occurrence patterns when species are detected imperfectly. *Journal of Animal Ecology* 73: 546–555.

MacKenzie, D.I., Nichols, J.D., Royle, J.A. Pollock, K.H., Bailey, L.L. and Hines, J.E. (2006) *Occupancy Estimation and Modeling: Inferring Patterns and Dynamics of Species Occurrence*. New York: Academic Press.

MacKenzie, D.I., Nichols, J.D., Seamans, M.E. and Gutierrez, R.J. (2009) Modeling species occurrence dynamics with multiple states and imperfect detection. *Ecology* 90: 823–835

McCarthy, M.A. (2007) *Bayesian Methods for Ecology*. Cambridge: Cambridge University Press.

O'Connell, A.F. and Bailey, L.L. (2011) Inference for occupancy and occupancy dynamics. In: O'Connell, A.F., Nichols, J.D. and Karanth, K.U. (eds), *Camera Traps in Animal Ecology Methods and Analyses*. New York: Springer. pp. 191–206.

Plummer, M. (2003) JAGS: a program for analysis of Bayesian graphical models using Gibbs sampling. *Proceedings of the 3rd International Workshop on Distributed Statistical Computing (DSC 2003)*, Technische Universität Wien, Vienna, Austria. https://www.r-project.org/conferences/DSC-2003/Proceedings/Plummer.pdf

Robert, C. and Casella, G. (2004) *Monte Carlo Statistical Methods*. New York: Springer.

Rovero, F., Zimmermann, F., Berzi, D. and Meek, P. (2013) "Which camera trap type and how many do I need?" A review of camera features and study designs for a range of wildlife research applications. *Hystrix: the Italian Journal of Mammalogy* 24: 148–156.

Rovero, F., Martin, E., Rosa, M., Ahumada, J.A. and Spitale, D (2014) Estimating species richness and modelling habitat preferences of tropical forest mammals from camera trap data. *PLoS ONE* 9(7): e103300.

Royle, J.A. and Dorazio, R. (2008) *Hierarchical Modeling and Inference in Ecology: The Analysis of Data from Populations, Metapopulations and Communities*. San Diego: Academic Press.

Soetaert, K. and Herman, P.M.J. (2009) *A Practical Guide to Ecological Modelling*. New York: Springer.

TEAM Network (2011) *Terrestrial Vertebrate Protocol Implementation Manual, v. 3.1.* Tropical Ecology, Assessment and Monitoring Network. http://www.teamnetwork.org/files/protocols/terrestrial-vertebrate/TEAMTerrestrialVertebrate-PT-EN-3.1.pdf

Yoccoz, N.G., Nichols, J.D. and Boulinier, T. (2001) Monitoring of biological diversity in space and time. *Trends in Ecology & Evolution* 16: 446–453.

7. Capture–recapture methods for density estimation

Fridolin Zimmermann and Danilo Foresti

7.1 Introduction

Conservation and management of animal populations require making decisions about what actions to take to bring about desired consequences (Nichols 2014). Effective conservation programmes like adaptive management include several key elements such as (i) the development of explicit objectives and targets; (ii) listing of potential management actions to be taken to meet objectives; (iii) a mean for measuring confidence in predictive models (i.e. to project the consequences of different possible actions in order to decide which action represents the 'best' choice); and (iv) a monitoring programme that is centred on providing system state variables. Ecological monitoring programmes usually focus on system state variables (i.e. a state variable is a characteristic of the system that reflects the status of the system; Nichols 2014). Commonly selected state variables include abundance, occupancy (see Chapter 6) and species richness (see Chapters 5, 9 and 10). State variables are fundamental for three key steps: (i) decision analysis; (ii) assessment of progress towards the objectives; and (iii) comparison against model predictions for the purpose of discriminating among competing models (Nichols and Williams 2006). Although not always the case, abundance estimates usually require more sampling effort than do estimates of occupancy or species richness. Indeed it is possible to estimate focal species abundance within a small number of specified areas (e.g. Zimmermann *et al.* 2011) and to use occupancy modelling over much larger areas (e.g. Karanth *et al.* 2011a; Barber-Meyer *et al.* 2013), hence allowing inferences to be made about distribution of abundance across the whole area of interest (Royle and Nichols 2003). Once it has been decided that abundance is the appropriate state variable within a given conservation and management programme, it is important to select appropriate abundance estimation methods among the large number of methods that have been developed (e.g. Seber 1982; Borchers *et al.* 2002; Williams *et al.* 2002). When choosing a method, careful consideration should be given to whether it deals adequately with geographic (or spatial) variation and detectability. In addition to these basic recommendations, the selection of the method should be tailored to the programme that those methods are designed to serve, with important considerations being the specific roles of estimates in the programme and the logistical issues that

accompany the programme (Nichols 2014). This leads to questions such as: 'For which area are abundance estimates needed?', 'Is the entire area easily accessible?', 'Is the focal species secretive?', and 'What financial and human resources are available?' (Nichols 2014).

The abundance of elusive animals with individually distinct fur patterns or artificial marks living at low densities is best estimated in the conceptual framework of capture–recapture methods, which can provide estimates of encounter probabilities and abundance along with associated statistical errors (e.g. Karanth 1995; Schwarz and Seber 1999). These models account for the fact that not all animals in the study area are necessarily observed. This methodology has been applied to a range of species, such as common genet (*Genetta genetta*; Sarmento *et al.* 2010), striped hyena (*Hyaena hyaena*; Harihar *et al.* 2010; Singh *et al.* 2010), and, in particular, large and small cats with individually distinct coat patterns (e.g. Karanth and Nichols 1998; Silver *et al.* 2004; Pesenti and Zimmermann 2013).

Several analytical options, which are not universally applicable, have been developed to estimate the abundance and density of species that do not have distinct natural or artificial marks (see Sollmann *et al.* 2013 for a critical review). These include calibrated (absolute) abundance indices (e.g. relative abundance index, RAI; Carbone *et al.* 2001; Chapter 5); the random encounter model (REM) by Rowcliffe *et al.* (2008); the Royle–Nichols model, which is based on species-level detection–non-detection data and makes use of the relationship between the probability of detecting a species at a given site and its site-specific abundance (Royle and Nichols 2003); the spatial capture–recapture model (SCR) without individual identities developed by Chandler and Royle (2013); and mark–resight models, when some tagged or otherwise marked individuals are available for sampling, both non-spatial (White 1996; McClintock *et al.* 2006, 2009a,b) and spatial (Chandler and Royle 2013). In line with Sollmann *et al.* (2013) and others we believe that rather than sticking to camera trapping, researchers should sometimes consider alternative survey methods to estimate abundance of species that have no natural marks and cannot easily be tagged. Depending on the study area and target species, non-invasive genetic sampling in combination with capture–recapture models (e.g. Mulders *et al.* 2007; Wilton *et al.* 2014), distance sampling (e.g. Wegge and Storaas 2009) or repeated point counts in combination with appropriate models accounting for detection (e.g. N-mixture models; Royle 2004) can provide statistically sound population estimates. Most of these emerging methods have been developed over the past decade, and hence their efficacy is still under study.

In this chapter, we first cover what needs to be considered when planning a camera trapping study to estimate abundance and density by means of capture–recapture models, namely equipment and field practices (i.e. camera traps and related equipment) and survey design considerations (i.e. camera trap site selection, season and survey duration, spatial sampling and assumptions). We briefly discuss the identification of individuals and describe some working steps and useful tools that could ease identification. We then provide an analytical example using camera trapping data for a Eurasian lynx (*Lynx lynx*) population, introducing the basic SCR model with likelihood inference (using the R package `secr`; Efford 2015). Subsequently, we present estimates based on conventional (i.e. non-spatial) capture–recapture models.

We refer the readers to Karanth *et al.* (2011b), O'Brien (2011), Ancrenaz *et al.* (2012) and Royle *et al.* (2014) for more detailed background to capture–recapture studies.

7.2 Equipment and field practices

7.2.1 Camera traps

Camera traps producing high-quality photos in terms of clarity, sharpness (moving objects should not be blurred) and resolution are especially critical for species that do not have easily distinguishable coat patterns and for those that lack individually identifiable natural marks. Currently the ideal camera traps for capture–recapture studies are those with PIR sensors, a xenon white flash and a high trigger speed (see Chapter 2). One exception is represented by a unique cat population of individuals that are almost all melanistic (e.g. leopard *Panthera pardus* in Malaysia; Hedges *et al.* 2015), where the identification of individuals is only possible by means of infrared flash camera traps modified to force the traps into night mode. As camera traps should be placed in pairs to photograph both flanks of the passing animal, it is possible to combine the non-overlapping advantages and disadvantages of xenon with infrared LED flash. This combination has proved to be an efficient system for gathering pictures of sufficient quality to enable individual identification while enabling detection of family groups or individuals following each other within short distances and short times (F. Rovero unpublished data). See Chapter 2 for a more detailed overview of critical camera trap features and settings for capture–recapture studies including a list of commercially available camera traps.

7.2.2 Focal species and other members of its guild

Ideally, some basic information about the focal species and other members of its guild – and its main prey if the species in question is a predator – should be obtained prior to planning the survey. This information can be obtained from literature searches, from interviews with people knowing the area or from preliminary surveys. Information like this helps to give a general idea about whether the species of interest are rare or abundant and if other species that could potentially interfere with the focal species (via competition, predation or intraguild predation) are present in the area. This information is important for choosing an adequate location for the study area and for selecting optimal camera trap sites.

7.2.3 Camera trap sites and camera trap placement

One of the most important aspects of the survey design is to choose camera trap locations that maximise the probability of encountering the focal species. This is even more important when targeting species that live at relatively low densities even in the best habitats, and thus have a very low probability of encountering a camera trap, typically large carnivores. Therefore camera trap sites should be sited on well-used travel routes, near food sources (e.g. fruiting trees in tropical forest) or near water resources – ideally identified based on species signs of presence (e.g. tracks, scent marks and scat deposit when targeting carnivores) – that are more likely to be visited by the focal species and its prey. Depending on the focal species, optimal camera trap sites are along game or hiking trails, roads, junctions between roads or trails, ridgelines, dry river beds, river crossing points, salt licks, mud wallows and water ponds.

In order to identify suitable trap sites, the survey area should be thoroughly explored before the beginning of the session using the best available local knowledge, maps and

BOX 7.1 Use of attractants in capture–recapture studies

In carnivore capture–recapture studies, attractants are sometimes used to entice animals to camera traps with the aim of increasing encounter rates or probability (e.g. Thorn *et al.* 2009; Braczkowski 2013; du Preez *et al.* 2014). Such attractants may be lures which include scent such as perfume/cologne (e.g. Thomas *et al.* 2005), sound or food that is inaccessible to the animal (Gerber *et al.* 2012) or baits, which entail the use of food rewards (Ariefiandy *et al.* 2013; du Preez *et al.* 2014). Lures are generally preferred over baits because they will not be taken by the first animal passing by the camera trap site, which is likely to be a more common species than the target one. Besides enticing animals to walk in front of the camera trap, attractants can cause the focal animal to linger in front of the camera trap, and be subject to multiple exposures. These additional photographs can aid identification of the species or individuals, as well as help to determine the sex. However, relatively few carnivore studies based on photographic capture–recapture estimates have used attractants so far (Trolle and Kéry 2003; Trolle *et al.* 2007; Gerber *et al.* 2010, 2012; Garrote *et al.* 2011, 2012), perhaps because of the various disadvantages they entail. Potential disadvantages include the extra time needed for data processing as memory cards can get filled with many photographs of the same animal if it lingers for a while in front of the camera trap. The use of lures and baits can also be laborious and expensive. For example, under heavy rains scent lures are quickly washed away and thus need to be renewed frequently to be of any use. Good attractants can modify the ranging behaviour of animals and may cause the animals to move beyond their usual home range, potentially violating the assumption of geographic closure (Gerber *et al.* 2012). Moreover, attractants can introduce a change in the behaviour of an individual in response to the first encounter event, which induces non-independence of encounter probability in the encounter history of that individual (Otis *et al.* 1978). In addition, attractants can also amplify individual heterogeneity in encounter probability as they might have variable effects on animals depending on age, sex or resident status. When baits are used as attractants, individuals might become habituated, which could expose them to a higher risk of mortality from encounters with humans (e.g. Balme *et al.* 2014). Baiting may also increase the risk of predation by other larger carnivores, and for some species (e.g. leopard *Panthera pardus*) it could also artificially elevate rates of infanticide if it increases interaction between females with cubs and males (Balme *et al.* 2014). Since the use of attractants can have multiple disadvantages, they are only likely warranted in capture–recapture studies if by improving the encounter probabilities, they increase the precision of abundance and density estimates significantly. Attaining a better understanding of the effects of attractants in capture–recapture studies is necessary as the few studies that have so far investigated this issue have produced contrasting results (e.g. Garrote *et al.* 2012; Gerber *et al.* 2012; Braczkowski 2013; du Preez *et al.* 2014). In the study of Gerber *et al.* (2012) the use of lures did not affect geographic closure, abundance and density estimation of Malagasy civet (*Fossa fossana*), but did provide more precise population estimates by increasing the number of re-encounters. Likewise Garrote *et al.* (2012) found that lures increased the efficiency of trail camera trap encounters and consequently increased the accuracy of abundance and density estimates of

Iberian lynx (*Lynx pardinus*). Although the presence of baits near camera traps increased leopard encounters 4-fold in a study by du Preez *et al.* (2014), there was only a marginal increase in precision (2–4%). This seems a small gain for the increased effort associate with baiting (an additional 314 man-hours per survey; Balme *et al.* 2014). While in the study of Braczkowski (2013) lures did not affect geographic closure, their use did not, however, increase the number of leopard encounters and accordingly did not provide more precise population estimates. Possible reasons for these contrasting findings are that each study used different forms of attractants, namely lures in the form of either scent (Braczkowski 2013), inaccessible meat (Gerber *et al.* 2012) or inaccessible live pigeons (Garrote *et al.* 2012), and baits (du Preez *et al.* 2014), and species might be attracted to a greater or lesser extent to a given form of attractant depending on the family to which they belong. For example lures might be especially suitable for studying species with superior olfactory senses such as viverrids (Gerber *et al.* 2012). The use of attractants might also be more warranted in low density populations or for species that are less routine in their movement pattern and thus more difficult to detect by camera traps. Therefore, attractants should only be used after their effects on population and spatial parameters have been adequately assessed and if their associated disadvantages remain within acceptable limits.

survey tools (e.g. GIS, GPS). Ideally double the number of trap sites than needed should be identified as this provides flexibility to locate traps optimally in the final survey design without lowering encounter probabilities or compromising on trap-spacing needs (Karanth *et al.* 2011b). It is recommended that investigators seek assistance from local guides or naturalists for such reconnaissance surveys and/or select optimal sites on maps based on their own experience of the movement behaviour of the focal species (e.g. following trails or other guiding structures such as topographical features). For repeated surveys, camera traps should be deployed using the same sampling design in each survey to minimise potential biases in data collection.

It is best to deploy two camera traps per site in order to photograph both flanks of the focal species to maximise the chances of identification. Although setting a single device per site is less optimal, abundance estimation is still possible, and until recently the typical approach when dealing with this situation was to conduct separate analyses using the left- and right-sided photographs and compare the results. However, the additional uncertainty associated with individual identification combined with a small sample size results generally in very imprecise estimates (e.g. Negrões *et al.* 2012). Nonetheless new analytical methods have recently been developed to take into account bilateral photo-identification in case it is unclear how to link the left- and right-side photos (McClintock *et al.* 2013). The first applications indicate that these new methods produce abundance estimates that are about twice as precise as those from analogous one-side models. These models have yet to be extended to allow for individual variation in parameters (but see McClintock 2015).

Each camera trap should be placed carefully to maximise image quality and preclude the chance of a 'skewed' image that can reduce similarity coefficients (i.e. probability that two photographs of the same individual match) when pattern recognition software is used to identify individuals (see Box 7.2 below). Hence camera traps should be set

perpendicular (or only slightly angled) to the trail to obtain a good side image of the passing animal. As the flash of the opposing camera can cause overexposure of the image, it is necessary to avoid setting camera traps exactly facing each other. In steep terrain it is not always easy to find a suitable tree beside the trail that will allow the camera trap to be mounted at approximately the same height as the target. This constraint can be easily solved by using a pole. In some situations natural hurdles (e.g. logs) can be placed on the forest road/hiking trail to ensure that the animals are centred in the camera trap field of view and to avoid overexposed pictures. Alternatively, obstacles can be placed to funnel the route of the animal past the camera trap, preventing animals from being out of flash range and/or very small in the image. Nevertheless, as a rule, the sites should be altered as little as possible to ensure that they remain unnoticed by passing animals, and thus poles or guiding structures should only be used if absolutely necessary.

7.3 Survey design

7.3.1 Season, survey duration and demographic closure

The season of the survey will be determined jointly by (i) the timing of the decision process of the larger programme (e.g. conservation) that the monitoring is designed to serve; (ii) the natural history of the focal species – for mammalian species with seasonal reproduction, females with young have a lower encounter probability during the period of birth and lactation as they have a reduced mobility, moreover demographic closure is not granted if the study period encompasses the main period of birth or dispersal; (iii) environmental issues (e.g. seasonal snow can help to optimize camera trap sites by revealing tracks of the focal species; temperature to effectively run the camera traps, accessibility of the study area in case of flooding); and (iv) logistical issues (e.g. incidence of human activities and factors such as availability of personnel, permits and equipment; Karanth *et al.* 2011b). It is usually an advantage to obtain abundance estimates very shortly before the time at which the decision is made and the action taken (Nichols 2014). However, if other biological, environmental or logistical factors are prevailing, these might take precedence over basic considerations of the decision process.

The survey duration is the time required to sample the entire area of interest with camera traps. Abundance estimation assuming demographic closure (Otis *et al.* 1978; White *et al.* 1982; Williams *et al.* 2002) dictates that the duration of capture–recapture surveys should be as 'short' as possible in relation to the likely turnover of the focal animal population as a result of recruitment, entry into the sampled population, mortality or exit from the sampled population (Karanth *et al.* 2011b). With rare and elusive species, there is a need to find a compromise between sampling for long enough to gather sufficient data to provide reliable abundance estimates, but short enough so that the closure assumption is not likely to be violated. Keeping camera traps running for months in the field is likely to break the closure assumption, and requires different types of analyses specific to demographically open populations (Pollock *et al.* 1990; Kendall *et al.* 1995; Karanth *et al.* 2006; Chandler and Clark 2014; Ergon and Gardner 2014).

Investigators usually divide data into discrete sampling occasions, typically 24 h periods, to construct the encounter history in either conventional (i.e. non-spatial) capture–recapture or SCR models. For wide-ranging species living at low densities, this could, however, result in 0-heavy encounter histories in conventional capture–recapture models. Therefore some studies define the occasion length as longer than 24 h (e.g. Dillon

and Kelly 2007; Kelly *et al.* 2008; Zimmermann *et al.* 2013). Pooling occasions may eliminate more 0s than 1s from the encounter history in conventional capture–recapture models and thus increase the overall encounter probability on any given occasion, which should be ≥0.1 to get reliable abundance (White *et al.* 1982) or even better ≥0.3, which is safer in the presence of a behavioural response (Tenan *et al.* 2013). However, such pooling will reduce the number of encounters, potentially making it more difficult to select an appropriate model. Therefore to compensate for the low number of encounters, some investigators increase the length of the survey duration to get enough encounters though this brings the risk that demographic closure is no longer fulfilled. Because aggregating camera trapping data into sampling occasions introduces subjectivity (i.e. the occasion length chosen by the investigator) and discards some information, continuous time models for both conventional capture–recapture (e.g. Hwang *et al.* 2002) and SCR models (Borchers *et al.* 2014) have been developed. The continuous-time SCR model developed by Borchers *et al.* (2014) is unbiased and more precise than discrete occasion estimators based on binary detection data rather than detection frequencies when there is no spatiotemporal correlation. Hence these authors identified the need to develop continuous-time methods that incorporate spatiotemporal dependence in detections.

Few population closure tests have been developed in conventional capture–recapture models mostly because behavioural variation in detection is indistinguishable from violation of demographic closure (Otis *et al.* 1978; White *et al.* 1982). Otis *et al.* (1978) developed a closure test that can handle heterogeneity in encounter probability, but does not perform well in the presence of time or behavioural variation in encounter probability. Stanley and Burnham (1999) developed a closure test for a model allowing time variation in detection, which works well when there is permanent emigration and a large number of individuals migrate. Both tests are implemented in the software CloseTest 3 (Stanley and Richards 2005; http://www.fort.usgs.gov/products/software/clostest/) and in the R package `secr` with the function `closure.test`. Like conventional capture–recapture, basic SCR models do not allow for any ongoing demographic processes. However, for the same reasons that violation of other model assumptions cannot necessarily be distinguished from a lack of population closure, there is no closure test in the SCR. Useful solutions to deal adequately with this problem in SCR are provided in Royle *et al.* (2014). For example, SCR can be expanded to handle open populations, allowing the estimation of demographic parameters such as survival and recruitment (e.g. Gardner *et al.* 2010a).

7.3.2 Spatial sampling and geographic closure

Estimation of animal abundance requires consideration of detectability and spatial variation in abundance (Nichols 2014). Detectability means that even when an individual of the focal species is present in a sample unit that is surveyed, there is some probability that it will be missed during a sampling effort. Individuals may vary in their detectability and detection may vary over time and space (O'Brien 2011). The likelihood of detecting an individual during a sampling occasion provides the key to converting the sample count statistic into an estimate of abundance or density. Spatial variation in abundance is not an issue if the sampling area is sufficiently small that it can be surveyed in its entirety. However, if inferences about large areas are of interest, a subset of sampling areas, representative of the area for which inferences are made, is selected to be surveyed and extrapolation is used to draw inferences about the areas not surveyed (Nichols 2014). Statisticians have long dealt with spatial variation and various approaches to the selection

of locations of sampling areas may be used including the rule of stratification or random sampling (see Cochran 1977; Thompson 2012).

Once a sampling area has been defined for a camera trap study, the investigator needs to deal with a number of critical design elements in the context of spatial sampling problems, where populations of mobile animals are sampled by an array of camera trap sites. Three of the most important ones are the spacing of camera trap sites (or sampling devices) relative to individual movement, their configuration within the camera trap array, and the total size and shape of the array (Foster and Harmsen 2011; Royle *et al.* 2014). Because the number of camera traps available is generally limited, researchers need to compromise between trap spacing, configuration within the camera trap array and the overall trap array.

An important requirement of conventional capture–recapture models is that each individual must have a probability >0 of being detected (although not all individuals may in fact be caught during the survey) and thus there should be at least one sampling site per smallest female home range (usually the smallest home range in the population) (Karanth and Nichols 1998, 2002), resulting in an upper limit to possible camera trap site spacing. The reason why individuals that are not exposed to camera trap sites cause problems in non-spatial models is that they induce heterogeneity in encounter probability. If the entire home range of an individual lies completely or partially in an area that does not contain any camera trap sites, then it will have a different probability of being detected than an individual whose home range is covered with a large number of camera trap sites. Hence the assumption that the encounter probability of every individual be >0 entails strong restrictions with respect to the study design. Although there is no need to cover an area systematically with camera trap sites, there has to be some consistent coverage of the entire area of interest. This is often achieved by dividing the study area in grid cells of a size that approximates the smallest home range recorded for the focal species (in the same or a similar area) and then place at least one camera trap site within each cell. It can be extremely challenging or even impossible to achieve a comprehensive coverage, especially when dealing with wide-ranging species and accordingly large study areas. Even if this is possible, spatial heterogeneity in encounter probability would still exist because individuals with home ranges near the borders of the camera trap site array will have a lower exposure to camera traps compared to individuals that spend all their time within the array. Therefore the geographic closure assumption (i.e. no movement in or off the sampling grid) is likely to be violated in most applications.

To estimate density with conventional capture–recapture models, the area effectively sampled needs to be estimated. This is usually done by obtaining estimates of movement from the camera trapping data itself, such as the mean maximum distance moved (MMDM) between photo-encounters for each individual caught by at least at two different camera trap sites (Soisalo and Cavalcanti 2006; Dillon and Kelly 2008) or half the mean maximum distance moved (1/2MMDM: Karanth 1995; Karanth and Nichols 1998, 2002), or from telemetry data collected simultaneously with the camera trapping session and using this distance to place a buffer around the camera trap array (see section 7.4). The spacing of camera trap sites clearly has an effect on movement estimates, since it determines the resolution of the information on individual movements (Wilson and Anderson 1985; Parmenter *et al.* 2003). If the camera trap site spacing is too great, most animals will only be detected at a single camera trap site, and little or no information on movement will be gained (Dillon and Kelly 2007). Further, the overall area sampled by camera traps should be large enough to capture the full extent of individual movements. Researchers using conventional capture–recapture models have suggested that the camera trap array

size should be at least four times that of individual home ranges (Bondrup-Nielsen 1983; Maffei and Noss 2008) to avoid any positive bias in estimates of density. Moreover, according to White *et al.* (1982), to obtain reliable abundance estimates with conventional capture–recapture models the overall sample size should be >20 individuals. While this recommendation can be followed for small mammals, with large mammals it may require covering thousands of square kilometers – a logistical and financial challenge that few projects can realistically tackle.

To increase geographical closure regular arrays of traps which maximise the ratio of sampled area size to its perimeter (which corresponds to circular sampled areas) are preferable to reduce the edge effect caused by detected individuals moving in and out of the area surveyed over the course of the study (Foster and Harmsen 2011). However, even such a constraining design cannot fully liberate conventional capture–recapture models from the assumption of geographic closure, especially for mammals with large home ranges.

Efford (2004) and Royle *et al.* (2009a,b) developed a method that uses location-specific individual encounter histories to construct a SCR model, hence relaxing a number of important assumptions. SCR explicitly models the movement and distribution of individuals in space, relative to the trap array, and thus circumvents the problem of estimating the area effectively sampled that is inherent to conventional (i.e. non-spatial) capture–recapture models, as in SCR studies the trap array is embedded in a large area called the state space. The requirements in terms of spatial study design for SCR models differ markedly from those for conventional capture–recapture. For instance 'holes' in the camera trap array are of no concern in SCR studies. Hence some individuals within the study area might have a probability of close to zero of being included in the sample. With SCR models, N (i.e. population size) is explicitly tied to the state space and not to the actual locations of the camera trap sites themselves. Thus, it is possible to make predictions outside the range of data by making inferences from the sample to individuals that live in these holes based on the explicit declaration that the SCR model applies to any area within the state space, even to unsampled areas (Royle *et al.* 2014). On the contrary, conventional capture- recapture models only apply to individuals that have encounter probabilities that are consistent with the model being considered and individuals with $p = 0$ are not accommodated in those models. This particularity alone allows for completely new and much more flexible study designs in SCR studies, such as linear designs, camera trap sites tracing the outline of a square, or small clusters of camera trap site grids spread over the landscape (Efford *et al.* 2005, 2009; Efford and Fewster 2013).

While conventional capture–recapture models are concerned with the number of individuals and re-encounters, SCR models need an additional level of information, namely that some individuals have to be re-encountered at least at several camera trap sites. Therefore, the design of SCR studies needs three pieces of information: (i) the total number of unique individuals encountered; (ii) the total number of re-encounters, which provides information about the baseline encounter rate; and (iii) spatial re-encounters, which provide information about the movement parameter (σ). The ability of SCR models to estimate movement even for relatively small trapping grids lies within the model itself: σ is estimated as a specified function of the ancillary spatial information collected in the survey and the encounter frequencies at those locations (Sollmann *et al.* 2012). As long as there is enough data across at least some range of distances, this function is able to make predictions across unobserved distances, even when they are larger (within reasonable limits) than the extent of the trap array (Royle *et al.* 2014). This

raises some constraints on how large the overall trap array must be to provide this range of distances (e.g. Marques *et al.* 2011).

Although potentially time consuming, scenario analysis by Monte Carlo simulations (e.g. Sollmann *et al.* 2012; Efford and Fewster 2013; Sun *et al.* 2014; Wilton *et al.* 2014) is very helpful for evaluating the study design in terms of the ability to generate useful estimates before any field survey is undertaken. Formal model-based strategies have great potential (Royle *et al.* 2014) and could be an alternative to simulation-based scenarios.

Using a simulation study, Sollmann *et al.* (2012) investigated how trap spacing and camera trap site array relative to animal movement influence SCR parameter estimates. Their simulation showed that SCR models performed well as long as the extent of the trap array was similar to or larger than the extent of individual movement during the study period, and movement was at least half the distance between traps. SCR models have much more realistic requirements in terms of area coverage than conventional capture–recapture models, which make them particularly suitable for species with large home ranges that are present at low densities. As long as sufficient data are collected, SCR models work well in study areas that are similar in size to an individual's home range (Marques *et al.* 2011; Sollmann *et al.* 2012; Zimmermann *et al.* 2013). Trap spacing is an essential aspect of design in SCR as long as the study area can be covered uniformly with camera traps. In practice, especially when targeting wide-ranging species, the study area tends to be large relative to the resources available. In such cases other strategies that deviate from a strict focus on camera trap site spacing need to be considered. Two general sampling strategies, which can be used by themselves or combined, have been suggested for sampling large areas (e.g. Sun *et al.* 2014): (i) sampling based on clusters of camera trap sites (i.e. groups of camera trap sites spaced throughout the larger area of interest; e.g. Efford and Fewster 2013); and (ii) sampling based on moving groups of camera trap sites over the landscape (Karanth and Nichols 2002). Efford and Fewster (2013) looked at the performance of different spatial study designs in an SCR framework, including a clustered design, and found that the latter performed well, although there were indications of a slight positive bias in estimates of N. The distribution of the clusters has to be spatially representative (e.g. systematic with a random origin). In addition, Efford and Fewster (2013) pointed out that if distances among clusters are large, individuals are unlikely to show up in several clusters, and then the method relies on spatial detections within clusters, meaning that spacing of camera trap sites within clusters has to be appropriate to the movement of the species under study. Similarly, Wilton *et al.* (2014) showed that with limited resources allocating traps to multiple arrays with intensive trap spacing similar in extent to the movement of individuals increased the precision of parameter estimates. In practice, combining clustering and moving traps might be necessary or advantageous (see Royle *et al.* 2014; Sun *et al.* 2014).

Generally, however, study design should be tailored to expose as many individuals as possible to sampling and to obtain adequate data on the movement of individuals (Royle *et al.* 2014). Large amounts of data in terms of numbers of individuals detected and numbers of re-encounters not only improve the precision of parameter estimates (Sollmann *et al.* 2012) but also allow potentially important covariates (e.g. sex and time effect) to be included in SCR models. In addition, the flexibility in the study design of SCR models also makes it more feasible to collect abundance and density estimates for several species in parallel (Sollmann *et al.* 2012; Royle *et al.* 2014).

Although, as we have seen, the basic SCR model relaxes a number of important assumptions compared to conventional models, there are nevertheless some important assumptions besides demographic closure already outlined in section 7.3.1 that need to be

considered. Geographic closure is loosened: while the SCR model assumes no permanent immigration or emigration from the state space, it allows for 'temporary' movements ('temporary emigration', as it is called in the capture–recapture literature, Kendall *et al.* 1997; Kendall 1999) around the state space and variable exposure to encounters as a result. Further assumptions include the following: (i) activity centres are randomly distributed; (ii) the probability of detection of an individual at a camera trap site declines as a function of distance from that individual's activity centre; (iii) the encounter of any individual is independent of the encounter of any other individual; and (iv) the encounter of an individual at any site is independent of its encounter at any other site, and on any other subsequent sampling occasion (Royle *et al.* 2014). However, for some of these core assumptions such as uniformity, and independence of individuals and of encounters, a fair amount of robustness to departures is to be expected (Royle *et al.* 2014). Moreover it is possible to extend these assumptions in many different ways (see Royle *et al.* 2014).

Likelihood-based inferences developed by Efford *et al.* (2009, 2015) can be obtained with the R package `secr` (see case study in section 7.4), while the software SPACECAP has been developed to implement flexible Bayesian approaches (Gopalaswamy *et al.* 2012). Many example analyses, including code using likelihood-based and Bayesian methods, can be found in Royle *et al.* (2014).

BOX 7.2 **Identification of individuals**

Identification of individuals is a key requirement in capture–recapture surveys. While molecular techniques have been used to distinguish individual animals (e.g. Marucco *et al.* 2009; Janecka *et al.* 2011), visual identification of individuals conducted either in real time in the field or later based on photographs can be more cost effective and is essential for a variety of ecological and behavioural studies (e.g. Karanth *et al.* 2006; Zimmermann *et al.* 2013; Vogt *et al.* 2014). Either artificially or naturally marked animals can be identified. Non-invasive methods are clearly preferred (e.g. Karanth 1995; Kelly 2001); however, the use of natural markings for individual identification can be labour intensive and problematic in terms of reliability.

For species with easily distinguishable natural markings that remain fairly constant over time (e.g. stripe or spot patterns) identification errors can occur because of lack of clarity in photographs (Yoshizaki *et al.* 2009) or because of difficulties in comparing photographs with a large set of individual reference photographs. This problem is further complicated when the method is applied to estimate abundance of species that lack clear body patterns but have phenotypic and/or environment-induced characteristics (Noss *et al.* 2003; Ríos-Uzeda *et al.* 2007; Kelly *et al.* 2008). For such species, misidentification can also occur because of the subjectivity involved in identifying individuals, but also because of temporal variability in natural markings (Yoshizaki *et al.* 2009; Goswami *et al.* 2012). Moreover, with increasing sample size, it is unlikely that all individuals within the sample have unique markers. Two types of identification errors can be found: false matches (i.e. incorrectly identifying images from multiple individuals as images from one individual), and false mismatches (i.e. incorrectly identifying multiple images of the same individual as images from multiple individuals). When the capture history data contains errors because of misidentification the conventional

estimators of population size can be seriously biased (Mills *et al.* 2000), and methods of analysis that account for this type of error are clearly needed (Yoshizaki *et al.* 2009). Several frameworks for closed populations have been developed, including a model that can account for temporal variation in detection probability under misidentification due to, for example, variable image quality or genotyping errors (Link *et al.* 2010; Schofield and Bonner 2015); a generalisation of this approach to account simultaneously for temporal variation, behavioural response and individual heterogeneity (McClintock *et al.* 2014), which has also been extended to open populations (McClintock 2015); and a model focusing on the situation where errors are due to temporal variability in natural markings (Yoshizaki *et al.* 2009). These frameworks, with the exception of the one developed by Schofield and Bonner (2015), allow only for bias corrections for false mismatches, not for false matches, which may be common in camera trap studies of species that lack unique natural marks (e.g. Oliveira-Santos *et al.* 2010). The evolving natural marks model assumes that once a new identity is created the old identity is not subject to re-encounter but the newly false identity is subject to re-encounter; however, for situations where changes in natural marks are not obvious, it is more realistic to assume that both old and new identities of an animal can be re-encountered and the model needs to be extended to incorporate this aspect if possible (Yoshizaki *et al.* 2009). Moreover the estimator developed by Yoshizaki *et al.* (2009) should not be used with low encounter probabilities (i.e. ≤0.2), and future research should develop guidelines or criteria to determine whether to use or not the new estimators or a conventional capture–recapture model (Yoshizaki *et al.* 2009). Modelling misidentification errors requires a detailed understanding of the mechanism and the effect on estimators can be substantial if misidentification is not appropriately modelled (Yoshizaki *et al.* 2009). Although these models do not require auxiliary information about misidentification probability (i.e. prior information), prior information can be helpful, especially for small data sets, but the models can have prior sensitivity so it is important that the auxiliary information is reliable (e.g. McClintock *et al.* 2014). When matching photographs to individuals actual identification errors cannot generally be determined solely from non-invasive photos of wild individuals (Ríos-Uzeda *et al.* 2007; Bashir *et al.* 2013) but accuracy and precision can be assessed by testing identification assigned blindly to known (i.e. captive) individuals (Oliveira-Santos *et al.* 2010; Higashide *et al.* 2012). Care should, however, be taken in using identification error estimates from captive individuals as there could be reasons to suspect that the misidentification rate differs for wild individuals and might differ across populations because of different proportions of individuals with less distinguishable coat patterns in each population (e.g. Eurasian lynx with rosettes, which are more difficult to identify, are represented markedly less in the Jura Mountains than in the population found in the northwestern Swiss Alps).

Following Foster and Harmsen (2011) and Russell *et al.* (2014), investigators conducting photographic capture–recapture analyses of species that lack clear body pattern should provide enough information to allow for adequate replication of results and an assessment of the reliability of the method. The following recommendations can be made: (i) investigators should indicate which fixed and

variable morphological traits were used for identification (e.g. Goswami *et al.* 2012); (ii) at least two investigators should independently identify the photos (e.g. Kelly *et al.* 2008); (iii) the level of inter-observer agreement or disagreement should be reported to assess the level of confidence in the result (e.g. Kelly *et al.* 2008); and (iv) investigators should explain how they dealt with ambiguous photographs, stating how many encounters were unidentifiable and explain whether or how they included them in the abundance estimate (Foster and Harmsen 2011). If the method is not reliable, investigators should consider alternative survey methods (e.g. genetic sampling) to estimate the abundance of species that lack clear body patterns.

When camera trapping studies cover a large temporal and/or spatial extent, the number of comparisons for identification will dramatically increase, especially for long-living species. For species with easily distinguishable natural markings, software that automates the identification process through the use of pattern matching has gained in popularity in recent years (Kelly 2001; Krijger 2002; Hiby *et al.* 2009 http://www.conservationresearch.co.uk/; Bolger *et al.* 2012; Bendik *et al.* 2013; Moya *et al.* 2015). Although no unsupervised process for the identification of individuals can be completely automated, the strength of such approaches stems from their ability to narrow the pool of potential matches, thereby reducing the time needed for identification and in parallel minimising mismatch errors to a large extent. However, software cannot yet be used to identify species with more complicated coat patterns (e.g. small spots or rosettes in Eurasian lynx) or species that lack clear body patterns (e.g. Kelly *et al.* 2008; Goswami *et al.* 2012). In such cases alternative, often imaginative, individual identification strategies are necessary (e.g. Goswami *et al.* 2012). With appropriate and skilled queries based on individual attributes such as coat patterns, year of birth or morphological traits, as well as spatial and temporal information, the number of comparisons can be significantly reduced. This requires that photographs of individuals with attributes (e.g. coat pattern, date and coordinates) be entered into a picture database (see Chapter 4), incorporated into a GIS that allows for spatial queries (see section 7.4).

7.4 Case study: the Eurasian lynx

We present an example of the basic SCR model using likelihood inference (R package `secr`; Efford 2015) as applied to camera trapping data of Eurasian lynx collected over 60 nights from 29 November 2013 to 28 January 2014[1] at 61 sites in a 1,051 km² area in the northwestern Swiss Alps (Figure 7.1; Zimmermann *et al.* 2014). We also provide estimates using conventional capture–recapture models. Detailed information about the study area, sampling design and timing (in relation to the natural history of the lynx) is found in Pesenti and Zimmermann (2013) and Zimmermann *et al.* (2013).

[1] The session started when all sites were set and stopped when the first sites were removed from the field

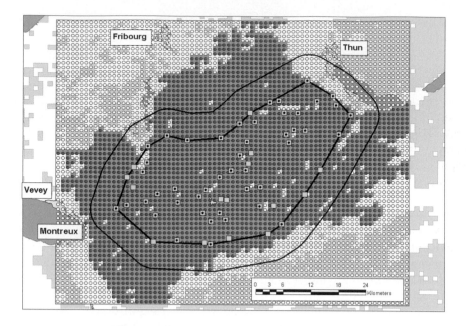

Figure 7.1 Study area in the northwestern Swiss Alps. The yellow squares show the camera trap sites, those with black dots indicate lynx detections; the thick black polygon 1,051 km² delimits the most peripheral camera trap sites. The thin black line shows the area effectively sampled (polygon plus buffer of 1/2MMDM) according to the method described by Karanth and Nichols (1998). Suitable Eurasian lynx habitat 1 × 1 km cells are in light green. A habitat fragment of orthogonally connected suitable habitat cells containing the camera trap sites within the boundaries of the outer rectangle delimiting the area of the state space (or mask in `secr`) is dark green (= shapefile `suitable_habitat_secr`). The green and white dots of the mask (= `mask_prox`; buffer strip of 13 km to the minimum and maximum *x,y* coordinates of the camera trap sites) show the potential 1,000 m spaced activity centres, within (= `habitat_mask`) and outside the suitable habitat fragment, respectively.

7.4.1 Analytical steps during field work

If camera traps can be regularly checked (e.g. every 1–2 weeks) it is recommended to keep track of the survey effort, number of individuals and cumulative encounters that are progressively recorded during the survey. This can identify if the survey is running properly in terms of sampling effort and whether the number of individuals detected is reaching a plateau, and makes it possible to intervene to resolve issues by, for example, extending the duration of the survey.

7.4.1.1 Sampling effort

In camera trapping studies the sampling effort is usually expressed as the number of camera trap nights or days accumulated (see Chapter 5). When a pair of camera traps is used at each site, one survey night should not be counted as two trap nights but only as one trap night, since under these settings both camera traps together make up one sampling unit and do not accumulate results independently. This also means that working nights

need to be subtracted from the sampling effort only if both cameras camera traps did not work simultaneously.

In capture–recapture studies, the greater the effort, the more pictures of (different) individuals are likely to accumulate. A practical way to record effort is to use Excel spreadsheets to report the number of trap nights (Figure 7.2, Figure 7.3 and Appendix 7.1).

After each control the number of realised trap nights in between two controls is entered for each of the two camera traps at each site in the sheet 'effort' of the Excel file 'NWA 2013_2014_eff_trap_nights.xls'. This sheet contains two tables: a basic table with trap nights (or trap days) and a linked table where the values in the cells are automatically computed from the numbers entered in the basic table. The sites and the camera traps are listed in the rows in the basic table (Figure 7.2). Each site has two rows, one for each of the two camera traps. The heads of the columns in the basic table correspond to the date of the days the survey is running. Following the previously described rules, each cell in the basic table gets a value of '1' if the camera trap was working over the 24 h period between noon of the previous day until noon of the date of that given cell; otherwise it has a value of '0'.

	B	C	D	R	S	T	U	V	W	X	Y	Z	AA	AB	AC	AD	AE
1	Definition of the trap night:																
2																	
3	The night before counts as trap night																
4																	
5	**Field contents in italic are calculated automatically !!!**																
6																	
7																	
8										1				2			
9	CODE	Site nb	Camera	26.11	27.11	28.11	29.11	30.11	1.12	2.12	3.12	4.12	5.12	6.12	7.12	8.12	9.12
10	1	A1	uphill		start	1	1	1	1	1	1	1	1	1	1	1	1
11	1	A1	downhill		start	1	1	1	1	1	1	1	1	1	1	1	1
12	2	A2	uphill		start	1	1	1	1	1	1	1	1	1	1	1	1
13	2	A2	downhill		start	1	1	1	1	1	1	1	1	1	1	1	1
14	3	A3	uphill		start	1	1	1	1	1	1	1	1	1	0	0	0
15	3	A3	downhill		start	1	1	1	1	1	1	1	1	1	0	0	0
16	4	A4	uphill		start	1	1	1	1	1	1	1	1	1	1	1	1
17	4	A4	downhill		start	1	1	1	1	1	1	1	1	1	1	1	1
18	5	A5	uphill		start	1	1	1	1	1	1	1	1	1	1	1	1
19	5	A5	downhill		start	1	1	1	1	1	1	1	1	1	1	1	1
20	6	A6	uphill	1	1	1	1	1	1	1	1	1	1	1	1	1	
21	6	A6	downhill	1	1	1	1	1	1	1	1	1	1	1	1	1	
22	7	A7	uphill	1	1	1	1	1	1	1	1	1	1	1	1	1	
23	7	A7	downhill	1	1	1	1	1	1	1	1	1	1	1	1	1	
24	8	B1	uphill	1	1	1	1	1	1	1	1	1	1	1	1	1	
25	8	B1	downhill	1	1	1	1	1	1	1	1	1	1	1	1	1	
26	9	B2	uphill	1	1	1	1	1	1	1	1	1	1	1	1	1	
27	9	B2	downhill	1	1	1	1	1	1	1	1	1	1	1	1	1	

Figure 7.2 Part of the basic Excel spreadsheet table used to fill in the trap nights of each of the two camera traps at each site. In this example we distinguish between camera traps placed downhill and uphill; as an alternative the camera trap ID number could be used instead. A given cell gets a value of '1' if the camera trap was working from noon of the previous day to noon of the date of the corresponding cell; otherwise it has a value of '0'. The first five sites numbered from A1 to A5 were set on 27 November 2013. Both camera traps at site A3 stopped working in the period starting from noon of 6 December 2013 onward and the corresponding cells got a value of '0' and were automatically highlighted in red in the table.

Once all the cells in the basic table have been filled in, the number of trap nights (or trap days) accumulated by a site (row in the table) are automatically summarised in the second table (Figure 7.3). Each cell of a given site and day (column in the table) only gets a value of '0' if both camera traps did not work over the corresponding 24 h period. The information provided in this table will be used to generate the table of trap deployment

	CODE	Site nb		26.11	27.11	28.11	29.11	30.11	1.12	2.12	3.12	4.12	5.12	6.12	7.12	8.12	9.12
137	1	A1			start	1	1	1	1	1	1	1	1	1	1	1	1
138	2	A2			start	1	1	1	1	1	1	1	1	1	1	1	1
139	3	A3			start	1	1	1	1	1	1	1	1	1	0	0	0
140	4	A4			start	1	1	1	1	1	1	1	1	1	1	1	1
141	5	A5			start	1	1	1	1	1	1	1	1	1	1	1	1
142	6	A6		1	1	1	1	1	1	1	1	1	1	1	1	1	1
143	7	A7		1	1	1	1	1	1	1	1	1	1	1	1	1	1
144	8	B1		1	1	1	1	1	1	1	1	1	1	1	1	1	1
145	9	B2		1	1	1	1	1	1	1	1	1	1	1	1	1	1

Figure 7.3 The numbers of trap nights accumulated by each camera trap site over the survey are automatically summarised in a table (of which only part is shown here). A cell only gets a value of '0' if both camera traps of the given site did not work over the corresponding 24 h period.

used in the analyses with `secr` (see section 7.4.3). During this session, we realized at total of 3,640 of the available 3,660 (60 nights × 61 camera trap sites) trap nights (99.5%). These numbers are shown in the bottom left corner of the second table (light blue cells).

7.4.1.2 Individual identification and sex

Lynx are identified visually from photographs by comparing the position of several spots/rosettes relative to each other on the individual's body (Figure 7.4). A comparison of all lynx photographs taken during a given camera trap survey with all reference photographs of the individuals previously identified is only needed in long-term studies intended to measure demographic parameters (e.g. Karanth *et al.* 2006), otherwise only the photographs taken during the specific survey are compared to each other.

New lynx photographs are identified over the course of the survey as they are added to the data. To ease the process, we add a recent extract of an Access picture database

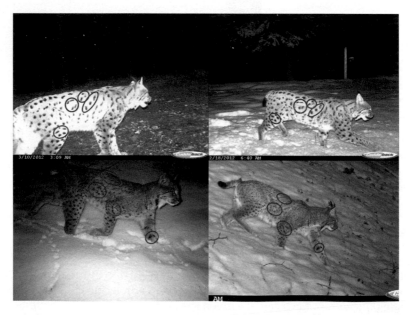

Figure 7.4 Like all spotted cats, Eurasian lynx have an individual fur pattern. These photos show two individuals with different fur patterns, detected at different locations. (KORA)

containing all the relevant information (e.g. individual ID, coat pattern, date, year of birth and mother if available) of the lynx identified so far into a GIS project (ESRI ArcGis 10.1®). Each newly photographed individual is first compared visually with the reference photographs of individuals belonging to the same coat pattern category photographed near the location (i.e. within a given radius) from where the new photographs came from and within a short time window starting from the date when the new photographs were taken. If no matches are found, the temporal and spatial windows are progressively enlarged until a match is found or all photographs of the individuals of the same coat pattern within the database have been checked. A newly identified individual gets a unique identifier composed of a letter and a number. When both flanks are known, it gets the letter B (e.g. B1), when only the left or the right flank are known it gets the letter L or R, respectively. At least two different investigators go through the identification process in order to reduce misidentification errors as much as possible. If no agreement is found between the investigators after more than one trial, it is considered that the individual cannot be identified. This usually happens when the image is of bad quality (e.g. blurred or under/overexposed), not well framed or skewed. In this case the photographs are entered into the picture database as a validated species record ('hardfact' C1, SCALP criteria; Molinari-Jobin *et al.* 2003) but do not get a unique identifier for the individual. Individuals are sexed as males if their scrotums are seen in pictures and as females if they are photographed with juveniles and in some rare occasions based on the genital area if it is clearly visible in pictures.

7.4.1.3 Number of different lynx and cumulative encounters

We use the sheet 'encounter history' of the Excel file 'NWA_2013_14_Lynx_encounter_ histories.xls' provided in Appendix 7.2 to construct the encounter history of each individual pictured during the session. As for the trap nights, this sheet contains two tables: a basic table where the individual encounters need to be filled in (Figure 7.5) and a linked table (Figure 7.6) where the values of most cells are automatically computed (entries in *italic*) from the entries provided in the basic table. The rows in the table correspond to the individuals and the columns to the dates of the photographs

REFERENCE	1					2					3				
lynx ID	30.11	1.12	2.12	3.12	4.12	5.12	6.12	7.12	8.12	9.12	10.12	11.12	12.12	13.12	14.12
1 B185												F4			
2 B196 (+B383)												F1 (Ad+2xJuv)			
3 B256						F3		G6							F3
4 B261	D2(4x)						D1								
5 B331			B2												
6 EYWA												B5(2x)			
7 GIRO					B4							A2			A2

Figure 7.5 Detailed encounter history table of each Eurasian lynx showing the first seven individuals (second column) and the first three sampling occasions (first row) defined as five consecutive time frames of 24 h starting at noon (second row). The site number of the photographic detection of each individual is entered in the corresponding cell in the table. In this example lynx B261 was detected four times at site D2 during the 24 h period ending at noon on 30 November 2013 in the first sampling occasion. B196 was detected once and its juvenile B383 was detected twice at site F1 during the 24 h period ending at noon on 10 December 2013 in the third sampling occasion.

or encounters. Each photographic detection of each individual lynx is entered in the encounter history table. Young lynx (juveniles) are visually distinct from adults and sub-adults in this season and still follow their mother. Because the xenon white flash camera traps used in this study may need up to 1 minute to charge the flash at night depending on the model, most of the time only the first individual of the family group is pictured, the other ones going undetected. For these reasons, following Zimmermann *et al.* (2013), a picture of any family group member is counted as an encounter of the respective female (if known) in the encounter history (the same procedure is followed to prepare the input files for the spatially explicit capture–recapture model `secr`; see below). Since independent dispersers cannot be distinguished from resident animals (adults) on the basis of pictures, the abundance estimates refer to 'independent lynx', i.e. these are residents plus dispersers, or adults plus sub-adults (Zimmermann *et al.* 2013). If the individual lynx has not yet been entered in the table, its name is added in the first free row in the column with 'lynx ID' as header. If it is already present, we can directly proceed to the second step, which consists in adding the site number of the photographic detection in the appropriate cell. The site number is added in the cell (in the row of the corresponding individual lynx) in the column that corresponds to the 24 h period when the individual lynx was detected, knowing that the date of each column covers the 24 h period between noon of the day before until noon of the date of the given column. For family groups, we add in parenthesis beside the site number if only adult (Ad) or juveniles (Juv) or both (Ad+Juv) were pictured at a given detection. We proceed in the same way for the subsequent encounters until all are entered into the table. If an individual was detected two or more times during the same 24 h period, the number of times is reported in parenthesis beside the site number; if it was detected at different sites, each site number is entered separated by a slash.

Once all the cells in the basic table are filled in, the detailed encounter history of each lynx is automatically summarised into an encounter history table (Figure 7.6). In our case a sampling occasion is defined as five consecutive time frames of 24 h starting at noon, which results in a total of 12 sampling occasions for the duration considered. A '1' is automatically entered if the corresponding lynx is photographed at least once during this sampling occasion or a '0' if it is not photographed at all during this particular sampling occasion. This design of encounter history can be used as an input format for modelling abundance using the CAPTURE module in the program MARK (http://www.phidot. org/software/mark/; see below). The four rows at the bottom of the table ('encounters', 'cumulative encounters', 'new individuals encountered' and 'individuals in total'; see

occasion (j)	occasion 1	occasion 2	occasion 3
1 B185	0	0	1
2 B196 (+B383)	0	0	1
3 B256	0	1	1
4 B261	1	1	0
5 B331	1	0	0
6 EYWA	0	0	1
7 GIRO	1	0	1

Figure 7.6 Encounter history table showing the first seven individuals (second column) and the first three sampling occasions (first row). The encounter history of each Eurasian lynx consists of a string of 1s and 0s, in which a '1' indicates encounter of the individual during a specific five day long sampling occasion, while a '0' indicates that the individual was not encountered.

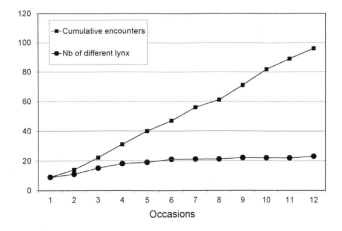

Figure 7.7 Cumulative number of Eurasian lynx encounters and different lynx with increasing number of sampling occasions.

NWA_2013_14_Lynx_encounter_histories.xls) are automatically updated with the exception of the number of 'new individuals encountered' during a given sampling occasion which needs to be filled in by hand by the user. The number of different lynx and the cumulative number of encounters is plotted against the number of sampling occasions in the graph provided in the sheet 'cumulative encounters' (Figure 7.7).

In this session the cumulative number of encounters increased almost linearly. At the 9th sampling occasion the number of different lynx stabilised at 22 individuals but a 23rd individual was encountered during the 12th and last sampling occasion. We can conclude that this session worked pretty well, as we detected 23 individuals (6 females, 11 males and 6 of unknown gender), which is more than the minimum of 20 needed to obtain reliable population estimates in the conventional capture–recapture models according to White *et al.* (1982). In addition, as only one new encounter occurred after the 9th occasion but the cumulative number of encounters increased steadily during the subsequent sampling occasions, we can be confident that we detected a large proportion of the individual present in the area. There were also a fair number of detections of individuals at different trap sites: three individuals were detected at one site, five each at two and three sites, four at four, two each at five and six, and one each at seven and eight sites.

7.4.2 Dates and times in R

The software R offers a flexible framework to manage observations from different time zones and summer and winter time notations. The easiest and more reliable way to manage them is to store date, time and time zone of the observations in a unique object of class POSIX. Two basic objects of class POSIX are found: (i) POSIXlt is a list of vectors including year, month, day, hour, etc.; and (ii) POSIXct represents the length of time in seconds that has passed since a given temporal origin as a numerical vector (in R the default origin is 1970-01-01 00:00.00 UTC). Objects of classes POSIXlt and POSIXct can be manipulated by means of the functions as.POSIX* and strptime. These two functions are essentially equivalent for general purposes; we will therefore use preferentially as.POSIX* for clarity.

```
as.POSIXlt("2015-03-29 01:30:00", format="%Y-%m-%d %H:%M:%S",
    tz="Europe/Berlin")
[1] "2015-03-29 01:30:00 CET"

as.POSIXct("2015-03-29 01:30:00", format="%Y-%m-%d %H:%M:%S",
    tz="Europe/Berlin")
[1] "2015-03-29 01:30:00 CET"
```

The information stored in the two classes looks exactly the same because it is displayed in the same way; however, it is crucial to be aware of the existence of these two classes.

Data sets from different sources, programs or databases store the temporal information in a multitude of different formats in which date and time of the observations may even be located in two separate columns. Moreover, Excel and Access occasionally change the cell content, introducing dummy values to suit certain cell formats. In order to organise this information and create a workable time format, it is suggested to prepare an object – say a vector – with the date and another object with the time in a character format. Hereinafter, we will handle as an example a single observation taken in Central Europe on 29 March 2015 at 1:30 am, as it may be commonly found in a database export sheet:

```
day<-"29.3.2015 00:00:00"
clocktime<-"30.12.1899 01:30:00"
```

We can separate the dummy values from the useful temporal information by means of the function strsplit. This function returns a list in which the first element holds the 'pieces' that have been separated from each other by means of the character argument split:

```
strsplit(day, split=" ")
[[1]]
[1] "29.3.2015" "00:00:00"
```

The different 'pieces' can be extracted by double indexing the results. We can therefore overwrite our day and clocktime objects as follows:

```
day<-strsplit(day, split=" ")[[1]][1]
clocktime<-strsplit(clocktime, split=" ")[[1]][2]
day; clocktime
[1] "29.3.2015"
[1] "01:30:00"
```

Now we can merge the two objects in a single character string using the general function paste and then transform this latter into an object of class POSIX by means of the functions as.POSIXlt or strptime. The different date and time formats can be accounted for by changing the format parameter of the functions as.POSIX* and strptime. For example "%Y-%m-%d" would be the right choice when reading the date "2015-03-29". The time zone required has to be chosen according to the location of the study area and must be specified correctly in R, otherwise the software will treat all misunderstood entries as UTC (Coordinated Universal Time). In order to find out the exact name of the time zone in which you are located (argument tz of the function

as.POSIX*), type `Sys.timezone()` in the R console. The full list of the possible time zone matches is available by typing `OlsonNames()`.

```
x<-paste(day,clocktime)
x
[1] "29.3.2015 01:30:00"
xPOSIXlt<-as.POSIXlt(x, format="%d.%m.%Y %H:%M:%S",
    tz="Europe/Berlin")
xPOSIXlt
[1] "2015-03-29 01:30:00 CET"
```

The definition of the time zone in objects of class POSIX additionally allows the user to deal with the issue of local time, fractional offsets and daylight savings time conventions. When a few observations are treated, it is straightforward to overcome the problem by adding or subtracting a given amount of minutes to the observation considered, but this can take enormous amount of time and could be subject to errors when bigger data sets are involved. Fortunately, R comes with a powerful set of functions allowing easy and safe manipulation of time objects. For a practical example let us consider three observations: our previous observation in winter time, a second observation on the same date in summer time in the same time zone and a third one on the same date in summer time on the other side of the world:

```
xPOSIXlt2<-as.POSIXlt("2015-03-29 03:30:00",
    tz="Europe/Berlin")
xPOSIXlt3<-as.POSIXlt("2015-03-29 03:30:00",
    tz="Australia/Melbourne")
xPOSIXlt; xPOSIXlt2; xPOSIXlt3
[1] "2015-03-29 01:30:00 CET"
[1] "2015-03-29 03:30:00 CEST"
[1] "2015-03-29 03:30:00 AEDT"
difftime(xPOSIXlt2,xPOSIXlt)
Time difference of 1 hours
difftime(xPOSIXlt2,xPOSIXlt3)
Time difference of 9 hours
```

The use of POSIX objects forces all computations (here `difftime`) to take into account the differences in daylight savings notations and time zones, making all conversions straightforward. As a matter of fact, we can easily calculate the corresponding Coordinated Universal Time (UTC) of these observations by means of the function `format`, which should not, however, be confused with the argument `format` of the functions used above. Format works with POSIXct objects and returns a character string free from any temporal shift.

```
xUTC<-format(as.POSIXct(xPOSIXlt),tz="UTC")
xUTC2<-format(as.POSIXct(xPOSIXlt2),tz="UTC")
xUTC;xUTC2
[1] "2015-03-29 00:30:00"
[1] "2015-03-29 01:30:00"
```

The present character strings already allow to calculate time differences by means of the function `difftime`, but have to be back-transformed in a `POSIX` object for any further treatment. We may actually add 60 min to these two observations to get the corresponding UTC+1 local time format in Central Europe. Transforming observations to local time is very important, for instance, in studies investigating the activity pattern of a given species (see Chapter 8). It is crucial to account for all the local time conventions and project the observations back to the right zone in order to obtain something that is meaningful for the biology of the species and readable by researchers.

```
xUTClocal<-as.POSIXlt(xUTC,tz="UTC") + (60*60)
xUTClocal2<-as.POSIXlt(xUTC2,tz="UTC") + (60*60)
xUTClocal;xUTClocal2
[1] "2015-03-29 01:30:00 UTC"
[1] "2015-03-29 02:30:00 UTC"
```

Some studies, for example behavioural studies investigating activity patterns in study areas with a strong longitudinal gradient in the same time zone (e.g. China), may need even finer conversions. In such cases, the use of true solar time instead of local time makes more sense. The function `local2solar` of the package `solaR` v0.41 (Lamigueiro 2015) can be used for this purpose. In addition to the time of the observation in form of a `POSIXct` object, this function needs the longitude where the observation was taken and includes two corrections: the difference in longitude between the location and the time zone, and the daylight saving time. In this chapter we are not going to consider corrections due to solar time variations in the same time zone because, given the size of the study area, they can be considered as negligible (<2 min).

7.4.3 Analysis with `secr`

Once the package `secr` (version 2.10.0 and later) has been loaded in R we can import the data set containing all the lynx encounters from our study area. The following information is required: site number, date and time of the photograph prepared according to the previous section, individual identification, sex, the name of the mother, and the year of birth for juveniles only (only if the investigator would like to take these juveniles into account as an encounter of their respective mothers in the encounter history; see above). The input table and especially the column containing the information about date and time have already been prepared (see section 7.4.2).

```
library(secr)
lynx_data<-read.delim("Lynx_data.txt", header=T,
    stringsAsFactors=F)
```

When data are stored into R dataframes, it is sometimes necessary to specify in detail the class of some variables, since the `read.*` functions often assign non-numeric values to the classes `factor` or `character`. Here we transform a `character` column into a column of class `POSIXct`.

```
lynx_data[,"Time"]<-as.POSIXct(lynx_data$Time)
```

```
lynx_data
```

	Site		Time	Lynx_Name	Sex	Mother	Year_Born
1	E2	2014-01-28	08:31:00	B335	m	B208	2012
2	E2	2014-01-28	08:30:00	B335	m	B208	2012
3	C5	2014-01-28	07:01:00	B400		B185	2012
4	B8	2014-01-27	21:36:00	EYWA	f	MARI	2011
5	B8	2014-01-27	21:36:00	EYWA	f	MARI	2011
...							
258	D2	2013-11-29	17:05:00	B261	m	B202	2010

We then import the table with the coordinates of all sites and add a column with a single numerical identifier for each one of them:

```
sites<-read.delim("Sites.txt", stringsAsFactors=F)
sites<-data.frame(LOC_ID=1:dim(sites)[1], sites)
sites
```

	LOC_ID	Site	x	y
1	1	A1	615262	167863
2	2	A2	608598	162329
3	3	A3	605040	159709
4	4	A4	604423	161485
5	5	A5	606097	162555
...				
61	61	I4	608447	148458

Finally, we import the table of the trap deployment details including dates when specific sites were active (this table was prepared from the information in the Excel file 'NWA 2013_2014_eff_trap_nights.xls'; see Appendix 7.1). This data set is used to correct systematic differences between sites or periods due to, for example, snow falls, battery problems or other technical malfunctions (see above for more details):

```
trap_nights<-read.delim("Trapnights.txt", header=T,
    stringsAsFactors=F)
trap_nights
```

	Site	Night1	Night2	Night3	Night4	Night5	...	Night60
1	A1	1	1	1	1	1	...	1
2	A2	1	1	1	1	1	...	1
3	A3	1	1	1	1	1	...	1
4	A4	1	1	1	1	1	...	1
5	A5	1	1	1	1	1	...	1
...								
61	I4	1	1	1	1	1	...	1

As explained in detail earlier in the present section, we count a photograph of any family group member as an encounter of the respective female (if known) in the encounter history. We therefore replace the names of the juveniles with the name of their corresponding mothers in the table, and make sure that their sex is 'f' for females, if the detected juveniles were born in 2013 and their mothers were known. If an investigator

does not want to integrate the encounter of juveniles into the analyses, he/she simply needs to delete them prior to the preparation of the data sets.

```
for (i in 1:dim(lynx_data)[1]){
    if(lynx_data$Mother[i]!="" & lynx_data$Year_Born[i]==2013){
        lynx_data[i,"Lynx_Name"]<-lynx_data$Mother[i]
        lynx_data[i,"Sex"]<-"f"}}
```

We then delete the columns holding the information about motherhood and year of birth, since the detections now refer to independent lynx (i.e. residents plus dispersers, or adults plus sub-adults).

```
lynx_data<-lynx_data[,-which(names(lynx_data)=="Mother")]
lynx_data<-lynx_data[,-which(names(lynx_data)=="Year_Born")]
```

In order to automatise the computation of the sampling effort and assign the detections to a given sampling occasion, we need to define the beginning and the end of the session, as well as the length of the sampling occasions (in nights or days). This session started on 29 November 2013 at 12 o'clock, lasted for 60 consecutive nights; the length of a single encounter event was defined as five consecutive nights. In this frame, our data set consists of 12 consecutive sampling occasions with a length of 120 h in a single block.

```
start_date <- as.POSIXlt("2013-11-29 12:00:00",
    format="%Y-%m-%d %H:%M:%S", tz="Europe/Berlin")
end_date <- as.POSIXlt("2014-01-28 12:00:00",
    format="%Y-%m-%d %H:%M:%S", tz="Europe/Berlin")
length_occasion<-5
max_occasions<-as.numeric(difftime(end_date,
    start_date,unit='days')/length_occasion)
max_occasions
[1] 12
```

We can then create the table describing the sampling effort by calculating for each sampling occasion of five nights the proportion of trap nights accumulated by a camera trap site (1 if the site worked for five nights, 0.8 if it worked only for four, and so on until 0 if both camera traps at the given site did not work at all).

```
traps_table<-matrix(nrow=dim(sites)[1], ncol=max_occasions)
for (i in 1:dim(traps_table)[1]){
    for (j in 1:max_occasions){
        traps_table[i,j]<-sum(trap_nights[i,
            (2+length_occasion*(j-1)):(1+length_occasion*j)])/
            length_occasion}}
```

```
traps_table
            [,1]      [,2]      [,3]      [,4]      [,5]      ...       [,12]
    [1,]       1       1.0       1.0         1         1       ...          1
    [2,]       1       1.0       1.0         1         1       ...          1
    [3,]       1       0.4       0.2         1         1       ...          1
    [4,]       1       1.0       1.0         1         1       ...          1
    [5,]       1       1.0       1.0         1         1       ...          1
    ...
   [61,]       1       1.0       1.0         1         1       ...          1
```

Similarly, we can automatise the assignment of all the observations to the sampling occasions calculating the difference between the time of the photo and the previously defined start of the session. This time difference is divided by the five nights duration of the sampling occasion and increased by one unit. The function floor returns the largest integer not greater than the giving number, which finally corresponds to the calculated sampling occasion:

```
captures<-data.frame(SESSION=integer(), ANIMAL_ID=integer(),
    SO=integer(), LOC_ID=integer(), SEX=integer())

for (i in 1:dim(lynx_data)[1]){
    captures[i,"SESSION"]<-1
    captures[i,"LOC_ID"]<-sites[sites[,"Site"]==
        lynx_data$Site[i],"LOC_ID"]
    captures[i,"ANIMAL_ID"]<-lynx_data$Lynx_Name[i]
    captures[i,"SO"]<-floor(difftime(lynx_data$Time[i],
        start_date,units='days')/length_occasion)+1
    captures[i,"SEX"]<-lynx_data$Sex[i]
    if (captures[i,"SEX"]=="") captures[i,"SEX"]<-NA}

captures
```

	SESSION	ANIMAL_ID	SO	LOC_ID	SEX
1	1	B335	12	33	m
2	1	B335	12	33	m
3	1	B400	12	20	<NA>
4	1	EYWA	12	15	f
5	1	EYWA	12	15	f
...					
258	1	B261	1	24	m

Many different detectors can be specified in secr (see the secr overview manual), but principally only two are useful for camera trap studies: 'count' and 'proximity'. Basically, the first detector allows multiple detection events of each individual at a given site on any sampling occasion, whereas the second one restricts the number of detections to at most one. In other words, we have to choose if – within our sampling occasion of five days – we accept only one or eventually more detection events of each individual at a particular site. A 'count' detector is more likely to be affected by temporal autocorrelation between consecutive photographs of the same individual at the same site

than a 'proximity' detector. Therefore, before running the analyses, investigators should address questions about temporal resolution, namely what constitutes an independent record of the same individual at the same site (for more details on subsampling and temporal autocorrelation, refer to Chapter 5). For this case study, we use the 'proximity' type of detector and therefore reduce the dimension of our data set by deleting all the repeated observations of the same lynx within the same sampling occasion at a given site simply by means of the function unique. We then reassign the names of the rows from 1 to *n* by means of the function rownames in order to match the dimensionality of the data frame:

```
captures_prox<-unique(captures)
rownames(captures_prox)<-1:length(rownames(captures_prox))
captures_prox
```

	SESSION	ANIMAL_ID	SO	LOC_ID	SEX
1	1	B335	12	33	m
2	1	B400	12	20	<NA>
3	1	EYWA	12	15	f
4	1	MISO	12	10	m
5	1	LOKI	12	21	m
...					
124	1	LARY	1	58	m

We are now ready to create the input datasets for secr. First we create the traps object, which hold all the information about the array of detectors, their type and other additional information. We define a first traps object without any information about the sampling effort (traps_analysis_nousage), and then we integrate the table describing the sampling effort that we calculated previously in a second traps object (traps_analysis).

```
traps_analysis_nousage<-read.traps(data=sites[,c(1,3:4)],
    detector="proximity", binary.usage=FALSE)
summary(traps_analysis_nousage)
Object class        traps
Detector type       proximity
Detector number     61
Average spacing     2951.235 m
x-range             567321 618502 m
y-range             137586 173237 m
traps_analysis<-traps_analysis_nousage
usage(traps_analysis)<-traps_table
summary(traps_analysis)
Object class        traps
Detector type       proximity
Detector number     61
Average spacing     2951.235 m
```

```
x-range              567321 618502 m
y-range              137586 173237 m
```

```
Usage range by occasion
```

	1	2	3	4	5	6	7	8	9	10	11	12
min	1	0	0.2	1	1	1	1	1	1	1	1	0.6
max	1	1	1.0	1	1	1	1	1	1	1	1	1.0

Then we create the capthist object, merging the detections that we retained previously and the just-created 'traps' object. The capthist objects can additionally carry the covariates that the researcher will eventually test in the model (e.g. sex of individuals), and we therefore specify the gender of the lynx when known. The fact that there are missing values for the gender variable does not represent a major problem for the inference, because among the several ways to incorporate sex effects into models with secr, there is one (see below) that is able to deal with occasional missing values (refer to the secr user manual for possible approaches when the gender is known for all the individuals):

```
lynx_capthist <-make.capthist(captures_prox, traps_analysis,
    fmt="trapID", noccasions=max_occasions, covnames="SEX")
summary(lynx_capthist)
Object class     capthist
Detector type    proximity
Detector number  61
Average spacing  2951.235 m
x-range          567321 618502 m
y-range          137586 173237 m
```

```
Usage range by occasion
```

	1	2	3	4	5	6	7	8	9	10	11	12
min	1	0	0.2	1	1	1	1	1	1	1	1	0.6
max	1	1	1.0	1	1	1	1	1	1	1	1	1.0

```
Counts by occasion
```

	1	2	3	4	5	6	7	8	9	10	11	12	Total
n	9	5	8	9	9	7	9	5	10	11	7	7	96
u	9	2	4	3	1	2	0	0	1	0	0	1	23
f	5	2	3	3	2	2	4	2	0	0	0	0	23
M(t+1)	9	11	15	18	19	21	21	21	22	22	22	23	23
losses	0	0	0	0	0	0	0	0	0	0	0	0	0
detections	12	9	10	13	13	9	12	6	11	12	9	8	124
detectors visited	11	9	10	11	11	8	9	6	11	11	9	8	114
detectors used	61	60	61	61	61	61	61	61	61	61	61	61	731

The last object that needs to be created for a `secr` analysis is the mask to be applied to the array of the camera trap sites. The definition of this object is not strictly necessary for running the model, because it is possible to generate it implicitly by specifying an adequate buffer size with the argument `buffer` of the function `secr.fit`. However, it is recommended to create the mask separately by means of `make.mask` to provide greater control. This function allows different parameters of the state space grid (mask in `secr` terminology) to be defined, primarily: (i) its shape (argument `type`) – in this case the 'traprect' method is chosen, which constructs a grid of points in the rectangle formed by adding a buffer strip to the minimum and maximum *x,y* coordinates of the camera trap sites (Figure 7.1); (ii) the spacing between potential activity centres (argument `spacing`, in this case 1000 m; Figure 7.1); and (iii) its buffer width (`buffer`, in m). A buffer width that is too narrow is likely to produce inflated density estimates, hence it is critical to determine the buffer width beyond which the density estimates start to stabilise. Following Pesenti and Zimmermann (2013), we create a series of masks for 12 different buffer widths ranging from 1 to 30 km (1, 3, 5, 7, 9, 11, 13, 15, 17, 20, 25 and 30 km) on the smallest grid encompassing the camera trap sites in order to find the minimum buffer width for which the density estimates start to stabilise.

As with all SCR models, `secr` fits a detection function relating the probability of encounter or the expected number of encounters for an animal to the distance of a detector, in this case the camera trap site, from a point usually thought of as its activity or home range centre. In our case study we use the default 'halfnormal' function (commonly called the Gaussian model), which considers that the encounter probability is highest when the camera trap site is placed exactly at the animal's activity centre and declines as the distance between camera trap site and activity centre increases based on the kernel of a bivariate normal probability distribution function. Additional detection functions can be specified by means of the argument `detectfn` of the function `secr.fit` and can be found by calling the help function for the detection function:

```
?detectfn
```

Most of the basic detection functions available in `secr` contain at least two parameters: g_0, the baseline encounter probability (i.e. the encounter probability when the distance between the animal's activity centre and the trap is zero), and some kind of spatial scale parameter that is usually labelled σ. The meaning of this parameter depends on the specific detection model being used, and it should not be directly compared as a measure of home range size across models.

For this series of analyses we use the 'null model' formulation, which assumes constant values for animal density D, baseline encounter probability g_0 and parameter σ. The corresponding null model formulation in R is implemented specifying '~1' in the parameter list of the `model` argument in the `secr.fit` function.

For simplicity, we report only the first analysis with the 1 km buffer width. All the other buffer widths are investigated simply by changing the arguments of these two functions (for the extended script, refer to the supporting material for the present chapter):

```
mask_1 <-make.mask(traps_analysis, buffer=1000, type="traprec",
    spacing=1000)
M0_1 <-secr.fit(lynx_capthist, mask=mask_1, model = list(D~1,
    g0~1, sigma~1))
Checking data
Preparing detection design matrices
Preparing density design matrix
Finding initial parameter values...
Initial values  D = 0.00014, g0 = 0.18028, sigma = 3354.50837
Maximizing likelihood...
Eval        Loglik           D           g0          sigma
  1       -543.874      -8.8913      -1.5144         8.1181
  2       -543.874      -8.8913      -1.5144         8.1181
...
 80       -531.489      -8.9120      -2.0414         8.3848

Completed in 46.51 seconds at 12:42:29 01 nov. 2015
mask_3<- ...
```

A simple plot of the density estimates resulting from this series of null models suggests that the estimates are fairly stable with a buffer width ≥13 km (Figure 7.8). This value also lies within the range of the buffer width of 2–3σ that should be targeted as a rule of thumb according to Royle *et al.* (2014) to ensure that no individual animal outside of the area delimited by the corresponding mask has any probability of being detected by the camera traps in the array during the survey.

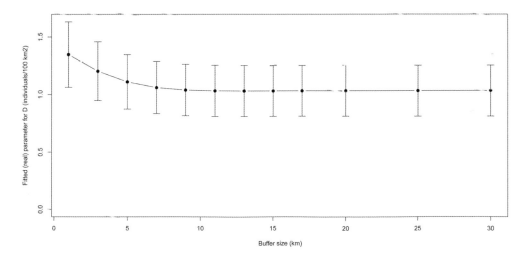

Figure 7.8 Estimated density (number of individuals per 100 km²) as a function of the mask buffer, based on a null model integrating the sampling effort.

We therefore retain this buffer width in the subsequent analyses:

```
mask_prox<-mask_13
summary(mask_prox)
Object class       mask
Mask type          traprect
Number of points   4774
Spacing m          1000
Cell area ha       100
Total area ha      477400
x-range m          554821 630821
y-range m          125086 186086

Bounding box
          x          y
1    554321    124586
2    631321    124586
4    631321    186586
3    554321    186586
```

The secr package easily fits a range of SCR equivalents of conventional capture–recapture models. The package has predefined versions of the classic model M_t where each occasion has its own encounter probability, denoted 't' in secr, as well as a linear trend in baseline encounter probability over occasions, denoted 'T'. The behavioural response can be either global (Gardner et al. 2010b) or local (Royle et al. 2011). The global trap response model (learned response in secr terminology) and the local trap response model (site-specific learned response in secr terminology) can be fitted in secr using formulae with 'b' and 'bk', respectively. The site-specific transient response model denoted 'Bk' is similar to the site-specific learned response, but only considers the location of the individual at the last occasion it was encountered. This model tests the hypothesis that lynx behaviour changes after being detected at a specific site, but only for that site and not for the duration of the survey. Additional model descriptions can be found in the secr manual or by calling the help function for models for detection parameters:

```
?secr.model.detection
```

We now run a series of analyses to investigate the effect of the predefined models on the baseline encounter probability g_0 while keeping the parameter σ constant:

```
M0 <-secr.fit(lynx_capthist, mask=mask_prox,
    model = list(D~1, g0~1, sigma~1))

Mb <-secr.fit(lynx_capthist, mask=mask_prox,
    model = list(D~1, g0~b, sigma~1))

Mt <-secr.fit(lynx_capthist, mask=mask_prox,
    model = list(D~1, g0~t, sigma~1))

Mbt <-secr.fit(lynx_capthist, mask=mask_prox,
    model = list(D~1, g0~b+t, sigma~1))
```

```
MT <-secr.fit(lynx_capthist, mask=mask_prox,
    model = list(D~1, g0~T, sigma~1))

MB <-secr.fit(lynx_capthist, mask=mask_prox,
    model = list(D~1, g0~B, sigma~1))

Mbk <-secr.fit(lynx_capthist, mask=mask_prox,
    model = list(D~1, g0~bk, sigma~1))

MBk <-secr.fit(lynx_capthist, mask=mask_prox,
    model = list(D~1, g0~Bk, sigma~1))

MK <-secr.fit(lynx_capthist, mask=mask_prox,
    model = list(D~1, g0~K, sigma~1))

MK_NM <-secr.fit(lynx_capthist, mask=mask_prox,
    model = list(D~1, g0~K, sigma~1),method="Nelder-Mead")

Mk <-secr.fit(lynx_capthist, mask=mask_prox,
    model = list(D~1, g0~k, sigma~1))

Mh2 <-secr.fit(lynx_capthist, mask=mask_prox,
    model = list(D~1, g0~h2, sigma~1))

Mh2_NM <-secr.fit(lynx_capthist, mask=mask_prox,
    model = list(D~1, g0~h2, sigma~1),method="Nelder-Mead")

Mh2_NM_SL <-secr.fit(lynx_capthist, mask=mask_prox,
    model = list(D~1, g0~h2, sigma~1),method="Nelder-Mead",
    start=list(D=0.00012,g0=0.24,sigma=3200))

Mh2_NM_SM0 <-secr.fit(lynx_capthist, mask=mask_prox,
    model = list(D~1, g0~h2, sigma~1),
    method="Nelder-Mead",start=M0)
```

We encounter problems fitting M_K and the finite mixture model (M_{h2}). While model M_K could be fitted by setting the method to 'Nelder–Mead', which is less prone to settling in local minima than the default 'Newton–Raphson', M_{h2} could not be fitted properly with this method even when providing starting values (see 'Troubleshooting' in the secr manual). The final result was, however, good enough to include M_{h2} in the comparison of models when the non-nested model M_0 (M_{h2} models have the additional real parameter pmix) was offered in the start 'argument'. Finite and hybrid mixture models are prone to fitting problems caused by multimodality of the likelihood. There is the risk that the numerical maximisation algorithm will get stuck on a local peak, in which case the estimates are simply wrong. Care is needed as the problem has not been explored fully for secr models (Efford 2014).

Following Royle *et al.* (2014), we use the AIC because it is not clear what the effective sample size is for most capture–recapture problems. Models are compared by means of the delta AIC (Δ_i). As a rule of thumb, a $\Delta_i < 2$ suggests substantial evidence for the model, values between 3 and 7 indicate that the model has considerably less support, whereas a $\Delta_i > 10$ indicates that the model is very unlikely (Burnham and Anderson 2002).

```
AIC(M0,Mb,Mt,Mbt,MT,MB,Mbk,MBk,MK_NM,Mk,Mh2_NM_SM0,
    criterion="AIC")
```

	Model	detectfn	npar	logLik	AIC	AICc	dAIC	AICwt
Mbk	D~1 g0~bk sigma~1	halfnormal	4	-528.5525	1065.105	1067.327	0.000	0.8346
MBk	D~1 g0~Bk sigma~1	halfnormal	4	-530.6484	1069.297	1071.519	4.192	0.1026
MB	D~1 g0~B sigma~1	halfnormal	4	-531.6720	1071.344	1073.566	6.239	0.0369
Mk	D~1 g0~k sigma~1	halfnormal	4	-532.4606	1072.921	1075.143	7.816	0.0168
M0	D~1 g0~1 sigma~1	halfnormal	3	-534.0645	1074.129	1075.392	9.024	0.0092
Mh2_NM_SM0	D~1 g0~h2 sigma~1 pmix~h2	halfnormal	5	-532.5812	1075.162	1078.692	10.057	0.0000
MT	D~1 g0~T sigma~1	halfnormal	4	-533.6885	1075.377	1077.599	10.272	0.0000
MK_NM	D~1 g0~K sigma~1	halfnormal	4	-533.9663	1075.933	1078.155	10.828	0.0000
Mb	D~1 g0~b sigma~1	halfnormal	4	-534.0220	1076.044	1078.266	10.939	0.0000
Mt	D~1 g0~t sigma~1	halfnormal	14	-531.3163	1090.633	1143.133	25.528	0.0000
Mbt	D~1 g0~b + t sigma~1	halfnormal	15	-531.2988	1092.598	1161.169	27.493	0.0000

Model selection reveals substantial evidence for the 'site-specific learned response' model M_{bk}. The two subsequent models, M_{Bk} and M_B with Δ_i of 4.192 and 6.239, respectively, have considerably less support. The 'site-specific learned response' model incorporates a site-sensitive change of behaviour for individuals after first detection, which implies that if an individual is captured in a specific camera trap site, the probability of a subsequent encounter is increased (i.e. the individual becomes 'trap happy') or decreased (i.e. the individual becomes 'trap shy') only for that particular camera trap site; secr provides estimates in units of individuals/hectare, and we thus need to multiply the given estimates by 10^4 in order to have our estimate as individuals/100 km^2. The estimated density (SE) from this model corresponds to 1.05 (0.23) independent lynx per 100 km^2, with baseline encounter probability g_0 (SE) 0.082 (0.015) and sigma σ (SE) 4,736 (336) m. In situations where an individual has the tendency to revisit a camera trap site subsequent to its initial visit (i.e. is 'trap happy'), as in the present study, the encounter probability is overestimated by the null model and is properly adjusted downward when a behavioural response is added to the model (0.117 vs. 0.082), yielding a corresponding increase in the estimated density (1.03 vs. 1.05 independent lynx per 100 km^2). A much more strongly positive site-specific learned response was found in a wolverine (*Gulo gulo*) SCR density estimation study using baited traps (Royle *et al.* 2011). Contrary to the wolverine study, our result may seem surprising as the camera trap sites were not baited. Moreover, we would have tended to have expected trap shyness given that lynx tracks bypassing camera trap sites are sometimes found in the snow (although this would only result in trap shyness if the individual avoiding the trap site had previously been detected at this site). Trap shyness has been documented in tiger (*Panthera tigris*) by Wegge *et al.* (2004): tigers became trap shy probably because of pad impressions, which provided a cue for the tigers about the presence of camera traps in front of their travel path. Hence, a possible explanation for the slight tendency for an individual to revisit a camera trap site subsequent to its initial visit as observed in this case study may be that

in a mountainous landscape such as the Alps, where animal movements are channelled by topographical features, individual lynx have a higher chance of being encountered and subsequently re-encountered at a particular camera trap site within their territory, especially if it is placed at a forced passage at the entrance of a valley regularly used by the lynx. An additional and complementary explanation is that an individual might have killed a larger prey in the vicinity of a camera trap site. This was corroborated during this session by a photograph showing male B333 dragging the carcass of a chamois, which it has just killed, along the trail passing by the camera trap site. As lynx usually feed for several nights (up to seven consecutive nights) on a kill (Jobin *et al.* 2000), they have a higher chance of being re-encountered at a given site while moving between the day lair and the kill site.

The function `region.N` is used to produce estimates of N for any given region. In the example here we generate expected (`E.N`) and realised (`R.N`) population sizes in the region delimited by the `mask_prox` by passing the best spatial model (M_{bk}) and the mask of inference to the function `region.N`. The area of the `mask_prox` is 4,774 km^2 and was obtained previously by typing `summary(mask_prox)`.

```
region.N(Mbk, region=mask_prox)

      estimate  SE.estimate        lcl        ucl     n
E.N   49.89757    10.812700   32.78972   75.93133    23
R.N   49.89757     8.186387   38.00936   71.20186    23
```

The realised N is simply the number of individuals actually detected plus a model-based estimate of the number of individuals in the region of interest that remain undetected (Johnson *et al.* 2010). The probability of remaining undetected is a function of location (high at the edges, low near detectors). The expected N is the integral (sum) over the mask of the product of (estimated) local density and the local probability of remaining undetected. The estimates of expected and realised N are generally very similar, or identical, but realised N usually has lower estimated variance, especially if the n detected animals comprise a large fraction (Efford 2015).

There are differences in movement patterns between male and female lynx: resident adult males have larger home ranges than females (Breitenmoser-Würsten *et al.* 2001), and adult males regularly patrol their territory borders, to deposit scent marks, to defend their territory against potential intruders, and during the mating season to find potential mates (Breitenmoser and Breitenmoser-Würsten 2008). For these reasons, we expect differences between the sexes in the baseline encounter probability (g_0) and the parameter σ. We therefore investigate the effect of sex on the detection function parameters g_0 and σ using the null and the best model (M_{bk}) of the previous analysis in order to check which model best explains our data. Because gender was missing for some individuals, the argument `hcov` in `secr.fit` is used to fit a hybrid mixture model (Efford 2015). 'Hybrid' refers to a flexible combination of latent classes (as for finite mixtures) and known classes (as for classic categorical covariates). A hybrid mixture model automatically estimates the parameter 'pmix', which corresponds to the mixing proportion of the different classes and additionally allows more complex model structures in which the detection parameters can be modelled as class specific (~h2). This is particularly useful for investigating sex ratios and sex differences in detection. The argument `hcov="SEX"` identifies in the corresponding column the individual covariate that should be a factor with two levels, or contain character values that will be coerced to a factor (e.g. 'female',

'male'). Missing values (NA) are used for individuals of unknown class. It is assumed that males and females are equally likely to be sexed from photographs. Models can be compared by means of AIC provided they all have the same hcov covariate in the call to secr.fit, whether or not the h2 notation appears in the model formulation:

```
M_g0bk_sigma<-secr.fit(lynx_capthist, mask=mask_prox,
    model = list(D~1, g0~bk, sigma~1), hcov="SEX")
M_g0sex_sigmasex<-secr.fit(lynx_capthist, mask=mask_prox,
    model = list(D~1, g0~h2, sigma~h2), hcov="SEX")
M_g0_sigmasex<-secr.fit(lynx_capthist, mask=mask_prox,
    model = list(D~1, g0~1, sigma~h2), hcov="SEX")
M_g0bk_sigmasex<-secr.fit(lynx_capthist, mask=mask_prox,
    model = list(D~1, g0~bk, sigma~h2), hcov="SEX")
M_g0bksex_sigma<-secr.fit(lynx_capthist, mask=mask_prox,
    model = list(D~1, g0~(bk+h2), sigma~1), hcov="SEX")
M_g0bksex_sigmasex<-secr.fit(lynx_capthist, mask=mask_prox,
    model = list(D~1, g0~(bk+h2), sigma~h2), hcov="SEX")
AIC(M_g0_sigmasex,M_g0sex_sigmasex,M_g0bk_sigma,
    M_g0bk_sigmasex,M_g0bksex_sigma,M_g0bksex_sigmasex,
    criterion="AIC")
```

	model	detectfn	npar	logLik	AIC	AICc	dAIC	AICwt
M_g0bk_ sigmasex	D~1 g0~bk sigma~h2 pmix~h2	halfnormal	6	-533.6145	1079.229	1084.479	0.000	0.6331
M_g0bksex_ sigmasex	D~1 g0~(bk + h2) sigma~h2 pmix~h2	halfnormal	7	-533.3252	1080.650	1088.117	1.421	0.3111
M_g0_ sigmasex	D~1 g0~1 sigma~h2 pmix~h2	halfnormal	5	-537.8293	1085.659	1089.188	6.430	0.0254
M_g0sex_ sigmasex	D~1 g0~h2 sigma~h2 pmix~h2	halfnormal	6	-537.1542	1086.308	1091.558	7.079	0.0184
M_g0bksex_ sigma	D~1 g0~(bk + h2) sigma~1 pmix~h2	halfnormal	6	-538.0351	1088.070	1093.320	8.841	0.0076
M_g0bk_ sigma	D~1 g0~bk sigma~1 pmix~h2	halfnormal	5	-539.5898	1089.180	1092.709	9.951	0.0044

From the six models we created in secr, the model incorporating the site-specific learned response in the baseline encounter probability g_0 and gender in σ is the best model. This is just a bit better than a model incorporating gender in the baseline encounter probability, in addition to the covariates already included in the best model. Following the rule of thumb of Burnham and Anderson (2002) we apply model averaging to the models with $\Delta_i < 2$:

```
model.average(M_g0bk_sigmasex,M_g0bksex_sigmasex,criterion="AIC")

, , D
                             estimate     SE.estimate           lcl             ucl
session=1,h2=f,bk=0    0.0001110802    2.461561e-05    7.232106e-05    0.0001706117
session=1,h2=m,bk=0    0.0001110802    2.461561e-05    7.232106e-05    0.0001706117

, , g0
                             estimate     SE.estimate           lcl             ucl
session=1,h2=f,bk=0      0.09908719       0.0282833      0.05580921       0.1698871
session=1,h2=m,bk=0      0.08978829      0.01697338      0.06161362       0.1290745

, , sigma
                             estimate     SE.estimate           lcl             ucl
session=1,h2=f,bk=0        3294.873        402.8715        2595.054        4183.417
session=1,h2=m,bk=0        5138.317        407.2987        4400.017        6000.499

, , pmix
                             estimate     SE.estimate           lcl             ucl
session=1,h2=f,bk=0        0.463887        0.128176       0.2396034       0.7037975
session=1,h2=m,bk=0        0.536113        0.128176       0.2962025       0.7603966
```

Model averaging yields a density estimate (SE) of 1.11 (0.25) individuals per 100 km^2 with baseline encounter probability g_0 (SE) 0.090 (0.017) and 0.099 (0.028) and σ (SE) 5,138 (407) m and 3,295 (403) m for males and females, respectively. As expected, males have a significantly larger σ than females. However, their baseline encounter probability g_0 is slightly lower, but not significantly, compared to females. The estimated sex ratio (SE) of 0.54 (0.13) is slightly skewed towards males, but with a 95% confidence interval (95% CI) including 0.5 does not diverge significantly from a 1:1 ratio. Model-averaged density is almost equal to the one provided by the previous best model M_{bk} (labelled `M_g0bk_sigma` according to the new mixture parameterisation), now ranked in sixth and last position with an estimated density of 1.05 (0.23) individuals per 100 km^2.

In the previous examples, we considered all potential lynx activity centres of the mask, whether in suitable or unsuitable lynx habitats. However, in `secr` it is possible to create a habitat mask that can eliminate all potential activity centres falling in non-lynx habitats and which should not be considered in the analyses. In this example we use a previously developed lynx habitat suitability model (Zimmermann 2004) with cut-off point of >20 for habitat suitability (habitat suitability ranges from 0 = unsuitable to 100 = highly suitable habitat) to discriminate suitable habitat fragments of orthogonally connected suitable habitat 1 × 1 km cells in the GIS ArcGis 10.1. Knowing that excluding habitats/areas potentially used by individuals during their movements can potentially bias estimates because this imposes constraints on space usage, we selected a cut-off point to exclude the highly unsuitable areas. These included settlements, intensively used agriculture areas, lakes, large rivers and high mountains peaks above 2,000 m that are not used by resident lynx. We consider only the regions available to resident lynx in our sampling area and thus restrict suitable habitats to the fragment containing the camera trap sites within the state space (dark green area in Figure 7.1). In `secr` the polygon (argument `poly` of the function `make.mask`) may either be a matrix or data frame of two

columns interpreted as *x* and *y* coordinates, or a `SpatialPolygonsDataFrame` object. Here we opt for the latter and create the shapefile 'suitable_habitat_secr' by intersecting the shapefile delimiting the `mask_prox` with the shapefile of the suitable lynx habitat fragment containing the camera trap sites in the GIS. The resulting shapefile is then imported into R via the function `readShapePoly` of the package `maptools`. The habitat mask can be easily created with `make.mask()`.

```
library(maptools)
HabitatPol <- readShapePoly("suitable_habitat_secr")
habitat_mask <- make.mask(traps_analysis, spacing=1000,
    type="polygon", poly = HabitatPol)
```

Before running further analyses it is useful to draw a map in R (see Figure 7.9) in order to figure out whether the camera trap sites, the potential activity centres and the shapefile of the polygon delimiting the suitable lynx habitat are correctly located relative to each other and if all camera trap sites are within the boundaries of the suitable lynx habitat:

```
plot(HabitatPol, axes=F)
plot(habitat_mask, pch=20, add=T)
points(traps_analysis[,"x"], traps_analysis[,"y"], pch=20,
    bg=grey(1), col='black')
```

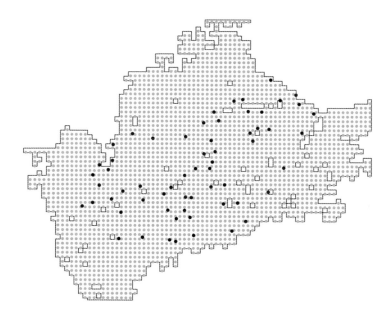

Figure 7.9 Map showing the extent of the shapefile delimiting the suitable lynx habitat (polygon), the potential 1 × 1 km spaced activity centres (grey dots) and the camera trap sites (black dots).

We now provide density estimates considering only the potential activity centres lying in lynx habitats in the analyses for the same models as considered in the previous example without the habitat mask:

```
M_g0bk_sigma_habitat<-secr.fit(lynx_capthist, mask=habitat_mask,
    model = list(D~1, g0~bk, sigma~1), hcov="SEX")
M_g0sex_sigmasex_habitat<-secr.fit(lynx_capthist,
    mask=habitat_mask, model = list(D~1, g0~h2, sigma~h2),
    hcov="SEX")
M_g0_sigmasex_habitat<-secr.fit(lynx_capthist, mask=habitat_mask,
    model = list(D~1, g0~1, sigma~h2), hcov="SEX")
M_g0bk_sigmasex_habitat<-secr.fit(lynx_capthist,
    mask=habitat_mask, model = list(D~1, g0~bk, sigma~h2),
    hcov="SEX")
M_g0bksex_sigma_habitat<-secr.fit(lynx_capthist,
    mask=habitat_mask, model = list(D~1, g0~(bk+h2), sigma~1),
    hcov="SEX")
M_g0bksex_sigmasex_habitat<-secr.fit(lynx_capthist,
    mask=habitat_mask, model = list(D~1, g0~(bk+h2), sigma~h2),
    hcov="SEX")
AIC(M_g0bk_sigma_habitat, M_g0sex_sigmasex_habitat, M_g0_
    sigmasex_habitat, M_g0bk_sigmasex_habitat,
    M_g0bksex_sigma_habitat, M_g0bksex_sigmasex_habitat,
    criterion="AIC")
```

	model	detectfn	npar	logLik	AIC	AICc	dAIC	AICwt
M_g0bk_ sigmasex_ habitat	D~1 g0~bk sigma~h2 pmix~h2	halfnormal	6	-533.0841	1078.168	1083.418	0.000	0.6407
M_g0bksex_ sigmasex_ habitat	D~1 g0~(bk + h2) sigma~h2 pmix~h2	halfnormal	7	-532.8438	1079.688	1087.154	1.520	0.2996
M_g0_ sigmasex_ habitat	D~1 g0~1 sigma~h2 pmix~h2	halfnormal	5	-537.2463	1084.493	1088.022	6.325	0.0271
M_g0sex_ sigmasex_ habitat	D~1 g0~h2 sigma~h2 pmix~h2	halfnormal	6	-536.6353	1085.271	1090.521	7.103	0.0184
M_g0bksex_ sigma_ habitat	D~1 g0~(bk + h2) sigma~1 pmix~h2	halfnormal	6	-537.3253	1086.651	1091.901	8.483	0.0092
M_g0bk_ sigma_ habitat	D~1 g0~bk sigma~1 pmix~h2	halfnormal	5	-538.9503	1087.901	1091.430	9.733	0.0049

The model ranks and the two competing models (`M_g0bk_sigmasex_habitat` and `M_g0bksex_sigmasex_habitat`) are the same as when models without the habitat mask were compared, though this must not always be the case (e.g. wolverine example, Royle *et al.* 2014, p. 223). Following the same procedure as before, we use model averaging to obtain unbiased parameter estimates:

```
model.average(M_g0bk_sigmasex_habitat,
    M_g0bksex_sigmasex_habitat,criterion="AIC")

, , D

                        estimate    SE.estimate           lcl           ucl
session=1,h2=f,bk=0  0.0001366614   2.96208e-05  8.979762e-05  0.0002079826
session=1,h2=m,bk=0  0.0001366614   2.96208e-05  8.979762e-05  0.0002079826

, , g0

                      estimate    SE.estimate         lcl           ucl
session=1,h2=f,bk=0  0.0960229    0.02649511   0.05517626     0.1619257
session=1,h2=m,bk=0  0.0880606    0.01670815   0.06035088     0.1267765

, , sigma

                     estimate    SE.estimate         lcl           ucl
session=1,h2=f,bk=0  3316.177     409.1837     2606.180      4219.599
session=1,h2=m,bk=0  5122.202     404.8148     4388.233      5978.932

, , pmix

                      estimate    SE.estimate         lcl           ucl
session=1,h2=f,bk=0  0.4582249    0.1262985    0.237830      0.696277
session=1,h2=m,bk=0  0.5417751    0.1262985    0.303723      0.762170
```

Model-averaged density (SE) corresponds to 1.37 (0.30) individuals per 100 km^2 of suitable habitat, with averaged baseline encounter probability g_0 (SE) 0.088 (0.017) and 0.096 (0.026) and averaged σ (SE) 5,122 (405) m and 3,316 (409) m for males and females, respectively. As previously, males have significantly larger σ than females and their baseline encounter probability g_0 is slightly lower, but not significantly, compared to females. The averaged resulting sex ratio (SE) of 0.54 (0.13) is slightly skewed towards males, but with a 95% CI including 0.5 does not diverge significantly from a 1:1 ratio.

7.4.4 Abundance and density estimation in conventional (i.e. non-spatial) capture–recapture models

For the purpose of comparing our results with earlier studies, we also present estimates based on conventional capture–recapture models. The statistical test for population closure of Stanley and Burnham (1999) is conducted with the program CloseTest 3 (Stanley and Richards 2005) and with $P = 0.20$ supports our assumption that the sampled population is closed ($P > 0.05$) for the study interval. We use the software MARK 5.1 (White and Burnham 1999) to estimate lynx abundance. The module CAPTURE tests

several models that differ in their assumed sources of variation in encounter probability, including: constant encounter probability (M_0); variation among individuals (M_h); variation across occasions (M_t); and responses to previous encounters (M_b). It selects the 'best' model from a set of eight closed-population models $(M_0, M_h, M_t, M_b, M_{bh}, M_{th}, M_{tb}$ and M_{tbh}; Otis *et al.* 1978). The overall model selection function scores potential models between 0.0 and 1.0, with a higher score indicating a better relative fit of the model to the specific encounter history data generated by the survey. The heterogeneity model M_h with a score of 1.0 fit our data best. Using the jackknife estimator, the module CAPTURE in MARK estimates the population size (SE) at 25 (3.41) independent lynx, with average encounter probability per sampling occasion of 0.32, yielding a density (SE) of 1.29 (0.19) independent lynx per 100 km² when a buffer (SE) of 5,829 (664) m based on 1/2MMDM is added to the polygon delimiting the most peripheral camera trap sites (Figure 7.1). The calculation of 1/2MMDM is provided in the sheet 'distance Pythagoras calculation' in the Excel file 'NWA_2013_14_Lynx_encounter_histories.xls'. Following Karanth and Nichols (1998), we use the delta method to calculate the variance of the density estimates. The formula is provided in the sheet 'options' in the same Excel file. When only the suitable lynx habitat within the area effectively sampled (polygon plus buffer) is considered, the resulting density (SE) is 1.49 (0.22) independent lynx per 100 km² suitable habitat.

7.5 Conclusions

This chapter has addressed the use of camera trapping to estimate the abundance and density of species with natural marks using spatially explicit and conventional capture–recapture models. We first explained that a monitoring programme for abundance estimation should be tuned to the larger conservation programme that those estimates are intended to serve (Nichols 2014). Then, we describe the steps to select an appropriate sampling area. After that, we discussed survey design considerations (i.e. season, survey duration and spatial sampling) and model assumptions (demographic and geographic closure) of conventional (i.e. non-spatial) capture–recapture and SCR models. Because the latter consider animal movement explicitly (through the parameter σ), they circumvent the problem of estimating the area effectively sampled (inherent to the conventional capture–recapture models) and allow for the estimation of quantities other than density, such as home range size and space usage (Royle *et al.* 2014). In addition, SCR models are able to make predictions across unobserved distances, even to non-sampled areas. This allows for completely new and much more flexible study designs when compared to conventional capture–recapture models. Moreover, SCR models work well in study areas similar in size to the home range of an individual, which makes them particularly suitable for species with large home ranges occurring at low densities (Sollmann *et al.* 2012). However, these results should not encourage investigators to choose suboptimal sampling strategies (Royle *et al.* 2014). Large amounts of data in terms of number of individuals detected and numbers of re-encounters do not only improve the precision of parameter estimates (Sollmann *et al.* 2012) but also allow for the inclusion of potentially important covariates (e.g. sex and behaviour effects) in SCR models as illustrated by the Eurasian lynx case study. We also stressed that compared to conventional (i.e. non-spatial) capture–recapture models a number of assumptions are relaxed in SCR models. These models also allow these assumptions to be extended in many different ways, e.g. to handle open populations (Royle *et al.* 2014).

In the case study of Eurasian lynx abundance and density estimation, we highlighted that it is important to track the sampling effort and number of different lynx detected over the course of the sampling and not only at the end. This enables us to recognise if the survey is running properly and potentially modify it. We then showed how to prepare the different input files for secr and fit different likelihood-based SCR models with and without covariates on the baseline encounter probability g_0 and the parameter σ. Furthermore, we explained how to construct a mask in order to provide density estimates that take into account only suitable lynx habitats. We finally provided density estimates for all habitats and suitable lynx habitats only using the SCR and conventional capture–recapture models.

The ongoing development of SCR modelling is not merely an extension of previous approaches but also provides a flexible framework for making ecological processes explicit in models of individual encounter history data, and for studying spatial processes such as individual movement, resource selection, space usage, population dynamics and density (Royle *et al.* 2014).

Appendices

Appendix 7.1 NWA 2013_2014_eff_trap_nights.xls (accumulated trap nights by camera traps and sites)

Appendix 7.2 NWA_2013_14_Lynx_encounter_histories.xls (number of different individuals and cumulative encounters)

Appendix 7.3 Dates and times in R.R (R script used for the data preparation)

Appendix 7.4 Lynx_data.txt (dataset containing all the photographs of lynx taken in our study area)

Appendix 7.5 Sites.txt (table with the coordinates of all sites)

Appendix 7.6 Trapnights.txt (table about the trap deployment details)

Appendix 7.7 suitable_habitat_secr.zip (shapefile of the suitable lynx habitat)

Appendix 7.8 Chapter 7.R (R script for running all the analyses with the package secr)

Appendix 7.9 Chapter_7.RData (R file containing the results)

Acknowledgements

We are grateful to Simone Tenan and Francesco Rovero for valuable comments on previous versions of this chapter, Murray Efford for his help regarding some issues with the R package secr and Brett McClintock for providing useful information regarding methods of analysis that account for misidentifications and bilateral photo-identification.

References

Ancrenaz, M., Hearn, A.J., Ross, J., Sollmann R. and Witting, A. (2012) *Handbook for Wildlife Monitoring Using Camera-traps*. BBEC II Secretariat, c/o Natural Resources Office, Chief Minister's Department, Kota Kinabalu, Sabah, Malaysia.

Ariefiandy, A., Purwandana, D., Seno, A., Ciofi, C. and Jessop, T.S. (2013) Can camera traps monitor Komodo Dragons a large ectothermic predator? *PLoS ONE* 8: e58800.

Balme, G., Hunter, L. and Robinson, H. (2014) Baited camera-trap surveys – marginally more precise but at what cost? A response to du Preez *et al.* (2014). *Biological Conservation* 179: 144–145.

Barber-Meyer, S.M., Jnawali, S.R., Karki, J.B., Khanal, P., Lohani, S., Long, B., MacKenzie, D.I., Pandav, B., Pradhan, N.M.B., Shrestha, R., Subedi, N., Thapa, G., Thapa, K. and Wikramanayake, E. (2013) Influence of prey depletion and human disturbance on tiger occupancy in Nepal. *Journal of Zoology* 289: 10–18.

Bashir, T., Bhattacharya, T., Poudyal, K., Sathyakumar, S. and Qureshi, Q. (2013) Estimating leopard cat *Prionailurus bengalensis* densities using photographic captures and recaptures. *Wildlife Biology* 19: 462–472.

Bendik, N.F., Morrison, T.A., Gluesenkamp, A.G., Sanders, M.S. and O'Donnell, L.J. (2013) Computer-assisted photo identification outperforms visible implant elastomers in an endangered salamander, *Eurycea tonkawae*. *PLoS ONE* 8: e59424.

Bolger, D.T., Morrison, T.A., Vance, B., Lee, D. and Farid, H. (2012) A computer-assisted system for photographic mark–recapture analysis. *Methods in Ecology and Evolution* 3: 813–822.

Bondrup-Nielsen, S. (1983) Density estimation as a function of live-trapping grid and home range size. *Canadian Journal of Zoology* 61: 2361–2365.

Borchers, D.L., Buckland, S.T. and Zucchini, W. (2002) *Estimating Animal Abundance: Close Populations*. London: Springer.

Borchers, D., Distiller, G., Foster, R., Harmsen, B. and Milazzo, L. (2014) Continuous-time spatially explicit capture–recapture models, with an application to a jaguar camera-trap survey. *Methods in Ecology and Evolution* 5: 656–665.

Braczkowski, A. (2013) *The susceptibility of leopards* (Panthera pardus) *to trophy hunting*. MSc thesis, University of Oxford.

Breitenmoser, U. and Breitenmoser-Würsten, C. (2008) *Der Luchs: Ein Grossraubtier in der Kulturlandschaft*. Wohlen Bern: Salm Verlag (in German).

Breitenmoser-Würsten, C., Zimmermann, F., Ryser, A., Capt, S., Laass, J., Siegenthaler, A. and Breitenmoser, U. (2001) *Untersuchungen zur Luchspopulation in den Nordwestalpen der Schweiz 1997–2000*. KORA-Report 9. pp. 88 (in German; summary, tables and figures in English and French).

Burnham, K.P. and Anderson, D.R. (2002) *Model Selection and Multimodel Inference: A Practical Information-theoretic Approach*, 2nd edn. New York: Springer.

Carbone, C., Christie, S., Conforti, K., Coulson, T., Franklin, N., Ginsberg, J.R., Griffiths, M., Holden, J., Kawanishi, K., Kinnaird, M., Laidlaw, R., Lynam, A., Macdonald, D.W., Martyr, D., McDougal, C., Nath, L., O'Brien, T., Seidensticker, J., Smith, D.J.L., Sunquist, M., Tilson, R. and Wan Shahruddin, W.N. (2001) The use of photographic rates to estimate densities of tigers and other cryptic mammals. *Animal Conservation* 4: 75–79.

Chandler, R.B. and Royle, A.J. (2013) Spatially-explicit models for inference about density in unmarked populations. *Annals of Applied Statistics* 7: 936–954.

Chandler, R.B. and Clark, J.D. (2014) Spatially explicit integrated population models. *Methods in Ecology and Evolution* 5: 1351–1360.

Cochran, W.G. (1977) *Sampling Techniques*, 3rd edn. New York: John Wiley.

Dillon, A. and Kelly, M.J. (2007) Ocelot activity, trap success and density in Belize: the impact of trap spacing and animal movement on density estimates. *Oryx* 41: 469–477.

Dillon, A. and Kelly, M.J. (2008) Ocelot home range, overlap and density: comparing radio-telemetry with camera-trapping. *Journal of Zoology* 275: 391–398.

du Preez, B.D, Loveridge, A.J. and Macdonald, D.W. (2014) To bait or not to bait: a comparison of camera-trapping methods for estimating leopard *Panthera pardus* density. *Biological Conservation* 176: 153–161.

Efford, M.G. (2004) Density estimation in live-trapping studies. *Oikos* 10: 598–610.

Efford, M.G. (2014) Finite mixture models in 'secr' 2.9. SECR in R http://www.otago.ac.nz/density/SECRinR.html

Efford, M.G. (2015) Package 'secr'. The comprehensive R archive network http://cran.r-project.org/

Efford, M.G. and Fewster, R.M. (2013) Estimating population size by spatially explicit capture–recapture. *Oikos* 122: 918–928.

Efford, M.G., Warburton, B., Coleman, M.C. and Barker, R.J. (2005) A field test of two methods for density estimation. *Wildlife Society Bulletin* 33: 731–738.

Efford, M.G., Borchers, D.L. and Byrom, A.E. (2009) Density estimation by spatially explicit capture–recapture: likelihood-based methods. In: D.L. Thomson, E.G. Cooch and M.J. Conroy (eds), *Modeling Demographic Processes in Marked Populations*. New York: Springer. pp. 255–269.

Ergon, T. and Gardner, B. (2014) Separating mortality and emigration: modelling space use, dispersal and survival with robust-design spatial capture–recapture data. *Methods in Ecology and Evolution* 5: 1327–1336.

Foster, R.J. and Harmsen, B.J. (2011) A critique of density estimation from camera-trap data. *Journal of Wildlife Management* 76: 224–236.

Gardner, B., Reppucci, J., Lucherini, M. and Royle, J.A. (2010a) Spatially explicit inference for open populations: estimating demographic parameters from camera-trap studies. *Ecology* 91: 3376–3383.

Gardner, B., Royle, J.A., Wegan, M. T., Rainbolt, R.E. and Curtis, P.D. (2010b) Estimating black bear density using DNA data from hair snares. *Journal of Wildlife Management* 74: 318–325.

Garrote, G., Perez de Ayala, R., Pereira, P., Robles, F., Guzman, N., García, F., Iglesias, M.C., Hervás, J., Fajardo, I., Simón, M. and Barroso, J.L. (2011) Estimation of the Iberian lynx (*Lynx pardinus*) population in the Doñana area, SW Spain, using capture–recapture analysis of camera-trapping data. *European Journal of Wildlife Research* 57: 355–362.

Garrote, G., Gil-Sánchez, J.M., McCain, E.B., de Lillo, S., Tellería, J.L. and Simón, M.A. (2012) The effect of attractant lures in camera trapping: a case study of population estimates for the Iberian lynx (*Lynx pardinus*). *European Journal of Wildlife Research* 58: 881–884.

Gerber, B., Karpanty, S.M., Crawford, C., Kotschwar, M. and Randrianantenaina, J. (2010) An assessment of carnivore relative abundance and density in the eastern rainforests of Madagascar using remotely-triggered camera traps. *Oryx* 44: 219–222.

Gerber, B.D., Karpanty, S.M. and Kelly, M.J. (2012) Evaluating the potential biases in carnivore capture–recapture studies associated with the use of lure and varying density estimation techniques using photographic-sampling data of the Malagasy civet. *Population Ecology* 54: 43–54.

Gopalaswamy, A.M., Royle, J.A., Hines, J.E., Singh, P., Jathanna, D., Kumar, N.S. and Karanth, K.U. (2012) Program SPACECAP: software for estimating animal density using spatially explicit capture-recapture models. *Methods in Ecology and Evolution* 3: 1067–1072.

Goswami, V.R., Lauretta, M.V., Madhusudan, M.D. and Karanth, K.U. (2012) Optimizing individual identification and survey effort for photographic capture–recapture sampling of species with temporally variable morphological traits. *Animal Conservation* 15: 174–183.

Harihar, A., Ghosh, M., Fernandes, M., Pandav, B. and Goyal, S.P. (2010) Use of photographic capture–recapture sampling to estimate density of striped hyena (*Hyaena hyaena*): implications for conservation. *Mammalia* 74: 83–87.

Hedges, L., Lam, W.Y., Campos-Arceiz, A., Rayan, D.M., Laurance, W.F., Latham, C.J., Saaban, S. and Clements, G.R. (2015) Melanistic leopards reveal their spots: infrared camera traps provide a population density estimate of leopards in Malaysia. *Journal of Wildlife Management* 79: 846–853.

Hiby, L., Lovell, P., Patil, N., Kumar, S.N., Gopalaswamay, A.M. and Karanth, K.U. (2009) A tiger cannot change its stripes: using a three-dimensional model to match images of living tigers and tiger skins. *Biology Letters* 5: 383–386.

Higashide, D., Miura, S. and Miguchi, H. (2012) Are chest marks unique to Asiatic black bear individuals? *Journal of Zoology* 288: 199–206.

Hwang, W., Chao, A. and Yip, P. (2002) Continuous-time capture–recapture models with time variation and behavioural response. *Australian and New Zealand Journal of Statistics* 44: 41–54.

Janecka, J.E., Munkhtsog, B., Jackson, R.M., Naranbaatar, G., Mallon, D.P. and Murphy, W.J. (2011) Comparison of non-invasive genetic and camera-trapping techniques for surveying snow leopards. *Journal of Mammalogy* 92: 771–783.

Jobin, A., Molinari, P. and Breitenmoser, U. (2000) Prey spectrum, prey preference and consumption rates of Eurasian lynx in the Swiss Jura Mountains. *Acta Theriologica* 45: 243–252.

Johnson, D.S., Laake, J.L. and Ver Hoef, J.M. (2010) A model-based approach for making ecological inference from distance sampling data. *Biometrics* 66: 310–318.

Karanth, K.U. (1995) Estimating tiger *Panthera tigris* populations from camera-trap data using capture–recapture models. *Biological Conservation* 71: 333–336.

Karanth, K.U. and Nichols, J.D. (1998) Estimation of tiger densities in India using photographic captures and re-captures. *Ecology* 79: 2852–2862.

Karanth, K.U. and Nichols, J.D. (2002) *Monitoring Tigers and Their Prey: A Manual for Researchers, Managers and Conservationists in Tropical Asia.* Bangalore, Karnataka: Center for Wildlife Studies.

Karanth, K.U., Nichols, J.D., Kumar, N.S. and Hines, J.E. (2006) Assessing tiger population dynamics using photographic capture–recapture sampling. *Ecology* 87: 2925–2937.

Karanth, K.U., Gopalaswamy, A.M., Kumar, N.S., Vaidyanathan, S., Nichols, J.D. and MacKenzie, D.I. (2011a) Monitoring carnivore populations at the landscape scale: occupancy modelling of tigers from sign surveys. *Journal of Applied Ecology* 48: 1048–1056.

Karanth, K.U., Nichols, J.D. and Kumar, S.N. (2011b) Estimating tiger abundance from camera trap data: field surveys and analytical issues? In: A.F. O'Connell, J.D. Nichols and K.U. Karanth (eds), *Camera Traps in Animal Ecology Methods and Analyses.* New York: Springer. pp. 97–117.

Kelly, M.J. (2001) Computer-aided photograph matching in studies using individual identification: an example from Serengeti cheetahs. *Journal of Mammalogy* 82: 440–449.

Kelly, M.J., Noss, A.J., Di Bitetti, M.S., Maffei, L., Arispe, R., Paviolo, A., de Angelo, C.D. and Di Blanco, Y.E. (2008) Estimating puma densities from camera trapping across three study sites: Bolivia, Argentina, Belize. *Journal of Mammalogy* 89: 408–418.

Kendall, W.L. (1999) Robustness of closed capture–recapture methods to violations of the closure assumption. *Ecology* 80: 2517–2525.

Kendall, W.L., Pollock, K.H. and Brownie, C. (1995) A likelihood-based approach to capture–recapture estimation of demographic parameters under the robust design. *Biometrics* 51: 293–308.

Kendall, W.L., Nichols, J.D. and Hines, J.E. (1997) Estimating temporary emigration using capture–recapture data with Pollock's robust design. *Ecology* 78: 563–578.

Krijger, H. (2002) Individual zebra identification: an investigation into image pre-processing, stripe extraction and pattern matching techniques. Unpublished thesis, Rhodes University, Grahamstown, South Africa.

Lamigueiro, O.P. (2015) Package 'solaR'. The comprehensive R archive network http://cran.r-project.org/

Link, W.A., Yoshizaki, J., Bailey, L.L. and Pollock, K.H. (2010) Uncovering a latent multinomial: Analysis of mark-recapture data with misidentification. *Biometrics* 66: 178–185.

Maffei, L. and Noss, A. (2008) How small is too small? Camera-trap survey areas and density estimates for ocelots in the Bolivian Chaco. *Biotropica* 40: 71–75.

Marques, T.A., Thomas, L. and Royle, J.A. (2011) A hierarchical model for spatial capture–recapture data: comment. *Ecology* 92: 526–528.

Marucco, F., Pletscher, D.H., Boitani, L., Schwartz, M.K., Pilgrim, K.L. and Lebreton, J.-D. (2009) Wolf survival and population trend using non-invasive capture–recapture techniques in the Western Alps. *Journal of Applied Ecology* 46: 1003–1010.

McClintock, B.T. (2015) Multimark: an R package for analysis of capture-recapture data consisting of multiple 'noninvasive' marks. *Ecology and Evolution* 5: 4920–4931.

McClintock, B.T., White, G.C. and Burnham, K.P. (2006) A robust design mark-resight abundance estimator allowing heterogeneity in resighting probabilities. *Journal of Agricultural, Biological, and Environmental Statistics* 11: 231–248.

McClintock, B.T., White, G.C., Antolin, M.F. and Tripp, D.W. (2009a) Estimating abundance using mark–resight when sampling is with replacement or the number of marked individuals is unknown. *Biometrics* 65: 237–246.

McClintock, B.T., White, G.C., Burnham, K.P. and Pryde, M.A. (2009b) A generalized mixed effects model of abundance for mark-resight data when sampling is without replacement. In: D.L. Thomson, E.G. Cooch and M.J. Conroy (eds), *Modeling Demographic Processes in Marked Populations*. New York: Springer. pp. 271–289.

McClintock, B.T., Conn, P.B., Alonso, R.S. and Crooks, K.R. (2013) Integrated modeling of bilateral photo-identification data in mark-recapture analyses. *Ecology* 94: 1464–1471.

McClintock, B.T., Bailey, L.L., Dreher, B.P. and Link, W.A. (2014) Probit models for capture–recapture data subject to imperfect detection, individual heterogeneity and misidentification. *Annals of Applied Statistics* 8: 2461–2484.

Mills, L.S., Citta, J.J., Lair, K.P., Schwartz, M.K. and Tallmon, D.A. (2000) Estimating animal abundance using noninvasive DNA sampling: promise and pitfalls. *Ecological Application* 10: 283–294.

Molinari-Jobin, A., Molinari, P., Breitenmoser-Würsten, C., Wölfl, M., Stanisa, C., Fasel, M., Stahl, P., Vandel, J.M., Rotelli, L., Kaczensky, P., Huber, T., Adamic, M. and Breitenmoser, U. (2003) Pan-Alpine conservation strategy for lynx. *Nature and Environment* 130: 1–20.

Moya, O., Mansilla, P.-L., Madrazo, S., Igual, J.-S., Rotger, A., Romano, A. and Tavecchia, G. (2015) APHIS: A new software for photo-matching in ecological studies. *Ecological Informatics* 27: 64–70.

Mulders, R., Boulanger, J. and Paetkau, D. (2007) Estimation of population size for wolverines *Gulo gulo* at Daring Lake, Northwest Territories, using DNA based mark-recapture methods. *Wildlife Biology* 13: 38–51

Negrões, N., Sollmann, R., Fonseca, C., Jácomo, A.T.A., Revilla, E. and Silveira, L. (2012) One or two cameras per station? Monitoring jaguars and other mammals in the Amazon. *Ecological Research* 27: 639–648.

Nichols, J.D. (2014) The Role of abundance estimates in conservation decision-making. In: L.M. Verdade, M.C. Lyra-Jorge and C.I. Pina (eds), *Applied Ecology and Human Dimensions in Biological Conservation*. Berlin: Springer. pp. 117–131.

Nichols, J.D. and Williams, B.K. (2006) Monitoring for conservation. *Trends in Ecology and Evolution* 21: 668–673.

Noss, A.J., Cuéllar, R.L., Barrientos, J., Maffei, L., Cuéllar, E., Arispe, R., Rúmiz, D. and Rivero, K. (2003) A camera trapping and radio telemetry study of lowland tapir (*Tapirus terrestris*) in Bolivian dry forests. *Tapir Conservation* 12: 24–32.

O'Brien, T.G. (2011) Abundance, Density and relative abundance: a conceptual framework. In: A.F. O'Connell, J.D. Nichols and K.U. Karanth (eds), *Camera Traps in Animal Ecology Methods and Analyses*. New York: Springer. pp. 71–96.

Oliveira-Santos, L.G.R., Zucco, C.A., Antunes, P.C. and Crawshaw, P.G. (2010) Is it possible to individually identify mammals with no natural markings using camera-traps? A controlled case-study with lowland tapirs. *Mammalian Biology* 75: 375–378.

Otis, D.L., Burnham, K.P., White, G.C. and Anderson, D.R. (1978) Statistical inference from capture data on closed animal populations. *Wildlife Monograph* 62: 1–135.

Parmenter, R.R, Yates, T.L., Anderson, D.R., Burnham, K.P., Dunnum, J.L., Franklin, A.B., Friggens, M.T., Lubow, B.C., Miller, M., Olson, G.S., Parmenter, C.A., Pollard, J., Rexstad, E., Shenk, T.M., Stanley, T.R. and White, G.C. (2003) Small-mammal density estimation: a field comparison of grid-based vs. web-based density estimators. *Ecological Monographs* 73:1–26.

Pesenti, E. and Zimmermann, F. (2013) Density estimations of Eurasian lynx (*Lynx lynx*) in the Swiss Alps. *Journal of Mammalogy* 94: 73–81.

Pollock, K.H., Nichols, J.D., Brownie, C. and Hines, J.E. (1990) Statistical inference for capture–recapture experiments. *Wildlife Monographs* 107: 1–97.

Ríos-Uzeda, B., Gómez, H. and Wallace, R.B. (2007) A preliminary density estimate for Andean bear using camera-trapping methods. *Ursus* 18: 124–128.

Rowcliffe, J.M., Field, J., Turvey, S.T. and Carbone, C. (2008) Estimating animal density using camera traps without the need for individual recognition. *Journal of Applied Ecology* 45: 1228–1236.

Royle, J.A. (2004) N-mixture models for estimating population size from spatially replicated counts. *Biometrics* 60: 108–115.

Royle, J.A. and Nichols, J.D. (2003) Estimating abundance from repeated presence– absence data or point counts. *Ecology* 84: 777–790.

Royle, J.A., Karanth, K.U., Gopalaswamy, A.M. and Kumar, N.S. (2009a) Bayesian inference in camera-trapping studies for a class of spatial capture–recapture models. *Ecology* 90: 3233–3244.

Royle, J.A., Nichols, J.D., Karanth, K.U. and Gopalaswamy, A.M. (2009b) A hierarchical model for estimating density in camera-trap studies. *Journal of Applied Ecology* 46: 118–127.

Royle, J.A., Magoun, A.J., Gardner, B., Valkenburg, P. and Lowell, R.E. (2011) Density estimation in a wolverine population using spatial capture–recapture models. *Journal of Wildlife Management* 75: 604–611.

Royle, J.A., Chandler, R.B., Sollmann, R. and Gardner, B. (2014) *Spatial Capture–Recapture*. Waltham, MA: Academic Press.

Russell, C., Van Horn, R.C., Zug, B., LaCombe, C., Velez-Liendo, X. and Paisley, S. (2014) Human visual identification of individual Andean bears *Tremarctos ornatus*. *Wildlife Biology* 20: 291–299.

Sarmento, P., Cruz, J., Eira, C. and Fonseca, C. (2010) Habitat selection and abundance of common genets *Genetta genetta* using camera capture–recapture data. *European Journal of Wildlife Research* 56: 59–66.

Schofield, M.R. and Bonner, S.J. (2015) Connecting the latent multinomial. *Biometrics* 71: 1070–1080.

Schwarz, C.J. and Seber, G.A.F. (1999) Estimating animal abundance: review III. *Statistical Science* 14: 427–456.

Seber, G.A.F. (1982) *The Estimation of Animal Abundance and Related Parameters*. New York: Macmillan.

Silver, S.C., Ostro, L.E., Marsh, L.K., Maffei, L., Noss, A.J., Kelly, M.J., Wallace, R.B., Gómez, H. and Ayala, G. (2004) The use of camera-traps for estimating jaguar *Panthera onca* abundance and density using capture/recapture analysis. *Oryx* 38: 148–154.

Singh, P., Gopalaswamy, A.M. and Karanth, K.U. (2010) Factors influencing densities of striped hyenas in arid regions of India. *Journal of Mammalogy* 91: 1152–1159.

Soisalo, M.K. and Cavalcanti, S.M.C. (2006) Estimating the density of a jaguar population in the Brazilian Pantanal using camera-traps and capture–recapture sampling in combination with GPS radio-telemetry. *Biological Conservation* 129: 487–496.

Sollmann, R., Gardner, B. and Belant, J.L. (2012) How does spatial study design influence density estimates from spatial capture–recapture models? *PLoS ONE* 7: e34575.

Sollmann, R., Mohamed, A., Samejima, H. and Wilting, A. (2013) Risky business or simple solution – relative abundance indices from camera-trapping. *Biological Conservation* 159: 405–412.

Stanley, T.R. and Burnham, P.K. (1999) A closure test for time-specific capture–recapture data. *Environmental and Ecological Statistics* 6: 197–209.

Stanley, T.R. and Richards, J.D. (2005) Software review: a program for testing capture–recapture data for closure. *Wildlife Society Bulletin* 33: 782–785.

Sun, C.C., Fuller, A.K. and Royle, J.A. (2014) Trap configuration and spacing influences parameter estimates in spatial capture–recapture models. *PLoS ONE* 9: e88025.

Tenan, S., Vallespir, A.R., Igual, J.M., Moya, O., Royle, J.A. and Tavecchia, G. (2013) Population abundance, size structure and sex-ratio in an insular lizard. *Ecological Modelling* 267: 39–47.

Thomas, P., Balme, G., Hunter, L. and McCabe-Parodi, J. (2005) Using scent attractants to non-invasively collect hair samples from cheetahs leopards and lions. *Animal Keepers Forum* 7/8: 342–384.

Thompson, S.K. (2012) *Sampling*, 3rd edn. New York: Wiley.

Thorn, M., Scott, D.M., Green, M., Bateman, P.W. and Cameron, E.Z. (2009) Estimating brown hyena occupancy using baited camera traps. *South African Journal of Wildlife Research* 39: 1–10.

Trolle, M. and Kéry, M. (2003) Ocelot density estimation in the Pantanal using capture–recapture analysis of camera-trapping data. *Journal of Mammalogy* 84: 607–614.

Trolle, M., Noss, A.J., Lima, E.D.S. and Dalponte, J.C. (2007) Camera-trap studies of maned wolf density in the Cerrado and the Pantanal of Brazil. *Biodiversity and Conservation* 16: 1197–1204.

Vogt, K., Zimmermann, F., Kölliker, M. and Breitenmoser, U. (2014) Scent-marking behaviour and social dynamics in a wild population of Eurasian lynx *Lynx lynx*. *Behavioural Processes* 106: 98–106.

Wegge, P. and Storaas, T. (2009) Sampling tiger ungulate prey by the distance method: lessons learned in Bardia National Park, Nepal. *Animal Conservation* 12: 78–84.

Wegge, P., Pokheral, C.P. and Jnawali, S.R. (2004) Effects of trapping effort and trap shyness on estimates of tiger abundance from camera trap studies. *Animal Conservation* 7: 251–256.

White, G.C. (1996) NOREMARK: population estimation from mark–resighting surveys. *Wildlife Society Bulletin* 24: 50–52.

White, G.C. and Burnham, K.P. (1999) Program MARK: survival estimation from populations of marked animals. *Bird Study* 46: 120–138.

White, G.C., Anderson, D.R., Burnham, K.P. and Otis, D.L. (1982) *Capture Recapture and Removal Methods for Sampling Closed Populations*. Los Alamos, NM: Los Alamos National Laboratory Publication LA-8787-NERP.

Williams, B.K., Nichols, J.D. and Conroy, M.J. (2002) *Analysis and Management of Animal Populations*. San Diego: Academic Press.

Wilson, K.R. and Anderson, D.R. (1985) Evaluation of a density estimator based on a trapping web and distance sampling theory. *Ecology* 66: 1185–1194.

Wilton, C.M., Puckett, E.E., Beringer, J., Gardner, B., Eggert, L.S. and Belant, J.L. (2014) Trap array configuration influences estimates and precision of black bear density and abundance. *PLoS ONE* 9: e111257.

Yoshizaki, J., Pollock, K.H., Brownie, C. and Webster, R.A. (2009) Modeling misidentification errors in capture–recapture studies using photographic identification of evolving marks. *Ecology* 90: 3–9.

Zimmermann, F. (2004) *Conservation of the Eurasian lynx (Lynx lynx) in a fragmented landscape – habitat models, dispersal and potential distribution*. PhD thesis, University of Lausanne.

Zimmermann, F., Molinari-Jobin, A., Ryser, A., Breitenmoser-Würsten, Ch., Pesenti, E. and Breitenmoser, U. (2011) Status and distribution of the lynx (*Lynx lynx*) in the Swiss Alps 2005–2009. *Acta Biologica Slovenica* 54: 74–84.

Zimmermann, F., Breitenmoser-Würsten, C., Molinari-Jobin, A. and Breitenmoser, U. (2013) Optimizing the size of the area surveyed for monitoring a Eurasian lynx (*Lynx lynx*) population in the Swiss Alps by means of photographic capture recapture. *Integrative Zoology* 8: 232–243.

Zimmermann, F., Foresti, D., Bach, J., Dulex, N., Breitenmoser-Würsten, Ch. and Breitenmoser, U. (2014) *Abundanz und Dichte des Luchses in den Nordwestalpen: Fang-Wiederfang-Schätzung mittels Fotofallen im K-VI im Winter 2013/14*. KORA-Report 64. pp. 16 (in German with English abstract).

8. Behavioural studies

Fridolin Zimmermann, Danilo Foresti and Francesco Rovero

8.1 Introduction

'We need to recognize at the outset that any attempt to define behavior is bound to be invalidated in time. The more we know about behavior, the more our definition changes. In a real sense, the whole aim of a science of behavior is to define behavior.' (Baum 2013)

In this chapter we introduce a range of different approaches and technologies used to study animal behaviour and discuss their advantages and disadvantages compared to camera trapping. We then present different applications of camera trapping in behavioural studies and provide insights into what needs to be considered when choosing camera trap sites for a variety of study aims. Finally, we present three examples as case studies: the first on marking behaviour in the Eurasian lynx (*Lynx lynx*), Box 8.2; the second on tree rubbing behaviour in the brown bear (*Ursus arctos*), Box 8.3; and the third is an example of temporal interactions between species, such as competing species, or predators and preys – specifically, we look at activity pattern overlap between the Eurasian lynx and its two main preys, i.e. roe deer (*Capreolus capreolus*) and chamois (*Rupicapra rupicapra*) in Switzerland (see section 8.6.2).

8.2 Advantages and disadvantages of camera trapping compared to other technologies used to study animal behaviour

Direct observations of animals in the field has been the predominant technique in ethological studies prior to the arrival of bio-logging and remote sensors such as camera traps, and despite many limitations it is still a common approach. The irreplaceable strengths of direct observational studies are detailed and complex data collection that would be difficult to achieve when researchers are not physically present with the animal. There are also positive impacts associated with the presence of researchers, e.g. incentives from ecotourism (Knight 2009), or a decrease in wildlife poaching around highly used research stations and field sites (Campbell *et al.* 2011). However, direct observation carries substantial weaknesses that can lead to spurious conclusions, such as behavioural or activity changes due to presence of the observer, unequal observability of different categories of individuals (e.g. Boyer-Ontl and Pruetz 2014),

observer-dependent bias in the data, and a limited number of focal individuals from which inferences can be drawn.

Bio-logging technology seeks to overcome these problems by enabling the remote measurement of continuous data streams on earth and in the air for free-ranging, undisturbed subjects without requiring continuous human support (Cooke *et al.* 2004; Ropert-Coudert and Wilson 2005). These technologies provide the opportunity to focus on animal behaviour and physiology on a variety of scales (e.g. temporal, spatial or biological organisation - from organ system, to individual to community interactions; Cook *et al.* 2004) and enable the linking of the behaviour and physiology of free-ranging animals in their own environment by collecting a wealth of data in the field including location information from telemetry, motion patterns from accelerometers, temperature and depth for aquatic animals, estimates of proximity to other animals, still images and video, and physiological data (e.g. metabolic rate) from a range of sensors (Moll *et al.* 2007). As all animals are handled when transmitters are attached, most individual specific parameters, such as individual identity, sex, age and reproductive status, are also gathered. However, as with all techniques, a suite of challenges and limitations exists that must be balanced against the positive aspects. Inferences based on bio-logging have inherent limitations due to biases associated with trapping and handling, variation among individuals, and potentially high costs which in some cases could lead to small sample sizes. Battery size and longevity continue to limit research on small organisms and to restrict long-term monitoring. Because data can be collected in real time there is the danger of collecting large data sets that are difficult to manage. Interpreting patterns of large data sets can be extremely difficult and challenging and needs to be coupled with other techniques, including detailed visual (Löttker *et al.* 2009) and/or video observation or by combining multiple biosensors. Data interpretation is scale dependent, for example in GPS data the ability to statistically discriminate different movement modes will depend on the sampling interval (Hebblewhite and Haydon 2010), and the monitoring frequency can also impact estimates of environmental effects on site selection (Carvalho *et al.* 2015). Time series, the repeated sampling of data of the same individual, are non-independent and could require complex statistical techniques but the current approaches are poorly suited to these types of data (Cook *et al.* 2004).

Recently, animal-borne video and environmental data collection systems (AVEDs), enabling investigators to 'see' what the animals themselves see in the field, offer new research potential in the field of bio-logging especially when fine-scale and continuous data for individuals are needed (Moll *et al.* 2007). These new technologies are most appropriate for elusive species living in inaccessible environments (e.g. deep-diving marine species) and for fine-scale assessments of animal behaviour such as food selection, reproduction, social behaviour, species interactions and disease transmission, and might also help to mitigate human–wildlife conflicts (e.g. reducing animal–vehicle collisions through studying road-crossing behaviour) and provide insight into habitat use if sampling schemes are well designed (Moll *et al.* 2007). AVEDs have the greatest potential for explaining ecological mechanisms when video is integrated with other animal-borne sensors, because data can subsequently be interpreted within the context of animal activity (Moll *et al.* 2007). However, unless the interval between images is small, it can be difficult to interpret animal behaviour in these snapshots of activity because important details are missing. Like direct observational studies and other bio-logging technologies, still imaging and AVEDs suffer from small sample sizes and thus may not permit the population-wide inferences that researchers have come to expect from camera traps (Nichols *et al.* 2011). An additional shortcoming of AVEDs is a greater potential to affect

the natural behaviour of animals than other bio-logging technologies (e.g. telemetry) because these devices are larger, heavier and cannot be implanted subcutaneously. Furthermore these systems are prone to damage and lens obstruction, especially in terrestrial habitats.

Camera trapping is a valid alternative to bio-logging as it essentially allows the placing of remote sensors in the environment rather than on animals. Camera trapping has indeed a long history in behaviour studies (see Bridges and Noss 2011 for a review). It combines many of the advantages of the techniques described above while offering a number of improvements. In the first place it is a highly non-invasive tool (see also Chapter 1), and although the camera trap itself, the flash and the noise in the infra-ultrasonic range produced may disturb the animal (Meek *et al.* 2014a), and hence potentially modify its behaviour, this disturbance is likely to be of much lower impact than that produced by observers. In addition, camera trapping can be applied over relatively large areas, including secluded and inaccessible areas, and provide data for a larger number of individuals, and a wider range of species relative to the earlier-mentioned techniques that require trapping and tagging. Importantly, moreover, newly developed camera traps with video mode can, unlike single photographs, record behaviour. Finally, photographs and/or videos from camera traps, similar to bio-logging data, can be archived and shared with the scientific community, allowing for a common interpretation of the observational data and future reanalysis as new scientific knowledge is acquired.

In recognition of the non-overlapping advantages of the different techniques, recently researchers have started to combine camera trapping with telemetry and sometimes also with direct visual observations. For example, Leuchtenberger *et al.* (2014) recorded the activity pattern of giant otters (*Pteronura brasiliensis*) using telemetry combined with visual observation during the day. The animals were radiotracked from boats and whenever visual observation was possible the predominant behaviour of the majority of the group was observed and recorded by focal group sampling. Camera traps positioned at entrances of active dens and on latrines provided information about the patterns of den use and scent marking over 24 h periods. Suselbeek *et al.* (2014) used an unique combination of an automated radiotelemetry system (ARTS; Kays *et al.* 2011), manual radiotelemetry and camera trapping to test whether activity at high-risk times declined with food availability as predicted by risk allocation hypothesis in a neotropical forest rodent, the Central American agouti (*Dasyprocta punctate*) in relation to the temporal pattern of predation risk by its principal predator, the ocelot (*Leopardus pardalis*). The measure of daily activity pattern for agoutis and ocelot at the population level was inferred from camera trapping. To determine which periods had elevated predation risk for agoutis the ratio of ocelot to agouti activity over time was quantified. ARTS, which enabled activity to be tracked continuously and recorded the exact time of death for radiocollared agouti, was used to determine how much of agouti mortality was due to ocelots and fell during the daily period of high predation risk. The ARTS included a wireless network making these data, including mortality events, available in real time to the investigator via a web-accessible database. As a mortality event was detected, the carcass was located to check for bite marks and a camera was deployed nearby to record any predators returning to their kills. Activity patterns between agoutis that lived in areas of contrasting food abundances were compared to determine how food abundance affected individual agouti activity patterns.

8.3 Application of camera trapping in behavioural studies

Camera trapping has seen a vast field of applications in behavioural studies, reviewed by Bridges and Noss (2011). These include studies of activity patterns (e.g. Di Bitetti *et al.* 2006; Story *et al.* 2014); niche partitioning (spatial and temporal separation or avoidance; e.g. Ridout and Linkie 2009; Di Bitetti *et al.* 2010; Monterroso *et al.* 2014; Rowcliffe *et al.* 2014); habitat and corridor usage (e.g. Gužvica *et al.* 2014); refugia (e.g. study on badger setts; Mori *et al.* 2015) and reproduction (e.g. quantify behaviour of nesting birds; Enderson *et al.* 1972); feeding ecology (e.g. chickadees, tits and owls at nest boxes; Royama 1970; Juillard 1987); foraging (e.g. DeVault *et al.* 2004; Bauer *et al.* 2005; Vernes *et al.* 2014; Zhi-Pang Huang *et al.* 2014); predation events mainly focusing on predation of bird nests (Cutler and Swann 1999); species ranging and grouping behaviours (e.g. by using camera traps Boyer-Ontl and Pruetz (2014) were able to observe chimpanzees grooming, playing, resting, feeding and performing agonistic displays); behavioural interactions among and between species, as well as between predator and prey (e.g. Díaz *et al.* 2005; Foster *et al.* 2013; Kuijper *et al.* 2014); social structure (Séquin *et al.* 2003; Vogt *et al.* 2014) and group compositions (e.g. Boyer-Ontl and Pruetz 2014); and marking behaviour (e.g. Vogt *et al.* 2014; Tattoni *et al.* 2015).

8.4 The importance of choosing the site in relation to a variety of study aims

Behavioural studies have capitalised on the ability of camera traps to monitor fixed (i.e. predetermined) locations where a specific behaviour or resource use, as well as interactions among and between species, occur. A non-exhaustive list of fixed locations include: birds' nests to study predation rates and to identify predators of eggs and fledglings (e.g. Major and Gowing 1994); entry or exit points of animal dens, setts or burrows (e.g. Mori *et al.* 2015); foraging areas including mast-fruiting tree resources (e.g. Miura *et al.* 1997); truffle patches (e.g. Vernes *et al.* 2014) to study seed dispersal, mineral licking or geophagy (i.e. the deliberate consumption of earth material; Galvis *et al.* 2014); kill sites or carcasses to identify carnivores feeding at the kill or stock raiders (e.g. Zimmermann *et al.* 2011) or the set of scavengers consuming the carcass (e.g. Bauer *et al.* 2005; Zhi-Pang Huang *et al.* 2014); and water resources such as water holes (e.g. Bleich *et al.* 1997).

Camera traps have also been used to monitor specific features such as: wood piles to study the marking behaviour of the Eurasian lynx (Vogt *et al.* 2014; see Box 8.2) or trees and poles to study the rubbing behaviour of brown bears (e.g. Tattoni *et al.* 2015; see Box 8.3); and green bridges or any other natural or artificial structure that facilitates the movement of animals (e.g. Gužvica *et al.* 2014; Taylor and Goldingay 2014).

The sampling design should always be related to the research question and focal species. Despite an accurate description of the sampling design being central to the interpretation of the results, there are still studies that do not report the methodological details in sufficient detail (guidelines for reporting on camera trapping studies can be found in Meek *et al.* 2014b). Furthermore, to our knowledge, no research has directly tested the influence of sampling design on behavioural studies. Therefore, we can only provide here some basic recommendations. When studying specific behaviours at fixed, predefined sites, investigators should try to sample a representative number of individuals of the studied population at a representative number of sites, to avoid individuals showing non-typical behaviours being over-represented in the sample. If the

study focuses on behaviour occurring at different categories of sites, a representative number of sites of each category should be sampled. Researchers should bear in mind that specific sampling designs (i.e. camera traps placed only at predefined locations) are adopted to meet specific objectives and as such they allow conclusions to be drawn only on the behaviour of the focal species at those sites. Because species do not use fixed locations such as clustered resources to the same extent across the daily cycle, this sampling design would certainly need some adjustment for activity pattern and temporal species interaction studies (see section 8.6.2 below) as it could lead to bias in activity level estimation. The central assumption regarding sampling design for activity pattern measurements is that camera trap sites are placed randomly with respect to diel patterns of movement (Rowcliffe *et al.* 2014). In practice, this means that activity pattern estimation requires that animals are not attracted to the camera trap site by means of lures or baits (as this is not generally recommended for occupancy and abundance estimation: see Chapters 6 and 7), as this could introduce non-random diel patterns of space use that would prevent accurate estimation of activity level. Most camera trapping studies place camera traps on trails to maximise trap rate. This strategy would be valid for activity level estimation as long as animals use trails to the same extent across the daily cycle (they could, for example, go off trail selectively during peak foraging hours). This potential bias can be tested by comparing trap rate patterns on and off trail. According to Rowcliffe *et al.* (2014), it will probably be safer to use a random camera trap site placement strategy in most cases, although this strategy may still not work in cases where some important habitat used by the target species is not suitable for camera trapping. For example, for semi-arboreal species, such as the pine marten *Martes martes*, it will not be practical to camera trap representatively in the tree canopy as well as on ground, which will lead to bias in activity level estimation.

Finally, behavioural studies should adopt sampling designs and analytical frameworks that take into account imperfect detection (i.e. detectability; see Chapters 6 and 7) instead of using detection rates as the metric of choice. Methodologies incorporating imperfect detection into modelling allow, for example, investigation of species co-occurrence patterns and can address questions about the importance of interspecific interactions such as competition and predator–prey relationships as potential determinants of community structure (MacKenzie *et al.* 2004).

8.5 Diel activity pattern and activity pattern overlap between species

Data from camera traps that record the time of the day at which photographs are taken are used widely to study daily activity patterns (e.g. Bridges *et al.* 2004; Di Bitteti *et al.* 2006; Gerber *et al.* 2012; Kamler *et al.* 2012; Leuchtenberger *et al.* 2014). Camera trap pictures are commonly grouped into regular (e.g. 1 h, 2 h) discrete time categories (e.g. Jácomo *et al.* 2004). To construct frequency histograms, two parameters are required, the bin width (e.g. 1 h) and origin (e.g. 00:00 h). Both parameters can have dramatic effects on the shape of the resulting histogram of the observed frequency. Another disadvantage is that the histogram estimators are usually not smooth, displaying bumps that may have been observed only due to noise. Therefore it is preferable to present kernel density estimates which require only one parameter, the window width, and will therefore always be a more robust estimate of the underlying probability density function (see Wand and Jones 2005). The independent detection records for each target species are regarded as

a random sample from the underlying circular continuous temporal distribution that describes the probability of a photograph being taken within any particular interval of the day (Ridout and Linkie 2009). The circular probability density function of this distribution is estimated non-parametrically using kernel density (Ridout and Linkie 2009). More details about statistical developments, and in particular the kernel density estimators, can be found in Ridout and Linkie (2009) and Rowcliffe *et al.* (2014).

The coexistence of similar species is difficult to explain if two species share very similar ecological niches, as competitive exclusion principles predict the extinction of the inferior competitor (Hutchinson 1978; Soberon 2007). Alternatively, competition can drive niche differentiation by which competing species pursue dissimilar patterns of resource use. Therefore coexistence is acquired through the segregation of ecological niches (Hutchinson 1978). How species use time and distribute their activity within the diel cycle is an important niche dimension, although it is often being regarded as the least important of the three main niche axes (i.e. spatial, temporal and resource exploitation). Indeed species may reduce intraguild competition and predation risk, and thus increase niche segregation, by minimising temporal overlap with similar species or predators. However, the activity pattern of a species along the diel cycle is not only regulated by competition and predation risk. It is also internally regulated by each species' endogenous clock (Kronfeld-Schor and Dayan 2003) and by external abiotic factors. Temporal niche segregation by ecologically similar carnivores has been demonstrated in diverse systems (Chen *et al.* 2009; Di Bitteti *et al.* 2009; Hayward and Slotow 2009; Lucherini *et al.* 2009; Monterroso *et al.* 2014). More contrasting temporal patterns were observed between predators and their main preys. While some studies have revealed marked temporal niche overlap (e.g. Núñez *et al.* 2000; Linkie and Ridout 2011; Ramesh *et al.* 2012; Foster *et al.* 2013; Ross *et al.* 2013), others have provided evidence of prey animals concentrating their activity at times of relatively low predation risk (e.g. Diaz *et al.* 2005; Ross *et al.* 2013; Suslebeek *et al.* 2014). Predator–prey avoidance may be enhanced in areas with higher food abundance for the prey (Sulsebeck *et al.* 2014).

8.5.1 Definition and assumptions of the activity level measured by means of camera traps

Here we review the definition and additional assumptions, besides the sampling design considerations already outlined in section 8.4, presented in Rowcliffe *et al.* (2014), which are the fundamentals for all studies of the activity patterns and temporal interactions of species (see section 8.6.2 for a case study). Camera traps typically detect animals only during the animals' routine daily movements, i.e. when they are outside their refuges (e.g. shelters, nests or sleeping sites). Following Rowcliffe *et al.* (2014), animals are defined as active whenever they move out of these locations, which cannot be observed by camera traps. While this definition covers the fundamental characteristic of activity, i.e. a more costly behavioural state than the rest, it differs from the finer categories of behaviour commonly used by ethologists (i.e. foraging, vigilant, sleeping or grooming) as these could potentially take place either within or outside refuges. By assuming that activity level is the only determinant of the rate at which animals are detected by camera traps, the trap rate at a given time of the day will be proportional to the level of activity in the population at that time, and the total amount of activity will be proportional to the area under the trap rate curve. Another assumption central to the method is that all animals are active when the camera trap rate reaches its maximum in the daily cycle

(see Rowcliffe *et al.* 2014 for the detailed reasoning behind this). Given the paucity of evidence currently available, Rowcliffe *et al.* (2014) caution a stronger research focus on such synchrony to demonstrate the validity of this assumption. As activity peaks are not always synchronised, the method clearly needs to be applied cautiously with this in mind. However, besides the proportion of the population being active, several additional factors could potentially affect trap rate. These include animal speed while active, camera detection zone size and animal density (Rowcliffe *et al.* 2008). Constant density and population closure over the daily cycle can reasonably be assumed if camera trap sites are placed randomly with respect to diel patterns of movement (see section 8.4). While Rowcliffe *et al.* (2014) did not find evidence for significant diel variation in animal speed among 12 Panamanian forest species, the camera detection radius was 21% higher during the day than during the night. Based on these findings, they developed a method that can correct for bias due to factors other than activity influencing the diel variation in trap rate (R package `activity`; Rowcliffe *et al.* 2014).

8.5.2 Overlap between pairs of activity patterns

Many different measures of overlap have been suggested for quantifying the affinity of overlap of two probability density functions (see Ridout and Linkie 2009 for a review). Ridout and Linkie (2009) used the coefficient of overlapping proposed by Weitzman (1970) for pairwise comparison of activity patterns. The coefficient of overlap Δ ranges from 0 (no overlap) to 1 (complete overlap) and is obtained taking the minimum of the density functions of the two cycles being compared at each time point. Non-parametric estimation of Δ was studied in more detail by Schmid and Schmidt (2006), who noted several equivalent mathematical expressions for Δ which lead to five different estimators. However, for circular data, the first two are equivalent ($\hat{\Delta}_1$, $\hat{\Delta}_2$) and the third ($\hat{\Delta}_3$) was excluded because it is not invariant to the choice of origin (Ridout and Linkie 2009). Therefore three distinct estimators need to be considered: $\hat{\Delta}_1$, $\hat{\Delta}_4$ and $\hat{\Delta}_5$ (see section 8.6.2). A smoothed bootstrap should be used to estimate the precision of the coefficient of overlapping. At least 1000 resamples (preferably 10,000) should be done. The evaluation of Δ values and consequent definition of high or low overlap between two distinct activity patterns is largely subjective. Some authors (e.g. Monterroso *et al.* 2014) ranked the activity overlap values resulting from overall pairwise comparisons into low, moderate or high based on percentiles (e.g. low = $\Delta \leq$ 50th percentile of the samples, moderate = 50th percentile < $\Delta \leq$ 75th percentile and high = $\Delta >$ 75th percentile). The significance of pairwise comparisons, either between relative activity levels at different times of the day or between overall activity levels, can be estimated by means of a Wald test (Wald and Wolfowitz 1940).

BOX 8.1 Studies at high latitudes and covering long periods

Suppose we find a nocturnal species that emerges immediately after sunset and a diurnal species which goes to roost just before sunset. Their activity patterns clearly do not overlap. However, in higher latitudes, as the time of sunset changes seasonally, there will be an apparent overlap if the study lasts over longer periods, which is an artefact of pooling the data. Caution is therefore required when the time of sunrise and sunset vary considerably. While this problem is negligible in

the tropics and in short studies, variations can be dramatic over longer periods at higher latitudes. Peaks in activity are usually tuned to sunrise and sunset, and the progression of these times therefore flattens peaks and overestimates activity level (Aschoff 1966), and consequently the coefficient of overlap. Care is needed when comparing activity patterns or coefficients of overlap among study areas or periods with significant seasonal differences, and data should not be pooled across such study areas and/or periods unless specific steps are taken to account for this issue (see below for ways of dealing with this). In these specific situations, probability density functions should be fitted to solar time (the deviation of clock time from sunrise and sunset). The function (SunTIME) written by Nouvellet *et al.* (2012) offers equations and R code to transform clock time data to deviation from sunrise (sunset), based on the location and date at which photographs were taken. This approach works well for simple activity patterns with unimodal distributions but has limitations when the distributions get more complicated. Activity patterns are usually concentrated around dusk and dawn (Aschoff 1966) and thus have a bimodal distribution, though dealing with such distributions is complex. Therefore, we recommend that instead of trying to account for variable day length retrospectively in the analyses, researchers should rather take this aspect into account when planning the study. For example, at higher latitudes where day length changes quickly from one day to the next, it would be better to set more camera traps over a short duration than a few camera traps over a long duration. In these regions it is highly recommended to compare the activity patterns between different study areas solely on surveys conducted roughly at the same latitude and around the same time of year.

8.6 Case studies

8.6.1 Marking behaviour studies in Eurasian lynx and brown bear

Scent-marking with faeces, urine or glandular secretion is widespread among mammals (see Gostling and Roberts 2001a,b for a review). This behaviour has also been observed in different felid (Macdonald 1985) and bear species (in the form of rubbing against trees; see Box 8.3). Although the behaviour is well described, little is known about its function in wild felid and bear populations.

BOX 8.2 Scent-marking behaviour of wild Eurasian lynx

We review the study by Vogt *et al.* (2014) which investigated the pattern of scent-marking and its role in intra- and intersexual communication among resident and non-resident Eurasian lynx (*Lynx lynx*) (Figure 8.1) by monitoring marking sites by means of infrared camera traps. The study was conducted in a 1,424 km^2 study area located in the northwestern Swiss Alps, on a population whose spatial and social structure is well known from several previous radiotelemetry studies (Haller

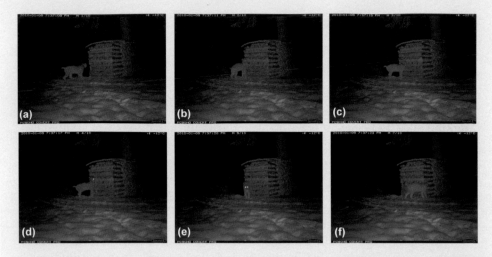

Figure 8.1 Typical behavioural sequence of Eurasian lynx scent-marking beginning with sniffing (a) the object, in this case a wood pile, to be marked followed by rubbing of cheeks and neck (b–d), and concluding with urine spraying (e). (KORA)

and Breitenmoser 1986; Breitenmoser-Würsten *et al.* 2001) and repeated camera trapping sessions (e.g. Pesenti and Zimmermann 2013; Zimmermann *et al.* 2013). The sampled marking sites were located along trails and forest roads frequently used by lynx and were previously identified either while setting and checking sites during camera trapping sessions, or during radio- or snow-tracking. Scent-marks are usually placed on visually conspicuous objects (i.e. wood piles, tree trunks, rocks, small spruce trees and the corner of a wooden shed), where lynx hair can be found and urine marks can be smelled, even by humans. Infrared (RC55) and no-glow (PC90) LED Reconyx camera traps, set to take 10 pictures at each trigger with no delay between triggers, were used in this study. Unlike the infrared video trap models available at the time, these camera traps had a fast trigger speed and offered a high enough image quality so that at least one of the multiple pictures per trigger was sufficient to recognise individuals by their fur pattern. Between 4 and 14 camera traps were operating at the same time. Each camera trap was adjusted to observe one marking site (i.e. one repeatedly marked object). From December 2009 to July 2012 a total of 22 marking sites were observed by means of camera trapping. Observational periods for different marking sites ranged from 4 months to 2.5 years. For the analyses of seasonal variation in marking activity data from two periods of comparable length (15 December–14 July 2010/11 and 2011/12) were used. During a total of 7,598 realised trap nights, 338 lynx visits of 40 individuals (19 males, 10 females, 11 unknown) were observed over the course of the study. The results showed that lynx marking activity was highest during the mating season and was lowest during the time when females gave birth and lactated. Both sexes scent-marked, but males visited marking sites more often than females and marked relatively more during visits. Most lynx at marking sites were residents but non-resident lynx also scent-marked occasionally. Juveniles were never observed marking. The presence of another individual's scent-mark

triggered over-marking (i.e. scent-marking on the same area of an object, including scent-marking on top, touching, as well as adjacent to, the previous mark) in male lynx. Males responded similarly to the presence of another individual's scent-mark irrespective of whether it was the top scent-mark or the underlying scent-mark in a mixture of scent-marks they encountered - over-marking was provoked in both cases. These results suggest that lynx when over-marking do not cover completely the scent-marks left by others so that only the latest scent-mark would be smelt. Marking sites could therefore serve as 'chemical bulletin boards', where males advertise their presence and gain information on ownership relationships in a given area. Female lynx over-marked mostly only the scent-marks left by the resident males, but further studies are needed to understand the function of over-marking in females.

BOX 8.3 Rubbing trees and brown bears

The behaviour displayed by brown bears (*Ursus arctos*) of rubbing against trees (Figure 8.2) is known to occur across the range of the species and is considered primarily a means of intraspecific communication (e.g. Clapham *et al.* 2014). Studies in North America have shown that rubbing is performed more by adult male bears and more during the mating season, indicating that the prime communication function is associated with reproductive strategies (Clapham *et al.* 2014). We here review the study by Tattoni *et al.* (2015), which showed how camera trapping was an essential tool for studying the use of rubbing trees by brown bears in northeast Italy (Trentino province, Adamello-Brenta Natural Park).

A large (>150) sample of rubbing trees had been previously identified by the local Wildlife Service, which uses hairs left in these trees by rubbing bears as samples to genetically monitor the population. Tattoni *et al.* (2015) set camera traps in front of a pool of 20 randomly selected rubbing trees to systematically detect passing bears over a period of 3 years (2012–2014), sampling each year the entire season for which bears were active (April–November). The study used UV565HD digital camera traps equipped with an infrared LED flash and set to record video; the cameras recorded continuous, i.e. with no delays between triggers, 20 s videos when triggered. Camera traps were fixed to a tree facing the rubbing tree, at a height of about 2 m and at an average distance of 4 m. The camera traps were checked every 3 weeks for data download and battery replacement.

The study realised 9,302 camera days overall and individual video sequences of bears were concatenated to derive 546 complete events of passing bears, which were then screened for sex/age identification and for classifying the rubbing behaviour. Four categories of rubbing behaviour were identified: (1) 'indifferent': the bear passed without considering the tree; (2) 'investigate': the animal sniffed or stopped to inspect the tree; (3) 'rub': the animal scratched its back or other body parts on the tree; (4) 'investigate and rub': when rubbing followed an obvious investigation. Sex could be determined only for adult bears, which comprised events for 37 females and 215 males, while the remaining 294 events

Figure 8.2 Adult male brown bear *Ursus arctos* rubbing against a tree in the Adamello-Brenta Natural Park, northeast Italy. (Francesco Rovero

were of undetermined sex. Among these, 14 were cubs and 55 sub-adults, leaving the remaining 255 bear events undetermined for age/sex. Table 8.1 reports the observed behaviours according to sex/age classification. Bears which rubbed the trees were predominantly males. The behaviours of 'rubbing' and of 'investigate and rubbing' were significantly (Pearson's chi-squared test $P < 0.01$) more frequent during the breeding season (May–July), while investigation of the trees occurred throughout the period of activity and by both sexes. Females passing rubbing trees were mainly indifferent, though they did, occasionally, investigate; however, only three females were observed to rub, only after investigation and only during the non-breeding season.

Table 8.1 Events of rubbing behaviour by age/sex classes, performed by the brown bear (*Ursus arctos*) in the eastern Alps as detected by camera trapping. From Tattoni *et al.* (2015).

Behaviour	Adult females	Adult males	Cubs	Indeterminate	Sub-adults
Investigate	14	62	6	81	30
Investigate and rub	3	62	0	7	4
Rub	0	35	0	3	0

This study provided new insights into the behaviour of brown bears at rubbing trees and showed that camera trapping was instrumental to revealing aspects that could not have been revealed through other methods, such as hair sampling for genetic analysis. Indeed, camera trapping allowed the sampling of bears belonging to different age/sex classes, hence overcoming the known male-bias of hair sampling. The authors found that adult males were the main performers of rubbing, confirming that rubbing has a primary role of intraspecific communication related to reproductive strategies. Ongoing analysis (C. Tattoni

unpublished data) is extending the investigation to the triggering effect that a bear using a rubbing tree has on other individuals. Preliminary results indicate that the rubbing sequences during a span of 90 days at any rubbing tree are triggered by a male bear in 82% of cases, and after that, 43% of the time the second bear was another male (and 28% of the time a bear of undetermined age/sex). This further supports the inter-male communication role of bear rubbing.

8.6.2 Comparison of activity patterns

We here provide an example of quantitative estimation of the overlap in activity pattern between a predator, the Eurasian lynx, and its two main prey species, roe deer and chamois, and used the data collected during the same survey presented in Chapter 7, where details on study area, season and sampling design are found. The complete data set file can be downloaded as Appendix 8.1.

8.6.2.1 Data preparation

In order to remove consecutive photographs of the same animal, which may bias the activity estimations towards some overrepresented moments of the day, some data preparation is needed. The raw data were subsampled to delete all consecutive detections of a given species on the same site occurring within less than 30 min. Different analytical routines allow this data preparation, and for further details and a practical example we refer to Chapter 5. *Users should be aware that modifying and saving data files with Microsoft Excel may change the format of the data, especially the date and time format. Therefore it is strongly suggested to perform any data preparation directly in R or with a text editor such as Notepad.*

8.6.2.2 Running the analysis in R (adapted from Meredith and Ridout 2014)

To set the working directory of the R console, type the following command line. This will open an explorer window for easy browsing:

```
setwd(choose.dir())
```

In order to get the current working directory and verify that it has been correctly set:

```
getwd()
```

Import the .CSV table into R:

```
events <- read.delim(file.choose(),header=TRUE,sep=',')
```

Choose the file containing the data, in this case 'true_events_NWA2013_14.csv'.

In order to verify that the file has been correctly imported, you can display the header of the table. Furthermore, this will serve to remind you of the exact column names in your data set, which is crucial for successfully running the functions presented hereinafter.

```
head(events)
```

	area	species	time
1	1	Vulpes vulpes	0.87652778
2	1	Vulpes vulpes	0.91672454
...			

Before proceeding with the analyses, it is always good to explore the data set. For instance, in order to see from how many different study areas the data come from, type:

```
table(events$area)
   1
3236
```

If you wish to learn how many species and events per species are available, type:

```
summary(events$species)
```

Aves spp	Canis lupus	Capreolus capreolus	Cervus elaphus
6	12	116	16
Felis catus	Lepus europaeus	Lepus spp	Lepus timidus
91	423	2	10
Lynx lynx	Martes foina	Martes martes	Martes spp
168	9	10	3
Meles meles	Mustela erminea	Rupicapra rupicapra	Sciurus vulgaris
260	2	92	12
Sus scrofa	Ungulata spp	Vulpes vulpes	
2	1	2001	

To check if the time format has been correctly transformed to the 0–1 range:

```
range(events$time)
[1] 0.0006944444 0.9993055556
```

The data set contains the time of photographic capture from one study area for 15 species and several animals that could not be identified to the species level (e.g. *Aves*, *Ungulata* and *Martes*). The time unit is the day, so values range from 0 to 1. The package `overlap` works entirely in radian units, but the conversion is straightforward:

```
timeRad<-events$time*2*pi
```

Once we have checked the integrity of our data set and collected the most important information, we can start fitting the kernel density. After having loaded the package `overlap` (Meredith and Ridout 2014), we can extract the data for the Eurasian lynx and plot a kernel density curve:

```
library(overlap)
lynx<-timeRad[events$area==1 & events$species== 'Lynx lynx']
densityPlot(lynx, rug=T)
```

Figure 8.3 shows the activity pattern. Periods of 3 h before and after midnight (the area in grey) were repeated as a reminder that the activity patterns are circular. The original records are shown at the foot of Figure 8.3 as a 'rug'.

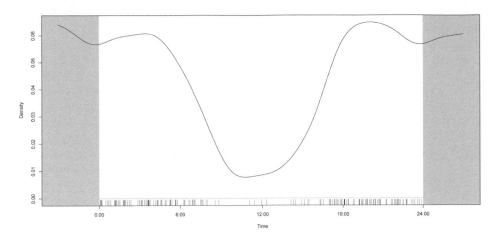

Figure 8.3 Fitted kernel density curve for Eurasian lynx in the northwestern Alps using default smoothing parameters. The original records of the lynx are shown at the foot of the chart as 'rugs'.

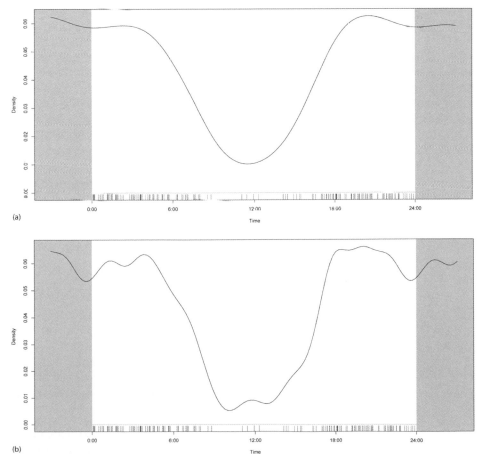

(a)

(b)

Figure 8.4 Kernel density fitted with (a) `adjust = 2` and (b) `adjust = 0.5`. The original records of the lynx are shown at the foot of the chart as 'rugs'.

The degree of smoothing of the density estimation is controlled by the argument `adjust` of the `densityPlot` function (values >1, the default value, give a flatter curve, values <1 give a more 'spiky' curve) as shown in Figure 8.4. It goes without saying that the choice of `adjust` affects the estimate of species' activity overlap.

```
densityPlot(lynx, rug=T, adjust=2)
densityPlot(lynx, rug=T, adjust=0.5)
```

8.6.2.3 Coefficient of overlap

The area under a density curve is by definition unity. The package `overlap` uses the coefficient of overlapping proposed by Weitzman (1970). As shown in Figure 8.5, the

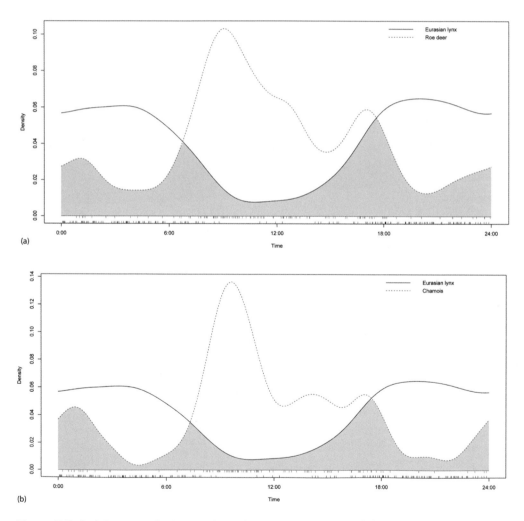

Figure 8.5 Activity curve for lynx and roe deer in (a) and lynx and chamois in (b) in the north-western Swiss Alps. The coefficient of overlapping equals the area in grey below both curves. The original records of the lynx (in black) and its two main prey species (in blue) are shown at the foot of the charts as 'rugs'.

coefficient of overlapping Δ is the area lying under both of the density curves. Five non-parametric estimators of the coefficient of overlapping were proposed by Schmid and Schmidt (2006). For circular distributions, the first two are equivalent and the third is unworkable (Ridout and Linkie 2009) and thus three were retained in the package overlap: $\hat{\Delta}_1$, $\hat{\Delta}_4$ and $\hat{\Delta}_5$. On the basis of simulations, Ridout and Linkie (2009) recommend using adjust = 0.8 to estimate $\hat{\Delta}_1$, adjust = 1 for $\hat{\Delta}_4$, and adjust = 4 for $\hat{\Delta}_5$. These are the default values for overlap functions. According to the simulations conducted by Ridout and Linkie (2009) and Meredith and Ridout (2014), the best estimator depends on the size of the smaller of the two samples: when the smaller has fewer than 50 records, $\hat{\Delta}_1$ performed best, while $\hat{\Delta}_4$ is better when the sample size is greater than 75. The coefficient of overlapping $\hat{\Delta}_5$ was found not to be useful as it turned out to be unstable – small, incremental changes in the data produce discontinuous changes in the estimate – and can give estimates >1.

We provide a practical example using the northwestern Alps data set. We will first extract the data for the Eurasian lynx and its prey, the roe deer, using the same procedure described above:

```
lynx<-timeRad[events$area==1 & events$species=='Lynx lynx']
roe<-timeRad[events$area==1 & events$species=='Capreolus
    capreolus']
```

To get the size of the smaller of the two samples, type:

```
min(length(lynx), length(roe))
[1] 116
```

Calculate the overlap with the three estimators:

```
lynxroeest<-overlapEst(lynx,roe)
lynxroeest
    Dhat1       Dhat4       Dhat5
0.5161881  0.5143836  0.4981527
```

Plot the curves:

```
overlapPlot(lynx,roe, rug=T)
legend('topright', c("Eurasian lynx", "Roe deer"), lty=c(1,2),
    col=c(1,4), bty='n')
```

Both of the samples have more than 75 observations, so the $\hat{\Delta}_4$ estimate, Dhat4 in R, is the most appropriate, giving an estimate of overlap of 0.51.

The best way to estimate the confidence interval of our coefficient of overlapping is to perform a bootstrap analysis. The usual bootstrap method assumes that the existing sample is fully representative of the population and generates a large number of new samples by randomly resampling observations with replacements from the original sample. However, this may not work very well when estimating activity patterns. For example, bootstrapping a nocturnal species with an observed activity range between 20:00 h and 06:00 h will never yield an observation outside that window, whereas a genuine sample from nature may do so. An alternative to strict bootstrapping is smoothed bootstrap. In this case a kernel density curve is fitted to the original data and then random

simulated observations are drawn from this distribution. Most simulated observations would fall in the same range as the observed ones, but a few will fall outside. In the overlap package, bootstraps are generated with resample and a smoothing argument can be specified: if smooth = TRUE (the default), smoothed bootstraps are generated.

For this example we will choose 10,000 smoothed bootstrap samples for Eurasian lynx and roe deer:

```
lynxboot<-resample(lynx,10000)
roeboot<-resample(roe, 10000)
dim(lynxboot)
[1]   168 10000
dim(roeboot)
[1]   116 10000
```

This produces matrices with a column for each bootstrap sample. The bootstrap sample size is the same as the original sample size. To generate estimates of the overlap from each pair of samples, these two matrices are passed to the function bootEst(). Since the size of the smaller of the two samples is greater than 75 only $\hat{\Delta}_4$ should be considered; consequently, the estimation of the others can be suppressed by setting adjust = c(NA, 1, NA), which considerably reduces the computation time.

```
lynxroe<-bootEst(lynxboot, roeboot, adjust=c(NA,1,NA))
```

The function bootEst() takes a while to generate estimates of the overlap from each pair of samples (about 1 min). The values resulting from the simulations may differ slightly; this is due to the random component of the bootstrapping process.

```
dim(lynxroe)
[1] 10000      3
BSmean<-colMeans(lynxroe)
BSmean
    Dhat1        Dhat4      Dhat5
       NA   0.5389412        NA
```

Note that the bootstrap mean, \overline{BS}, differs from $\hat{\Delta}$: 0.54 vs. 0.51. The difference, $\overline{BS} - \hat{\Delta}$, is the bootstrap bias and needs to be taken into account when calculating the confidence interval. Although the bootstrap bias would have been a good estimator of the original sampling bias, a better estimator of Δ would be $\tilde{\Delta} = 2\hat{\Delta} - \overline{BS}$. Simulations show that $\tilde{\Delta}$ results in higher root mean square deviation (RMSE) than the original $\hat{\Delta}$, so it is not recommended to apply this correction.

The following estimates of the confidence interval for the Eurasian lynx–roe deer data are obtained after having extracted the right column from the bootstrap matrix:

```
tmp<-lynxroe[,2]

bootCI(lynxroeest[2],tmp)
                   lower        upper
norm          0.3961900    0.5834619
norm0         0.4207476    0.6080195
```

```
basic        0.3966518   0.5825330
basic0       0.4216765   0.6075577
perc         0.4462341   0.6321153
```

`perc` corresponds to the 2.5% and 97.5% percentiles for a 95% confidence interval. As seen above, the bootstrap values differ from the estimates because of the bootstrap bias. Therefore the raw percentiles produced by `perc` need to be adjusted to account for this bias. The appropriate confidence interval is $perc - (\overline{BS} - \hat{\Delta})$ which corresponds to `basic0` in the `bootCI` output. An alternative approach is to consider the standard deviation of the bootstrap results, s_{BS}, as an estimate of the spread of the sampling distribution and then to calculate the confidence interval as $\hat{\Delta} \pm z_{\alpha/2} s_{BS}$. Using $z_{0.025} = 1.96$ gives the usual 95% confidence interval. This corresponds to `norm0` in the `bootCI` output. This procedure assumes that the sampling distribution is normal. If this is the case, `norm0` will be close to `basic0`; however, if the distribution is skewed, as will be the case if $\hat{\Delta}$ is close to 0 or 1, `basic0` is the better estimator. `bootCI` produces two further estimators: `basic` and `norm`. These are analogous to `basic0` and `norm0` but are intended for use with the bias-corrected estimator, $\tilde{\Delta}$. The coefficient of overlapping takes a value in the interval [0,1]. All the confidence interval estimators except `perc` involve additive correction which might result in values outside of this range. `bootCIlogit` can avoid this problem by carrying out the corrections on a logistic scale and back-transforming.

```
tmp<-lynxroe[,2]
bootCIlogit(lynxroeest[2],tmp)
                 lower       upper
norm         0.3958140   0.5837067
norm0        0.4199636   0.6077879
basic        0.3950336   0.5820023
basic0       0.4216721   0.6085658
perc         0.4462341   0.6321153
```

Based on simulations, Meredith and Ridout (2014) recommend using the `basic0` output from `bootCI` with smoothed bootstraps as the confidence interval. Users should, however, be aware that it will be too narrow for small sample sizes and Δ close to 1.

The overlaps for Eurasian lynx and chamois, including the estimation of the confidence interval, were estimated following the same procedure:

```
chamois<-timeRad[events$area==1 & events$species=='Rupicapra
    rupicapra']
min(length(lynx), length(chamois))
[1] 92
lynxchamoisest<-overlapEst(lynx,chamois)
lynxchamoisest
    Dhat1       Dhat4       Dhat5
0.4668991  0.4608886   0.4552277
```

```
overlapPlot(lynx,chamois, rug=T)
legend('topright', c("Eurasian lynx", "Chamois"), lty=c(1,2),
    col=c(1,4), bty='n')
chamoisboot<-resample(chamois, 10000)
lynxchamois<-bootEst(lynxboot, chamoisboot, adjust=c(NA,1,NA))
BSMean<-colMeans(lynxchamois)
BSMean
        Dhat1        Dhat4        Dhat5
           NA    0.4837872           NA

tmp<-lynxchamois[,2]
bootCI(lynxchamoisest[2],tmp)
                   lower        upper
norm            0.3400009    0.5359790
norm0           0.3628995    0.5588776
basic           0.3408138    0.5361775
basic0          0.3627010    0.5580647
perc            0.3855996    0.5809633

bootCIlogit(lynxchamoisest[2],tmp)
                   lower        upper
norm            0.3442636    0.5370180
norm0           0.3651424    0.5596105
basic           0.3451875    0.5380054
basic0          0.3642222    0.5586023
perc            0.3855996    0.5809633
```

The coefficient of overlap is purely descriptive and thus does not provide a threshold value below which two activity patterns might be significantly different. The function compareCkern() in the package activity (Rowcliffe 2015) provides a test probability that two sets of circular observations come from the same distribution. The computation takes about 6 min when reps is set to 10,000 (the progress is indicated via a progress bar).

```
library(activity)

compareCkern(lynx, roe, reps = 10000)
   Overlap               p
 0.5143836      0.0000000

compareCkern(lynx, chamois, reps = 10000)
   Overlap               p
 0.4608886      0.0000000

compareCkern(roe, chamois, reps = 10000)
   Overlap               p
 0.8618328      0.5773000
```

The results of both comparisons therefore support what can be seen in Figure 8.5, i.e. the activity pattern of the Eurasian lynx is significantly different from that of its two main prey species. However, the activity patterns of the two prey species do not differ significantly.

The significance of pairwise comparisons, either between relative activity levels at different times of day or between overall activity levels, can be estimated by a Wald test using the functions compareTimes(fit, times) and compareAct(fits) provided in the package activity (Rowcliffe 2015), respectively. A circular kernel density on the original data set is fitted by means of the fitact() function. Users should be aware of their sample size, because the coverage of the confidence interval seems to be better estimated with sample = "model" when the sample size is greater than 100–200, whereas smaller sample sizes should be investigated using sample = "data" (see the manual of activity written by Marcus Rowcliffe). In order to account for the previously mentioned issue of unrepresentative bootstrapping with regards to the true activity of the target species, we will choose the bootstrapping on a model basis for lynx and roe deer given their sample size (>100), which should represent an approach closer to the 'smooth' bootstrapping described above (M. Rowcliffe, personal communication 2015). Furthermore, it is important to notice that the parameter adj of the fitact() function is not the same as the parameter adjust of the densityPlot() and bootEst() functions in the package overlap written by Ridout and Linkie (2009). However, they are tightly linked since they are reciprocal to each other, e.g. if the argument adjust of fitact() equals 2, it will be ½ = 0.5 in the densityPlot() and bootEst() functions (M. Rowcliffe, personal communication 2015), allowing for straightforward compatibility between the two packages. Since the recommended value of adjust in the densityPlot() function is 1 for $\hat{\Delta}_4$ (default value in the function), adj in the fitact() function was set to 1, the reciprocal.

```
lynxactmod<-fitact(lynx,adj=1, sample="model", reps=10000)
```

The function fitact() takes a while to fit the circular kernel density to radian time-of-day data and to bootstrap the distribution (about 10 min). The progress of the computation is indicated via a progress bar.

```
lynxactmod
        act           se     lcl.2.5%    ucl.97.5%
0.64120570   0.05373172   0.48604744   0.69416682

roeactmod<-fitact(roe,adj=1, sample="model", reps=10000)
roeactmod
        act           se     lcl.2.5%    ucl.97.5%
0.40359416   0.06268712   0.33149550   0.57408550
```

Then the bootstrapped activity patterns of lynx and roe deer are compared by means of a Wald statistic on a chi-square distribution with one degree of freedom, in order to test for significant differences at the 5% level:

```
compareAct(list(lynxactmod,roeactmod))
          Difference          SE           W            p
1v2        0.2376115   0.08256374    8.282401   0.004003115
```

The Wald test indicates that the lynx and the roe deer in the western Swiss Alps do not show the same overall activity level. We perform the same analysis for the Chamois:

As the sample size for chamois is <100, the argument `sample` of the function was set to `data` (see above).

```
chamoisactmod<-fitact(chamois,adj=1, sample="data", reps=10000)
chamoisactmod
          act            se      lcl.2.5%     ucl.97.5%
   0.30531043    0.04970332    0.22110202    0.41541196

compareAct(list(lynxactmod,chamoisactmod))
              Difference            SE            W             p
   1v2         0.3358953    0.07310097     21.11356   4.328548e-06
```

Lynx and chamois also do not show the same overall activity level:

```
compareAct(list(roeactmod,chamoisactmod))
              Difference            SE            W             p
   1v2        0.09828373    0.07932442     1.535145     0.2153419
```

On the other hand, the overall activity level of both prey species does not differ significantly.

Another interesting investigation would be to compare the activity level of both the predator and the prey for different periods of the day (e.g. day, night, dawn and dusk). This could be performed by means of the function `compareTimes` (fit, times) of the package `activity`. It should, however, be stressed that cameras must be randomly distributed over the study area in order to obtain reliable inferences about the true activity pattern of a given species (see Chapters 5 and 6 for details on robust sampling designs). If the camera sites are chosen exclusively on forest roads and hiking trails, as in the present study, the resulting activity refers only to animal movements along roads and trails. Therefore overlap indicates the extent to which two species move on roads and trails at the same period of the day. According to this definition, a browsing roe deer and the lynx stalking it are probably both inactive. As a consequence, conclusions about temporal species interactions need to be drawn with care.

8.7 Conclusions

This chapter addressed the use of camera trapping in behavioural studies. We first discussed the advantages and disadvantages of camera trapping compared to other technologies to study animal behaviour (e.g. direct observations of animals in the field, bio-logging, animal-borne video and AVEDs). We highlighted that camera trapping is a valid alternative to other technologies as it combines many of their advantages while offering a number of improvements. Compared to other technologies, it is a highly non-invasive tool that can be applied over relatively large areas, and that potentially provides data for a larger number of individuals and a wider range of species. In recognition of the non-overlapping advantages of these technologies, researchers have started to combine camera trapping with telemetry and direct visual observations. However, camera

trapping alone has been applied to a range of behaviour studies such as reproduction, grouping behaviour, social structure, marking behaviour and activity patterns.

We then discussed the importance of choosing the site in relation to a variety of study aims and showed that behavioural studies have capitalised on the ability of camera traps to monitor fixed (i.e. predetermined) locations, where specific behaviours occur. As no study has directly tested the influence of sampling design on behavioural studies, we provided basic recommendations. We suggest that more research is needed to test the effect of sampling design on behavioural studies. Through case studies of the scent-marking behaviour of Eurasian lynx and the tree-rubbing behaviour of brown bears, we showed how camera trapping has the potential to reveal aspects not revealed through other technologies. The last example was chosen to highlight how camera trapping and appropriate analytical methods enable the study of temporal interactions between species. Finally, we are confident that in the near future newly developed video camera traps and the integration of camera trapping with other technologies will allow for enhanced use of this technology in behavioural studies.

Appendices

Appendix 8.1 Case study comparison of activity patterns: 'true_events_NWA2013_14.csv'
Appendix 8.2 R script: 'R script_chapter 8.R'

Acknowledgements

We are grateful to Clara Tattoni for her analysis of rubbing behaviour by brown bears featured as one of the case studies in this chapter and Marcus Rowcliffe for his help on the use of the R package 'activity'.

References

Aschoff, J. (1966) Circadian activity patterns with two peaks. *Ecology* 47: 657–662.

Baum, W.M. (2013) What counts as behavior? The molar multiscale view. *Behavior Analyst* 36: 283–293.

Bauer, J.W., Logan, K.A., Sweanor, L.L. and Boyce, W.M. (2005) Scavenging behavior in Puma. *Southwestern Naturalist* 50: 466–471.

Bleich, V.C., Bowyer, R.T. and Wehausen, J.D. (1997) Sexual segregation in mountain sheep: resources or predation? *Wildlife Monographs* 134: 1–50.

Boyer-Ontl, K.M. and Pruetz, J.D. (2014) Giving the forest eyes: the benefits of using camera traps to study unhabituated chimpanzees (*Pan troglodytes verus*) in southeastern Senegal. *International Journal of Primatology* 35: 881–894.

Breitenmoser-Würsten, C., Zimmermann, F., Ryser, A., Capt, S., Laass, J., Siegenthaler, A. and Breitenmoser, U. (2001) *Untersuchungen zur Luchspopulation in den Nordwestalpen der Schweiz 1997–2000.* KORA-Report 9. 88 pp. (in German; summary, tables and figures in English and French).

Bridges, A. and Noss, A. (2011) Behavior and activity patterns. In: A.F. O'Connell, J.D. Nichols and K.U. Karanth (eds), *Camera Traps in Animal Ecology Methods and Analyses.* New York: Springer. pp. 57–69.

Bridges, A.S. Vaughan, M.R. and Klenzendorf, S. (2004) Seasonal variation in American black bear *Ursus americanus* activity patterns: quantification via photography. *Wildlife biology* 10: 277–284.

Campbell, G., Kuehl, H., Diarrassouba, A., N'Goran, P.K. and Boesch, C. (2011) Long-term research sites as refugia for threatened and over-harvested species. *Biology Letters* 7: 723–726.

Carvalho, F., Carvalho, R., Galantinho, A., Mira, A. and Beja, P. (2015) Monitoring frequency influences the analysis if resting behaviour in a forest carnivore. *Ecological Research* 30: 537–546.

Chen, M.-T., Tewes, M.E., Pei, J.J. and Grassman, L.I. (2009) Activity patterns and habitat use of sympatric small carnivores in southern Taiwan. *Mammalia* 73: 20–26.

Clapham, M., Nevin, O.T., Ramsay, A.D. and Rosell, F. (2014) Scent-marking investment and motor patterns are affected by the age and sex of wild brown bears. *Animal Behaviour* 94: 107–116.

Cook, S.J., Hinch, S.G., Wikelski, M., Andrews, R.D., Kuchel, L.J., Wolcott, T.G. and Butler, P.J. (2004) Biotelemetry: a mechanistic approach to ecology. *Trends in Ecology and Evolution* 19: 334–343.

DeVault, T.L., Brisbin, I.L. and Rhodes, O.E. (2004) Factors influencing the acquisition of rodent carrion by vertebrate scavengers and decomposers. *Canadian Journal of Zoology* 82: 502–509.

Díaz, M., Torre, I., Peris, A. and Tena, L. (2005) Foraging behavior of wood mice as related to presence and activity of genets. *Journal of Mammalogy* 86: 1178–1185.

Di Bitetti, M.S., Paviolo, A. and De Angelo, C. (2006) Density, habitat use and activity patterns of ocelots (*Leopardus pardalis*) in the Atlantic Forest of Misiones, Argentina. *Journal of Zoology* 270: 153–163.

Di Bitteti, M.S., Di Blanco, Y.E., Pereira, J.A., Paviolo, A. and Pérez I.J. (2009) Time partitioning favors the coexistence of sympatric crab-eating foxes (*Cerdocyon thous*) and Pampas foxes (*Lycalopex gymnocercus*). *Journal of Mammalogy* 90: 479–490.

Di Bitteti, M.S., De Angelo, C.D., Di Blanco, Y.E. and Paviolo, A. (2010) Niche partitioning and species coexistence in a Neotropical felid assemblage. *Acta Oecologia* 36: 403–412.

Enderson, J.H., Temple, S.A. and Swartz, L.G. (1972) Time-lapse photographic records of nesting peregrine falcons. *Living Bird* 11: 113–128.

Foster, V.C., Sarmento, P., Sollmann, R., Tôrres, N., Jácomo, A.T.A., Negrões, N., Fonseca, C. and Silveira, L. (2013) Jaguar and puma activity patterns and predator-prey interactions in four Brazilian biomes. *Biotropica* 45: 373–379.

Galvis, N., Link, A. and Di Fiore, A. (2014) A novel use of camera traps to study the demography and life history in wild animals: a case study of spider monkeys (*Ateles belzebuth*). *International Journal of Primatology* 35: 908–918.

Gerber, B.D., Karpanty, S.M. and Randrianantenaina, J. (2012) Activity pattern of carnivores in the rain forests of Madagascar: implications for species coexistence. *Journal of Mammalogy* 93: 667–676.

Gosling, L.M. and Roberts, S.C. (2001a) Scent-marking by male mammals: cheat-proof signals to competitors and mates. *Advances in the Study of Behavior* 30: 169–217.

Gosling, L.M. and Roberts, S.C. (2001b) Testing ideas about the function of scent marks in territories from spatial patterns. *Animal Behaviour* 62: F7–F10.

Gužvica, G., Bošnjak, I., Bielen, A., Babić, D., Radanović-Gužvica, B. and Šver, L. (2014) Comparative analysis of three different methods for monitoring the use of green bridges by wildlife. *PLoS ONE* 9: e106194.

Haller, H. and Breitenmoser, U. (1986) Zur Raumorganisation der in den Schweizer Alpen wiederangesiedelten Population des Luchses *Lynx lynx*. *Zeitschrift für Säugetierkunde* 51: 289–311 (in German).

Hayward, M.W. and Slotow, R. (2009) Temporal partitioning of activity in large African carnivores: tests of multiple hypotheses. *South African Journal of Wildlife Research* 39: 109–125.

Hebblewhite, M. and Haydon, D.T. (2010) Distinguishing technology from biology: a critical review of the use of GPS telemetry data in ecology. *Philosophical Transactions of the Royal Society B – Biological Sciences* 365: 2303–2312.

Huang, Z.-P., Qi, X.-G., Garber, P.A., Jin, T., Guo, S.-T., Li, S. and Li, B.-G. (2014) The use of camera traps to identify the set of scavengers preying on the carcass of a golden snub-nosed monkey (*Rhinopithecus roxellana*). *PLoS ONE* 9: e87318.

Hutchinson, G.E. (1978) *An Introduction to Population Ecology*. New Haven, CT: Yale University Press.

Jácomo, A.T.A., Silveira, L. and Diniz-Filho, J.A.F. (2004) Niche separation between the maned wolf (*Chrysocyon brachyurus*), the crab-eating fox (*Dusicyon thous*) and the hoary fox (*Dusicyon vetulus*) in central Brazil. *Journal of Zoology* 262: 99–106.

Juillard, M. (1987) La photographie sur pellicule infrarouge, une méthode pour l'étude du régime alimentaire des oiseaux cavicoles. *Terre et Vie* 84: 223–287.

Kamler, J.F., Johnson, A., Vongkhamheng, C. and Bousa, A. (2012) The diet, prey selection, and activity of dholes (*Cuon alpinus*) in northern Laos. *Journal of Mammalogy* 93: 627–633.

Kays, R., Tilak, S., Crofoot, M., Fountain, T., Obando, D., Ortega, A., Kuemmeth, F., Mandel, J., Swenson, G., Lambert, T., Hirsch, B. and Wikelski, M. (2011) Tracking animal location and activity with an automated radio telemetry system in a tropical rainforest. *Computer Journal* 54: 1931–1948.

Knight, J. (2009) Making wildlife viewable: habituation and attraction. *Society and Animals* 17: 167–184.

Kronfeld-Schor, N. and Dayan, T. (2003) Partitioning of time as an ecological resource. *Annual Review of Ecology Evolution and Systematics* 34: 153–181.

Kuijper, D.P.J., Verwijmeren, M., Churski, M., Zbyryt, A., Schmidt, K., Jedrzejewska, B. and Smit, K. (2014) What cues do ungulates use to assess predation risk in dense temperate forests? *PLoS ONE* 9: e84607.

Leuchtenberger, C., Zucco, C.A., Ribas, C., Magnusson, W. and Mourão, G. (2014) Activity patterns of giant otters recorded by telemetry and camera traps. *Ethology Ecolgy & Evolution* 26: 19–28.

Linkie, M. and Ridout, M.S. (2011) Assessing tiger–prey interactions in Sumatran rainforests. *Journal of Zoology* 284: 224–229.

Löttker, P., Rummel, A., Traube, M., Stache, A., Šustr, P., Müller, J. and Heurich, M. (2009) New possibilities of observing animal behaviour from a distance using activity sensors in GPS-collars: an attempt to calibrate remotely collected activity data with direct behavioural observations in red deer *Cerphus elaphus*. *Wildlife Biology* 15: 425–434.

Lucherini, M., Reppucci, J., Walker, R., Villalba, M., Wurstten, A., Gallardo, G., Iriarte, A., Villalobos, R. and Perovic, P. (2009) Activity pattern segregation of carnivores in the high Andes. *Journal of Mammalogy* 90: 1404–1409.

Macdonald, D.W. (1985) The carnivores: order carnivora. In: R.E Brown and D.W. Macdonald (eds), *Social Odours in Mammals*. Oxford: Clarendon Press. pp. 619–722.

MacKenzie, D.I., Bailey, L.L. and Nichols, J.D. (2004) Investigating species co-occurrence patterns when species are detected imperfectly. *Journal of Animal Ecology* 73: 546–555

Major, R.E. and Gowing, G. (1994) An inexpensive photographic technique for identifying nest predators at active nests of birds. *Wildlife Research* 21: 657–666.

Meek, P.D., Ballard, G.-A., Fleming, P.J.S., Schaefer, M., Williams, W. and Falzon, G. (2014a) Camera traps can be heard and seen by animals. *PLoS ONE* 9: e110832.

Meek, P.D., Ballard, G., Claridge, A., Kays, R., Moseby, K., O'Brien, T., O'Connell, A., Sanderson, J., Swann, D.E., Tobler, M. and Townsend, S. (2014b) Recommended guiding principles for reporting on camera trapping research. *Biodiversity and Conservation* 23: 2321–2343.

Meredith, M. and Ridout, M. (2014) Overview of the `overlap` package. http://cran.r-project.org/web/packages/overlap/vignettes/overlap.pdf (accessed 31 May 2015)

Moll, R.G., Millspaugh, J.J., Beringer, J., Startwell, J. and He, Z. (2007) A new 'view' of ecology and conservation through animal-borne video systems. *Trends in Ecology and Evolution* 22: 660–668.

Monterroso, P., Alves, P.C. and Ferreras, P. (2014) Plasticity in circadian activity patterns of mesocarnivores in Southwestern Europe: implications for species coexistence. *Behavioral Ecology and Sociobiology* 68: 1403–1417.

Mori, E., Menchetti, M. and Balestrieri, A. (2015) Interspecific den sharing: a study on European badger setts using camera traps. *Acta Ethologica* 18: 121–126.

Miura, S., Yasuda, M. and Ratnam, L.C. (1997) Who steals the fruits? Monitoring frugivory of mammals in a tropical rain-forest. *Malayan Nature Journal* 50: 183–193.

Nichols, J.D., O'Connell, A.F. and Karanth, K.U. (2011) Camera traps in animal ecology and conservation: what's next? In: A.F. O'Connell, J.D. Nichols and K.U. Karanth (eds), *Camera Traps in Animal Ecology Methods and Analyses*. New York: Springer. pp. 253–263.

Nouvellet, P., Rasmussen, G.S.A., Macdonald, D.W. and Courchamp, F. (2012) Noisy clocks and silent sunrises: measuremnt methods of daily activity pattern. *Journal of Zoology* 286: 179–184.

Núñez, R., Miller, B. and Lindzey, F. (2000) Food habits of jaguars and pumas in Jalisco, Mexico. *Journal of Zoology* 252: 373–379.

Pesenti, E. and Zimmermann, F. (2013) Density estimation of Eurasian lynx *Lynx lynx* in the Swiss Alps. *Journal of Mammalogy* 94: 73–81.

Ramesh, T., Kalle, R., Sankar, K. and Qureshi, Q. (2012) Spatio-temporal partitioning among large carnivores in relation to major prey species in Western Ghats. *Journal of Zoology* 287: 269–275.

Ridout, M.S. and Linkie, M. (2009) Estimating overlap of daily activity patterns from camera trap data. *Journal of Agricultural, Biological, and Environmental Statistics* 14: 322–337.

Ropert-Coudert, Y. and Wilson, R.P. (2005) Trends and perspectives in animal-attached remote sensing. *Frontiers in Ecology and the Environment* 3: 437–444.

Ross, J., Hearn, A.J., Johnson, P.J. and Macdonald, D.W. (2013) Activity patterns and temporal avoidance by prey in response to Sunda clouded leopard predation risk. *Journal of Zoology* 290: 96–106.

Rowcliffe, J.M. (2015). Package 'activity'. http://cran.r-project.org/web/packages/activity/activity.pdf (accessed 31 May 2015).

Rowcliffe, J.M., Field, J., Turvey, S.T. and Carbone, C. (2008) Estimating animal density using camera traps without the need for individual recognition. *Journal of Applied Ecology* 45: 1228–1236.

Rowcliffe, J.M., Kays, R., Kranstauber, B., Carbone, C. and Jansen, P.A. (2014) Quantifying levels of animal activity using camera trap data. *Methods in Ecology and Evolution* 5: 1170–1179.

Royama, T. (1970) Factors governing the hunting behaviour and selection of food by great tit (*Parus major* L.). *Journal of Animal Ecology* 39: 110–111.

Schmid, F. and Schmidt, A. (2006) Nonparametric estimation of the coefficient of overlapping – theory and empirical application. *Computational Statistics and Data Analysis* 50: 1583–1596.

Story, G., Driscoll, D. and Banks, S. (2014) What can camera traps tell us about the diurnal activity of the nocturnal bare-nosed wombat (*Vombatus ursinus*)? In: P.D. Meek, A.G. Ballard, P.B. Banks, A.W. Claridge, P.J.S. Fleming, J.G. Sanderson and D.E. Swann (eds), *Camera Trapping Wildlife Management and Research*. Collingwood, Australia: CSIRO Publishing. pp. 35–43.

Séquin, E.S., Jaeger, M.M., Brussard, P.F. and Barrett, R.H. (2003) Wariness of coyotes to camera traps relative to social status and territory boundaries. *Canadian Journal of Zoology* 81: 2015–2025.

Soberon, J. (2007) Grinnellian and Eltonian niches and geographic distributions of species. *Ecological Letters* 10: 1115–1123.

Suselbeek, L., Emsens, W.-J., Hirsch, B.T., Kays, R., Rowcliffe, J.M., Zamora-Gutierrez, V. and Jansen, P.A. (2014) Food acquisition and predator avoidance in a Neotropical rodent. *Animal Behaviour* 88: 41–48.

Tattoni, C., Bragalanti, N., Groff, C. and Rovero, F. (2015) Patterns in the use of rub trees by the Eurasian brown bear. *Hystrix: the Italian Journal of Mammalogy* doi:10.4404/hystrix-26.2-11414.

Taylor, B. and Goldingay, R. (2014) Using camera traps to monitor use of roadside glide poles and rope canopy-bridges by Australian gliding mammals. In: P.D. Meek, A.G. Ballard, P.B. Banks, A.W. Claridge, P.J.S. Fleming, J.G. Sanderson and D.E. Swann (eds), *Camera Trapping Wildlife Management and Research*. Collingwood, Australia: CSIRO Publishing. pp. 245–252.

Vernes, K., Smith, M. and Jarman, P.J. (2014) A novel camera-based approach to understanding the foraging behaviour of mycophagous mammals. In: P.D. Meek, A.G. Ballard, P.B. Banks, A.W. Claridge, P.J.S. Fleming, J.G. Sanderson and D.E. Swann (eds), *Camera Trapping Wildlife Management and Research*. Collingwood, Australia: CSIRO Publishing. pp. 215–224.

Vogt, K., Zimmermann, F., Kölliker, M. and Breitenmoser, U. (2014) Scent-marking behaviour and social dynamics in a wild population of Eurasian lynx *Lynx lynx*. *Behavioural Processes* 106: 98–106.

Wald, A. and Wolfowitz, J. (1940) On a test whether two samples are from the same population. *Annals of Mathematical Statistics* 11: 147–162.

Wand, M.P. and Jones, M.C. (2005) *Kernel Smoothing*. London: Chapman & Hall.

Weitzman, M.S. (1970) *Measure of the Overlap of Income Distribution of White and Negro Families in the United States*. Technical Report No. 22, US Department of Commerce, Bureau of Census, Washington, DC

Zimmermann, F., Molinari-Jobin, A., Ryser, A., Breitenmoser-Würsten, Ch., Pesenti, E. and Breitenmoser, U. (2011) Status and distribution of the lynx (*Lynx lynx*) in the Swiss Alps 2005–2009. *Acta Biologica Slovenica* 54: 74–84.

Zimmermann, F., Breitenmoser-Würsten, C., Molinari-Jobin, A. and Breitenmoser, U. (2013) Optimizing the size of the area surveyed for monitoring a Eurasian lynx (*Lynx lynx*) population in the Swiss Alps by means of photographic capture-recapture. *Integrative Zoology* 8: 232–243.

9. Community-level occupancy analysis

Simone Tenan

9.1 Introduction

Static and dynamic occupancy models were orginally intended to investigate occurrence and occupancy dynamics of single species (see Chapter 6). Among the wide variety of extensions proposed for this class of models, those allowing the investigation of community-level metrics and dynamics are certainly relevant for readers who want to extend inference to a higher hierarchical level of ecological organisation, from populations of individuals to populations of species (i.e. community) or populations of spatially organised communities (metacommunities) (Royle and Dorazio 2008). In fact, as ecological systems are fundamentally hierarchical, the correspondence between ecological levels of organisation (population, metapopulation, community and metacommunity) and the levels of a hierarchical model can be very important in the modelling process. Population size, i.e. the number of individuals comprising a population, can be viewed as conceptually equivalent to species richness, which defines the number of species in a community. When our system state is allowed to vary temporally, the classic population dynamic parameters, survival and recruitment of individuals, have their analogues in local extinction and local colonisation of species, respectively, and can provide a description of changes in the pool of species over time. In addition, sampling a population or a community results in binary data (i.e. mutually exclusive outcomes, such as 'observed' and 'not observed') on individuals or species and we can thus use similar model formulations to describe the observation process relating to ecological systems at different scales. This conceptual equivalence, i.e. the fact that the observation and the state models often translate across systems (from populations to metacommunities), facilitated the extension of single-species occupancy models to a multi-species framework. The latter is flexible enough to be relevant for abundance, occurrence and species richness, the three main state variables in ecology (Royle and Dorazio 2008). It is also important to recall, as additional background information, that occupancy models are hierarchical models, expressed using the so-called 'state-space' formulation (e.g. De Valpine and Hastings 2002) whereby two models are in fact specified, one for the latent ecological or state process (the primary object of inference) and, conditional on that, a model for the observation process.

In this chapter, we extend the single-species occupancy models described in Chapter 6 to a hierarchical, multi-species framework that allows modelling of species occurrence separately from detectability and, at the same time, can be used to estimate community-level parameters and derive measures of community size and structure. The approach can thus be useful to study spatial and temporal changes in biodiversity. We illustrate static (single-season) and dynamic (multi-season) models using the same camera trapping data for a community of medium-to-large mammals collected in the Udzungwa Mountains of Tanzania in the framework of the TEAM Network, and already showcased in Chapters 5 and 6.

9.2 Measuring biodiversity while accounting for imperfect detection

Measuring and assessing biological diversity and understanding the relationship between living organisms and their environment are major goals in ecology. Biodiversity is commonly measured by species richness, Shannon entropy (also called Shannon's diversity index or Shannon–Wiener index) and the Gini–Simpson index (e.g. Jost 2006; Chao et al. 2014). Species richness, i.e. the number of species in a community, is the simplest and most common measure of biodiversity. However, species richness alone does not distinguish between species with different abundances. Two communities may contain the same number of species, but their composition in terms of the number of individuals belonging to each species can differ, making one community more diverse than the other (Gotelli et al. 2013). In other words, species richness counts all species equally, weighting rare species the same as common ones. However, the Shannon entropy and the Gini–Simpson index incorporate information about the relative abundance of species. The Shannon entropy 'quantifies the uncertainty in the species identity of a randomly chosen individual in the assemblage', whereas the Gini–Simpson index 'measures the probability that two randomly chosen individuals (selected with replacement) belong to two different species' (Gotelli et al. 2013). Variations to the latter index include the Simpson concentration, the inverse Simpson concentration, the second-order Renyi entropy or the Hurlebert–Smith–Grassle index (Jost 2006).

A common attribute of these estimators is that they do not take imperfect detection into account (see Chapter 6 for details on imperfect detection) and they are sensitive to sample size. Concepts such as rarefaction and extrapolation have been proposed to deal with unequal sample sizes (Chao and Jost 2012) but the issue of imperfect detection has been solved only with the advent of the multi-species occupancy framework (Dorazio and Royle 2005). In general, multi-species occupancy models provide more precise and less biased estimates of species richness than single-visit approaches, such as the jackknife and the Chao estimators (Kéry and Royle 2008; McNew and Handel 2015). Since detectability will not be equal across sites, species and sampling occasions, diversity measures should account for the mismatch between the proportion in which individuals are detected vs. their actual proportion in the community. In fact, information on communities is often available as apparent presence or absence of each species. However, a proportion of zeros in these data will likely stem from an imperfect detection process, and these false zeros have to be separated from true zeros, which are associated with the absence of a species. Bias in biodiversity estimators can be higher in communities that contain a large proportion of rare or difficult-to-detect species. In occupancy models we can account for this source of bias since species occurrence and detection can be estimated separately

within the same framework using presence–absence data or, more precisely, detection/non-detection data.

In addition to the above-mentioned measures of biodiversity, many others can be derived from a multi-species occupancy model, such as alpha, beta and gamma diversities, and the Sorensen and Jacard coefficients (Magurran and McGill 2011). For an example of beta diversity derivation, see Dorazio *et al.* (2011). Furthermore, Broms *et al.* (2014) showed that Hill numbers can also be easily derived through a multi-species occupancy model. Hill numbers provide a unifying framework to summarise all three measures of biodiversity (alpha, beta and gamma diversity) into a single expression (Hill 1973; Chao *et al.* 2014).

9.3 Static (or single-season) multi-species occupancy models

In an occupancy-based approach to modelling communities, both community- and species-level attributes can be estimated, as these are combined in the same framework. We need replicated detection/non-detection data to estimate species occurrence separately from detectability and to resolve the ambiguity of an observed zero, which can indicate either that the species is absent, or present but not detected. All models developed for the analysis of replicated detection–non-detection data include parameters for an incidence matrix (e.g. Gotelli 2000) which contains the binary occupancy state (presence or absence) for each species at each sample location. As a consequence of imperfect detection the incidence matrix is only partly observed, but can be estimated along with any quantity derived from the matrix itself, such as species richness and other diversity measures. Multi-species occupancy models were first developed by Dorazio and Royle (2005) and Dorazio *et al.* (2006). Further extensions included spatial covariates of occupancy and detectability (Royle and Dorazio 2008; Kéry and Royle 2009) and quantification of anthropogenic and natural factors affecting community size and other community-level attributes (Burton *et al.* 2012; Zipkin *et al.* 2009; 2010; Carrillo-Rubio *et al.* 2014).

We start from data collected at multiple sample locations, or sites, which can correspond to an array of J cameras. The latter remain active for a certain number of days K, and thus each site is sampled on $K > 1$ occasions. The data we collect (y_{ij}) are encounter frequencies of species $i = 1, \ldots, n$ at each of $j = 1, \ldots, J$ sites, sampled $k = 1, \ldots, K$ times, and can be summarised in a $n \times J$ matrix (\mathbf{Y}) so that rows are associated with distinct species and columns with distinct sites. Note that the number of visits, K, need not to be identical for all sites, but here we assume K is fixed for the sake of clarity. We assume that the occupancy state of each species, and thus the number of species, at each sample site remains constant during the time required to perform the K replicate observations.

The detection frequency matrix \mathbf{Y} is a subset of the (imperfectly observable) $N \times J$ matrix \mathbf{Z} of latent occupancy states of each species in each site (z_{ij}). N is the actual number of species in the community, and the number of undetected species (with all-zero encounter histories) is $N - n$. To estimate the 'true' occupancy states in \mathbf{Z} we use the repeated detection/non-detection information contained in \mathbf{Y}. Note that in estimating species richness N, the number of observed species n represents a lower bound for the estimate of N.

Multi-species occupancy models cannot be fitted in a classical (or frequentist) framework since the evaluation of the marginal likelihood function involves analytically intractable, high-dimensional integrations. We can, however, adopt a Bayesian mode

of inference with Markov chain Monte Carlo (MCMC) methods (Robert and Casella 2004) (Box 6.1). However, one main challenge in this framework is that the dimension of the parameter vector for community size N can change at every iteration of the MCMC algorithm. The solution adopted to overcome this difficulty is called parameter-expanded data augmentation (Tanner and Wong 1987; Dorazio and Royle 2005; Dorazio *et al.* 2006; Royle *et al.* 2007; Royle and Young 2008; Royle and Dorazio 2011). In practice, this technique implies the addition of an arbitrary number of all-zero trap frequencies, which can be seen as potentially unobserved species, to the detection matrix \mathbf{Y}, and thus the analysis of the augmented matrix. The latter has dimension $M \times J$, where $M \gg N$,[1] and we can estimate which of the $M - n$ species (rows of the augmented data set) are members of the community (sampling zeros) or not (structural zeros). We do this by adding an indicator ω_i for whether a row of the augmented data matrix represents a 'real' species ($\omega_i = 1$) or not ($\omega_i = 0$), for $i = 1, \ldots, M$. By assuming $\omega_i \sim \text{Bern}(\Omega)$ we can estimate the probability Ω that the species is a member of the community of size N.

Note that data augmentation converts the problem of estimating N into the equivalent problem of estimating Ω, and species richness N is computed as a derived parameter by summing up the latent indicators ω_i, since the expectation of N is equal to $M\Omega$ (Kéry and Schaub 2012). Elements of the augmented matrix \mathbf{Z}, of dimension $M \times J$, indicate whether species i is present at sample site j ($z_{ij} = 1$) or not ($z_{ij} = 0$). Since z_i is defined conditional on the value of ω_i, each element of z_i is equal to zero if species i is not a member of the community (i.e. $\omega_i = 0$), with \mathbf{Z} treated as a random variable: $z_{ij} \sim \text{Bern}(\psi_{ij}\, \omega_i)$. Matrix \mathbf{Z} can be used as the already-mentioned incidence matrix to derive community-level attributes. For instance, the number of species present at each sample site (alpha diversity) is obtained by summing the columns of \mathbf{Z}. We can also express differences in species composition among sites (beta diversity) by comparing columns of \mathbf{Z}. For an example of derivation of alpha, gamma and beta diversity (Jaccard index), see Dorazio *et al.* (2011). Dorazio and Royle (2005) and Royle and Dorazio (2008) report the estimation of the similarity of species present at two different sampling locations, the Dice (1945) index of similarity, also known as the coefficient of community (Pielou 1977). In addition, Dorazio *et al.* (2006) derive species-accumulation curves (Gotelli and Colwell 2001) from estimates of species richness and species occurrence. Species-accumulation curves can be used to compare the size of different communities at similar levels of sampling effort, to improve the efficiency of future surveys, and to select priority areas for conservation (Dorazio *et al.* 2006).

Conditional on the state model for z_{ij}, the simplest assumption we can make about the observation process is that if species i is present at site j (i.e. $z_{ij} = 1$) its probability of capture p_{ij} is the same at each sampling site and occasion: $y_{ij} \sim \text{Bin}(K; p_{ij}\, z_{ij})$. Note that if a species is absent at site j, i.e. $z_{ij} = 0$, then the camera trap in that site will not record contacts for that species and the probability that $y_{ij} = 0$ is 1.

In many cases covariates are thought to affect species occurrence and detection. We can easily incorporate site- and/or replicate-level covariates, such as measures of environmental features or sampling effort. For instance, we can assume that detectability is affected by seasonality, in relation to species phenology, and occurrence differs with elevation. We might also expect a peak in both detection and occurrence for certain values of the related covariate, and thus include a quadratic effect. We can write the

[1] M can be either arbitrary large, or can be set on the basis of prior information about the total diversity of species known for the region (Dorazio *et al.* 2011).

relationships in two linear predictors for the observation and the state process, on the logit-scale, as follows:

$$\text{logit}(p_{ijk}) = a_{i0} + a_{i1} \text{ date}_{jk} + a_{i2} \text{ date}_{jk}^2 \tag{9.1}$$
$$\text{logit}(\psi_{ij}) = b_{i0} + b_{i1} \text{ elevation}_j + b_{i2} \text{ elevation}_j^2. \tag{9.2}$$

Note that detection can vary among species (i), sites (j) and sampling occasions (k), whereas occurrence has to be fixed for all replicates. In this case intercepts a_{i0} and b_{i0} denote, respectively, the probability (on the logit-scale) of occurrence and detection of species i at the average value of the covariates. It is advisable to standardise covariates to have zero mean and unit variance, in order to avoid numerical issues during the calculations.

At this point, further model assumptions are needed (i) to characterise the heterogeneity in occurrence and detectability among species, and (ii) to estimate the occurrence of species members of the community that are not observed at any sampling site. A common approach is to assume ecological similarity among species, that is to say that species are likely to have a similar, but not identical, response to environmental changes (Dorazio *et al.* 2006, 2011; Kéry and Royle 2009). We must note that in the case of interspecific interactions where occurrence of a species is affected by the presence or absence of another species, as expected between competing species or between predator and prey, the ecological similarity assumption does not hold and patterns of co-occurrence should instead be considered (MacKenzie *et al.* 2004; Waddle *et al.* 2010). When the assumption of ecological similarity is reasonable, we can model unobserved sources of heterogeneity in occurrence and detection among species by adding one hierarchical level and assuming that the species-specific parameters in the related linear predictors (such as a_i and b_i in eqs (1) and (2)) are independent random effects. That can be written as $a_{il} \sim \text{Normal}(\alpha_l, \sigma_{al}^2)$ with $l = 1, ..., P$ (where P is the number of parameters in the linear predictor), and $b_{il} \sim \text{Normal}(\beta_l, \sigma_{bl}^2)$, for detectability and occurrence parameters, respectively. We can thus estimate the community-level hyperparameters, the means (α_l, β_l) and variances (σ_{al}^2, σ_{bl}^2) of the distributions. In this way we can estimate parameters for species observed a small number of times (often the rarest ones) or never observed, in a framework that borrows information from any individual species in the sample. In this way, occurrence and detectability estimates of individual species depend not only on the data of that species but also on the information available for every other species. In practice, species-specific estimates are 'shrunk' toward the mean parameter value of the community.

In addition, we might expect that occupancy and detection probability increase as the abundance of species increase, and the model can thus be extended to define a correlation structure between the two probabilities. For further details about the model component for heterogeneity among species and related distributional assumptions, see e.g. Dorazio (2007) and Royle and Dorazio (2008).

Different approaches exist to assess the effect of covariates on the occurrence and detectability of each species, in a Bayesian framework. Unfortunately, these approaches can be difficult to implement and there is no 'canned' method for model selection like the AIC in a classical analysis based on maximum likelihood. Readers who want to deepen their understanding of Bayesian model selection and averaging can refer to Link and Barker (2006), Link and Barker (2009), O'Hara and Sillanpää (2009), Hooten and Hobbs (2014) and Tenan *et al.* (2014). For a direct application of a Bayesian variable selection approach to multi-species occupancy models, see Dorazio *et al.* (2011) and Burton *et al.* (2012). In conclusion, we want to emphasise the usefulness of multi-species occupancy

models in estimating the community's incidence matrix while accounting for imperfect detection. The estimated incidence matrix is key, since all measures of biodiversity are directly derived from it. Note that, under the multi-species occupancy framework, biodiversity measures are derived for a single spatial unit or 'region' sampled at different sites. Single-region models have been recently extended to simultaneously estimating species richness across communities from multiple regions. This new, multi-region framework allows direct modelling of spatial variation in species richness using region-specific covariates, representing a formal mechanism to test hypotheses on the drivers of geographic variation of community size and structure (Sutherland *et al.* 2016; Tenan *et al.* 2016).

9.3.1 Case study

The case study is based on the same dataset from the TEAM Network project in the Udzungwa Mountains of Tanzania as used for Chapters 5 and 6 (file 'team.yr2009_2013. csv'), and contains five years of repeated camera trapping at 60 locations within the target forest. The ensuing analysis requires the extraction from the database of yearly matrices of species (arranged in rows) by sampling locations (columns) and populated by the number of 'independent' events, i.e. separated by 1 day (see Chapter 5 for details of this raw metric). The analysis also requires the sampling effort (camera days) by sampling unit.

We first load the TEAM libraries, the data and the packages for data checking and inclusion of taxonomic attributes as done in Chapters 5 and 6:

```
source("TEAM library 1.7.R")
library(chron)
library(reshape)
team_data <-read.csv(file="teamexample.csv",
    sep=",",h=T,stringsAsFactors=F)
iucn.full<-read.csv("IUCN.csv", sep=",",h=T)
iucn<-iucn.full[,c("Class","Order","Family","Genus","Species")]
team<-merge(iucn, team_data, all.y=T)
```

We then check the data, remove records of humans and extract the mammals only:

```
data<-fix.dta(team)
data<- droplevels(data[data$bin!="Homo sapiens", ])
mam<-data[data$Class=="MAMMALIA",]
```

We can now extract the events year by year (the code below refers to the baseline year, 2009), using the same function `event.sp` as in Chapter 5. Note that the `thresh` value set at 1440 min is indeed equivalent to 1 day:

```
ev2009<-event.sp(dtaframe=mam, year=2009.01, thresh=1440)
rownames(ev2009)<-ev2009[["Sampling.Unit.Name"]]
```

The resultant matrix needs to be transposed for the subsequent analysis, before being saved as a .TXT file:

```
sp<-t(ev2009)
```

```
write.table(sp,"spudz_2009.txt")
```

The sampling effort is also extracted and saved in .TXT, using the function `cam.days`:

```
camera_days<-cam.days(data,2009.01)
write.table(camera_days, file="camera_days_2009.txt",quote=F,
    sep="\t",row.names = F)
```

Detection frequencies collected in 2009 are related to 58 camera trap points, whereby each camera trap was active from a minimum of 7 to a maximum of 37 days (median 31). In total, 26 species of mammals were detected.

As a simple case study, we assume constant occurrence and detection probabilities across sites, i.e. logit(ψ_{ij}) = b_{i0} and logit(p_{ij}) = a_{i0}, with b_{i0} ~ Normal(β_0, σ_{b0}^2) and a_{i0} ~ Normal(α_0, σ_{a0}^2).

The model is implemented in the program JAGS (Plummer 2003; see also Chapter 6 and Box 6.1), which we execute from R (R Core Team 2012; see also the case study in Chapter 6, section 6.6.2) with the R packages `rjags` (Plummer 2013) and `dclone` (Sólymos 2010). We can reduce computational time by parallelising the process with the `jags.parfit()` function of the `dclone` package. This allows us to use one CPU per chain. Summaries of the parameter posterior distribution are calculated from three Markov chains initialised with random starting values, run 30,000 times after a 10,000 burn-in and thinned every 10 draws. The script is shown below, with lines beginning with '#' being descriptive notes for the ensuing code (see the file in Appendix 9.1 for a downloadable version of the R script).

```
# load detection data

Y <- as.matrix(read.table(file="spudz_2009.txt",header=T,sep="
    "))
# load effort
effort <- read.table(file="camera_days_2009.txt",header=T,
    sep="\t")
# load libraries
library(rjags)
library(dclone)
# set seed
set.seed(1980)
# BUGS model
modelFilename = "smsom.txt"
cat("
model {
# Priors for community-level parameters
omega ~ dunif(0,1)
psi.mean ~ dunif(0,1)
beta <- log(psi.mean) - log(1-psi.mean)      # logit(psi.mean)
p.mean ~ dunif(0,1)
alpha <- log(p.mean) - log(1-p.mean) # logit(p.mean)
```

```
sigma.psi ~ dunif(0,10)
sigma.p ~ dunif(0,10)
tau.psi <- pow(sigma.psi,-2)
tau.p <- pow(sigma.p,-2)
# Likelihood
for (i in 1:M) {
   w[i] ~ dbern(omega)
   # occupancy
   phi[i] ~ dnorm(beta, tau.psi)
   # detectability
   eta[i] ~ dnorm(alpha, tau.p)

   logit(psi[i]) <- phi[i]
   mu.psi[i] <- psi[i]*w[i]
   logit(p[i]) <- eta[i]

   for (j in 1:n.site) {
        Z[i,j] ~ dbern(mu.psi[i])
        mu.p[i,j] <- p[i]*Z[i,j]
        Y[i,j] ~ dbin(mu.p[i,j], K[j])
   }
   }
# compute species richness
   N <- sum(w[])
   }
", fill=TRUE, file=modelFilename)
# number of sampling occasions for each trap
   K <- effort$ndays
# number of traps
nsites <- dim(Y)[2]
# number of observed species
nspecies <- dim(Y)[1]
# Augment data set
nzeros <- 100
   Y_aug <- rbind(Y,matrix(0,nrow=nzeros,ncol=nsites))
# Latent states
w <- c(rep(1, nspecies), rep(NA, nzeros))
# parameters monitored
parameters <- c("omega","psi.mean","sigma.psi","p.
   mean","sigma.p","N")
# data
bugs.data <- list(M=(nspecies+nzeros),n.site=nsites,K=K,Y=Y_aug,
```

```
    Z=(Y_aug>0)*1,w=w)
# initial values
inits <- function() { list(omega=runif(1),
    psi.mean=runif(1), p.mean=runif(1),
    sigma.psi=runif(1,0,4), sigma.p=runif(1,0,4))}
#mcmc settings
n.adapt <- 5000        # adaptation
n.update <- 10000      #burnin
n.iter <- 30000        #iterations post-burnin
thin <- 10
chains<-3
# run the model and record the run time
cl <- makeCluster(chains, type = "SOCK")
start.time = Sys.time()
out <- jags.parfit(cl, data = bugs.data,
            params = parameters,
            model = "smsom.txt",
            inits = inits,
            n.adapt = n.adapt,
            n.update = n.update,
            n.iter = n.iter,
            thin = thin, n.chains = chains)
end.time = Sys.time()
elapsed.time = difftime(end.time, start.time, units='mins')
cat(paste(paste('Posterior computed in ', elapsed.time, sep=''),
    ' minutes\n', sep=''))
stopCluster(cl)
#Posterior computed in 3.37720005909602 minutes
```

We can now call a summary of the results, as follows:

```
# Summarize posteriors
summary(out)
Iterations = 15010:45000
Thinning interval = 10
Number of chains = 3
Sample size per chain = 3000
1. Empirical mean and standard deviation for each variable, plus
   standard error of the mean:
                Mean        SD  Naive SE Time-series SE
   N        33.26767 7.063695 7.446e-02      0.2311746
   omega     0.33642 0.082850 8.733e-04      0.0022905
   p.mean    0.06218 0.008325 8.776e-05      0.0001181
```

```
psi.mean    0.09622 0.051847 5.465e-04        0.0013030
sigma.p     0.61917 0.114874 1.211e-03        0.0019658
sigma.psi   2.18955 0.549273 5.790e-03        0.0164386
```

2. Quantiles for each variable:

	2.5%	25%	50%	75%	97.5%
N	26.00000	29.00000	31.00000	35.00000	51.02500
omega	0.21801	0.28280	0.32326	0.37333	0.53965
p.mean	0.04671	0.05645	0.06189	0.06754	0.07917
psi.mean	0.01264	0.05780	0.09133	0.12805	0.21219
sigma.p	0.43470	0.53583	0.60658	0.68620	0.87949
sigma.psi	1.40231	1.79519	2.09438	2.47771	3.51416

Thus, while in this case study the observed species richness was 26, our model estimates a community size of 31 species (median; 26–51 95% credible interval). The inclusion probability Ω, i.e. the probability with which a species member of the augmented data set (with dimension M) is included in the community of size N, is estimated at 0.34 (0.22–0.54). The average (among species) probabilities of detection and occurrence are indicated by p.mean and psi.mean, respectively, and are reported on the probability scale. Heterogeneity in detection and occurrence probability among species are indicated by sigma.p and sigma.psi, which are on the logit scale.

Convergence is achieved quickly. We can use the diagnostics in the coda package in R to check for convergence by inspecting plots of the chains visually using the xyplot() function (originally implemented in the lattice package). We can also display the posterior density distributions of the parameters with the densityplot() function. Autocorrelation in the MCMC series can be explored with the acfplot() function. A more formal convergence check is based on the Gelman–Rubin statistics (Brooks and Gelman 1998; gelman.plot() function), which needs more than one chain started at randomly selected values. When this statistic is close to 1 it indicates likely convergence; as a rule of thumb, it can be safe to assume convergence of an MCMC algorithm for values <1.1 (Gelman *et al.* 2004).

```
# check model output
xyplot(out[,c("omega","psi.mean","sigma.psi","p.mean","sigma.p"),
    drop=F])
densityplot(out[,c("omega","psi.mean","sigma.psi",
    "p.mean","sigma.p"), drop=F])
acfplot(out[,c("omega","psi.mean","sigma.psi",
    "p.mean","sigma.p"), drop=F])
gelman.plot(out[,c("omega","psi.mean","sigma.psi",
    "p.mean","sigma.p"), drop=F])
```

We can now plot (see Figure 9.1) the posterior distribution of the estimated richness for the local community using the following code:

```
# bind chains for the plot
out2 <- mcmc(do.call(rbind, out))
```

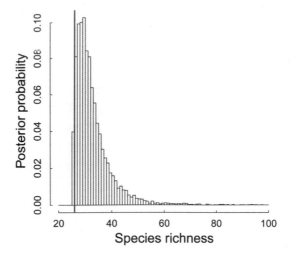

Figure 9.1 Posterior distribution of species richness *N*. The red line indicates the observed number of species.

```
# plot
par(mar = c(5,4.5,4,1.5)+.1, cex.axis=1.5, cex.lab=2, tcl = 0.25)
hist(out2[,"N"],breaks=seq(20,100,by=1),main="",
    xlab="Species richness",ylab="Posterior probability",freq=F)
abline(v=nspecies,col="red",lwd=3)
```

The bar chart shows very clearly how the estimated richness is greater than the observed one. For more details on the ecological interpretation of this result, see Rovero *et al.* (2014), which uses the same data set as in this example.

Finally we remember that, in a Bayesian analysis, we need to assess the sensitivity of the posterior distributions to alternative priors. For further details on prior sensitivity analysis, see e.g. King (2009).

9.4 Dynamic (or multi-season) multi-species occupancy models

Detection/non-detection data gathered during multiple, instead of single, sampling periods can be used to assess changes in communities over time, similarly to what has been described for species-level occupancy models (Chapter 6). Hence, we need a 'robust design' (Pollock 1982), whereby *K* replicate visits to sampling sites correspond to secondary periods nested within *T* primary periods (e.g. seasons or years), during which we repeated our sampling protocol. In this case, we need to account for the fact that during the time between primary sampling periods, which is assumed to be long relative to secondary periods, community composition and size can change.

Dynamics in species composition and occurrence can be analysed by means of an extension of the multi-species occupancy modelling framework (section 9.3) to multiple time periods. Once again, the previously mentioned incidence matrix represents the core of this statistical modelling framework, where community and metacommunity dynamics are specified at the species level by modelling changes in the incidence matrix

(Dorazio *et al.* 2010). For each primary period $t = 1, ..., T$ we define an incidence matrix \mathbf{Z}_t of dimension $N \times J$, where N denotes the number of species in the (meta)community and J the number of sampling sites. The sequence of incidence matrices $\mathbf{Z}_1, \mathbf{Z}_2, ..., \mathbf{Z}_T$ is partially observed, due to imperfect detectability. By estimating that sequence we can infer the spatial and temporal dynamics of (meta)community composition. At least three different formulations are available to describe the state process of the dynamic model, and an overall comparison is provided by Royle and Dorazio (2008). In the first formulation, temporal changes in species occurrence are modelled conditional on changes in covariate values between primary periods (Kéry *et al.* 2009). A second kind of model includes a form of conditional dependence in the occurrence of a species over time at a specific site, and a third formulation represents a hybrid between the first two (autologistic parameterization; Royle and Dorazio 2008).

We describe here the second model type, where changes in species occurrence depend on a set of species- and site-specific extinction and colonisation probabilities, and are modelled using a first-order Markov process (MacKenzie *et al.* 2003). The approach is similar to the single-species dynamic occupancy model described in Chapter 6. The initial occupancy state at $t = 1$ of species i at site j is modelled as $z_{ij1} \sim \mathrm{Bern}(\psi_{ij1}\,\omega_i)$, where ψ_{ij1} denotes the occurrence probability and ω_i indicates whether species i is a member of the community of size N exposed to sampling during any of the T primary periods. The Markov process is specified by assuming that states in primary periods $t = 2, ..., T$ depend on the states at $t - 1$: $z_{ij,t+1} \sim \mathrm{Bern}(\pi_{ijt}\,\omega_i)$, for $t = 1, ..., T - 1$, where $\pi_{ijt} = \varphi_{ijt}\, z_{ijt} + \gamma_{ijt}(1 - z_{ijt})$. φ_{ijt} denotes the probability that a site occupied at time t remains occupied at $t + 1$ by species i (i.e. species i 'survives' or persists at site j). The complement of φ_{ijt} is the local extinction probability, $\varepsilon_{ijt} = 1 - \varphi_{ijt}$. Local colonisation is denoted by γ_{ijt}, the probability that a site not occupied at time t becomes occupied at $t + 1$ by species i. With this formulation, occurrence probability for primary sampling periods from 2 to T is expressed as a function of local persistence and colonisation $\psi_{ij,t+1} = \varphi_{ijt}\,\psi_{ijt} + \gamma_{ijt}(1 - \psi_{ijt})$.

The observation process can be specified in the same way we did with the static multi-species occupancy model, for the observed number of detections y_{ijt} of species i at site j and primary period t: $y_{ijt} \sim \mathrm{Bin}(K_{jt}; p_{ijt}\, z_{ijt})$. Here p_{ijt} indicates detection probability, and K_{jt} the number of sampling occasions for each trap in each primary period. We can extend this general model by including covariates thought to be informative of species occurrence (only occurrence at $t = 1$ with this formulation), detection, colonisation and persistence, in the same way we did in section 9.3. An advantage of the autologistic parameterisation is that it can be extended to include spatial or temporal covariates of occurrence probability (Royle and Dorazio 2008). For details about modelling heterogeneity among species, see Dorazio *et al.* (2010).

We can use this framework to derive quantities of ecological interest for individual species, local communities or an entire metacommunity. From the estimated incidence matrices $\mathbf{Z}_1, \mathbf{Z}_2, ..., \mathbf{Z}_T$, and thus for every primary period, we can compute the number of species present at different subsamples of sites, which can represent biogeographic regions as in Dorazio *et al.* (2010) or treatment plots as in Russell *et al.* (2009). Among the quantities of scientific interest we can also derive turnover rates, defined as the probability that a site occupied at time t was not occupied at $t - 1$ by a randomly selected species (Nichols *et al.* 1998; Royle and Dorazio 2008; Russell *et al.* 2009; Ruiz-Gutiérrez and Zipkin 2011; Walls *et al.* 2011), as well as growth rate which is the ratio of species occurrence probability at time $t + 1$ and t (MacKenzie *et al.* 2003). An important biodiversity index derived from camera trapping data is the Wildlife Picture Index (WPI, O'Brien *et al.* 2010; see Chapter 10 for details on this index which is an official indicator of the Convention on

Biological Diversity). The WPI can be estimated within the dynamic multi-species model fitted in a Bayesian framework, to fully account for the uncertainty in the estimated occurrence probabilities (Nichols 2010; see case study below, section 9.4.1). The index can be computed for an entire group of target species or for different subgroups of species, in relation to their conservation status or functional group (Ahumada *et al.* 2013).

Finally, we note that multi-species occupancy models assume a constant camera trap layout (i.e. data must be collected at the same sites during all primary periods) and they are thus not suited to model species occurrence across multiple sites or time periods if the camera trap layout changes. To this end, Tobler *et al.* (2015) provided a multi-session multi-species occupancy model that can combine data from multiple camera trap surveys.

9.4.1 Case study

We again use the data collected by the TEAM Network in the Udzungwa Mountains of Tanzania during the period 2009–2013 (as in the example above and in Chapters 5 and 6), whereby of the 60 camera trap sites originally set, 56 operated for more than 1 day during each of the 5 years of repeated sampling. Note that each camera operated a different number of days among the years, with the default sampling effort being set at 30 days per camera trap. From 24 to 28 species were detected during the 5 year period.

The reader should first extract the data needed in the following analysis by using the same code reported in section 9.3.1 to obtain the 2009 matrix of detection events for species by sampling sites events, and repeating the six lines beginning with the following one, for the remaining 4 years. Thus, for year 2010 the matrix extraction starts with this line of code:

```
ev2010<-event.sp(dtaframe=mam, year=2010.01, thresh=1440)
```

The five detection matrices, as they were extracted, contain sites (i.e. camera traps) that for the last 2 days of sampling did not operate every year. In addition, detection matrices have different number of rows in relation to the number of species detected every year, and the order of the species in the rows can vary among years. We thus first need to manipulate the data in order to remove camera trap sites that were not active all years and keep the same species order along the rows of every detection matrix. The following code performs this task. Readers will need to customise some parts of the following code to manipulate their data.

```
# load detection data and effort for the period 2009-2013
# get files' names
filesY <- list.files(pattern="spudz_")
names_objY <- paste("Y_",substring(filesY, first=9,
    last=10),sep="")
fileseff <- list.files(pattern="camera_days_")
names_objeff <- paste("effort_",substring(fileseff, first=15,
    last=16),sep="")
# open files and assign them names
for(i in seq(along=filesY)) {
    assign(names_objY[i],
        as.matrix(read.table(filesY[i],header=T,sep=" ")))
```

```
    assign(names_objeff[i], read.table(fileseff[i],
    header=T,sep="\t"))
}
# check dimensions of each data set
dimcheck <- sapply(mget(names_objY),FUN=dim)
dimcheck
      Y_09 Y_10 Y_11 Y_12 Y_13
[1,]    26   26   28   24   26
[2,]    58   59   59   60   59
```

We can see from the table above that the number of detected species ranged from 24 to 28, whereas the number of active cameras ranged from 58 to 60.

```
### keep only sites active every year for at
# least two sampling occasions
# get trap names for each year
Yl <- list()
for (i in 1:length(names_objeff)){
    Yl[[i]] <- get(names_objeff[i])[,1]
}
# homogenize trap names between detection matrices
# and effort data sets
Yl2 <- lapply(Yl,function(x) gsub("-",".",x))
for (i in 1:length(names_objeff)){
    tmp <- get(names_objeff[i])
    tmp[,1] <- Yl2[[i]]
    assign(paste(names_objeff[i],"b",sep=""),tmp)
}
# check which traps in a specific year (Yl2[[n]])
# were not active in other years (unlist(Yl2[-n]))
traptodel <- lapply(1:length(Yl2), function(n)
    setdiff(unlist(Yl2[-n]),Yl2[[n]]))
traptodel2 <- unlist(traptodel)
traptodel3 <- traptodel2[-duplicated(unlist(traptodel2))]
traptodel3
[1] "CT.UDZ.3.13" "CT.UDZ.1.08" "CT.UDZ.1.12" "CT.UDZ.2.16"
# delete traps not active every year
names_objeff_b <- objects(pattern="b$")
for(i in 1:length(names_objeff_b)){
    col_todel_Y <- which(colnames(get(names_objY[i]))
    %in% traptodel3)
    row_todel_eff <- which(Yl2[[i]] %in% traptodel3)
    assign(paste("Y",i,sep=""),get(names_objY[i])[,-col_todel_Y])
```

```
    assign(paste("effort",i,sep=""),get(names_objeff_b[i])
    [-row_todel_eff,])
}
### insert all-zero rows for species not detected
# in a certain year
names_objY_b <- objects(pattern="^Y[1-5]")
# get species names for each year-specific dataset and
# a list of species names detected at least once
colnamesYs <- data.frame(matrix(nrow=28, ncol=5))
allnames <- NULL
for(i in 1:(length(names_objY_b))){
    tmp <- rownames(get(names_objY_b[i]))
    colnamesYs[(1:length(rownames(get(names_objY_b[i])))),i]
    <- tmp
    allnames <- c(allnames,tmp)
}
allnames2 <- allnames[-(which(duplicated(allnames)==T))]
allnames3 <- allnames2[order(allnames2)]
# total number of observed species during the period 2009-2013

allnames3
 [1] "Atilax paludinosus"        "Bdeogale crassicauda"
 [3] "Cephalophus harveyi"       "Cephalophus spadix"
 [5] "Cercocebus sanjei"         "Cercopithecus mitis"
 [7] "Civettictis civetta"       "Colobus angolensis"
 [9] "Cricetomys gambianus"      "Crocuta crocuta"
[11] "Dendrohyrax arboreus"      "Genetta servalina"
[13] "Hystrix africaeaustralis"  "Leptailurus serval"
[15] "Loxodonta africana"        "Mellivora capensis"
[17] "Mungos mungo"              "Nandinia binotata"
[19] "Nesotragus moschatus"      "Panthera pardus"
[21] "Papio cynocephalus"        "Paraxerus vexillarius"
[23] "Petrodromus tetradactylus" "Potamochoerus larvatus"
[25] "Procolobus gordonorum"     "Rhynchocyon cirnei"
[27] "Rhynchocyon udzungwensis"  "Syncerus caffer"
[29] "Thryonomys swinderianus"   "Tragelaphus scriptus"

# see which species are not present in the different years

for(i in 1:(length(names_objY_b))){
    print(which(sapply(allnames3,"%in%",colnamesYs[,i])==FALSE))
    print("-------------------------")
```

```
}
```

```
 Crocuta crocuta    Leptailurus serval Thryonomys swinderianus    Tragelaphus scriptus
              10                    14                     29                      30
```

```
1] "-------------------------"
 Civettictis civetta  Leptailurus serval Papio cynocephalus Thryonomys swinderianus
               7                   14                 21                     29
```

```
[1] "-------------------------"
 Civettictis civetta    Hystrix africaeaustralis
               7                   13
```

```
[1] "-------------------------"
 Civettictis civetta    Crocuta crocuta  Leptailurus serval     Mungos mungo
               7               10                14               17

 Papio cynocephalus  Rhynchocyon cirnei
              21                  26
```

```
[1] "--------------------------------"
 Civettictis civetta Crocuta crocuta  Hystrix africaeaustralis    Leptailurus serval
               7             10                    13                      14
```

```
[1] "-------------------------"
# edit the detection matrices in order to incorporate
# undetected species
not_detected <- rep(0,dim(Y1)[2])
Y1b <- rbind(Y1[1:9,],not_detected,Y1[10:12,],
    not_detected,Y1[13:26,],not_detected,not_detected)
Y2b <- rbind(Y2[1:6,],not_detected,Y2[7:12,],not_
    detected,Y2[13:18,],not_detected,Y2[19:25,],not_
    detected,Y2[26,])
Y3b <- rbind(Y3[1:6,],not_detected,Y3[7:11,],
    not_detected,Y3[12:28,])
Y4b <- rbind(Y4[1:6,],not_detected,Y4[7:8,],
    not_detected,Y4[9:11,],not_detected,Y4[12:13,],
    not_detected,Y4[14:16,],not_detected,Y4[17:20,],
    not_detected,Y4[21:24,])
Y5b <- rbind(Y5[1:6,],not_detected,Y5[7:8,],
    not_detected,Y5[9:10,],not_detected,not_detected,Y5[11:26,])
```

Following this rather long data handling, we can begin analysis by first augmenting the five year-specific detection matrices and bundle all the data into a three-dimensional matrix (Yaug_tot).

```
# augment detection data
names_objY_c <- objects(pattern="^Y[1-5]b")
```

```
nzeros <- 100
for(i in 1:(length(names_objY_c))){
    nc <- dim(get(names_objY_c[i]))[2]
    assign(paste(names_objY_c[i],"_aug",sep=""),
        rbind(get(names_objY_c[i]), matrix(0, nrow=nzeros, ncol=nc))
            )
}
# bind augmeted matricies
library(abind)
Yaug_tot <- abind(Y1b_aug,Y2b_aug,Y3b_aug,Y4b_aug,Y5b_aug,
    along=3)
attr(Yaug_tot, "dimnames") <- NULL
# number of sampling occasions for each camera in each year
names_objeff_c <- objects(pattern="^effort[1-5]")
K_tot <- matrix(NA, nrow=dim(Yaug_tot)[2],
ncol=length(names_objeff_c))
for(i in 1:length(names_objeff_c)){
    K_tot[,i] <- get(names_objeff_c[i])[,"ndays"]
}
```

Finally, to derive subsequently the WPI within the model we need to define the target species for which the WPI is computed. For simplicity we choose a pool of only 10 species which includes carnivores, forest ungulates and the elephant.

```
# Target species for the WPI
speciesWPI <- c("Atilax paludinosus",
"Bdeogale crassicauda",
"Cephalophus harveyi",
"Cephalophus spadix",
"Genetta servalina",
"Loxodonta africana",
"Mellivora capensis",
"Nandinia binotata",
"Nesotragus moschatus",
"Panthera pardus")
nspeciesWPI <- length(speciesWPI)
# find out to which rows of the detection matrix
# these target species correspond
id_speciesWPI <- which(allnames3 %in% speciesWPI)
```

Now we are ready to write the model in BUGS language and run it. We define occurrence, detection, colonisation and persistence rates constant across sites, as follows:

$$\text{logit}(\psi_{ij1}) = b_{i0}, \text{ with } b_{i0} \sim \text{Normal}(\mu_{\psi 1}, \sigma_{\psi 1}^2)$$
$$\text{logit}(p_{ijt}) = a_{it0}, \text{ with } a_{it0} \sim \text{Normal}(\mu_{p}, \sigma_{p}^2)$$

$$\text{logit}(\gamma_{ijt}) = c_{it0}, \text{ with } c_{it0} \sim \text{Normal } (\mu_\gamma, \sigma_\gamma^2)$$
$$\text{logit}(\varphi_{ijt}) = d_{it0}, \text{ with } d_{it0} \sim \text{Normal } (\mu_\varphi, \sigma_\varphi^2).$$

```
# load libraries
library(rjags)
library(dclone)
# set seed
set.seed(1980)
# BUGS model
modelFilename = "dmsom.txt"
cat("
model {
# priors
omega ~ dunif(0,1)
psiMean ~ dunif(0,1)
for (t in 1:T) {
    pMean[t] ~ dunif(0,1)
}
for (t in 1:(T-1)) {
    phiMean[t] ~ dunif(0,1)
    gamMean[t] ~ dunif(0,1)
}
lpsiMean <- log(psiMean) - log(1-psiMean)
for (t in 1:T) {
    lpMean[t] <- log(pMean[t]) - log(1-pMean[t])
}
for (t in 1:(T-1)) {
    lphiMean[t] <- log(phiMean[t]) - log(1-phiMean[t])
    lgamMean[t] <- log(gamMean[t]) - log(1-gamMean[t])
}
lpsiSD ~ dunif(0,10)
lpsiPrec <- pow(lpsiSD,-2)
lpSD ~ dunif(0,10)
lphiSD ~ dunif(0,10)
lgamSD ~ dunif(0,10)
for (t in 1:T) {
    lpPrec[t] <- pow(lpSD,-2)
}
for (t in 1:(T-1)) {
    lphiPrec[t] <- pow(lphiSD,-2)
    lgamPrec[t] <- pow(lgamSD,-2)
}
```

```
# likelihood
for (i in 1:M) {
    # initial occupancy state at t=1
    w[i] ~ dbern(omega)
    b0[i] ~ dnorm(lpsiMean, lpsiPrec)T(-12,12)
    lp[i,1] ~ dnorm(lpMean[1], lpPrec[1])T(-12,12)
    p[i,1] <- 1/(1+exp(-lp[i,1]))
    for (j in 1:n.site) {
            lpsi[i,j,1] <- b0[i]
            psi[i,j,1] <- 1/(1 + exp(-lpsi[i,j,1]))
            mu.z[i,j,1] <- w[i] * psi[i,j,1]
            Z[i,j,1] ~ dbern(mu.z[i,j,1])
            mu.y[i,j,1] <- p[i,1]*Z[i,j,1]
            Y[i,j,1] ~ dbin(mu.y[i,j,1], K_tot[j,1])
    }
    # model of changes in occupancy state for t=2, ...,
    # T for (t in 1:(T-1)) {
            lp[i,t+1] ~ dnorm(lpMean[t+1], lpPrec[t+1])T(-12,12)
            p[i,t+1] <- 1/(1+exp(-lp[i,t+1]))
            c0[i,t] ~ dnorm(lgamMean[t], lgamPrec[t])T(-12,12)
            d0[i,t] ~ dnorm(lphiMean[t], lphiPrec[t])T(-12,12)
            for (j in 1:n.site) {
                lgam[i,j,t] <- c0[i,t]
                gam[i,j,t] <- 1/(1+exp(-lgam[i,j,t]))
                lphi[i,j,t] <- d0[i,t]
                phi[i,j,t] <- 1/(1+exp(-lphi[i,j,t]))
                psi[i,j,t+1] <- phi[i,j,t]*psi[i,j,t] +
    gam[i,j,t]*(1-psi[i,j,t])
                mu.z[i,j,t+1] <- w[i] * (phi[i,j,t]*Z[i,j,t] +
    gam[i,j,t]*(1-Z[i,j,t]))
                Z[i,j,t+1] ~ dbern(mu.z[i,j,t+1])
                mu.y[i,j,t+1] <- p[i,t+1]*Z[i,j,t+1]
                Y[i,j,t+1] ~ dbin(mu.y[i,j,t+1], K_tot[j,t+1])
            }
    }
}
# Derive total species richness for the metacommunity
N_tot <- sum(w[])
# Derive yearly species richness
for (i in 1:M) {
    for (t in 1:T) {
            tmp[i,t] <- sum(Z[i,,t])
```

```
            tmp2[i,t] <- ifelse(tmp[i,t]==0,0,1)
      }
}
for (t in 1:T) {
    N[t] <- sum(tmp2[,t])
}
# Derive WPI
for (i in 1:nspeciesWPI) {
    for (t in 1:T) {
            psi_ratio[i,t] <- psi[id_speciesWPI[i],1,t]/psi[id_
    speciesWPI[i],1,1]
            log_psi_ratio[i,t] <- log(psi_ratio[i,t])
    }
}
for (t in 1:T) {
    WPI[t] <-  exp((1/(nspeciesWPI))*sum(log_psi_
    ratio[1:nspeciesWPI,t]))
}
# rate of change in WPI
for (t in 1:(T-1)) {
    lambda_WPI[t] <- WPI[t+1]/WPI[t]
    }
}
", fill=TRUE, file=modelFilename)
# number of traps
nsites <- dim(Yaug_tot)[2]
# number of primary periods (years)
T <- dim(Yaug_tot)[3]
# latent states
w <- c(rep(1,length(allnames3)),rep(NA,nzeros))
# Parameters monitored
parameters <- c("omega","psiMean","pMean","phiMean","gamMean",
    "lpsiSD","lpSD","lphiSD","lgamSD","N"
    ,"N_tot","WPI","lambda_WPI")
# data
bugs.data <- list(M=dim(Yaug_tot)[1],n.site=nsites,
    K_tot=K_tot,Y=Yaug_tot,T=T,nspeciesWPI=nspeciesWPI,
    id_speciesWPI=id_speciesWPI)
# Initial values
```

```
inits <- function() { list(omega=runif(1),Z=(Yaug_tot>0)*1,w=w,
    psiMean=runif(1),pMean=runif(T),phiMean=runif(T-1),
    gamMean=runif(T-1),lpsiSD=runif(1,0,4),lpSD=runif(1,0,4),
    lphiSD=runif(1,0,4),lgamSD=runif(1,0,4))}
#mcmc settings
n.adapt <- 5000          #pre-burnin
n.update <- 10000        #burnin
n.iter <- 50000          #iterations post-burnin
thin <- 10
chains<-3
# run the model and record the run time
cl <- makeCluster(chains, type = "SOCK")
start.time = Sys.time()
out <- jags.parfit(cl, data = bugs.data,
                    params = parameters,
                    model = "dmsom.txt",
                    inits = inits,
                    n.adapt = n.adapt,
                    n.update = n.update,
                    n.iter = n.iter,
                    thin = thin, n.chains = chains)
end.time = Sys.time()
elapsed.time = difftime(end.time, start.time, units='mins')
cat(paste(paste('Posterior computed in ', elapsed.time, sep=''),
    ' minutes\n', sep=''))
stopCluster(cl)
#Posterior computed in 137.004419155916 minutes
```

We can now call a summary for our model.

```
# Summarize posteriors
summary(out)
Iterations = 15010:65000
Thinning interval = 10
Number of chains = 3
Sample size per chain = 5000
1. Empirical mean and standard deviation for each variable, plus
standard error of the mean:
                Mean       SD  Naive SE Time-series SE
N[1]         27.78893 1.029007 8.402e-03    1.235e-02
N[2]         28.48967 0.931353 7.604e-03    9.475e-03
N[3]         29.34153 0.506990 4.140e-03    5.275e-03
N[4]         28.69493 0.965710 7.885e-03    1.336e-02
```

```
N[5]            28.28767 1.151030 9.398e-03      1.648e-02
N_tot           30.01780 0.135220 1.104e-03      1.603e-03
WPI[1]           1.00000 0.000000 0.000e+00      0.000e+00
WPI[2]           1.13097 0.150326 1.227e-03      2.143e-03
WPI[3]           1.24410 0.180865 1.477e-03      2.707e-03
WPI[4]           1.23190 0.184772 1.509e-03      2.717e-03
WPI[5]           1.02812 0.174009 1.421e-03      2.604e-03
gamMean[1]       0.08744 0.040097 3.274e-04      6.043e-04
gamMean[2]       0.06339 0.031454 2.568e-04      5.015e-04
gamMean[3]       0.06154 0.030513 2.491e-04      4.720e-04
gamMean[4]       0.06193 0.032020 2.614e-04      5.349e-04
lambda_WPI[1]    1.13097 0.150326 1.227e-03      2.143e-03
lambda_WPI[2]    1.10449 0.120746 9.859e-04      2.053e-03
lambda_WPI[3]    0.99352 0.090155 7.361e-04      1.524e-03
lambda_WPI[4]    0.83724 0.093903 7.667e-04      1.436e-03
lgamSD           2.15969 0.280631 2.291e-03      6.452e-03
lpSD             1.27407 0.113177 9.241e-04      2.217e-03
lphiSD           0.88787 0.197087 1.609e-03      7.370e-03
lpsiSD           1.86554 0.351989 2.874e-03      5.608e-03
omega            0.23496 0.036658 2.993e-04      3.043e-04
pMean[1]         0.03260 0.008937 7.297e-05      1.145e-04
pMean[2]         0.03010 0.008020 6.548e-05      9.986e-05
pMean[3]         0.03518 0.008908 7.273e-05      1.058e-04
pMean[4]         0.03084 0.008291 6.769e-05      1.135e-04
pMean[5]         0.03474 0.009992 8.159e-05      1.518e-04
phiMean[1]       0.81442 0.049928 4.077e-04      1.080e-03
phiMean[2]       0.81805 0.048029 3.922e-04      1.003e-03
phiMean[3]       0.81799 0.048028 3.921e-04      9.896e-04
phiMean[4]       0.67198 0.063989 5.225e-04      1.250e-03
psiMean          0.21384 0.061575 5.028e-04      7.532e-04
```

2. Quantiles for each variable:

```
                  2.5%      25%      50%      75%      97.5%
N[1]           26.00000 27.00000 28.00000 28.00000 30.00000
N[2]           27.00000 28.00000 29.00000 29.00000 30.00000
N[3]           29.00000 29.00000 29.00000 30.00000 30.00000
N[4]           27.00000 28.00000 29.00000 29.00000 30.00000
N[5]           26.00000 28.00000 28.00000 29.00000 30.00000
N_tot          30.00000 30.00000 30.00000 30.00000 30.00000
WPI[1]          1.00000  1.00000  1.00000  1.00000  1.00000
WPI[2]          0.89558  1.02430  1.11009  1.21524  1.48681
WPI[3]          0.94696  1.11432  1.22574  1.35121  1.63941
WPI[4]          0.92501  1.10241  1.21440  1.34174  1.64390
```

```
WPI[5]           0.73858  0.90534  1.00930  1.13461  1.42572
gamMean[1]       0.02867  0.05855  0.08079  0.10915  0.18470
gamMean[2]       0.01888  0.04071  0.05788  0.08015  0.13910
gamMean[3]       0.01905  0.03973  0.05591  0.07698  0.13552
gamMean[4]       0.01781  0.03894  0.05597  0.07822  0.14175
lambda_WPI[1]    0.89558  1.02430  1.11009  1.21524  1.48681
lambda_WPI[2]    0.90269  1.01815  1.09330  1.17664  1.37304
lambda_WPI[3]    0.83552  0.93143  0.98709  1.04780  1.19086
lambda_WPI[4]    0.66615  0.77388  0.83301  0.89472  1.03676
lgamSD           1.67304  1.96502  2.13657  2.32952  2.77632
lpSD             1.06920  1.19471  1.26746  1.34574  1.51366
lphiSD           0.54052  0.75118  0.87635  1.01121  1.30588
lpsiSD           1.30522  1.61931  1.82154  2.06431  2.67835
omega            0.16650  0.20940  0.23397  0.25946  0.31046
pMean[1]         0.01819  0.02619  0.03156  0.03786  0.05305
pMean[2]         0.01712  0.02445  0.02918  0.03482  0.04831
pMean[3]         0.02057  0.02891  0.03419  0.04046  0.05546
pMean[4]         0.01739  0.02497  0.02984  0.03558  0.05013
pMean[5]         0.01872  0.02775  0.03349  0.04038  0.05814
phiMean[1]       0.70686  0.78323  0.81861  0.84974  0.90063
phiMean[2]       0.71132  0.78835  0.82238  0.85237  0.89839
phiMean[3]       0.71281  0.78913  0.82193  0.85188  0.90042
phiMean[4]       0.53851  0.63140  0.67470  0.71593  0.78954
psiMean          0.10875  0.17042  0.20789  0.25148  0.35049
```

```r
# check output (there are many parameters monitored,
# therefore it is advisable to plot them in separate bunches)
xyplot(out[,c("omega","psiMean","lpsiSD","lpSD","lphiSD",
    "lgamSD"), drop=F])
xyplot(out[,c("pMean[1]","pMean[2]","pMean[3]","pMean[4]",
    "pMean[5]"), drop=F])
xyplot(out[,c("gamMean[1]","gamMean[2]","gamMean[3]",
    "gamMean[4]"), drop=F])
xyplot(out[,c("phiMean[1]","phiMean[2]","phiMean[3]",
    "phiMean[4]"), drop=F])
```

We have derived both species richness for each year (N; Figure 9.2) and total species richness for the 5 year period (N_tot; Fig. 9.3). Note that the median value for the latter corresponds to the total number of observed species, but the 99% credible interval for the estimate is 30–31, indicating that almost all species (exposed to sampling) of the (meta) community were overall observed during the 5 years of study. The average (among species) probabilities of detection, persistence and colonisation are indicated in the model output, for each year, by pMean (which corresponds to expit(μ_p), where expit is the inverse-logit function), phiMean (expit(μ_φ)) and gamMean (expit(μ_γ)), respectively,

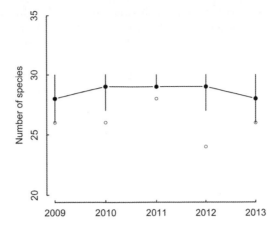

Figure 9.2 Variation of species richness among years (posterior median along with the 95% credible interval). Open symbols indicate the number of species detected in each year.

and are all reported on the probability scale. The average occurrence probability for the first year is denoted by `psiMean` (expit($\mu_{\psi1}$)). Heterogeneity among species of these probabilities are indicated by `lpSD` (σ_p), `lphiSD` (σ_φ), `lgamSD` (σ_γ) and `lpsiSD` ($\sigma_{\psi1}$), respectively. Parameter `omega` (ω) denotes the probability that a species is a member of the community of size N exposed to sampling during the 5 years. Persistence and colonisation probabilities are nearly constant among years and their 95% credible intervals largely overlap.

We derived the WPI (Figure 9.3) directly within the *dynamic* multi-species occupancy model, an advantage only provided by the latter framework. As an alternative, we may

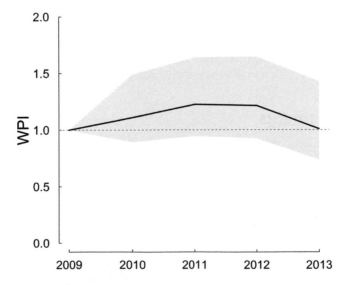

Figure 9.3 Temporal changes in the Wildlife Picture Index (WPI) of 10 mammal species in the Udzungwa Mountains. The black solid line indicates the yearly median values of the posterior distribution of the WPI, and the shaded area defines the 95% credible interval for the estimate. The red dashed line indicates WPI stability.

choose to monitor the matrix of year-specific occurrence probabilities of target species in JAGS, and then export it to R where the WPI can be derived. An example of this approach can be found in Ahumada *et al.* (2013), where WPI was not derived directly in JAGS since the authors used *single*-species dynamic occupancy models.

Note that we also derived the rate of change in WPI from year t to $t + 1$ (`lambda_WPI`) calculated as $\mathrm{WPI}_{t+1}/\mathrm{WPI}_t$.

9.5 Conclusions

We have described multi-species occupancy models, a versatile framework that can be used to estimate quantities of ecological interest at different levels of ecological organisation, from single species, to local communities of species, and even to metacommunities. In this framework, estimates for species richness and other biodiversity measures that account for imperfect detection can be derived within the model. This statistical approach is flexible, allowing for modelling covariates on species occurrence and detection probabilities and, in a dynamic, multi-season version, on persistence and colonisation probabilities. In the latter case, the spatiotemporal dynamics of biodiversity estimators can be also analysed.

We have to be aware of the fact that estimates of community-level parameters can be sensitive to the underlying assumptions of the model, such as the type of the distribution chosen to model heterogeneity among species and sites. Standard goodness-of-fit approaches might not be adequate to test these assumptions. The models presented here also rely on a closure assumption (replicated observations of species are made over a short time interval during which occurrence states of species are assumed constant). Currently the closure assumption has been relaxed only for single-species dynamic occupancy models (Chambert *et al.* 2015). Another assumption of these models is the absence of false-positives, i.e. all species are assumed to be correctly identified (an assumption which is usually easily met by camera trapping data). False-positive errors in detection tend to positively bias estimates of occurrence probability because species detections are erroneously assigned to sites where the species is not present (Royle and Link 2006). Finally, Yamaura *et al.* (2011) developed a multi-species abundance model for presence–absence data that can estimate species abundance in space and time by using the Royle–Nichols formulation (Royle and Nichols 2003) of detection heterogeneity.

Acknowledgements

The author is grateful to Jorge Ahumada and Fridolin Zimmermann for valuable comments on a previous version of this chapter.

Appendices

For dataset and extraction of detection matrices, see the following appendices to Chapter 5:

Appendix 5.1. Case study data set: 'team.yr2009_2013.csv'
Appendix 5.3. R library with all functions: 'TEAM library 1.7.R'

For the code for both case studies in this chapter:

Appendix 9.1. 'Chapter_9_script.R'

References

Ahumada, J.A., Hurtado, J. and Lizcano, D. (2013) Monitoring the status and trends of tropical forest terrestrial vertebrate communities from camera trap data: a tool for conservation. *PLoS ONE* 8: e73707.

Broms, K.M., Hooten, M.B. and Fitzpatrick, R.M. (2014) Accounting for imperfect detection in Hill numbers for biodiversity studies. *Methods in Ecology and Evolution* 6: 99–108.

Brooks, S.P. and Gelman, A. (1998) Alternative methods for monitoring convergence of interative simulations. *Journal of Computational and Graphical Statistics*: 434–455.

Burton, A.C., Sam, M.K., Balangtaa, C. and Brashares, J.S. (2012) Hierarchical multi-species modeling of carnivore responses to hunting, habitat and prey in a West African protected area. *PLoS ONE* 7: e38007.

Carrillo-Rubio, E., Kéry, M., Morreale, S.J., Sullivan, P.J., Gardner, B., Cooch, E.G. and Lassoie, J.P. (2014) Use of multispecies occupancy models to evaluate the response of bird communities to forest degradation associated with logging. *Conservation Biology* 28: 1034–1044.

Chambert, T., Kendall, W.L., Hines, J.E., Nichols, J.D., Pedrini, P., Waddle, J.H., Tavecchia, G., Walls, S.C. and Tenan, S. (2015) Testing hypotheses on distribution shifts and changes in phenology of imperfectly detectable species. *Methods in Ecology and Evolution* 6: 638–647.

Chao, A. and Jost, L. (2012) Coverage-based rarefaction and extrapolation: standardizing samples by completeness rather than size. *Ecology* 93: 2533–2547.

Chao, A., Gotelli, N.J., Hsieh, T., Sander, E.L., Ma, K., Colwell, R.K. and Ellison, A.M. (2014) Rarefaction and extrapolation with Hill numbers: a framework for sampling and estimation in species diversity studies. *Ecological Monographs* 84: 45–67.

De Valpine, P. and Hastings, A. (2002) Fitting population models incorporating process noise and observation error. *Ecological Monograph* 72: 57–76.

Dice, L.R. (1945) Measures of the amount of ecologic association between species. *Ecology* 26: 297–302.

Dorazio, R.M. (2007) On the choice of statistical models for estimating occurrence and extinction from animal surveys. *Ecology* 88: 2773–2782.

Dorazio, R.M. and Royle, J.A. (2005) Estimating size and composition of biological communities by modeling the occurrence of species. *Journal of the American Statistical Association* 100: 389–398.

Dorazio, R.M., Royle, J.A., Söderström, B. and Glimskär, A. (2006) Estimating species richness and accumulation by modeling species occurrence and detectability. *Ecology* 87: 842–854.

Dorazio, R.M., Kéry, M., Royle, J.A. and Plattner, M. (2010) Models for inference in dynamic metacommunity systems. *Ecology* 91: 2466–2475.

Dorazio, R.M., Gotelli, N.J. and Ellison, A.M. (2011) Biodiversity loss in a changing planet. In: Grillo, O. and Venora, G. (eds), *Modern Methods of Estimating Biodiversity from Presence–Absence Surveys*. Rijeka, Croatia: InTech. pp. 277–302.

Gelman, A., Carlin, J.B., Stern, H.S., Rubin, D.B. (2004) *Bayesian Data Analysis*, 2nd edn. Boca Raton, FL: CRC/Chapman & Hall.

Gotelli, N.J. (2000) Null model analysis of species co-occurrence patterns. *Ecology* 81: 2606–2621.

Gotelli, N. and Colwell, R. (2001) Quantifying biodiversity: procedures and pitfalls in the measurement and comparison of species richness. *Ecology Letters* 4: 379–391.

Gotelli, N., Chao, A. and Levin, S. (2013) Measuring and estimating species richness, species diversity, and biotic similarity from sampling data. *Encyclopedia of Biodiversity* 5: 195–211.

Hill, M.O. (1973) Diversity and evenness: a unifying notation and its consequences. *Ecology* 54: 427–432.

Hooten, M.B. and Hobbs, N.T. (2014) A guide to Bayesian model selection for ecologists. *Ecological Monographs* 85: 3–28.

Jost, L. (2006) Entropy and diversity. *Oikos* 113: 363–375.

Kéry, M. and Royle, J. (2008) Hierarchical Bayes estimation of species richness and occupancy in spatially replicated surveys. *Journal of Applied Ecology* 45: 589–598.

Kéry, M. and Royle, J.A. (2009) Inference about species richness and community structure using species-specific occupancy models in the national Swiss breeding bird survey. In: Thomson, D.L., Cooch, E.G. and Conroy, M.J. (eds), *Modeling Demographic Processes in Marked Populations*. Berling: Springer. pp. 639–656.

Kéry, M. and Schaub, M. (2012) *Bayesian Population Analysis Using WinBUGS: A Hierarchical Perspective*. New York: Academic Press.

Kéry, M., Royle, J.A., Plattner, M. and Dorazio, R.M. (2009) Species richness and occupancy estimation in communities subject to temporary emigration. *Ecology* 90: 1279–1290.

King, R. (2009) *Bayesian Analysis for Population Ecology*. Boca Raton, FL: CRC Press.

Link, W.A. and Barker, R.J. (2006) Model weights and the fundations of multimoldel inference. *Ecology* 87: 2626–2635.

Link, W.A. and Barker, R.J. (2009) *Bayesian Inference: With Ecological Applications*. New York: Academic Press.

MacKenzie, D.I., Nichols, J.D., Hines, J.E., Knutson, M.G. and Franklin, A.B. (2003) Estimating site occupancy, colonization, and local extinction when a species is detected imperfectly. *Ecology* 84: 2200–2207.

MacKenzie, D.I., Bailey, L.L. and Nichols, J.D. (2004) Investigating species co-occurrence patterns when species are detected imperfectly. *Journal of Animal Ecology* 73: 546–555.

Magurran, A.E. and McGill, B.J. (2011) *Biological Diversity: Frontiers in Measurement and Assessment*, Vol. 12. Oxford: Oxford University Press.

McNew, L.B. and Handel, C.M. (2015) Evaluating species richness: biased ecological inference results from spatial heterogeneity in detection probabilities. *Ecological Applications*, in press.

Nichols, J. (2010) The wildlife picture index, monitoring and conservation. *Animal Conservation* 13: 344–346.

Nichols, J.D., Boulinier, T., Hines, J.E., Pollock, K.H. and Sauer, J.R. (1998) Estimating rates of local species extinction, colonization, and turnover in animal communities. *Ecological Applications* 8: 1213–1225.

O'Brien, T., Baillie, J., Krueger, L. and Cuke, M. (2010) The wildlife picture index: monitoring top trophic levels. *Animal Conservation* 13: 335–343.

O'Hara, R.B. and Sillanpää, M.J. (2009) A review of Bayesian variable selection methods: what, how and which. *Bayesian Analysis* 4: 85–118.

Pielou, E.C. (1977) *Mathematical Ecology*. New York: Wiley.

Plummer, M. (2003) JAGS: a program for analysis of Bayesian graphical models using Gibbs sampling. *Proceedings of the 3rd International Workshop on Distributed Statistical Computing (DSC 2003)*, Technische Universität Wien, Vienna, Austria. https://www.r-project.org/conferences/DSC-2003/Proceedings/Plummer.pdf

Plummer, M. (2013) *rjags: Bayesian graphical models using MCMC*. R package v. 3-10.

Pollock, K.H. (1982) A capture–recapture design robust to unequal probability of capture. *Journal of Wildlife Management* 46: 757–760.

R Core Team (2012) *R: A Language and Environment for Statistical Computing*. Vienna: R Foundation for Statistical Computing. ISBN 3-900051-07-0.

Robert, C. and Casella, G. (2004) *Monte Carlo Statistical Methods*. New York: Springer.

Rovero, F., Martin, E., Rosa, M., Ahumada, J.A. and Spitale, D (2014) Estimating species richness and modelling habitat preferences of tropical forest mammals from camera trap data. *PLoS ONE* 9(7): e103300.

Royle, J.A. and Nichols, J.D. (2003) Estimating abundance from repeated presence–absence data or point counts. *Ecology* 84: 777–790.

Royle, J.A. and Link, W.A. (2006) Generalized site occupancy models allowing for false positive and false negative errors. *Ecology* 87: 835–841.

Royle, J.A. and Dorazio, R. (2008) *Hierarchical Modeling and Inference in Ecology: The Analysis of Data from Populations, Metapopulations and Communities*. San Diego: Academic Press.

Royle, J.A. and Young, K.V. (2008) A hierarchical model for spatial capture–recapture data. *Ecology* 89: 2281–2289.

Royle, J.A. and Dorazio, R. (2011) Parameter-expanded data augmentation for Bayesian analysis of capture–recapture models. *Journal of Ornithology* 152 (Suppl. 2): S521–S537.

Royle, J.A., Dorazio, R.M. and Link, W.A. (2007) Analysis of multinomial models with unknown index using data augmentation. *Journal of Computational and Graphical Statistics* 16: 67–85.

Ruiz-Gutiérrez, V. and Zipkin, E.F. (2011) Detection biases yield misleading patterns of species persistence and colonization in fragmented landscapes. *Ecosphere* 2: art61.

Russell, R.E., Royle, J.A., Saab, V.A., Lehmkuhl, J.F., Block, W.M. and Sauer, J.R. (2009) Modeling the effects of environmental disturbance on wildlife communities: avian responses to prescribed fire. *Ecological Applications* 19: 1253–1263.

Sólymos, P. (2010) dclone. Data cloning in R. *The R journal* 2: 29–37.

Sutherland, C., Brambilla, M., Pedrini, P. and Tenan, S. (2016) A multi-region community model for inference about geographic variation in species richness. *Methods in Ecology and Evolution* doi: 10.1111/2041-210X.12536.

Tanner, M.A. and Wong, W.H. (1987) The calculation of posterior distributions by data augmentation. *Journal of the American Statistical Association* 82: 528–540.

Tenan, S., O'Hara, R.B., Hendriks, I. and Tavecchia, G. (2014) Bayesian model selection: the steepest mountain to climb. *Ecological Modelling* 283: 62–69.

Tenan, S., Brambilla, M., Pedrini, P. and Sutherland, C. (2016) Evaluating biodiversity gradients while accounting for ecological stratification of communities (in review).

Tobler, M.W., Zúñiga Hartley, A., Carrillo-Percastegui, S.E. and Powell, G.V. (2015) Spatiotemporal hierarchical modelling of species richness and occupancy using camera trap data. *Journal of Applied Ecology* 52: 413–421.

Waddle, J.H., Dorazio, R.M., Walls, S.C., Rice, K.G., Beauchamp, J., Schuman, M.J. and Mazzotti, F.J. (2010) A new parameterization for estimating co-occurrence of interacting species. *Ecological Applications* 20: 1467–1475.

Walls, S.C., Waddle, J.H. and Dorazio, R.M. (2011) Estimating occupancy dynamics in an anuran assemblage from Louisiana, USA. *Journal of Wildlife Management* 75: 751–761.

Yamaura, Y., Andrew Royle, J., Kuboi, K., Tada, T., Ikeno, S. and Makino, S. (2011) Modelling community dynamics based on species-level abundance models from detection/nondetection data. *Journal of Applied Ecology* 48: 67–75.

Zipkin, E.F., DeWan, A. and Andrew Royle, J. (2009) Impacts of forest fragmentation on species richness: a hierarchical approach to community modelling. *Journal of Applied Ecology* 46: 815–822.

Zipkin, E.F., Andrew Royle, J., Dawson, D.K. and Bates, S. (2010) Multi-species occurrence models to evaluate the effects of conservation and management actions. *Biological Conservation* 143: 479–484.

10. Camera trapping as a monitoring tool at national and global levels

Jorge A. Ahumada, Timothy G. O'Brien, Badru Mugerwa and Johanna Hurtado

10.1 Introduction

The Conference of Parties to the Convention on Biological Diversity has clearly stated the need for and importance of monitoring to assess the progress of signatory nations towards meeting the 2020 Aichi Targets (UNEP/COP/DEC/X/2). The 2020 Aichi Targets are a set of standards that must be addressed by 2020 in order to arrest the global loss of biodiversity. Strategic Goal C of the Aichi 2020 is '[t]o improve the status of biodiversity by safeguarding ecosystems, species and genetic diversity' by the end of the decade. Within Strategic Goal C, Target 11 seeks to strengthen the management and effectiveness of protected areas as a key strategy in the conservation of biodiversity. Target 12 states that: 'By 2020, the extinction of known threatened species has been prevented and their conservation status, particularly of those most in decline, has been improved and sustained.' These targets make clear that the key to reversing declining trends in biodiversity is the better management of protected areas and species' populations and monitoring of interventions and outcomes.

Monitoring programmes to achieve Aichi Target 12 need to be able to determine whether management interventions are: (1) preventing local extinction of susceptible species; (2) promoting recovery and colonisation of threatened species; and (3) retaining stable or expanding populations of birds and mammals. They also need to be sensitive to detection of change at the decadal level. Target 12 indicators therefore focus on the response of wildlife populations to targeted management interventions. Currently there are three primary indicators for Target 12: the Red List Index (RLI, Butchart *et al.* 2004, 2005), the Living Planet Index (LPI, Loh *et al.* 2005; Collen *et al.* 2009); and the Wildlife Picture Index (WPI, O'Brien 2010), which is explained in more detail later in this chapter. The RLI measures trends in extinction risk for species based on movement between threat classes (i.e. critically endangered, endangered, vulnerable, near threatened, least concerned) in the IUCN Red List and aggregates the information across taxa to produce a biodiversity extinction risk index. IUCN threat status is evaluated every 5 years, and,

in principle, three assessments are possible during a decade (year 0, year 5 and year 10). Three points are the minimum to detect a trend. The LPI tracks the aggregated trend in 10,380 populations of 3,038 species (WWF 2014) of mammals (18%), birds (58%), reptiles, and amphibians and fish (23%). Assessments are published every 2 years, allowing the possibility of six assessments per decade. Both the RLI and LPI are global indicators that can potentially be disaggregated to the national level (Bubb *et al.* 2009; Szabo *et al.* 2012; Collen *et al.* 2009), but so far national level indicators have been developed for the RLI only.

Three key features of the data included in the RLI and LPI are: (1) the wide variation in data quality, ranging from unbiased estimates to expert opinions; (2) the reliance on published data from an uncontrolled range of sources; and (3) the time lags between data collection and appearance in the index. Furthermore, although these indices provide assessments of wildlife trends, they are not designed to assess the underlying causes of trends or to answer the question of whether management interventions on behalf of wildlife populations have the desired outcome. Such an index would rely on systematic data collection with clear specification of conservation objectives and targets and specific management interventions to be taken to meet objectives in mind. To date, however, we have seen little movement toward coordinated, national-level monitoring of wildlife in protected areas by signatory countries or of global monitoring efforts by international bodies, except in North America and Europe. India has started a coordinated camera trap monitoring programme for tigers (*Panthera tigris*) in 40 reserves (Bindra 2012), and Malaysia has a large number of camera trap monitoring programmes, although they are not apparently coordinated (Mohd-Azlan 2009). Part of the problem has been a lack of sampling protocols that yield high-quality data, are easy to implement, and provide timely data that nations can use to assess the condition of their protected areas and the species therein. In this chapter we describe a scalable framework for the systematic sampling of wildlife in protected (and other) areas at the national and global scale using camera traps.

Camera trap technology has been used in ecological research and conservation for more than 20 years (see Chapter 1). Data collection using camera traps offers advantages and challenges over direct observation data collection, such as line transect surveys and ranger-based monitoring. Camera traps are relatively passive data collection devices that do not evoke the hide/flight response from wildlife that humans elicit when walking in the forest. Camera traps can be deployed for long periods in the field without a support network before they have to be picked up and processed. They collect a permanent record of what is observed, as opposed to visual and audio information by humans that cannot be verified after the data are collected (further information about the advantages/disadvantages of camera trapping compared to other monitoring techniques can be found in Chapters 1 and 8). Importantly, the cost of camera traps has fallen over the past 20 years at the same time that the cost of employing and deploying human monitors has increased. The challenges of using camera traps for monitoring wildlife at a national scale include high start-up costs, equipment attrition due to theft, vandalism and wildlife damage, and data management issues (see Chapter 4) involving hundreds of thousands or even millions of images. There are also challenges in the interpretation of data, although these problems are shared with many data sets collected by human observers. The development of defensible indicators that are robust, accurate and precise remains a challenge irrespective of the data collection device. Camera trap data can be used to address a number of the CBD/Aichi 2020 Targets (Table 10.1).

Table 10.1 The intersection between CBD and Aichi 2020 Targets, Operational indicators (https://www.cbd.int/sp/) and well-collected camera trap data.

TARGET 4: Plans for sustainable production and consumption implemented

Headline indicator	Operational indicator/*data sources*	Relevant camera trap data
Trends in pressures from unsustainable agriculture, forestry, fisheries and aquaculture	Trends in population and extinction risk of utilised species, including species in trade. *Global IUCN Red List, National Red Lists, LPI*	Terrestrial vertebrate time series data. Subset of time series for exploited species

TARGET 5: The rate of loss of all natural habitats at least halved

Headline indicator	Operational indicator/*data sources*	Relevant camera trap data
Trends in extent, condition and vulnerability of ecosystems, biomes and habitats	Extinction risk trends of habitat-dependent species in each major habitat type. *RLI*	Terrestrial vertebrate time series data. Subset of time series for habitat-dependent species
Trends in pressures from direct and underlying drivers	Population trends of habitat dependent species in each major habitat type. *LPI, Wild Bird Index (WBI)*	Terrestrial vertebrate time series data. Subset of time series for habitat-dependent species

TARGET 10: Multiple anthropogenic pressures on vulnerable ecosystems minimised

Headline indicator	Operational indicator/*data sources*	Relevant camera trap data
Trends in pressures from direct and underlying drivers	Trends in climate change impacts on extinction risk. *IUCN Red List*	Terrestrial vertebrate time series data
	Trends in climatic impacts on community composition. *Distribution of species, temperature data*	Terrestrial vertebrate community structure data
	Trends in climatic impacts on population trends. *WBI, models of climate impacts*	Terrestrial vertebrate time series data

TARGET 11: Expand protected area system and strengthen management and effectiveness of protected areas

Headline indicator	Operational indicator/*data sources*	Relevant camera trap data
Trends in coverage, condition, representativeness and effectiveness of protected areas	Trends in protected area condition and/or management effectiveness including more equitable management. *Key Biodiversity Areas (KBAs), Important Bird Areas (IBAs), Important Plant Areas (IPAs), Alliance for Zero Extinction, Ramsar, World Heritage*	Terrestrial vertebra data including time series, community structure, species richness

Table 10.1 – *continued*

	Trends in the delivery of ecosystem services and equitable benefits from protected areas. *Various*	Terrestrial vertebrate community structure, species richness

TARGET 12: Extinction of known threatened species prevented and population status improved

Headline indicator	Operational indicator/*data sources*	Relevant camera trap data
Trends in abundance, distribution and extinction risk of threatened species	Trends in abundance of selected threatened species. *LPI, WBI, WPI*	Terrestrial vertebrate time series data. Subset of time series for threatened species.
	Trends in distribution of selected species. *Global Biodiversity Information Facility (GBIF) occurrence data, Red List Partnership, eBird, Worldbirds*	Terrestrial vertebrate spatial distribution and occurrence.
	Trends in extinction risk of species. *IUCN Red List, National Red Lists*	Terrestrial vertebrate species time series. Subset of time series for threatened species.

TARGET 14: Ecosystems that provide essential services are restored and safeguarded

Headline indicator	Operational indicator/*data sources*	Relevant camera trap data
Trends in distribution, condition and sustainability of ecosystem services	Population trends and extinction risk trends of species that provide ecosystem services. *Global IUCN Red List, National Red Lists*	Population trends of vertebrate seed dispersers and vertebrates used as food.

TARGET 15: Ecosystem resilience and carbon stocks enhanced through conservation and restoration

Headline indicator	Operational indicator/*data sources*	Relevant camera trap data
Trends in distribution, condition and sustainability of ecosystem services	Population trends and extinction risk trends of species that provide ecosystem services. *Global IUCN Red List, National Red Lists*	Population trends and community composition of terrestrial vertebrates

10.2 A national monitoring system for wildlife: from idea to a functioning system

Using the Tropical Ecology Assessment and Monitoring Network (TEAM) model outlined below as an example of an integrated global monitoring system, we propose here a conceptual framework tailored to fulfil the monitoring needs of protected area networks at the subnational, national and regional levels (Figure 10.1). We start by clearly defining the goals of such a system, followed by a careful statistical design that is

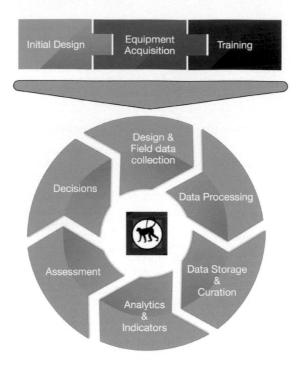

Figure 10.1 Conceptual framework for a wildlife monitoring system that can be deployed in national protected area networks.

appropriate to capture and detect change in wildlife populations based on the original stated goals. We then move on to more practical aspects, such as equipment acquisition, field implementation and data processing. Finally, we focus on indicators that can be derived from camera trap data, and how these indicators can help park authorities make data-driven decisions on issues that affect the management of communities of species. Finally, we sketch out a tentative budget in terms of relative costs, since every country's situation will be unique.

10.2.1 A global model for national monitoring: The TEAM Camera Trap Network

TEAM is a consortium composed of Conservation International, the Wildlife Conservation Society and the Smithsonian Institution. TEAM's mission is to generate real-time data for monitoring long-term trends in tropical biodiversity through a global network, providing an early warning system on the status of biodiversity to effectively guide conservation action. The consortium has been functioning since 2007 and is composed currently of 17 sites located in protected areas of 15 countries. TEAM works closely with national governments and NGOs and has more than 80 institutional partners (http://www.teamnetwork.org). TEAM was designed to detect trends in biodiversity and to distinguish between the effects of projected climate change and changes in land use. Using climate and land-use change modelling, TEAM has stratified the wet tropical forests into four levels of risk: (1) low risk of climate change, low risk of habitat change; (2) high risk of climate change, low risk of habitat change; (3) low risk of climate change, high risk of

habitat change; and (4) high risk of climate change, high risk of habitat change. At field sites within these strata, TEAM monitors terrestrial birds and mammals across 200 km² sampling units using camera trap arrays, and monitors changes in the larger landscape (the matrix) resulting from anthropogenic drivers using remote sensing. Monitoring results are produced annually for terrestrial birds and mammals, and biannually for land-use change. The choice of monitoring techniques has been optimised to balance the trade-offs in costs of monitoring and monitoring results (TEAM Network 2011a). The terrestrial mammals and bird protocol tracks the top trophic levels of species that are aesthetically, economically and ecologically important. These species are most often the target of management interventions for tourism, hunting, local livelihoods and ecosystem services. They are the lions and tigers and bears and elephants of the world. They are also the seed dispersers, and sources of human–wildlife conflict.

TEAM has built a comprehensive system for data management and analytics (Baru *et al.* 2012). Data collection protocols are standardised across sites. Specialised software has been developed for desktop and web-based data entry and data management that includes automated data-quality assurance and quality-control features (Figure 10.1; see also Chapter 4; Fegraus *et al.* 2011). Data on endangered species are filtered to deter use of TEAM data for exploitative purposes. Perhaps most importantly, TEAM data are publicly available on the web within months of collection (not years), providing a level of transparency that is almost unrivalled. Publicly available data include information on 890 populations of 491 species of tropical mammals and terrestrial birds. By comparison, the LPI for tropical terrestrial mammals and terrestrial birds includes 946 species (70% birds) as of 2014 (WWF 2014). TEAM has contributed data to ~200 scientific publications through 2015. A recent study evaluating the trends of ~500 populations of mammals and birds across 15 TEAM sites suggests a more optimistic view of the effectiveness of protected areas in conserving biodiversity (Beaudrot *et al.* 2016).

In collaboration with its business partner Hewlett Packard, TEAM has developed a range of data products for scientists and policymakers. These include the WPI analytics system, an online tool that calculates and displays the WPI (O'Brien *et al.* 2010; Ahumada *et al.* 2013; see 'Data analysis and indicators' in section 10.2.4, and Chapter 9 for a case study that includes the computation of the WPI) and its constituent species trends in near real time (http://wildlifeinsights.org). With this tool, the WPI is updated whenever new data are added, and provides an assessment of the relative importance of climate, humans and edge effects on all species at all sites. The index is scalable from the site level to subnational, national, regional and global levels. The index also is designed to meet the criteria of a CBD indicator (Buckland *et al.* 2005; O'Brien *et al.* 2010). The TEAM WPI is the only real-time indicator in the CBD indicator portfolio.

10.2.2 Goals and targets of a national monitoring system for wildlife

The previous section described TEAM, a global monitoring system with the goal of answering questions at the global level. National monitoring systems will have different goals depending on the political and environmental commitments of the country. In particular for biodiversity and wildlife, a national monitoring system using camera traps could have several goals, including:

- Ensuring the national protected area system overall is safeguarding biodiversity (e.g. maintaining viable populations of most species).

- Assessing the effectiveness of specific protected areas or corridors in maintaining wildlife populations and ensuring gene flow.
- Understanding the effects of anthropogenic activities on wildlife within and around protected areas (e.g. legal and illegal selective logging, hunting, extraction of non-timber forest products).
- Safeguarding endangered and critically endangered species.
- Ensuring that legislation and actions taken to control illegal wildlife trade are effective and result in healthy, sustainable wildlife populations.

Before designing and implementing a camera trap-based monitoring system, relevant authorities and stakeholders need to agree on which of these goals (or any others) will be the guiding principles of the system. In addition to clear goals, there needs to be a consensus on the targets for each goal; without both of these elements, the data and indicators derived from the system will not be useful for informing whether the intended targets are being achieved. Some examples of targets for each of the goals outlined above are:

- More than 80% of species monitored show stability or moderate increases across the whole protected area network.
- At least 90% of species monitored in protected areas are detected in corridors that connect these areas.
- Human activities, such as selective logging and subsistence hunting, have no detectable effects in the trends of selected species that are potentially affected by these activities.
- All populations of endangered and critically endangered species show stability or increasing trends in protected areas.
- Upon implementation of interventions to reduce wildlife trafficking in a protected area or network or protected areas, more than 70% of populations of species that are hunted illegally show significant recovery (i.e. statistically significant positive trend post intervention), compared to the baseline (before interventions took place).

These are just examples; exact goals and targets need to be derived in a participatory fashion with all stakeholders of protected areas (local and national government officials, indigenous communities, local civic representatives, scientists, etc.).

10.2.3 Design of a national monitoring system

With clear goals in mind, the design of the system is the next key step. The major elements to take into account for a robust design are:

- *Number and distribution of protected areas.* How many protected areas need to be included in the system? Should it be all of them or a carefully selected, representative sample?
- *Spatial sampling intensity.* How many camera trap points need to be sampled at each protected area?
- *Temporal sampling intensity.* How many times in the year (or sampling period) will camera traps be deployed at each protected area? How long will the camera traps be sampling in the field during each deployment?

- *Sampling stratification within a protected area.* Should camera traps be deployed at random? Should they follow a particular biophysical or disturbance gradient (e.g. elevation, distance from the closest human settlement/road)?

Let us examine each of these in more detail below.

10.2.3.1 Number and distribution of protected areas

The decision of how many protected areas need to be monitored will depend on several factors including the total number of protected areas in the country, the budget available for monitoring, and the trainable (not necessarily available) technical capacity in the country. As a general rule, if the number of protected areas is 20 or fewer, the monitoring programme should aim to cover the entire protected area system. If it is necessary to monitor along environmental gradients (e.g. elevation, disturbance, rainfall), then the monitoring programme should cover enough protected areas to ensure that all combinations of environmental gradients are represented. If it is impossible to monitor the entire 20 or fewer protected area network, then it is advisable to distribute a smaller sample of protected areas along the most spatially heterogeneous gradient (with the highest contrast), to ensure protected areas along this gradient are adequately replicated.

When the number of protected areas is large, it becomes logistically difficult to sample all of them, so it is necessary to select a representative sample of protected areas. This could be a simple random sample, or a sample stratified across relevant biophysical variables (soil type, precipitation, temperature, elevation, etc.) or disturbance variables (closeness to big cities, road density, etc.). For simplicity, it is better to choose two or three strata with a maximum number of three levels each; otherwise the design becomes too complex. Table 10.2 shows an example of a hypothetical design using three strata: soil type, precipitation and human footprint.

Another possible stratum that might be key to the design is the type of protected area (total protection, extractive reserve, indigenous community reserve, etc.). When selecting levels of different strata it is better to have the greatest possible contrast between

Table 10.2 Example of the number of protected areas selected in a country for sampling, distributed along three strata: soil type (two levels), precipitation (three levels) and human footprint (two levels).

Soil type	Human footprint: High Precipitation			Total
	Dry	Wet	Very wet	
Rich soils	0	4	5	9
Poor soils	3	3	4	10
	Human footprint: Low Precipitation			
	Dry	Wet	Very wet	
Rich soils	0	3	5	8
Poor soils	2	4	3	9
Total	5	14	17	36

levels rather than a very fine-grained continuum. As an illustration in the example of Table 10.2, soil type is classified into rich and poor, even though there might be a dozen different soil types or more. This allows for a cleaner design and easier interpretation of the data gathered by the monitoring system. It is always important to remember that strata selection depends on the question(s) being asked, and the goals of the monitoring system. There is no cookie-cutter approach here.

10.2.3.2 Stratification within the protected area

How should the camera trap points be distributed within the protected area? There are several possible scenarios here. One common goal for protected areas is to monitor the overall community of vertebrates that are representative of that protected area. If that is the case, we recommend that camera trap points be distributed on a regular grid, encompassing the major habitat type(s) in the area. If the protected area spans an altitudinal gradient, it is advisable to distribute the cameras along that gradient, to ensure most species are represented. Also, and based on specific questions/issues for each protected area, camera traps can be distributed along disturbance gradients (e.g. distance from a river/edge) or between areas that have different uses within the park. For example, in some protected areas there might be zones for different uses/activities (e.g. extractive activities vs. no-take zones) and camera traps could be distributed between these different areas to understand the impact of these activities on wildlife. The design should always be driven by the overall questions and goals of the system; thus the decision of where to place the camera traps within the protected area can be very specific to the needs and particular situation in that protected area.

When a design agreement has been reached, it is important to create a shape file in the GIS that contains the expected locations of the camera traps in each protected area. TEAM has developed a guidance document of how to implement a design step by step (TEAM Network 2011b). Once the design is finalised, all the planned locations of the points should be loaded into a GPS unit that will be used during field implementation (see Chapter 3 for additional practical aspects). This ensures that deployment will accurately follow the design guidelines.

10.2.3.3 Spatial and temporal sampling intensity

Sampling intensity in camera trap studies is determined by the number of sample points and the number of sample days per point. The number and spacing of camera trap points determines the extent of the monitoring area, and the length of time the cameras are operational determines the likelihood that rare species will be detected.

Most analyses of camera trap data assume that populations are closed within the sampling period. This means that the sampling is limited in time and space such that the population experiences no births or deaths, and no immigration or emigration. Population closure is achieved by restricting the time period during which data are collected. Spatial closure is rarely achieved, except on habitat islands where there are physical barriers to movement out of the study area (see Chapter 7). Spatial closure can be approximated, however, by assuming that net immigration and emigration are equal.

To have enough statistical power for making inferences about changes in species that are reasonably common (50% or more average detections per point), we recommend at least 60 sampling points, spaced out on a regular grid at a density of one point per 2

km^2. Hence, this translates into a *minimum* area of 120 km^2 sampled. With 90 points, the statistical power is better for species that range from common to uncommon (30–50% average detections per point) but not rare. Sampling arrays larger than 100 points at the same density do not usually result in significant gains in power (O'Brien 2010). Typically, camera trap studies that target entire communities are designed to sample for 30 days per sample point within a given season. More specialised studies (e.g. population estimation of large cats) use a temporal frame appropriate for the species. Restricting sampling to a given season improves the chances of population closure because species migration is often a seasonal phenomenon. Seasonal restriction is also a form of stratification.

10.2.4 Implementation

Once there is agreement about the design – i.e. the number of protected areas that will be monitored, and the sampling effort in each protected area – then implementation of monitoring can start. Several key activities need to happen for a successful implementation: equipment acquisition, field training, field deployment, data processing, and data analysis and interpretation. We discuss each of these in more detail in the sections below.

10.2.4.1 Equipment and supplies

For general background to field deployment we refer the reader to Chapter 3; here we provide information that is additional and/or specific to the suggested programme and context.

Most of the supplies and some of the equipment (see Table 10.3) can be acquired in country, but unless high-quality camera traps are readily available for sale in the country, these will need to be imported. It is important to ensure that imported equipment is ordered in advance (at least 6–9 months) before field deployment, to give adequate time for shipping, customs clearance and other regulations. This will vary from country to country.

Supplies (memory cards, rechargeable batteries, chain locks, etc.; see Chapter 3) can be reused year after year during the monitoring programme, but there should always be some spares to account for malfunction, theft and/or loss. A good rule of thumb is to ensure that there is always 10% more equipment and supplies than required for smooth continuity of monitoring. For example, if 30 camera traps are needed for each deployment each year, ensure there are three more each year that could be used as spares.

10.2.4.2 Training for field deployment

The critical importance of appropriate training for key personnel is highlighted in Chapter 3. Training should be conducted by experts who are familiar with the design of the field deployment and knowledgeable about the country where the system is being set up. It is advisable to train all lead field personnel (e.g. technical leads for each protected area) at the same training event, so they can benefit from exchanging experiences and lessons learned. Lead field personnel can then train local field technicians, students and other personnel who will be involved in the field deployment at each protected area.

- *Field campaign design.* Training should involve a process to map out the rate at which camera traps will be deployed (how many camera traps per day), how many parallel

Table 10.3 List, quantity and suggested brands of equipment and materials needed for a large-scale camera trap deployment (60 points) following TEAM Terrestrial Vertebrate Protocol Standards. Batteries and other supplies might vary depending on camera trap model used.

Item	Quantity needed	Manufacturer	Model
Camera trap	33	Reconyx	HC500-Hyperfire with 10% discount
Cable locks	30	Master Lock	Python Professional cable lock
Memory cards	66	SanDisk	2GB Ultra II SD Memory card
AA NiMH batteries	400	Total Energy	AA NiMH – 2,600 mAh batteries (12 batteries per camera)
Battery charger	23	Vanson	Best Battery Charger: BC1HU 110-240V Universal Fast Smart Charger
Memory card reader	2	SanDisk	Imagemate 12-in-1 USB reader
Aluminium tags: one box	2	Forestry suppliers	Aluminium-wrapped cardboard, writable 7.62 cm × 22.2 cm, 15.24 cm wire, two holes
Moisture control packets (resusable)	100	Zorb-it	5 cm × 5 cm packets (two per camera)
Whiteboard	2	NA	Small whiteboard (30 cm × 20 cm) to write camera trap number for start/end photo
Erasable markers	10	Sharpie	Erasable, black, thick tip

teams are needed for deployment, particular routes that should be followed in the field, and locations of temporary sleeping camps during deployment. Good training on designing the field campaign will ensure that the field deployment is successful and on schedule.

- *Finding the locations for camera trap points.* The spatial coordinates of all points should be loaded in a GPS, so training should cover basic use of a GPS and how to navigate to a particular point. This is essential to maintain the integrity of the design.
- *Installation and testing of camera traps.* Training should include a field component where trainees install camera trap points in the field, which are then verified by instructors.

10.2.4.3 Field deployment

Having established a spatial design and a sampling framework for a camera trap deployment, and after receiving proper training, the team needs to develop a deployment strategy. Successful and efficient deployment of camera traps requires careful planning and preparation. First prepare a map of the study area that includes the locations of the camera trap points using a GIS system with a digital elevation map. Plan the travel route to minimise time spent walking and to avoid obvious landscape features such as steep slopes. Locate base camps strategically to minimise travel time to camera trap points; this may require two or more camps that should be located close to a water source. Conduct a preliminary site visit to establish where to locate camps and to determine the exact location of the camera trap points. Follow best practices for choosing camera trap sites

(see TEAM Network 2011a; O'Brien 2010). Mark the camera trap location with a tag, or coloured flag, and georeference the location using a GPS. When deploying the cameras, expect to set up two or three points per day per team. See Chapter 3 for comprehensive details on setting up camera traps and starting the sampling.

Often traps have to be deployed more than once during a season to achieve adequate coverage. Usually the same team can pick up more camera traps per day than they deploy, perhaps 3–5 per team per day. See Chapter 3 for details on camera retrieval, data storing and preparation of equipment for redeployment. It is important to minimise the time between pickup and redeployment of traps, especially if the sampling season is short, or the deployment effort is long.

10.2.4.4 Data processing

Once the field sampling is completed, it is time to gather all the memory cards and start processing all this information. There are many possible ways of doing this, but we strongly recommend the use of specialised software such as OpenDesk TEAM (Fegraus *et al.* 2011; see Chapter 4) Wild.ID (https://www.wildlifeinsights.org/WMS/#/) or eMammal (https://emammal.wordpress.com/about/), which are capable of automatically linking images and metadata. Such software extracts several pieces of information from each image (date, time, name of the camera trap point, etc.) leaving the user to fill information about the species name and the number of animals in each image. Wild.ID and OpenDesk TEAM speed up this process by grouping images in each camera trap that are consecutive and close together in time. This can significantly reduce the processing time, especially when there are several thousand images for each camera trap. As mentioned in the last section above, appropriate training is required to identify camera trap images, and good technical knowledge of the species being identified is a must. For more information about camera trap data-processing software, see Chapter 4.

10.2.4.5 Data analysis and indicators

Camera trap surveys can generate a vast amount of data on species and communities, leading to challenges for data analysis and interpretation. Sampling designs can affect the range of analyses possible, and the accuracy and precision of metrics (see Chapter 6 for background on sampling design). There will be a temptation for park managers to attempt to maximise the information content of a survey for many species and this is rarely possible. For example, a camera trap survey designed to maximise detection probability for a particular species may result in poor detection potential for other species that have different movement patterns (e.g. tiger *Panthera tigris* vs. chital *Axis axis*, jaguar *Panthera onca* vs. peccary *Pecari* spp.) or tend to avoid the target species. For biodiversity monitoring of terrestrial mammals and terrestrial birds we recommend that systematic sampling using grid centroids or randomised location within a grid be used. This approach optimises sampling for the largest number of species.

When developing an analysis for inference from surveys, we must formalise the relationship between the data collected, usually some form of counts and covariates to explain counts, and the variable of interest (species richness, abundance, occupancy: Royle *et al.* 2008). Camera traps are useful for generating a variety of count data in the form of counts of species, of locations where a species is detected, counts of recognised individuals and counts of independent encounters between a camera trap and a species.

Biologists and statisticians recognise that counts are always biased low relative to the parameters of interest, because detection is almost always less than 1. In the past 40 years or so, biologists and statisticians have developed a wide array of methods for unbiased estimation of species richness, population size, density, occupancy and demographic parameters (Williams *et al.* 2002; see also Chapters 6 and 7). A count, C can be considered a random variable that varies each time a sample is collected. $E(C)$ is the expected value or average value of the count over a very large number of replicated samples. C relates to the population size, N, by the average probability of detection, so that $E(C) = Np$. We can then estimate N by $\hat{N} = c/\hat{p}$. This formula is known as the canonical estimator of abundance (Williams *et al.* 2002) and forms the basis for a large range of population estimates, including the estimated abundance of a species, estimated species richness and the estimated number of occupied sampling units.

10.2.4.6 Species richness

The question of 'how many species occur' is important because biodiversity is often equated with species diversity and number of species at a site (Schluter and Ricklefs 1993; Lande 1996). There are three classes of species richness estimators that correct for imperfect detection (ignoring species accumulation curves) in a sample when detection is imperfect. The classic approach is the jackknife estimator developed by Burnham and Overton (1978, 1979), based on capture–recapture estimation. This method provides generally unbiased estimates of species richness (Walther and Morand 1998; Boulinier *et al.* 1998) and an estimate of precision that is useful for comparative purposes. Second, jackknife estimators can be expanded to multi-season models that allow for estimation of extinction, colonisation and turnover at a site. The drawback is that they do not allow for covariate modelling that might reveal factors influencing species richness changes at a site. Third, when a regional species list is available, we can use occupancy methods to estimate species richness. Whereas the jackknife estimator estimates species richness directly, occupancy methods use the regional species pool as the sampling units and estimate the relative species richness or the proportion of the sampling units (species) that are present (occupied). This method allows the incorporation of covariates that might affect the occurrence of species (habitat, disturbance) and the detection of species (body size). Relative species richness can be modelled over time to estimate extinction, colonisation and turnover. Bayesian formulations of species richness estimators (Dorazio and Royle 2005; Dorazio *et al.* 2006; Kéry and Royle 2008) rely on a multi-species model of occurrence. If $z(i,j)$ is an indicator of whether species *i* is present at location *j*, then one way to estimate species richness would be to estimate these indicator variables. Using data augmentation techniques, these models estimate the number of species exposed to sampling out of an arbitrarily large species pool. The advantage of this model is that it combines information across spatial sampling units and may be less biased and more precise than other methods, especially when many species are rare or elusive. Bayesian models also allow the incorporation of covariates. For further details on community-level analysis including analytical procedures, readers are referred to Chapter 9.

10.2.4.7 Occupancy

Changes in species distribution are of interest to park managers because shifts in distribution are an expected outcome of management interventions (Mackenzie *et*

al. 2003, 2006). For example, effective patrolling might cause a shift in distribution of mammals toward park edges and access roads. Estimates of distribution are usually described as the proportion of sampling units that are occupied by a target species. Simple presence/absence models are based on two-state outcomes and do not allow for a class of observations 'present but not detected', thus introducing an unquantified bias into the monitoring metric. Occupancy models allow the modelling of occurrence and detection as separate processes to account for species that are present but undetected during sampling. Occupancy modelling allows for great flexibility in approaches, including single-season and multi-season models, and incorporation of covariates. Multi-season occupancy models are especially appropriate for monitoring purposes because they allow the estimation of extinction and colonisation, important parameters for understanding population dynamics for a species. Bayesian dynamic occupancy models (Royle and Kéry 2007) have also been described; see Chapter 6 for a full account of species-level occupancy analysis.

Occupancy models also include a class of models that consider local abundance in the sampling unit as a source of heterogeneity in detection probability. The first model is an abundance-induced heterogeneity model (Royle and Nichols 2003) based on the premise that heterogeneity in abundance causes heterogeneity in detection probability – the more abundant a species is, the easier it is to detect the species. This relationship allows one to use a heterogeneous detection probability model to estimate the underlying abundance from presence/absence data without having to identify individuals in the population. A second approach is to consider the sampling units as a metapopulation of sites each with a local abundance. Under a replicated sampling scheme, such as daily camera trapping, local abundances may be estimated from point counts while controlling for detection probability. Expanding local abundance to total abundance or density on the study area requires additional assumptions, but both methods should provide estimates that fluctuate with abundance and density in the study area.

10.2.4.8 Abundance and density

Abundance and density are uncommonly used as metrics in biodiversity monitoring programmes due to the difficulty of estimating these parameters for all species under consideration. For most capture–recapture and spatially explicit capture–recapture analyses, information on capture histories of individuals is required (see Chapter 7). For random encounter models (Rowcliffe *et al.* 2008), additional information on velocity, or rate of movement, is required. Relative abundance indices (RAIs) based on camera trap encounter rates or counts of individuals in camera trap images make assumptions about the relationship between the index and true abundance/density that need to be tested or calibrated (O'Brien 2011; see also Chapter 5). If an index is required, the estimates from the abundance-induced heterogeneity model and the metapopulation model should be considered.

10.2.4.9 Indicators

A fundamental goal of national monitoring programmes is to determine whether biodiversity is changing over time, and at what rate. Buckland *et al.* (2005) present criteria that a biodiversity indicator should satisfy to detect trends over time. These non-statistical criteria relate to the components of biodiversity: species richness, species evenness and

species abundance/distribution. The statistical criteria are that the indicator has good precision, measurable precision and is independent of sample size. The treatment of rare species is also important for indicators. Rare species often dominate community species richness, but reduce species evenness while contributing little to species abundance. Generally, inclusion of rare species increases the variance associated with an indicator (Buckland *et al.* 2005, 2010).

A number of biodiversity indicators use the geometric mean, G, of RAIs as their biodiversity measure, including the Living Planet Index (Loh *et al.* 2005) and UK Wild Bird Indicators (Gregory 2008). RAI has a special connotation here. Consider a community of S species observed (counted) over a number of years. We convert the measure for a species to a relative abundance by dividing the count in year i by the count in the baseline year or first year of the survey. The relative abundance refers to the abundance of species j to its baseline value, not to any community-level abundance. Thus each species is scaled equivalently irrespective of its abundance in the community. This form of relative abundance is considered a multiplicative measure. When averaging multiplicative measures, it is normal to use a geometric mean. Therefore the average value for S species in year i is the geometric mean of the relative abundances for the S species in the community. This process assumes that all species receive equal weighting in the indicator, although weighting species would be an option. The geometric mean tends to dampen the effect of extreme values and can thus be used to develop a trend for a population of species (O'Brien *et al.* 2010). The geometric mean relative abundance is unaffected by differences in species detection probabilities because it is based on within-species trends. Furthermore, if detection within a species is constant (a rare event in itself), the use of ratios means we do not need to estimate detection probability to avoid bias in the within species trends (O'Brien 2011; Buckland *et al.* 2012). The Wildlife Picture Index (WPI, O'Brien *et al.* 2010; Ahumada *et al.* 2013; see also Chapter 9) is based on the geometric mean and within-species trends are corrected for detection probability.

The WPI is a suitable indicator to monitor temporal changes in the biodiversity of the community of vertebrates sampled with camera traps. The calculations behind the WPI are complex, because of the underlying occupancy models, but the TEAM network in conjunction with Hewlett Packard have created a system, the WPI Analytics System (http://www.wildlifeinsights.org), to calculate the WPI given a set of camera trap data. This system enables park managers and officials to concentrate on the interpretation of the patterns at the species and community level, rather than on the mechanics of the analysis. The WPI system is a component of the integrated Wildlife Monitoring System that TEAM offers and is essential for closing the loop between data collection, analysis, indicator production and decision making. For more information, visit http://www. teamnetwork.org/solution.

10.2.5 Cost components

In this section we discuss in more detail the costs incurred in setting up and implementing a monitoring system based on camera traps. We also outline some of the main funding sources for governments and other institutions that might assist in monitoring. Although the costs vary from country to country, we outline a typical situation for tropical Africa where we set up monitoring for seven protected areas. First we present some calculations for a single protected area and then we aggregate the costs for the whole system.

As described below, the costs of setting up and maintaining a wildlife monitoring system based on camera traps is modest compared to other monitoring methods, especially when compared to the quality and relevance of the information produced. However, many countries might have budget limitations in funding these activities, so here we give some guidelines of possible funding sources.

10.2.5.1 International aid agencies

Many countries have bilateral agreements with international development and environmental aid agencies, such as the Deutsche Gesellschaft für Internationale Zusammenarbeit (GIZ), the United States Agency for International Development (USAID) or the Norwegian Agency for Development Cooperation (NORAD), among others. Government officials and researchers should partner with other stakeholders (NGOs, indigenous community organisations, local community organisations, etc.) to approach missions of these agencies to consult about available opportunities. Many of these agencies are open to funding environmental and wildlife monitoring as a way to assess development impacts and/or conservation activities.

10.2.5.2 Multilateral banks

An important source of environmental funding for governments is the Global Environmental Facility (GEF). Based at the World Bank, GEF is a partnership of donor countries, agencies and civil society organisations that acts as a funding instrument to implement major global environmental convention mandates, such as the Convention of Biological Diversity (CBD), the United Nations Framework Convention on Climate Change (UNFCCC) and the United Nations Convention to Combat Desertification (UNCCD). At each project cycle (typically 4 years), the GEF allocates funding to countries according to a range of environmental initiatives (biodiversity, climate change, land degradation, etc.). Again, in collaboration with other partners, government officials can approach local GEF contacts to explore current opportunities. GEF projects are complex and should be prepared a long way in advance (one year or more) of expected implementation in the field.

10.2.5.3 Private corporations

Many companies in the technology, financial and extractive sectors also can provide funding for monitoring activities, although many of them require a specific product or output from these activities. This varies from country to country, but, in general, many corporations have social responsibility and/or environmental responsibility divisions that might provide assistance in kind (equipment, technology, etc.) or in cash. Government officials can engage with other stakeholders in approaching many of these companies to explore opportunities.

10.2.5.4 Foundations and non-governmental organisations

Many local and international foundations fund environmental work throughout the world. A good starting point is the Foundation Center website at http://foundationcenter.

org/getstarted/topical/environment.html. Many foundations, however, have limited funding for long-term projects, so they should be seen more as complementary funding.

Other possible sources of funding include individual donors and philanthropists at the national and international level. For this, and other sources of funding, it is essential to have a good development department that can assist stakeholders in identifying possible sources of funding.

10.2.5.5 Costs per protected area

Table 10.4 shows the different costs associated with monitoring a protected area for 3 years. These costs are indicative for typical countries in Africa, but should not be taken at face value; individual country costs can vary widely. We only outline the costs of acquiring and running the monitoring system; costs associated with training and other services (e.g. software licenses) are included when looking at the whole network of protected areas.

Table 10.4 Major costs (in thousands of US dollars) of deploying camera traps in a typical protected area in Africa for 3 years. Field deployment costs include costs of equipment (60–90 camera trap points or 30–45 camera traps), field supplies, food and travel; staff costs increase over time due to inflation and include a half-time manager-level position, plus four or five field technicians; IT costs include computers and a server.

Cost type	Year 1	Year 2	Year 3	Total
Field deployment	18–41	6.5–9.8	6.7–9.9	32–60
Staff	22	22	23	67
IT costs	1.6–7.2	–	–	1.6–7.2
Total	**41.6–70.2**	**28.5–31.8**	**29.7–32.9**	**101–134**

Costs in the first year are higher than in other years, due to the initial investment in equipment. We give a low and a high range for some of these depending on how many camera traps are initially purchased and the type of IT solution established for that protected area (e.g. dedicated server or cloud storage). Staff includes a local site manager at 30% full-time equivalent (FTE), who coordinates all field data collection and data processing, four field rangers at 20% FTE, and a technical in-country advisor at 30% FTE to troubleshoot with technical issues related to field implementation (we have added yearly inflation as well). Setup costs (first year) range between US$42,000 and US$70,000 and recurring costs run between US$28,500 and US$32,900 per year. The total costs for 3 years of monitoring at one protected area is of the order of US$100,000 (see Table 10.4).

10.2.5.6 Costs for a network of protected areas

When scaling up the system to a network of protected areas, some of these costs scale up linearly but some do not. Additional costs include training workshops for field implementation, data processing and analysis, and software licenses. Table 10.5 shows estimated costs for a network of seven protected areas in Africa.

Again, costs in the first year are higher due to initial acquisition of equipment and supplies. We assume here that each protected area will have its own set of camera traps,

Table 10.5 Major costs (in thousands of US dollars) of deploying camera traps in a network of seven protected area in Africa for 3 years. Field deployment costs include costs of equipment (60–90 camera trap points or 30–45 camera traps), field supplies, food and travel; staff costs include a one-third FTE manager-level position at each protected area, plus one-third FTE of four or five field technicians at each protected area, plus a full-time technical manager; IT costs include computers, servers and software licenses. Training includes four workshops on field deployment, data processing, analysis and interpretation, and data-driven decision making.

Cost type	Year 1	Year 2	Year 3	Total
Field deployment	129–287	47–68	48–70	224–425
Staff	104–117	123–136	141–173	368–426
IT costs	52–68	28–52	28–52	108–172
Training	75–95	45–50	30–38	150–183
Technical support	17–21	21–25	21–25	59–71
Total	**406–559**	**277–318**	**268–357**	**951–1,235**

but in some cases equipment might be shared between neighbouring protected areas, thus saving 30–50% of this cost. *Training* is an important component in the first 3 years of implementation; we assume two workshops in the first year (one for field deployment, one for data processing) and then annual workshops in years 2 and 3 for data analysis, indicator interpretation and decision-making. *IT costs* include a dedicated server or cloud solution for data storage and/or processing of data and images, software licenses and software consulting. *Technical support* includes dedicated services provided by experts for managing and analysing camera trap data, troubleshooting components of the system (e.g. software, hardware) and other technical advice (science and/or design issues).

The setup costs of a monitoring system of this size (seven protected areas) range between US$406,000 and US$559,000 with annual recurring costs of US$268,000–357,000. The average annual cost of monitoring per protected area is between US$38,000 and US$51,000. Running the system for 3 years costs around US$1 million.

Compared to other methods to monitor wildlife (e.g. line transects), camera trapping is more cost effective because it can sample a larger area per unit of cost, and can capture more species including nocturnal ones (O'Brien and Kinnaird 2013). In general, camera trap monitoring is 15% cheaper to implement than line transects in tropical forests and 30% cheaper for savannahs (*ibid*).

10.3 How a wildlife monitoring system can improve protected area effectiveness: examples from the TEAM Network

Finally, we want to illustrate how a camera trap-based monitoring system can help park managers use this information and improve the management of their protected areas. We discuss two cases in Bwindi Impenetrable Forest, Uganda and the Volcán Barva transect in Costa Rica.

10.3.1 African golden cats in Bwindi Impenetrable Forest, Uganda

The African golden cat (*Caracal aurata*) is a medium-sized cat distributed over the rainforests of West and Central Africa and is currently classified as Vulnerable (VU) by the IUCN. It is an extremely reclusive species, so little is known about its behaviour and ecology and much less is known about its population status in several areas. Golden cats have been sampled with camera traps for several years at Bwindi Impenetrable Forest, Uganda, a TEAM site since 2009. Camera traps were set up following the standard TEAM sampling design and are placed along two regular grids of 30 cameras each.

Using the camera trap data, a general declining trend in the number of occupied sites was detected in Bwindi's golden cat population and other carnivores since 2010, while herbivores and other guilds are stable or rising (Figure 10.2 and Figure 10.3). Associated with this, human detection on camera traps (mostly due to tourists visiting the area) is also on the rise (not shown). There is a negative association between increasing human presence and declining carnivore occupancy, probably due to increased number of tourists using trails to visit mountain gorilla (*Gorilla beringei beringei*) groups. Hunting does not seem to be responsible for this trend, because other species that are hunted in the area do not seem to be declining significantly.

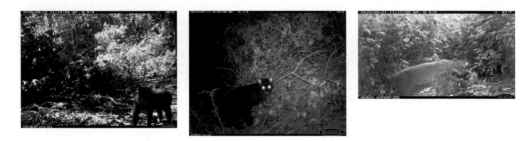

Figure 10.2 Camera trap images of African golden cat (*Caracal aurata*) in Bwindi Impenetrable Forest, Uganda, showing the three coat patterns found there: golden, melanistic and grey (left to right).

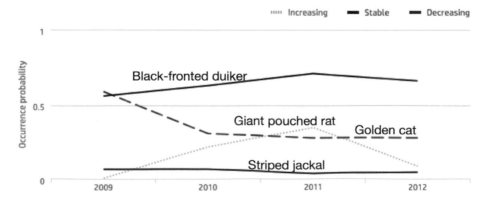

Figure 10.3 Changes in occupancy in African golden cat (*Caracal aurata*) and striped jackal (*Canis adustus*), compared to herbivores at Bwindi Impenetrable Forest, Uganda as shown by the WPI Analytics System (wpi.teamnetwork.org).

These patterns have important implications for the management of golden cats and other carnivores in Bwindi. For example, do park authorities reduce or control the intensity of tourism? Do they focus on decreasing poaching of key herbivores? Since the occupancy estimates are already corrected for detection probability, we know that these populations are declining, but we do not yet know why. This has sparked a series of studies in Bwindi aimed at trying to understand the relationships between golden cat population changes, human presence inside the park, prey abundance for the cats, interspecific competition and conflict with local communities surrounding the protected area. Without the camera traps we would not even know that these changes are occurring.

10.3.2 Effects of hunting at the Volcán Barva transect, Costa Rica

The Volcán Barva TEAM site in northeastern Costa Rica comprises a large area of protected forest spanning an elevational gradient from 100 m to >3,000 m above sea level,

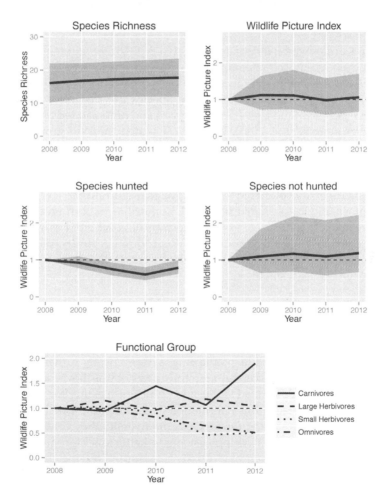

Figure 10.4 Species richness, overall WPI just for hunted species, WPI for species that are not hunted and WPI split according to functional group at Volcan Barva transect, Costa Rica (from Ahumada *et al.* 2013).

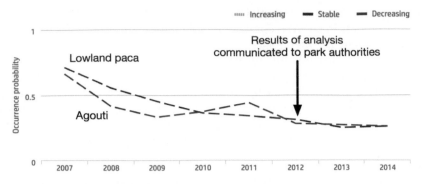

Figure 10.5 Changes in occupancy of lowland paca (*Cuniculus paca*) and agouti (*Dasyprocta punctata*) at the Volcan Barva TEAM site since 2007 as shown by the WPI Analytics System (wpi.teamnetwork.org). After the information about these declines was communicated to park authorities and specific measures were implemented both species stabilized but have not yet recovered.

within Braulio Carillo National Park and La Selva Biological Station (a private reserve). This area has been monitored annually with camera traps since 2007 using the TEAM protocol, and sampling points are located along the elevational gradient. An analysis of the camera trap data showed that several species are declining including agouti (*Dasyprocta punctata*), lowland paca (*Cuniculus paca*) and nine-banded armadillo (*Dasypus novemcinctus*) (Ahumada *et al.* 2013). We also calculated the WPI grouped by hunting status of species and showed that the diversity of hunted species is declining compared to species that are not hunted (Figure 10.4).

Grouping the WPI by functional group showed that herbivores and omnivores are also declining in diversity compared to other groups (Figure 10.5).

All this information was shared with park authorities in both protected areas, and measures were taken to increase patrolling and control poaching. Figure 10.5 shows the effects of these actions after this information was communicated to park authorities in both reserves. It seems that two of the species that were declining the fastest (agouti and lowland paca) have at least stabilised.

10.4 Conclusions

In this chapter we have outlined the main conceptual framework and processes required to setup a national-level wildlife monitoring system using camera traps. Various considerations are key for a successful monitoring system of this type: clear goals and targets, a solid statistical design, adequate and sufficient training for field deployment and data processing, and use of this information to derive indicators that can be used to better manage protected areas and the precious biodiversity they contain. We hope that more countries adopt these monitoring systems to better track progress of global and national targets towards reducing biodiversity loss and increasing the effectiveness of protected areas.

References

Ahumada, J.A., Hurtado, J. and Lizcano, D. (2013) Monitoring the status and trends of tropical forest terrestrial vertebrate communities from camera trap data: a tool for conservation. *PLoS ONE* 8: e73707.

Beaudrot, L., Ahumada, J.A., O'Brien, T., Alvarez-Loayza, P., Boekee, K., Campos-Arceiz, A., Eichberg, D., Espinosa, S., Fegraus, E., Fletcher, C., Gajapersad, K., Hallam, C., Hurtado, J., Jansen, P.A., Kumar, A., Larney, E., Lima, M., Mahony, C., Martin, E.H., McWilliam, A., Mugerwa, B., Ndoundou-Hockemba, M., Razafimahaimodison, J.C., Romero-Salto, H., Rovero, F., Salvador, J., Santos, F., Sheil, D., Spironello, W.R., Willig, M.R., Winarni, N.L., Zvoleff, A. and Andelman, S.J. (2016) Standardized Assessment of Biodiversity Trends in Tropical Forest Protected Areas: The End is Not in Sight. *PLoS Biology* 14: e1002357.

Baru, C., Fegraus, E.H., Andelman, S.J., Chandra, S., Kaya, K., Lin, K. and Youn, C. (2012) Cyberinfrastructure for observatory and monitoring networks: a case study from the TEAM Network. *BioScience* 62: 667–675.

Bindra, P.S. (2012) *India Adopts a New Refined Protocol to Monitor Tigers*. Conservation India. http://www.conservationindia.org/articles/india-adopts-a-new-refined-protocol-to-monitor-tigers (accessed 24 June 2015).

Boulinier, T., Nichols, J.D., Sauer, J.R., Hines, J.H. and Pollock, K.H. (1998) Estimating species richness: the importance of heterogeneity in species detectability. *Ecology* 79: 1018–1028.

Buckland, S.T., Magurran, A.E., Green, R.E. and Fewster, R.M. (2005) Monitoring changes in biodiversity through composite indices. *Philosophical Transactions of the Royal Society London B* 360: 243–254.

Bubb, P.J., Butchart, S.H.M., Collen, B., Dublin, H.T., Capos, V., Pollock, C., Stuart, S.N. and Vie, J.C. (2009) *IUCN Red List Index – Guidance for National and Regional use*. Gland Switzerland: IUCN.

Buckland, S.T., Studeny, A.C., Magurran, A.E. and Newson, S.E. (2010) Biodiversity monitoring: the relevance of detectability. In: A. Magurran and B. McGill (eds), *Biological Diversity: Frontiers in Measurement and Assessment*. Oxford: Oxford University Press. pp. 25–36.

Buckland, S.T., Studney, A.C., Magurran, A.E., Illian, J.B. and Newsom, S.E. (2011) The geometric mean of relative abundance indices: a biodiversity measure with a difference. *Ecosphere* 2: 100.

Burnham, K.P. and Overton, W.S. (1978) Estimation of the size of a closed population when capture probabilities vary among animals. *Biometrika* 65: 625–633.

Burnham, K.P. and Overton, W.S. (1979) Robust estimation of population size when capture probabilities vary among animals. *Ecology* 60: 927–936.

Butchart, S.H.M, Sattersfield, A.J., Bennum, L.A., Shutes, S.M., Akcakaya, H.R., Baillie, J.E.M., Stuart, S.N., Hilton-Taylor, C. and Mace, G.M. (2004) Measuring global trends in the status of biodiversity: Red List indices for birds. *PLoS Biology* 2: 2294–2304.

Butchart, S.H.M, Sattersfield, A.J., Bennum, L.A., Shutes, S.M., Akcakaya, H.R., Baillie, J.E.M., Stuart, S.N., Hilton-Taylor, C. and Mace, G.M. (2005) Using Red List indices to measure progress towards the 2010 target and beyond. *Philosophical Transactions of the Royal Society London B* 360: 255–268.

Collen, B., Loh, J., Whitmee, S., McRae, L., Amin, R., and Baillie, J.E.M. (2009) Monitoring change in vertebrate abundance: the Living Planet Index. *Conservation Biology* 23: 317–327.

Dorazio, R.M. and Royle, J.A. (2005) Estimating size and composition of biological communities by modeling the occurrence of species. *Journal of the American Statistical Association* 100: 389–398.

Dorazio, R.M., J.A. Royle, Söderström, B. and Glimskär, A. (2006) Estimating species richness and accumulation by modeling species occurrence and detectability. *Ecology* 87: 842–854.

Fegraus, E.H., Lin, K., Ahumada, J.A., Baru, C., Chandra, S. and Youn, C. (2011) Data acquisition and management software for camera trap data: a case study from the TEAM Network. *Ecological Informatics* 6: 345–353.

Kéry, M. and Royle, J.A. (2008) Hierarchical Bayes estimation of species richness and occupancy in spatially replicated surveys. *Journal of Applied Ecology* 45: 589–598.

Lande, R. (1996) Statistics and partitioning of species diversity, and similarity among multiple communities. *Oikos* 76: 5–13

Loh, J., Green, R.E., Ricketts, T., Lamoreux, J., Jenkins, M., Kapos, V. and Randers, J. (2005) The Living Planet Index: using species population time series to track trends in biodiversity. *Philosophical transactions of the Royal Society London B* 360: 289–295.

MacKenzie, D.I., Nichols, J.D., Hines, J.E., Knutson, M.G. and Franklin, A.B. (2003) Estimating site occupancy, colonization, and local extinction when a species is detected imperfectly. *Ecology* 84: 2200–2207.

MacKenzie, D.I., Nichols, J.D., Royle, J.A., Pollock, K.H., Bailey, L.L. and Hines, J.E. (2006) *Occupancy Estimation and Modeling: Inferring Patterns and Dynamics of Species Occurrence.* San Diego, CA: Academic Press.

Mohd-Azlan, J. (2009) The use of camera traps in Malaysian rainforests. *Journal of Tropical Biology and Conservation* 5: 81–86.

O'Brien, TG. (2010) *Wildlife Picture Index Implementation Manual Version 1.0.* WCS Working Papers No. 39.

O'Brien, T.G. (2011) Abundance, density and relative abundance: a conceptual framework. In: A.F. O'Connell, J.D. Nichols and K.U. Karanth (eds), *Camera Traps in Ecology: Methods and Analyses.* New York: Springer. pp. 71–96.

O'Brien, T.G. and Kinnaird, M.F. (2010) The Wildlife Picture Index: a biodiversity indicator for top trophic levels. In: B. Collen, N. Pettorelli, S. Durant, J. Baillie and L. Krueger (eds), *Biodiversity Monitoring and Conservation: Bridging the Gaps Between Global Commitment and Local Action.* Cambridge: Wiley-Blackwell Publishing. pp. 45–70.

O'Brien, T.G., Baillie, J.E.M., Krueger, L. and Cuke, M. (2010) The Wildlife Picture Index: monitoring top trophic levels. *Animal Conservation* 13: 335–343.

Rowcliffe, J.M., Field, J., Turvey, S.T. and Carbone, C. (2008) Estimating animal density using camera traps without the need for individual recognition. *Journal of Applied Ecology* 45: 1228–1236.

Royle, J.A. and Nichols, J.D. (2003) Estimating abundance from repeated presence–absence data or point counts. *Ecology* 84: 777–790.

Royle, J.A. and Kéry, M. (2007) A Bayesian state-space formulation of dynamic occupancy models. *Ecology* 88: 1813–1823.

Royle, J.A., Stanley, T.R. and Lukacs, P.M. (2008) Statistical modeling and inference from carnivore survey data. In: R. Long, P. McKay, J. Ray and W. Zielinski (eds), *Noninvasive Survey Methods for Carnivores.* Washington, DC: Island Press. pp. 293–312.

Schluter, D. and Ricklefs, R.E. (1993) Species diversity: an introduction to the problem. In: R.E. Ricklefs and D. Schluter (eds), *Species diversity in ecological communities.* Chicago: University of Chicago Press. pp. 1–10.

Szabo, J.K., Butchart, S.H.M., Possingham H.P. and Garnett S.T. (2012) Adapting global biodiversity indicators to the national scale: a Red List index for Australian birds. *Biological Conservation* 148: 61–68.

TEAM Network (2011a) *Terrestrial Vertebrate Protocol Implementation Manual, v. 3.1.* Tropical Ecology, Assessment and Monitoring Network, Conservation International, Arlington, VA.

TEAM Network (2011b) *TEAM Network Sampling Design Guidelines.* Tropical Ecology, Assessment and Monitoring Network, Conservation International, Arlington. http://www.team-network.org/files/protocols/TEAM_Sampling_Design_Guidelines.pdf.

Walther, B.A. and Morand, S. (1998) Comparative performance of species richness estimation methods. *Parasitology* 116: 395–405.

Williams, B.K., Nichols, J.D. and Conroy, M.J. (2002) *Analysis and Management of Animal Populations.* San Diego, CA: Academic Press.

WWF (2014) *Living Planet Report 2014. Species and Spaces, People and Places.* Gland, Switzerland: WWF International.

11. Camera traps and public engagement

Paul Meek and Fridolin Zimmermann

11.1 Introduction

'Citizen science (CS) also called "crowdsourced science" or more formally, public participation in scientific research, is the systematic collection and analyses of data, development of technology, testing of natural phenomena, and dissemination of these activities by researchers on a primarily avocational basis' (Toerpe 2013). CS is not new: members of the public have for most of recorded history investigated scientific questions, often by noting observations of the world around them (Miller-Rushing *et al.* 2012). Almost all scientific research was conducted by amateurs prior to the professionalisation of science in the late 19th century (Vetter 2011). Although CS is still common, as demonstrated by the many groups of naturalists that exist worldwide, the role of amateurs in conducting research has changed in the past 150 years or so as the number of professional scientists has drastically increased and the culture of science has changed (Miller-Rushing *et al.* 2012). CS has now evolved to the extent that community-based monitoring (CBM) or voluntary biological monitoring is well entrenched in environmental and natural resource management programmes globally (Conrad and Hilchey 2011). Participation in efforts such as bird watching, frog counting, river water quality assessment and habitat restoration is commonplace (Dickinson *et al.* 2010). CS, with its army of observers, can be an effective way to find rare organisms, track invasions, and detect boom-and-bust events such as irrupting bird populations, and connect scientific circles with the wider public on a scale that would otherwise not be possible (Hochachka *et al.* 1999; Dickinson *et al.* 2010; Dickinson and Bonney 2012). CS is especially powerful when combined with conservation goals (Dickinson *et al.* 2012).

Concomitant with the increasing involvement of the community in monitoring and research has been the growth of camera trapping as a survey tool (McCallum 2013; Rovero *et al.* 2013; Burton *et al.* 2015; Meek *et al.* 2015a). The ease of use of camera traps for gathering data with apparent minimal training makes them an attractive tool for CS programmes. Essentially, the public can place a device to detect wildlife, and within days can acquire images confirming the presence of species in a given area. To the non-scientifically trained community member, seeing animals in photographs is very powerful and infinitely rewarding. To this end camera traps are an ideal platform for developing

community engagement and participation because they appeal to our visual curiosity (Othman and Amiruddin 2010; Meek *et al.* 2015b). Moreover, camera traps provide an insight into the secret lives of animals both day and night – perhaps something that appeals to human voyeuristic tendencies and our obsession with knowing about the lives of others.

In 1913 the Piqua Auto Supply House, USA promoted the availability of their vehicle accessories in a newspaper advertisement stating 'one look is worth a thousand words', an adage that has resonated in various forms over the decades. This adage provides an insight into why camera traps are such a successful wildlife education tool. Photographs have visual impact and humans are visual beings (Othman and Amiruddin 2010), so it makes sense that images produced by camera traps have great potential to promote participation in conservation and enhance education opportunities.

As technology infiltrates our daily lives, and the public have easy accessibility to smart technology, smartphones and similar devices now provide for immediate validation of observations including transmission of data (Burke *et al.* 2006; Dickinson *et al.* 2010). Indeed, devices such as camera traps, which are promoted as being 'easy-to-use technology', have become readily available and can produce very powerful imagery that explains biology and ecology better than words. The nexus between experimental science and CS poses numerous challenges and the involvement by untrained civilians in well-designed experiments must be managed appropriately. Failure to recognise the need to adequately inform and support untrained personnel can lead to logistical and scientific obstacles, the management of which may not compensate for the benefit of public participation.

In this chapter, we first outline the main principles and research process in CS with a special focus on camera trapping. We then provide a few examples of CS projects around the world that successfully used camera traps. Finally, we discuss what the near future of CS projects could be and which aspects need special attention.

11.2 Principles in citizen science

11.2.1 Categories of public participation in scientific research

Miller-Rushing *et al.* (2012) proposed a ranking system adapted from Bonney *et al.* (2009) based on the depth of scientist–volunteer collaboration. This system distinguished between *contributory* (designed by scientists with data primarily contributed by the public and analysed by scientists), *collaborative* (designed by scientists with data primarily contributed by public who may also help to refine project design, analyse data or disseminate findings), and *co-created projects* (designed by scientists and the public with some of the public participants actively involved in most or all steps of the scientific process).

11.2.2 General approaches to programme development

Following the recommendation of Dickinson *et al.* (2012), models of CS often begin with a well-defined team of participant stakeholders, ecologists and computer scientists to determine clear, project-specific research targets and goals. This team then identifies explicit, measurable end results and the necessary tools and features required to achieve those results through a process of intended design. Iterative periods of design, evaluation

and revision ensure successful protocols, training materials, recruitment, data entry and integrity, and data-sharing platforms, while continuing to align scientific (and educational) objectives with project activities and the abilities/expectations of participants. This model is applicable to both participant-driven (collaborative or co-created) and scientist or institution-led (contributory projects).

11.3 Citizen science research process with a special focus on camera trapping studies

Despite differences between projects, the typical research process for most CS projects including camera trapping can been conceptualised as: gathering team/resource/ partners; defining governance structure; defining a genuine research question or goal (i.e. aims of the project and the questions that need to be answered); defining appropriate methods; collecting, identifying and managing data; analysing and interpreting data (i.e. what might the data mean?); providing feedback to the participants (e.g. how their data are being used, and what the research, policy or societal outcomes are); making project data and metadata publicly available during or after the project (unless there are security or privacy concerns that prevent this); disseminating results in an open access format; and evaluating programme success (i.e. scientific output, data quality, participant experience and wider societal or policy impact) and participant outcomes (i.e. new skill sets, increased understanding of scientific research, stewardship and opportunities to deepen relationships with the natural world as well as with other people; Shirk *et al*. 2012) (adapted from Bonney *et al*. 2009; European Citizen Science Association 2014). In this section, we will specifically focus on collecting, identifying and managing data that are specific to each methodology. For the remaining points, readers should consult Bonney *et al*. (2009) and Newman *et al*. (2012).

11.3.1 Data collection and identification

Where citizen scientists are playing a role in setting camera traps and retrieving data, it is recommended to choose robust camera traps that are easy to program and set to enable volunteers with varying degrees of experience to set these traps. In addition, it is imperative that appropriate guiding principles are defined and that training (section 11.5.1) is provided to those responsible for camera trap placement and maintenance, to prevent bias through inadequate placement. The means of retrieving data from SD cards and management of data will vary between organisations, although recent attempts through data federation aim to minimise variability and errors (see http://www.teamnetwork.org/wildlife-monitoring-solutions and http://www.teamnetwork.org/solution).

At the other end of data collection is the accurate identification of animals from images. In broad-scale surveys, where the number of images accumulates quickly, the process of reviewing all these records by experts can be extremely time consuming. There are various ways to make this process more efficient including crowdsourcing the identification of species (e.g. Snapshot Serengeti at www.zooinverse.org/projects) and automated software-based image analysis (e.g. Hiby *et al*. 2009; Yu *et al*. 2013; Falzon *et al*. 2014). Project managers should be aware that when crowdsourcing species and individual identification, accurate identification of animals from images can be difficult even for the best-trained practitioners (Meek *et al*. 2013). This constraint can be partly

resolved by providing diagnostic checklists, guidance, training and quality control (Sheil *et al.* 2013).

11.3.2 Data management and cyber-infrastructure

A common issue for managers of CS programmes is the management and accessibility of data collected in these programmes (Dickinson *et al.* 2010; Conrad and Hilchey 2011; Chapter 4). Presently, most camera trap users resort to basic storage systems to manage their image libraries, i.e. Microsoft Explorer, and progress to more sophisticated software as the burden of electronic storage slows their computers to a standstill. In large programmes where groups are using camera traps, this issue is magnified exponentially because large volumes of electronic files can be collected by a single camera trap in a very short period, potentially over-extending the storage capacity. Well-funded and well-managed programmes such as TEAM Network have recognised and resolved this issue for their organisation through provision of open access software, Wild.ID, for data management (see Chapter 4 and http://www.teamnetwork.org/solution), but few bodies have the capacity to replicate such image banks. The advent of cloud storage is timely for CS camera trapping because it provides easy access for the community to store large image data files without the need for individual computers to store these. Accessibility for citizens to upload camera trap images will be crucial to the success of CBM using these devices and is an emerging field. For example eMammal (http://emammal.si.edu, accessed 18 March 2015) provides a portal for CS project data to be uploaded by the public and used by scientists to map mammal distribution and abundance. Similarly, Smithsonian Wild (http://siwild.si.edu/about.cfm, accessed 18 March 2015) provides opportunities for CS projects to lodge data in their cyber-infrastructure. There have also been examples of other successful camera trap data management systems using official websites in the USA (Erb *et al.* 2012). In addition cloud storage enables the outsourcing of the identification of animals, which, despite issues of observer bias, is inevitable for large camera trap image libraries collected by organisations such as Galaxy Zoo Project (Fortson *et al.* 2012), Snapshot Serengeti (Swanson *et al.* 2015) and eMammal (McShea *et al.* 2015).

However, the accessibility of e-resources is demanding and requires considerable financial and resource investment by organisations, an issue complicated by social values and culture. In countries such as the USA where there is a culture of civil and social charitable expectation, and where philanthropy is entrenched in society, crowdsourcing and donations can provide resources to community groups. However, in countries where this culture is neither present, nor fostered, such resources are less likely to exist and this deficit can hamper the evolution of community-driven participation in science and natural resource management.

11.4 Examples of camera trap citizen science projects

The involvement of citizens in science offers enormous advantages to wildlife managers throughout the world and there are many examples of how effective the incorporation of camera trapping into programmes can be (Figure 11.1). CS can be used to engage people, inform the community, enhance awareness of important intangible issues, and provide opportunities to influence policy (see http://www.npansw.org.au/index.php/campaigns/citizen-science/who-s-living-on-my-land). CS is considered to be an effective

way of decreasing costs, expanding the spatial extent of sampling, while maintaining robust methods of measuring population status and trends (Erb *et al.* 2012). There are, however, several caveats with citizen participation including conservation issues –for example, ensuring that camera traps are used to 'detect and conserve' not to 'detect and kill' (Swann and Perkins 2014). Community involvement in science does not come without a cost and the constraints and limitations need to be carefully managed through governance frameworks to maximise the benefits to both researchers and the community.

The adoption of camera traps in large-scale projects has merit and has been embraced widely throughout the world. Some programmes are focused around the use of camera traps (Fegraus *et al.* 2011; Swanson 2014; Thomas 2014; Ariefiandy *et al.* 2015; McShea *et al.* 2015; Swanson *et al.* 2015) while others include camera trapping as part of a broad approach (Nagy 2012; Swann and Perkins 2014). In Saguaro National Park, USA, camera traps were included in the 24 h biodiversity event in 2011 to survey all taxonomic groups where 60 high and middle school students conducted the monitoring (Swann and Perkins 2013). The results of these surveys were provided back to the volunteers through a number of media, in particular through a photo sharing website http://www.shutterfly. com. This project has continued as a CS programme for high school students, providing unique opportunities for interested citizens to contribute to ecological management. This kind of participation requires considerable management and coordination and cannot be undertaken without appropriate staff training and protocols.

Camera traps have been a valuable part of monitoring and education in efforts to protect the Komodo dragon (*Varanus komodoensis*) in Flores, Indonesia, where community involvement in camera trap data collection is now considered to be critical to protecting this species (Ariefiandy *et al.* 2015). In other traditionally managed ecosystems, the involvement of indigenous communities in camera trapping studies has many social and conservation benefits. For example, in Papua New Guinea, the Tenkile Conservation Alliance has used camera traps as its main source of surveying for endangered fauna in the Torricelli Mountain Range since 2011 (Thomas 2014). The use of camera trapping by villagers from the local areas has proven effective at building a taxonomic picture and cultural history of species that are rarely seen by villagers (Thomas 2014). Moreover the sense of enthusiasm and pride of the villagers when detecting the presence of the tenkile tree kangaroo (*Dendrolagus scottae*) has led to their desire to increase the numbers of camera traps in their forest. Thomas (2014) not only reported better conservation outcomes in terms of biodiversity, but also noted the absence of device theft because villagers were involved in the programme and welcomed the knowledge being collected in their local conservation areas. The inclusion of the indigenous people of the Torcelli Mountain Range is undoubtedly a leading example of how CS has led to better conservation outcomes, particularly in a country where hunting is necessary for human survival. However, smaller-scale citizen engagement projects can also provide significant outcomes where individuals are responsible for critically endangered fauna on large properties such as in Australia.

Camera traps can have a big impact with a small investment by a few people. In the Western Australian wheat belt (arid zone rangelands), flightless birds such as the malleefowl (*Leipoa ocellata*) have suffered huge declines due to habitat destruction and predation (Priddel *et al.* 2007; Parsons and Gosper 2011). These birds pair for life and jointly nurture eggs laid in large mounds made of compost. Populations can be easily extirpated by localised impacts and their conservation rests in the hands of a few people over very large areas of arid zone landscapes. In the Avon wheat belt bioregion in southwest Australia, local farmers were recruited to a mallefowl monitoring programme

Figure 11.1 Australian Indigenous Protected Area rangers setting camera traps in the Kimberley region of Western Australia. (Paul Meek)

that has been heralded as a local social-conservation achievement (Griffiths and Lewis 2014). Through an awareness and training programme, local farmers were encouraged to use camera traps to monitor mallefowl nests to observe behaviours and identify threats. The involvement of citizen scientists in this programme led the local farmers to champion malleefowl habitat protection and provided extensive insights into the ecology of these intriguing birds (Griffiths and Lewis 2014). For a small investment in time and equipment, the use of camera traps to gather video data on these birds has generated greater awareness of, and better outcomes for, malleefowl conservation than historical approaches. Community capacity building, understanding and commitment by a few land managers responsible for large areas of land is considered money well spent.

In Switzerland a 'lynx group' was established in 2002 in the northern part of the Swiss Jura Mountains, bringing together people who spend much of their time outdoors either in the course of their work or during their leisure activities (Zimmermann *et al.* 2002). The group consisted of different interest groups including game wardens, hunters, nature lovers and a few livestock breeders. One of the aims of this group was to facilitate dissemination of information about signs of presence of Eurasian lynx (*Lynx lynx*) and to improve the surveillance of this species in the area. One role of this group was to encourage opportunistic camera trapping surveys for lynx on carcasses and on trails regularly used by the species. The involvement of this group boosted lynx monitoring in this area, fostered exchanges between different interest groups, and increased the ecological knowledge and awareness of group members. The integration of local people into the data collection process has helped to increase acceptance of the monitoring results, and thereby fostered in the community a greater awareness and acceptance of the presence of lynx and their importance as a top order predator in the Jura Mountains.

In the Serengeti National Park, Tanzania, camera traps have operated continuously since 2010 and produced 1.2 million sets of pictures (each image set contains 1–3 photographs taken in a single burst of about 1 s) in just 3 years. More than 28,000 registered users and about 40,000 unregistered users contributed 10.8 million classifications for the 1.2 million image set, recording the species, number of individuals, associated behaviour and the presence of young animals via the website www.snapshotserengeti.org (Swanson 2014; Swanson *et al.* 2015). The researchers behind the project then applied a simple algorithm to aggregate these individual classifications into a 'general agreement' data set, providing a final classification for each image and a measure of agreement between individual responses. This project has provided a rare opportunity to investigate multi-species dynamics in an intact ecosystem and has proved a valuable resource for machine-learning and computer-vision research.

In the USA, citizens have been involved in research to cross-validate coyote distribution records in order to test a human–coyote interaction model (Nagy 2012). Citizens are also engaged in large-scale studies in many countries with hundreds of camera traps and sites, and millions of images (see http://www.nwf.org/news-and-magazines/national-wildlife/animals/archives/2012/camera-traps-and-conservation.aspx). The opportunities for community engagement in camera trap research and monitoring are endless but projects require careful management to maximise the benefits and minimise the risks.

11.5 What is the future of citizen science camera trapping?

The availability of camera traps for CS has created many splendid opportunities, although there are several obstacles to overcome. Conrad and Hilchey (2011) reviewed the last 10 years of relevant CS literature for areas of consensus, divergence and knowledge gaps. They examined and contrasted different CBM activities and governance structures and provided a summary of benefits and challenges of CBM for consideration that we have customised so as to relate to camera trapping (Table 11.1).

Meek *et al.* (2014) distilled four priorities to which particular attention should be paid when considering camera trap CS: (1) privacy laws (Butler and Meek 2013; Meek and Butler 2014) pose a risk to camera trappers, particularly in CS projects where image data cannot be administered rigorously; (2) appropriate training of citizen scientists is essential to ensure consistent, high-quality outputs; (3) camera trap protocols are needed; and (4) remote access to facilitate data storage. All of these issues are important and should be considered in camera trapping CS programmes, and despite the requirement for project managers, well-managed programmes have considerable benefits to conservation

In summary, the challenges that camera trap CS projects must address in the future include organisational issues, especially funding for long-term studies; data collection and integrity (including training), data management and use; motivation and engagement of citizen scientists; and cultural sensitivity and privacy. In the following sections in addition to the four priorities distilled by Meek *et al.* (2014), we will outline in more detail how to ensure data integrity as well as the motivation, engagement and retention of participants, which form the basis for managing the future of CS camera trapping studies.

Table 11.1 Some of the potential benefits and difficulties with camera trapping-based CS projects, adapted from Conrad and Hilchey (2011).

Benefits	Challenges
Increasing environmental democracy (sharing of information using visual media on public and private lands)	Potential privacy issues with legal ramifications Lack of volunteer interest/lack of networking opportunities in accordance with programme requirements
Scientific literacy (broader community/ public education through visual appeal)	Lack of funding
Social capital (volunteer engagement, agency connection, leadership building, problem-solving and identification of resources)	Inability to access appropriate information/ expertise
Citizen inclusion in local issues with tangible visual evidence to foster support	Data fragmentation, identification inaccuracy, lack of objectivity and scientific rigour
Data provided at no cost to government or agencies/organisations	Lack of experimental design in surveys
Public desire for government to be more inclusive in environmental decision-making	Monitoring for the sake of monitoring
Ecosystems, sites and species being monitored that otherwise would not receive this level of attention	Insufficient monitoring expertise/quality assurance and quality control
Support/drive proactive changes to policy and legislation	Utility of CBM data (for decision-making; environmental management; conservation)
Early warning/detection system (i.e. wild dog alert, see http://www.pestsmart.org.au/ wild-dog-alert)	Failure by governments to recognise the value

11.5.1 Training

Training is a fundamental requirement of CS as volunteers will have varying levels of experience, ability (Dickinson *et al.* 2010) and exposure to techniques. Participation by the public requires specific training and instruction to provide the skills needed to undertake survey tasks (Figure 11.2). Importantly, such training must allow time for personal reward and enjoyment so that volunteers receive positive experiences and retain the knowledge.

Tools such as camera traps can prove inefficient in the hands of untrained users: the devices appear simple to use and therefore people are more likely to 'give it a go', ignorant of the importance of understanding how such devices work and how they must be used. Training and instruction are paramount, and will lead to greater participation and effectiveness of programmes, especially in contexts where indigenous communities are a core part of programmes (Thomas 2014). The development of best-practice guidelines, including standardised data-collection and data-management protocols, is crucial (Dickinson *et al.* 2010; Newman *et al.* 2012). Many organisations have developed manuals (Henschel and Ray 2003; Silver 2004; Breitenmoser *et al.* 2005; Chavez and Ceballos 2006;

Figure 11.2 A training course and instructions are given to volunteers involved in the camera trapping survey aimed at delivering robust abundance and density estimates of Eurasian lynx in one of the reference areas in Switzerland. (Fridolin Zimmermann)

O'Brien 2010; TeamNetwork 2011; Ancrenaz *et al.* 2012) or online training (McShea *et al.* 2015) to provide clear instruction to camera trap users in programmes that cover large areas and where participants are less likely to meet with the team leaders. Standardised forms and manuals or online training are important elements of CS projects using camera traps, although data capture and storage systems are equally important, so are tools that enable the accurate identification of animals in images (see below).

11.5.2 Data integrity

Subjectivity in data collection and identification can derail the best scientific studies and can be difficult to avoid (Toerpe 2013). According to Bowser *et al.* (2013), gamifying a CS project could potentially make the project more engaging, especially for younger participants; however, there are also many challenges in doing this. For example, how can designers ensure that gamification does not have an adverse effect on data quality? These are important challenges that need to be considered when designing CS projects.

In addition to training volunteers on the requirements of specific project elements, additional training in the overall conduct and methodology of science could be advantageous (Toerpe 2013). Well-designed 'wiki' models that offer open peer-review forums may also help to maintain data integrity (Hoffmann 2008). Moreover, errors can be minimised by appropriate e-technologies (see section 11.5.5), such as tools for digital photo validation of questionable observations (e.g. COASST, see https://depts. washington.edu/coasst/), mapping tools to avoid errors in position, and context-aware alerts, which notify volunteers and project managers that an observation is outside the normal range for that species. Although all the points outlined above can improve data quality, every CS project should be evaluated for data integrity to validate accuracy rates. In this regard, data collected by CS camera trapping projects are suitable for validation protocols as pictures can be archived and shared among members of the

network, allowing for corroboration of observations. Such an approach is described in the Snapshot Serengeti survey (Swanson *et al.* 2015), whereby an algorithm is used to aggregate individual identifications from multiple users to produce a final classification for each image. Further validation based on accuracy rate is achieved by asking experts with extensive wildlife identification experience to classify a random selection of images out of this final data set. The eMammal programme has implemented an Expert Review online tool, where experts review all volunteer survey data. Volunteers whose camera trap placements are rejected for poor camera trap setup (i.e. aimed too high or too low) are informed, which led to a rapid improvement (i.e. the rejection rate declined from 15% during the first setup to 1% by the third camera trap setup; McShea *et al.* 2015). The eMammal programme has focused on reviewing all image records by experts, not just a subset and will develop approaches including a combination of crowdsourcing and algorithms to validate the most common mammals recorded in the future (McShea *et al.* 2015 and section 11.5.5).

11.5.3 Motivation, engagement and retention in citizen science

In addition to training, recruitment and retention continue to be problems for projects dedicated to ongoing research (Toerpe 2013). Relatively few projects have been successful in maintaining the continued involvement of volunteers over long periods of time. Getting people to contribute to CS projects requires major effort (Dickinson *et al.* 2012). This means that professional staff need to focus much of their time on attracting and retaining volunteers, instead of analysing data, formulating conclusions, and writing and disseminating the research results (Toerpe 2013).

While initial participation stems, in most cases, from self-directed motivations, long-term participation is more complex and includes both self-directed motivation and collaborative motivation (Rotman *et al.* 2014). Behavioural change within communities or groups is an evolutionary process and continually changes over time (Massung *et al.* 2013). The scientific component of CS is important and volunteers are often motivated by contributing to authentic scientific research (European Citizen Science Association 2014). Thus, CS should be about science and not only about public engagement or education. Additional motivations include altruistic motivations, enjoyment of the outdoors, social interactions (Snyder and Omoto 2001; Van Den Berg *et al.* 2009), and, in online gaming contexts, competition and symbolic rewards, such as badges (Cooper *et al.* 2010; Clery 2011; Darg *et al.* 2011). Also successful are more active forms of communication, such as incentives, certificates of recognition and quarterly challenges (e.g. photography contests) (Dickinson *et al.* 2012). The potential influence of gaming and award systems on participant motivation shows the importance of incorporating recreation and competition into CS. Feedback from social peers is considered to be a strong motivation tool for participants (Massung *et al.* 2013), and it is therefore important to give groups time for conscious reflection on their work and to share their experience (Lawrence 2005).

Volunteer dropout or loss of interest can be tackled with positive reinforcement by keeping volunteers informed about how the data they collect are used, and how these are impacting on research, conservation, policy or societal outcomes. It is also important to recognise individuals and groups for their effort, and to acknowledge them in the project results and publications (Whitelaw *et al.* 2003; Legg and Nagy 2006). Effective communication strategies take into account both participant recruitment and retention, especially for long-term projects (Dickinson *et al.* 2012). Well-timed press releases

in national and local media, and ongoing communication, are also useful at boosting interactions between scientists and participants.

Recruiting and retention, however, would be easier if project planners had a firmer understanding of the average, or even ideal, volunteers to attract (Toerpe 2013). Understanding the motivation for a participant's initial involvement in CS activities and capitalising on these motivations for continued involvement are key to affecting changes in behaviour (Jones 2013). Dickinson *et al.* (2012) go even one step further by suggesting that activities that are formulated by participants themselves can lead to strong and long-lasting ties and commitment.

11.5.4 Cultural sensitivity and privacy

The use of camera traps in community projects will continue to expand and new challenges will arise and need resolution. We need to be aware of social, economic, political and cultural sensitivities (Newman *et al.* 2012), especially where traditional values and peoples are involved in data collection and decision-making. Where indigenous people are involved in camera trap CS studies the benefits of using local environmental knowledge (LEK) and traditional environmental knowledge (TEK) (Jordan *et al.* 2014) are significant. Traditional CS requires additional considerations to ensure local/traditional knowledge is respected, but importantly to ensure that traditional and cultural taboos are recognised and embraced. Nowhere is the benefit of camera trapping by communities regarded as highly as in Buddhist countries such as Bhutan where the loss of animals for research purposes is not accepted. The capacity to study biodiversity without physical intervention by using camera traps is highly supported by the Bhutanese (Sangay *et al.* 2014). This relationship between research, religious culture and citizen participation offers unique opportunities for conservation research and management in the future. However, the recognition of respecting and recognising human values can also have a more sinister dimension that pertains to the potential conflicts of privacy that may arise in camera trap surveys in some countries and cultures.

Examples of litigation for breaches of privacy through the misuse of images including in social media are increasing and the inappropriate use of camera trap images of people poses a risk to organisations and individuals (Butler and Meek 2013). This is heightened in programmes where accesses to images, potentially of people, are made more publicly available and open to exploitation. In Australia the public dissemination of pictures of people is not allowed as it is effectively a privacy violation, and hence the distribution and use of such images are protected under specific legislation. Warning people of the presence of camera traps in publicly accessible sites using signage and other advertising methods is highly advisable. Moreover, any images taken of people must be carefully stored or deleted; if any such images are disseminated publicly, including via social media, the person who collected the images and manages the image database may face privacy issues that could lead to prosecution. Meek and Butler (2014) provide a summary of the issues faced by camera trap practitioners and provide some suggested guidance on avoiding litigation. Where the general public is involved, there are additional opportunities for breaches of privacy that are ultimately the responsibility of the project manager, exposing them to prosecution irrespective of whether they were party to distribution of private information, i.e. pictures of a person. The same issues obviously apply to other countries, even though the extent of regulations governing privacy varies among countries, and the legal implications are equally diverse. However, in some

countries the consequences are hefty fines (http://www.spiegel.de/international/europe/forest-sex-footage-sparks-debate-in-austria-a-838691.html) and even prison sentences.

Conversely, research and monitoring programmes can be adversely affected by the inappropriate distribution of sensitive images, resulting in the adoption of cumbersome or restrictive protocols to counter this risk. This may lead to modifications to sampling design, with consequences for scientific rigour and conservation outcomes. In anticipation of increasing cases of privacy breaches related to camera trapping, organisations that use citizen scientists should expand their protocols and systems to include privacy issues. Further ethical considerations arise where imagery identifies illegal activities (Pebsworth and LaFleur 2014) and practitioners must decide on an appropriate course of action.

11.5.5 Technology and e-innovations in camera trapping

Newman *et al.* (2012) advocated five recommendations related to technology in CS projects:

1. Choose technology appropriate to your participants.
2. Evaluate the technology, use a make vs. buy decision on choosing the technology, do a cost–benefit audit and pay particular attention to reliability.
3. Only use well-established technologies that are well supported.
4. Consider interoperable, customisable, open-source solutions.
5. Use best practice and standardise data-collection and data-management protocols.

The promulgation of e-technology and camera trapping in CS is seemingly successful: there appears to be a significant expansion of internet-based camera trap projects. Among other innovations, the Zoological Society of London's EDGE of Existence programme has created InstantWild (http://www.edgeofexistence.org/instantwild), a smartphone application that allows community members to review and identify mammals captured on camera traps in several countries, thereby conceivably reducing the time that scientists have to sit in front of computer screens identifying wildlife. The use of citizens to wade through millions of images using crowdsourcing has been used widely by groups such as Zooniverse (https://www.zooniverse.org) and Snapshot Serengeti (http://www.snapshotserengeti.org). In Antarctica, Oxford University and the Australian Antarctic Division have united camera traps with citizens keen to look at hundreds of thousands of gentoo penguin (*Pygoscelis papua*) images to study colonies (http://www.penguinwatch.org). These image libraries have uncovered new ecological knowledge on penguins and their relationship with their diminishing landscape. In parallel, we need to fast-track automated species and individual identification software (see Hiby *et al.* 2009; Falzon *et al.* 2014; and others) to prevent bottlenecks in the expert review processes for broad-scale surveys, where images accumulate quickly. For example, Falzon *et al.* (2014) and McShea *et al.* (2015) have developed image-processing algorithms that use a stepwise approach: (1) at the object layer, the animal within a sequence of images is detected and its body is isolated from the background vegetation; (2) at the feature layer, the goal is to extract the appearance, motion and biometric features of the animal; and finally (3) at the pattern layer, the goal is to create machine learning algorithms to identify animal species automatically. At the object layer, given that the most time-consuming part of manually processing images is finding the smaller animals in the frame or deciding that there is actually no animal in the frame, McShea *et al.* (2015) created a tool that can identify where animals are within the frame of a camera trap picture. This tool was integrated in the

Leopold desktop application to help volunteers with their initial classification of images. Falzon *et al.* (2104) developed an algorithm to overcome the challenges of distinguishing between Australian rodent species that are similar in appearance. Computer-assisted recognition tools, such as these, are designed to assist wildlife researchers and citizen scientists by making the workflow more efficient, but are not designed to completely replace people in the workflow (McShea *et al.* 2015).

These innovative approaches to data analysis are intriguing but the data governance of these programmes nevertheless needs to be tight to ensure accurate reporting and assignment of reliability indexes according to surveyor expertise. All of which requires some form of human intervention and management. Computer-assisted technologies and cloud database systems are invaluable tools that will provide greater opportunities for data-hungry methods such as camera trapping in the future. Australia has a newly developing CS movement and has capitalised on the vast resource of willing volunteers to help in animal identification with programmes such as the Victorian Nature Watch programme (http://vnpa.org.au/page/volunteer/naturewatch/bites,-camera,-action!-critters-get-their-own-motion-pictures?hc_location=ufi). These types of programmes have a much longer history in the USA (e.g. http://www.inaturalist.org/projects/backyard-bobcats) and it is inevitable that there will be an international expansion of e-innovation in the coming years.

There is no doubt that new technologies will increase the interest and involvement of citizens in natural resource management and research (Newman *et al.* 2012) if the opportunities are made available. Collectively, these and other emerging technologies have the potential to engage broad audiences, motivate volunteers, improve data collection, control data quality, corroborate model results and increase the speed with which decisions can be made (Newman *et al.* 2012). However, 'future programmes [need] to think critically about current technology adoption and to be open to experimenting with and exploiting new technologies as they emerge' (Newman *et al.* 2012).

Despite their broader reach, new technologies may inadvertently create barriers that increase economic and social inequality with regard to access to, use of, or impact of information and communication technologies between those adopting/having the technology and those avoiding/lacking it (Ess and Sudweeks 2001). Still left out of the picture are potential recruits from developing countries where limitations in high-speed internet access may make online projects difficult – not to mention the existence of other underlying social and economic barriers (Toerpe 2013). Furthermore, as highlighted by Pulsifer *et al.* (2011), different beliefs about how we advance science, what scientific methods ought to be used to improve our understanding, and how we share information across international boundaries may confound data sharing and data re-use, limiting long-term benefits. As CS programmes adopt new technologies, sensitivity to social, cultural, economic and political factors will be critical to the success of cross-boundary projects involving local/traditional ecological knowledge (Ballard *et al.* 2008).

11.6 Conclusions

In this chapter, we briefly outlined some general principles of CS, namely the different categories of scientist–volunteer collaboration (i.e. contributory, collaborative and co-created) and the general approaches and working steps to programme development. We described the research process with a special focus on collecting, identifying and managing data which are specific to each methodology and in particular camera

trapping. We provided different examples of successful camera trapping CS projects around the world and showed that camera traps can be used in a range of ways to engage the community in research and management, including involvement in device deployment, data collection and identification to pure species identification via images on the internet. However, the social benefits of using image data to elicit cultural change towards species and their management is still undervalued by scientists. Moreover, if citizens are invited to have a role in camera trap surveys, it is incumbent on the camera trap fraternity rapidly to develop standards and procedures, training courses (including online) and data federation systems to enable uploading and access to image libraries.

There are great ecological, conservation and social gains to be achieved from embracing the goodwill of the community to assist in setting camera traps, uploading data and assisting with animal counting and identification. Improvements in e-technology in the coming years will bring enormous changes to how we utilise camera trapping in ecological monitoring. CS camera trapping will further extend the opportunities for scientists to engage with a wider community, and will help motivate volunteers, improve data collection, control data quality, disseminate results, corroborate model results, increase the speed with which decisions can be made, and provide visual imagery that is suited to bridging cultural barriers with indigenous peoples. But this comes with costs and these must be recognised and managed. Failure to identify the problems – including political factors, ambiguity of image data, the tendency of humans to please, cultural sensitivities, legal issues associated with privacy, importance of training and data control systems, volunteer dropout or loss of interest, and social recognition and expectations – will impede adoption and stymie success.

Acknowledgements

We are grateful to Francesco Rovero for valuable comments on previous versions of this chapter.

References

Ancrenaz, M., Hearn, A.J., Ross, J., Sollmann R. and Witting, A. (2012) *Handbook for Wildlife Monitoring Using Camera-traps*. BBEC II Secretariat, c/o Natural Resources Office, Chief Minister's Department, Kota Kinabalu, Sabah, Malaysia.

Ariefiandy, A., Purwandana, D., Natali, C., Imansyah, M.J., Surahman, M., Jessop, T.S. and Ciofi, C. (2015) Conservation of Komodo Dragons Varanus komodoensis in the Wae Wuul nature reserve, Flores, Indonesia: a multidisciplinary approach. *International Zoo Yearbook* 49: 67–80.

Ballard, H.L., Trettevick, J.A. and Collins D. (2008) Comparing participatory ecological research in two contexts: an immigrant community and a Native American community on Olympic Peninsula, Washington. In: C. Wilmsen, W. Elmendorf, L. Fisher, J. Ross, B. Sarathy and G. Wells (eds), *Partnerships for Empowerment: Participatory Research for Community-based Natural Resource Management*. London and Sterling, VA: Earthscan. pp. 187–216.

Breitenmoser, U., Breitenmoser-Würsten, C., Molinari, P., Ryser, A., von Arx, M., Molinari-Jobin, A., Zimmermann, F., Siegenthaler, A., Angst, C. and Weber, J.-M. (2005) *Balkan Lynx Field Book*. KORA and Cat Specialist Group.

Bonney, R., Ballard, H., Jordan, R., McCallie, E., Phillips, T., Shirk, J. and Wilderman, C.C. (2009) *Public Participation in Scientific Research: Defining the Field and Assessing its Potential for Informal Science Education*. Washington, DC: CAISE.

Bowser, A., Hansen, D. and Preece, J. (2013) Gamifying citizen science. Lessons and future directions. *Designing Gamification: Creating Gameful and Playful Experiences*, Workshop, CHI 2013.

Burke, J., Estrin, D., Hansen, M., Parker, A., Ramanathan, N., Reddy, S. and Srivastava, M.B. (2006) Participatory sensing. *World-Sensor-Web (WSW'06): Mobile Device Centric Sensor Networks and Applications*.

Burton, A.C., Neilson, E., Moreira, D., Ladle, A., Steenweg, R., Fisher, J.T., Bayne, E. and Boutin, S. (2015) Wildlife camera trapping: a review and recommendations for linking surveys to ecological processes. *Journal of Applied Ecology* 52: 675–685.

Butler, D. and Meek, P.D. (2013) Camera trapping and invasions of privacy: an Australian legal perspective. *Torts Law Journal* 20: 234–264.

Chavez, C. and Ceballos, G. (2006) The Mexican jaguar in the XXI century: current status and management. In: *Proceedings of the First Symposium*, CONABIO-Alliance WWF-Telcel, National Autonomous University of Mexico.

Clery, D. (2011) Galaxy Zoo volunteers share pain and glory of research. *Science* 333: 173–175.

Conrad, C. and Hilchey, K. (2011) A review of citizen science and community-based environmental monitoring: issues and opportunities. *Environmental Monitoring and Assessment* 176: 273–291.

Cooper, S., Khatib, F., Treuille, A., Barbero, J., Lee, J., Beenen, M., Leaver-Fay, A., Baker, D., Popović, Z. and Players, F. (2010) Predicting protein structures with a multiplayer online game. *Nature* 466: 756–760.

Darg, D.W., Kaviraj, S., Lintott, C.J., Schawinski, K., Silk, J., Lynn, S., Bamford, S. and Nichol, R.C. (2011) Galaxy Zoo: multimergers and the Millennium Simulation. *Monthly Notices of the Royal Astronomical Society* 416: 1745–1755.

Dickinson, J.L. and Bonney, R. (2012) *Citizen Science: Public Collaboration in Environmental Research*. Ithaca, NY: Cornell University Press.

Dickinson, J.L., Zuckerberg, B. and Bonter, D.N. (2010) Citizen science as an ecological research tool: challenges and benefits. *Annual Review of Ecology, Evolution, and Systematics* 41: 149–172.

Dickinson, J.L., Shirk, J., Bonter, D., Bonney, R., Crain, R.L., Martin, J., Phillips, T. and Purcell, K. (2012) The current state of citizen science as a tool for ecological research and public engagement. *Frontiers in Ecology and the Environment* 10: 291–297.

Erb, P.L., McShea, W.J. and Guralnick, R.P. (2012) Anthropogenic influences on macro-level mammal occupancy in the Appalachian Trail Corridor. *PLoS ONE* 7: e42574.

Ess, C. and Sudweeks, F. (2001) On the edge – cultural barriers and catalysts to IT diffusion among remote and marginalized communities. *New Media and Society* 3: 259–269.

European Citizen Science Association (2014) Ten Principles of Citizen Science. http://citizenscience.blogg.gu.se/2014/12/10/ten-principles-of-citizen-science/ (accessed 14 August 2015)

Falzon, G., Meek, P.D. and Vernes, K. (2014) Computer-assisted identification of Australian rodents in camera trap imagery. In: P.D. Meek, A.G. Ballard, P.B. Banks, A.W. Claridge, P.J.S. Fleming, J.G. Sanderson and D.E. Swann (eds), *Camera Trapping in Wildlife Research and Management*. Collingwood, Australia: CSIRO Publishing. pp. 299–306.

Fegraus, E.H., Lin, K., Ahumada, J.A., Baru, C., Chandra, S. and Youn, C. (2011) Data acquisition and management software for camera trap data: a case study from the TEAM Network. *Ecological Informatics* 6: 345–353.

Fortson, L., Masters, K., Nichol, R., Borne, K.D., Edmondson, E., Lintoot, C., Raddick, J., Schawinski, K. and Wallin, J. (2012). Galaxy Zoo: morphological classification and citizen science. In: M.J. Way, J.D. Scargle, K.M. Ali and A.N. Srivastava (eds), *Advances in Machine Learning and Data Mining for Astronomy*. London: Chapman & Hall. pp. 1–11.

Griffiths, M. and Lewis, P. (2014) Monitoring mallefowls with camera traps in Western Australia's wheatbelt: a case study in citizen science. In: P.D. Meek, A.G. Ballard, P.B. Banks,

A.W. Claridge, P.J.S. Fleming, J.G. Sanderson and D.E. Swann (eds), *Camera Trapping: Wildlife Management and Research*. Collingwood, Australia: CSIRO Publishing. pp. 77–86.

Henschel, P. and Ray, J.C. (2003) *Leopards in African Rainforests: Survey and Monitoring Techniques*. Wildlife Conservation Society.

Hiby, L., Lovell, P., Patil, N., Kumar, S.N., Gopalaswamay, A.M. and Karanth, K.U. (2009) A tiger cannot change its stripes: using a three-dimensional model to match images of living tigers and tiger skins. *Biology Letters* 5: 383–386.

Hochachka, W.M., Wells, J.V., Rosenberg, K.V., Tessaglia-Hymes, D.L. and Dhondt, A.A. (1999) Irruptive migration of common redpolls. *Condor* 101: 195–204.

Hoffmann, R. (2008) A wiki for the life sciences where authorship matters. *Nature Genetics* 40: 1047–1051.

Jones, M. (2013) *The Impact of Citizen Science Activities on Participant Behaviour and Attitude*. Conservation Volunteers Project Report, November 2013.

Jordan, C.A., Urquhart, G.R. and Kramer, D.B. (2014) On using mental model interviews to improve camera trapping: adapting research to Costeño environmental knowledge. *Conservation and Society* 11: 159–175.

Lawrence, A. (2005) Reluctant citizens? The disjuncture between participatory biological monitoring and participatory environmental governance. Presented at the International Conference on Environment, Knowledge and Democracy, Marseilles, July 2005.

Legg, C.J. and Nagy, L. (2006) Why most conservation monitoring is, but need not be, a waste of time. *Journal of Environmental Management* 78: 194–199.

Massung, E., Coyle, D., Cater, K.F., Jay, M. and Preist, C.W. (2013) Using crowdsourcing to support pro-environmental community activism. In: *Proceedings of the SIGCHI conference on Human Factors in Computing Systems 2013*. New York: ACM. pp. 371–380

McCallum, J. (2013) Changing use of camera traps in mammalian field research: habitats, taxa and study types. *Mammal Review* 43: 196–206.

McShea, W.J., Forrester, T., Costello, R., He, Z. and Kays, R. (2015) Volunteer-run cameras as distributed sensors for macrosystem mammal research. *Landscape Ecology* 31: 55–66.

Meek, P.D. and Butler, D. (2014) Now we can 'see the forest and the trees too' but there are risks: camera trapping and privacy law in Australia. In: P.D. Meek, A.G. Ballard, P.B. Banks, A.W. Claridge, P.J.S. Fleming, J.G. Sanderson and D.E. Swann (eds), *Camera Trapping: Wildlife Management and Research*. Collingwood, Australia: CSIRO Publishing. pp. 331–345.

Meek, P.D., Vernes, K. and Falzon, G. (2013) On the reliability of expert identification of small-medium sized mammals from camera trap photos. *Wildlife Biology in Practice* 9: 1–19.

Meek, P.D., Fleming, P.J.S., Ballard, A.G., Banks, P.B., Claridge, A.W., McMahon, S., Sanderson, J.G. and Swann, D.E. (2014) Putting contemporary camera trapping in focus. In: P.D. Meek, A.G. Ballard, P.B. Banks, A.W. Claridge, P.J.S. Fleming, J.G. Sanderson and D.E. Swann (eds), *Camera Trapping: Wildlife Management and Research*. Collingwood, Australia: CSIRO Publishing. pp 349–356.

Meek, P.D., Ballard, G.-A., Vernes, K. and Fleming, P.J.S. (2015a) The history of wildlife camera trapping as a survey tool in Australia. *Australian Mammalogy* 37: 1–12.

Meek, P.D., Ballard, G.-A. and Fleming, P.J.S. (2015b) The pitfalls of wildlife camera trapping as a survey tool in Australia. *Australian Mammalogy* 37: 13–22.

Miller-Rushing, A., Primack, R. and Bonney, R. (2012) The history of public participation in ecological research. *Frontiers in Ecology and the Environment* 10: 285–290.

Nagy, C. (2012) Validation of a citizen science-based model of coyote occupancy with camera traps in suburban and urban New York, USA. *Wildlife Biology in Practice* 8: 23–35.

Newman, G., Wiggins, A., Crall, A., Graham, E., Newman, S. and Crowston, K. (2012) The future of citizen science: emerging technologies and shifting paradigms. *Frontiers in Ecology and the Environment* 10: 298–304.

O'Brien, T. (2010) *Wildlife Picture Index: Implementation Manual Version 1.0*. Wildlife Conservation Society, USA.

Othman, N. and Amiruddin, M.H. (2010) Different Perspectives of learning styles from VARK model. *Procedia – Social and Behavioral Sciences* 7: 652–660.

Parsons, B.C. and Gosper, C.R. (2011) Contemporary fire regimes in a fragmented and an unfragmented landscape: implications for vegetation structure and persistence of the fire-sensitive malleefowl. *International Journal of Wildland Fire* 20: 184–194.

Pebsworth, P. and LaFleur, M. (2014) Advancing primate research and conservation through the use of camera traps: introduction to the special issue. *International Journal of Primatology* 35: 825–840.

Priddel, D., Wheeler, R. and Copley, P. (2007) Does the integrity or structure of mallee habitat influence the degree of fox predation on malleefowl (*Leipoa ocellata*)? *Emu* 107: 100–107.

Pulsifer, P.L., Laidler, G.J., Taylor, D.R.F. and Hayes, A. (2011) Towards an indigenist data management program: reflections on experiences developing an atlas of sea ice knowledge and use. *Canadian Geographer/Le Géographe canadien* 55: 108–124.

Rotman, D., Hammock, J., Preece, J., Hansen, D., Boston, C., Bowser, A. and He, Y. (2014) Motivations affecting initial and long-term participation in citizen science projects in three countries. *iConference 2014 Proceedings* 110–124.

Rovero, F., Zimmermann, F., Berzi, D. and Meek, P.D. (2013) "Which camera trap type and how many do I need?" A review of camera features and study designs for a range of wildlife research applications. *Hystrix: the Italian Journal of Mammalogy* 24: 148–156.

Sangay, T., Rajanathan, R. and Vernes, K. (2014) Wildlife camera trapping in the Himalayan kingdom of Bhutan with recommednadtions for the future. In: P.D. Meek, A.G. Ballard, P.B. Banks, A.W. Claridge, P.J.S. Fleming, J.G. Sanderson and D.E. Swann (eds), *Camera Trapping: Wildlife Management and Research*. Collingwood, Australia: CSIRO Publishing. pp. 87–98.

Sheil, D., Mugerwa, B. and Fegraus, E.H. (2013) African golden cats, citizen science, and serendipity: tapping the camera trap revolution. *South African Journal of Wildlife Research* 43: 74–78.

Shirk, J.L., Ballard, H.L., Wilderman, C.C., Phillips, T., Wiggins, A., Jordan, R., McCallie, E., Minarchek, M., Lewenstein, B.V., Krasny, M.E. and Bonney, R. (2012) Public participation in scientific research: a framework for deliberate design. *Ecology and Society* 17: 29.

Silver, S. (2004) *Assessing Jaguar Abundance Using Remotely Triggered Cameras*. Wildlife Conservation Society.

Snyder, M. and Omoto, A.M. (2001) Basic research and practical problems: volunteerism and the psychology of individual and collective action. In: W. Wosinska, R. Cialdini, D. Barrett, and J. Reykowski (eds), *The Practice of Social Influence in Multiple Cultures*. Mahwah, NJ: Lawrence Erlbaum. pp. 287–307.

Swann, D.E. and Perkins, N. (2013) Inventory of terrestrial mammals in the Rincon Mountains using camera Traps. In: G.J. Gottfried, P.F. Ffolliott, B.S. Gebow, L.G. Eskew and L.C. Collins (eds), *Proceedings RMRS-P-67: Merging Science and Management in a Rapidly Changing World: Biodiversity and Management of the Madrean Archipelago III*, 1–5 May 2012, Tucson, AZ. Fort Collins, CO: US Department of Agriculture, Forest Service, Rocky Mountain Research Station. pp. 269–276.

Swann, D.E. and Perkins, N. (2014) Camera trapping for animal monitoring and management: a review of applications. In: P.D. Meek, A.G. Ballard, P.B. Banks, A.W. Claridge, P.J.S. Fleming, J.G. Sanderson and D.E. Swann (eds), *Camera Trapping: Wildlife Management and Research*. Collingwood, Australia: CSIRO Publishing. pp. 3–11.

Swanson, A.B. (2014) *Living with Lions: Spatiotemporal Aspects of Coexistence in Savanna Carnivores*. PhD thesis, University of Minnesota.

Swanson, A., Kosmala, M., Lintott, C., Simpson, R., Smith A. and Packer, C. (2015) Snapshot Serengeti, high-frequency annotated camera trap images of 40 mammalian species in an African savanna. *Scientific Data* 2: art. no. 150026.

TeamNetwork (2011) *Terrestrial Vertebrate Protocol Implementation Manual*. Tropical Ecology Assessment and Monitoring Network, Arlington, VA.

Thomas, J. (2014) Fauna surveys by camera trapping in the Torcelli Mountain Range, Papua New Guinea. In: P.D. Meek, A.G. Ballard, P.B. Banks, A.W. Claridge, P.J.S. Fleming, J.G. Sanderson and D.E. Swann (eds), *Camera Trapping: Wildlife Management and Research*. Collingwood, Australia: CSIRO Publishing. pp. 69–76.

Toerpe, K. (2013) The rise of citizen science. *The Futurist*, http://www.wfs.org/futurist/2013-issues-futurist/july-august-2013-vol-47-no-4/rise-citizen-science (accessed 22 July 2015)

Van Den Berg, H.A., Dann, S.L. and Dirkx, J.M. (2009) Motivations of adults for non-formal conservation education and volunteerism: implications for programming. *Applied Environmental Education and Communication* 8: 6–17.

Vetter, J. (2011) Introduction: lay participation in the history of scientific observation. *Science in Context* 24: 127–141.

Whitelaw, G., Vaughan, H., Craig, B. and Atkinson, D. (2003) Establishing the Canadian Community Monitoring Network. *Environmental Monitoring and Assessment* 88: 409–418.

Yu, X., Wang, J., Kays, R., Jansen, P.A., Wang, T. and Huang, T. (2013) Automated identification of animal species in camera trap images. *EURASIP Journal on Image and Video Processing* 2013: 52.

Zimmermann, F., Molinari-Jobin, A. and Capt, S. (2002) Formation d'un groupe lynx. *KORA Jahresbericht 2002* (in French).

Appendices

Free resources are available online to support your use of this book. Please visit:

http://www.pelagicpublishing.com/camera-trapping-for-wildlife-research-resources.html

Appendix 2.1 List of camera trap manufacturers' websites (accessed 22 April 2015).

Company name	Website
Acorn*	http://www.ltlacorn.com/index.php?page=mods/Products/showprod&catid=17
Bolymedia*	http://www.bolymedia.com/
Buckeye	http://www.buckeyecam.com/site/
Bushnell	http://www.bushnell.com/all-products/trail-cameras
Covert	http://covertscoutingcameras.com/
Cuddeback	http://cuddeback.com/
Day 6 outdoors	http://day6outdoors.com/
Faunatech Australia	http://www.faunatech.com.au/products.html
Fototrappolaggio.com*	http://www.fototrappolaggio.net/uploaded/0English/Home/home-eng.htm
Moultrie	http://www.moultriefeeders.com/products/cameras/game-cameras
PhotoTrap	http://www.phototrap.com/
Pixcontroller	http://www.pixcontroller.com/
Reconyx	http://www.reconyx.com/
Scoutguard	http://www.scoutguard.com.au/
Spypoint	http://www.spypoint.com/
Uway	http://www.uwayoutdoors.com/

*Brands which are distributors as well as manufacturers of camera trap units.

Appendix 3.1 Form to record metadata when setting camera traps.

Study area	Camera site ID #	Camera unit #	Camera model	Memory card #	Name of field person	Start date/time	End date/time	Planned latitude and longitude	Actual latitude and longitude	Elevation	Notes*

*For example, camera settings, notes on the site, camera damage or malfunction upon retrieval, type of camera trap site (trail, road, etc.).

Appendix 3.2 Form to check and remove camera traps.

Camera site ID # (Appendix 3.1)	Camera unit # (new # if changed)	Name of field person	Date/time	Camera removed (yes/no)	Camera checked (yes/no)	# of images/videos	Camera trap working (yes/no)	New memory card # (if changed)	Batteries changed (yes/no)	Remarks*

*For example, camera malfunctioning, vandalism, camera moved by animals, tracks of animals avoiding site, etc.

Appendix 5.1 Case study data set: 'teamexample.csv' – see online resources.

Appendix 5.2 R script: 'R script_chapter 5.R'

```
### Chapter 5 - data analysis
### set the working directory
### source library with functions
### tested on teamexample.csv file; 08/11/2015 FR

source("TEAM library 1.7.R")
library(chron)
library(reshape)
library(vegan)
library(plotrix)
library(ggplot2)
library(maptools)

### loading data

team_data<-read.csv(file="teamexample.csv", sep=",",h=T,stringsAsFactors=F)

### add Class, Order, Family attributes using the IUCN database

iucn.full<-read.csv("IUCN.csv", sep=",",h=T)
iucn<-iucn.full[,c("Class","Order","Family","Genus","Species")]
team<-merge(iucn, team_data, all.y=T)

### fixing data formats for analysis

data<-fix.dta(team)

data<- droplevels(data[data$bin!="Homo sapiens", ]) # remove Homo sapiens
    from data set

### looking at data only for the year 2009 (sampling sites, species, dates)
names(data)
yr2009<-data[data$Sampling.Event =="2009.01" & data$Class=="MAMMALIA",]
unique(yr2009$Sampling.Unit.Name)
unique(yr2009$bin) # binomial name of species
unique(yr2009$Camera.Start.Date.and.Time)
unique(yr2009$Camera.End.Date.and.Time)

### descriptive analyses

# camera trap days
camera_days<-cam.days(data,2009.01)
summary(camera_days[,2:4])
write.table(camera_days, file="camera_days_2009.txt",quote=F, sep="\t",
    row.names = F)

# independent events by chosen time interval
events_hh<-event.sp(dtaframe=data, year=2009.01, thresh=60)
    # thresh in minutes
events_dd<-event.sp(dtaframe=data, year=2009.01, thresh=1440)

# saving away tables with events by species and camera site
write.table(events_hh, file="events_hh.txt",quote=F, sep="\t")
write.table(events_dd, file="events_dd.txt",quote=F, sep="\t")
```

```
# cumulative events per species
events_hh_species<-colSums(events_hh)
write.table(events_hh_species, file="events_hh_species.txt", quote=F,
    sep="\t")

events_dd_species<-colSums(events_dd)
write.table(events_dd_species, file="events_dd_species.txt",quote=F, sep="\t")

# cumulative events per camera sites
cameras<-rowSums(events_hh)
write.table(cameras, file="events_species.txt",quote=F, sep="\t")

### naive occupancy
yr2009<-data[data$Sampling.Event =="2009.01" & data$Class=="MAMMALIA",]
mat<-f.matrix.creator(yr2009) # list of matrices camera x days for each
    # species
naive_occu_2009<-naive(mat) # get naive occupancy for each species
write.table(naive_occu_2009, file="naive_occu_2009.txt",quote=F, sep="\t",row.
    names = F)

# accumulation curve
accumulation<-acc.curve(data,2009.01)
write.table(accumulation, file="accsp_2009.txt",quote=F, sep="\t")
ggplot(accumulation, aes(x=Camera.trap.days, y=species)) +
  geom_line(aes(y=species-sd), colour="grey50", linetype="dotted") +
  geom_line(aes(y=species+sd), colour="grey50", linetype="dotted") +
  theme_bw() +
  geom_line()

# activity pattern of species
activity_24h<-events.hours(yr2009)
write.table(activity_24h, file="events_24hour_2009.txt",quote=F, sep="\t",
    row.names = F)

activity_24h<-events.hours(data)

# example of plotting activity pattern of selected species (3 forest
    # antelope)
clock<-c(0:23)
clock24.plot(activity_24h$Cephalophus.harveyi,clock,show.grid=T,lwd=2,
    line.col="blue", main="Cephalophus.harveyi",cex.lab=0.5)

par(mfrow=c(1,3),cex.lab=0.5, cex.axis=0.5)
clock24.plot(activity_24h$Cephalophus.spadix,clock,show.grid=T,lwd=2,
    line.col="green", main="Cephalophus.spadix")
clock24.plot(activity_24h$Cephalophus.harveyi,clock,show.grid=T,lwd=2,
    line.col="blue", main="Cephalophus.harveyi")
clock24.plot(activity_24h$Nesotragus.moschatus,clock,show.grid=T,lwd=2,
    line.col="red", main="Nesotragus.moschatus")

# map of two species of sengi
library(maptools)
shape <- readShapeSpatial("park.shp", repair=T)
```

```
ev.dd.map<-merge(unique(data[,c("Sampling.Unit.Name","Longitude",
    "Latitude")]),events_dd)
coord<-ev.dd.map[,c("Longitude","Latitude")]
xy <- project(as.matrix(coord), "+proj=utm +zone=37 +south +ellps=clrk80
    +units=m +no_defs")
ev.dd.map$Longitude<-xy[,1]
ev.dd.map$Latitude<-xy[,2]

par(mfcol=c(1,2), mar=c(0.5,0.5,0.5,0.5), oma=c(1,1,1,1))
plot(shape,axes=F)
mtext("Rhynchocyon cirnei", cex = 1.5,font =3 )
Rc<-ev.dd.map[,c("Rhynchocyon cirnei")]/max(ev.dd.map[,c("Rhynchocyon
    cirnei")])
points(ev.dd.map[,"Longitude"],ev.dd.map[,"Latitude"],pch = 21,bg=grey(1-
    Rc))
plot(shape,axes=F)
mtext("Rhynchocyon udzungwensis",cex = 1.5, font =3)
Ru<-ev.dd.map[,c("Rhynchocyon udzungwensis")]/max(ev.dd.map[,c("Rhynchocyon
    udzungwensis")])
points(ev.dd.map[,"Longitude"],ev.dd.map[,"Latitude"],pch = 21,
    bg=grey(1-Ru))
```

Appendix 5.3 R library with all functions: 'TEAM library 1.7.R' – see online resources.

Appendix 5.4 Shape file of forest contour: 'park.shp' – see online resources.

Appendix 5.5 IUCN species taxonomy: 'IUCN.csv' – see online resources.

Appendix 6.1 'Chapter 6 R script

```
source("TEAM library 1.7.R")
library(chron)
library(reshape)
library(ggplot2)
library(vegan)
library(unmarked)
library(AICcmodavg)
library(MuMIn)
library(plyr)
library(R2jags)

### loading data
team_data<-read.csv(file="teamexample.csv", sep=",",h=T,stringsAsFactors=F)
iucn.full<-read.csv("IUCN.csv", sep=",",h=T)
iucn<-iucn.full[,c("Class","Order","Family","Genus","Species")]
team<-merge(iucn, team_data, all.y=T)
fd<-fix.dta(team)
yr2009<-fd[fd$Sampling.Event =="2009.01" & fd$Class=="MAMMALIA",]

### load covariate data
cov<-read.table("covariates.txt", header=TRUE)
workingcam<-which(cov$Sampling.Unit.Name %in%
    unique(yr2009$Sampling.Unit.Name)) # removing cameras that did not work
cov.or<-cov[workingcam, ] # retain only working cameras in 2009
cov.num<-cov.or[,sapply(cov.or,is.numeric)]
cov.std<-decostand(cov.num,method="standardize")
cov.fac<-cov.or[,sapply(cov.or,is.factor)]  # extract factor variables
```

```
covs<-data.frame(cov.fac, cov.std)
covs

## create matrices for each species
mat.udz.09<-f.matrix.creator(yr2009)
names(mat.udz.09)
naivetable<-naive(mat.udz.09)
naivetable

#=======================================#
#  Cercocebus sanjei; Sanje mangabey    #
#=======================================#
Cs<-shrink(mat.udz.09[["Cercocebus sanjei"]],5)
umCs<-unmarkedFrameOccu(y=Cs,siteCovs= covs)

m0<- occu(~1~1,umCs)
d1<- occu(~edge~1,umCs)
d2<- occu(~border~1,umCs)
d3<- occu(~edge+border~1,umCs)
o1<- occu(~1~border,umCs)
o2<- occu(~1~habitat,umCs)
o3<- occu(~1~habitat+border,umCs)
m1<- occu(~edge~border,umCs)
m2<- occu(~border~border,umCs)
m3<- occu(~edge+border~border,umCs)
m4<- occu(~edge~habitat,umCs)
m5<- occu(~border~habitat,umCs)
m6<- occu(~edge+border~habitat,umCs)
m7<- occu(~edge+border~habitat+border,umCs)

## examine model m1 as an example:
m1
backTransform(linearComb(m1, coefficients = c(1, 0), type = "det"))
backTransform(linearComb(m1, coefficients = c(1, 0), type = "state"))

## model selection
dlist<-fitList(Nullo = m0,d1=d1,d2=d2,d3=d3,o1=o1,o2=o2,o3=o3,m1=m1,m2=m2,
    m3=m3,m4=m4,m5=m5,m6=m6,m7=m7)
selmod<-modSel(dlist,nullmod="Nullo")
selmod

newhab<-data.frame(habitat=c("Deciduous","Montane"))
pred<-predict(o2,type="state",newdata=newhab,appendData=T)

ggplot(pred,aes(x=habitat,y=Predicted))+
  geom_point(size=4) +
  ylab("Predicted Psi Cercocebus sanjei") +
  theme_bw()+
  geom_errorbar(aes(ymin=Predicted-SE, ymax=Predicted+SE), width=.2)

# prepare the raster matrix with standardized covariates
map<-read.table("covs100x100.txt",h=T)  # covs100x100.txt is a matrix with
    # the covariate values on a grid of points
mapst<-data.frame(x=map$x,y=map$y, habitat=map$habitat,    # standardize the
    # matrix using mean and sd of covs measured at camera points
```

```
        edge=(map$edge-mean(cov.or$edge))/sd(cov.or$edge),
        border=(map$border-mean(cov.or$border))/sd(cov.or$border),
        river=(map$river-mean(cov.or$river))/sd(cov.or$river))
# map
predmap<-predict(o2,type="state",newdata=mapst,appendData=T)
    # it takes ~ 30 sec
levelplot(predmap$Predicted ~ x + y, map, aspect="iso", xlab="Easting (m)",
    ylab="Northing (m)", col.regions=terrain.colors(100))

#===============================================#
# Rhynchocyon udzungwensis; Grey-faced sengi     #
#===============================================#
Ru<-shrink(mat.udz.09[["Rhynchocyon udzungwensis"]],5)
umRu<-unmarkedFrameOccu(y=Ru,siteCovs=covs)

m0<- occu(~1~1,umRu)
d1<- occu(~edge~1,umRu)
d2<- occu(~border~1,umRu)
o1<- occu(~1~edge,umRu)
o2<- occu(~1~border,umRu)
o3<- occu(~1~habitat,umRu)
o4<- occu(~1~river,umRu)
o5<- occu(~1~edge+habitat+border,umRu)
o6<- occu(~1~habitat+border,umRu)
o7<- occu(~1~edge+habitat,umRu)

dlist<-fitList(Nullo=m0,d1=d1,d2=d2,o1=o1,o2=o2,o3=o3,o4=o4,o5=o5,o6=o6,o7=o7)
sel<-modSel(dlist,nullmod="Nullo")
sel
best<-list(o7,o3,o5)
avgmod <- model.avg(best, fit=T)
summary(avgmod)
modnames<-as.character(c(o5,o3,o6))
modavgpred(best,modnames=modnames,newdata=site.cov,parm.type="psi")

# map

predmap<-predict(avgmod,type="state",newdata=mapst,appendData=T)
    # it takes about 253 sec
levelplot(predmap$fit ~ x + y, map, aspect="iso", xlab="Easting (m)",
    ylab="Northing (m)",col.regions=terrain.colors(100))

#########################
# Multiseason analyses  #
#########################

## reload data
teamc<-read.csv(file="team.yr2009_2013.csv", sep=",",h=T,stringsAsFactors=F)
fd<-fix.dta(teamc)

#Separate data by year
samp<-unique(fd$Sampling.Event)
res<-numeric()
```

```
for(i in 1:length(samp)){
  temp<-which(fd$Sampling.Event==samp[i])
  fd2<-fd[temp,]
  res<-c(res,list(fd2))
}
data.byYear<-res
names(data.byYear)<-samp

data.byYear<-lapply(X=data.byYear,f.minusBirds)

mats<-sapply(data.byYear,f.matrix.creator)

#=======================================#
#  Cercocebus sanjei; Sanje mangabey    #
#=======================================#
spl<-sapply(mats, "[[", "Cercocebus sanjei")  # this is the list with all
    # the years for this species
sl<-llply(spl,.fun=function (x) shrink(x,5))  # apply shrink to the list
mat.yrs<-adjMult(sl)                          # transform the list in a
    # dataframe adjusting the number of working cameras and sampling events

colnames(mat.yrs) # check periods after shrinking

#JAGS
J<-array(as.matrix(mat.yrs),dim=c(60,25,5)) #60 sites, 25 events, 5 years

# the model
modJ.bug<- function () {

# Specify priors
psi1 ~ dunif(0, 1)
for (k in 1:(nyear-1)){
   phi[k] ~ dunif(0, 1)
   gamma[k] ~ dunif(0, 1)
   p[k] ~ dunif(0, 1)
   }
p[nyear] ~ dunif(0, 1)

# Ecological submodel: Define state conditional on parameters
for (i in 1:nsite){
   z[i,1] ~ dbern(psi1)
   for (k in 2:nyear){
      muZ[i,k]<- z[i,k-1]*phi[k-1] + (1-z[i,k-1])*gamma[k-1]
      z[i,k] ~ dbern(muZ[i,k])
      } #k
   } #i

# Observation model
for (i in 1:nsite){
   for (j in 1:nrep){
      for (k in 1:nyear){
         muy[i,j,k] <- z[i,k]*p[k]
         y[i,j,k] ~ dbern(muy[i,j,k])
         } #k
      } #j
   } #i

# Derived parameters: Sample and population occupancy,
# growth rate and turnover
```

```
psi[1] <- psi1
n.occ[1]<-sum(z[1:nsite,1])
for (k in 2:nyear){
    psi[k] <- psi[k-1]*phi[k-1] + (1-psi[k-1])*gamma[k-1]
    n.occ[k] <- sum(z[1:nsite,k])
    growthr[k] <- psi[k]/psi[k-1]
    turnover[k-1] <- (1 - psi[k-1]) * gamma[k-1]/psi[k]
    }
}

# Initial values
zst <- apply(J, c(1, 3), sum, na.rm=T)  # Observed occurrence as inits for z
zsti<-ifelse(zst>0,1,0)
jags.inits <- function(){ list(z = zsti)}
jags.params <- c("psi", "phi", "gamma", "p", "n.occ", "turnover")

# call jags
jagsfit<-jags(data=list(y = J, nsite = dim(J)[1], nrep = dim(J)[2],
    nyear = dim(J)[3]), inits=jags.inits, jags.params,
n.iter=2000, n.chains=3, model.file=modJ.bug)

print(jagsfit, dig=2)

# checking convergence and diagnostic
library(coda)
summary(jagsfit)
codaout.jags <- as.mcmc(jagsfit)
plot(codaout.jags , ask=TRUE)
densityplot(codaout.jags)

# naive for Cercocebus sanjei
nv<-function (x) sum(ifelse(rowSums(x, na.rm=T)>=1,1,0))/nrow(x)
naive<-aaply(J,3,.fun=nv)   # naive occupancy

# Summarize posteriors and plot
meanB<-jagsfit$BUGSoutput$mean$psi
CRI2.5<-jagsfit$BUGSoutput$summary[20:24,3] # credible interval
CRI97.5<-jagsfit$BUGSoutput$summary[20:24,7]

plot(2009:2013,meanB, type="b",xlab = "Year", ylab = "Occupancy Sanje
    mangabey", ylim = c(0,1))
segments(2009:2013, CRI2.5, 2009:2013,CRI97.5, lwd = 1)
points(2009:2013, naive, type = "b", col = "blue", pch=16) # add this line to
    # compare real occupancy with naive (blue line)
legend(x=2011, y=0.2, legend=c("estimated occupancy","naive occupancy"),
    col=c("black","blue"), pch=c(1,16), lty=c(1,1), bty="n")
```

Appendix 6.2 'covariates.txt' (environmental covariates for modelling)

Sampling. Unit.Name	elevation	river	border	edge	habitat	slope	aspect
CT-UDZ-1-01	1329	489	5612	579	Montane	31.171652	158.500671
CT-UDZ-1-02	726	339	2011	569	Deciduous	14.157136	130.842163
CT-UDZ-1-03	391	326	673	70	Deciduous	9.114254	49.746979
CT-UDZ-1-04	1468	260	6048	719	Montane	15.038474	159.318817
CT-UDZ-1-05	1424	114	4620	1607	Montane	16.788244	122.805679
CT-UDZ-1-06	1343	353	3331	1271	Montane	14.243545	167.781799
CT-UDZ-1-07	972	336	1774	1387	Deciduous	42.382351	175.788177
CT-UDZ-1-08	642	413	595	769	Deciduous	14.720253	136.903992
CT-UDZ-1-09	1370	241	4967	1024	Montane	20.764597	45.439575
CT-UDZ-1-10	1362	264	3813	1348	Montane	7.441946	99.025879
CT-UDZ-1-11	1283	224	2499	2408	Montane	14.2138	19.5345
CT-UDZ-1-12	879	808	1235	1548	Deciduous	30.56826	137.137207
CT-UDZ-1-13	1297	632	6565	109	Montane	43.625916	31.486725
CT-UDZ-1-14	1173	545	5132	129	Montane	33.857132	93.018219
CT-UDZ-1-15	913	382	3794	626	Deciduous	18.700281	64.289749
CT-UDZ-1-16	731	15	2445	1410	Deciduous	30.039766	39.513672
CT-UDZ-1-17	687	325	1085	1602	Deciduous	18.564236	111.392426
CT-UDZ-1-18	954	342	2764	184	Deciduous	14.467772	164.099518
CT-UDZ-1-19	556	230	1347	830	Deciduous	25.546774	160.288788
CT-UDZ-1-20	525	159	66	829	Deciduous	11.844898	47.796661
CT-UDZ-2-01	887	52	4068	298	Deciduous	21.797432	121.256622
CT-UDZ-2-02	888	240	3218	402	Deciduous	45.174389	85.468353
CT-UDZ-2-03	1107	688	1917	1184	Deciduous	25.036476	158.566681
CT-UDZ-2-04	640	1427	629	1329	Deciduous	6.786586	30.884933
CT-UDZ-2-05	1499	226	6324	533	Montane	17.523985	151.707397
CT-UDZ-2-06	1415	197	5042	1297	Montane	17.047123	141.390839
CT-UDZ-2-07	1463	696	3843	1763	Montane	27.146767	171.647186
CT-UDZ-2-08	1232	1306	2405	2231	Montane	32.067642	64.98703
CT-UDZ-2-09	777	829	1024	1748	Deciduous	21.048759	112.364838
CT-UDZ-2-10	378	302	330	482	Deciduous	15.874851	105.622742
CT-UDZ-2-11	1586	233	6771	1661	Montane	26.093153	142.474869
CT-UDZ-2-12	1798	329	5424	2191	Montane	36.879498	164.395401
CT-UDZ-2-13	1675	62	4118	2911	Montane	21.356987	137.176025
CT-UDZ-2-14	1239	33	2834	3524	Montane	20.735252	128.731903
CT-UDZ-2-15	1122	452	1637	2316	Montane	25.771677	174.719513
CT-UDZ-2-16	680	5	372	1034	Deciduous	16.711714	59.790466
CT-UDZ-2-17	1277	616	7247	308	Montane	25.422089	37.496155
CT-UDZ-2-18	1463	714	5976	907	Montane	24.354555	47.156006
CT-UDZ-2-19	1733	311	4678	1911	Montane	12.842546	159.716324
CT-UDZ-2-20	1423	269	3523	2814	Montane	18.765783	111.79538
CT-UDZ-3-01	1377	1442	2281	2131	Montane	23.171885	141.506195

CT-UDZ-3-02	1016	705	1033	1831	Montane	16.274677	124.370514
CT-UDZ-3-03	561	890	313	521	Deciduous	27.199131	117.692749
CT-UDZ-3-04	1400	1038	6545	281	Montane	24.048208	53.836731
CT-UDZ-3-05	1462	101	5373	984	Montane	15.579961	45.108337
CT-UDZ-3-06	1522	655	4072	2174	Montane	10.502537	24.311676
CT-UDZ-3-07	1355	2062	2708	1110	Montane	25.247536	29.130707
CT-UDZ-3-08	1108	2118	1341	486	Montane	21.379456	150.998016
CT-UDZ-3-09	566	1326	13	116	Deciduous	20.028168	11.348724
CT-UDZ-3-10	1374	1014	5751	263	Montane	12.622332	173.337128
CT-UDZ-3-11	1282	1655	4410	1536	Montane	14.58766	12.423004
CT-UDZ-3-12	1027	2605	3005	638	Montane	25.568869	1.909851
CT-UDZ-3-13	709	323	557	438	Deciduous	27.282797	89.585175
CT-UDZ-3-14	1358	680	6133	425	Montane	22.889853	129.13324
CT-UDZ-3-15	1265	2067	4811	891	Montane	20.815947	161.386459
CT-UDZ-3-16	1109	2998	3593	9	Montane	28.511292	105.559219
CT-UDZ-3-17	728	463	1203	89	Deciduous	25.796947	64.604858
CT-UDZ-3-18	1724	903	5811	802	Montane	23.294996	122.409103
CT-UDZ-3-19	1756	2276	5548	1427	Montane	13.870706	167.710632
CT-UDZ-3-20	1488	2489	4384	643	Montane	14.783385	137.370052

Appendix 6.3 'covs100x100.txt' (grid of covariate values for spatially explicit maps) – complete version available in the online resources.

ID	x	y	edge	border	river	road	habitat
1	259662.60	9131368.69	186.99	6116.04	612.36	6392.01	Montane
2	259762.60	9131368.69	258.57	6019.64	712.31	6304.52	Montane
3	259862.60	9131368.69	284.72	5923.37	647.37	6217.40	Montane
4	259962.60	9131368.69	244.42	5827.22	552.96	6130.60	Montane
5	260062.60	9131368.69	217.35	5731.21	460.91	6044.37	Montane
6	260162.60	9131368.69	198.02	5635.33	372.98	5958.49	Montane
7	260262.60	9131368.69	183.55	5539.60	292.90	5873.05	Montane
8	260362.60	9131368.69	166.29	5444.02	229.06	5788.08	Montane
9	260462.60	9131368.69	160.11	5348.61	197.85	5703.60	Montane
10	260562.60	9131368.69	143.47	5253.36	214.06	5619.62	Montane
...							
12864	269662.60	9149468.69	215.63	3849.77	296.05	3837.18	Montane
12865	269762.60	9149468.69	168.78	3765.77	240.04	3763.95	Deciduous
12866	269862.60	9149468.69	130.74	3678.31	218.15	3690.72	Deciduous
12867	269962.60	9149468.69	102.47	3591.50	239.92	3617.49	Montane
12868	270062.60	9149468.69	91.37	3505.40	295.40	3544.27	Montane
12869	270162.60	9149468.69	93.08	3420.05	358.80	3471.04	Montane
12870	270262.60	9149468.69	126.70	3335.51	430.42	3397.81	Montane
12871	270362.60	9149468.69	195.75	3251.85	511.66	3324.59	Montane
12872	270462.60	9149468.69	182.43	3169.15	598.60	3251.36	Montane
12873	270562.60	9149468.69	101.50	3087.46	688.88	3178.13	Montane
12874	270662.60	9149468.69	28.88	3006.88	779.68	3105.05	Montane

Appendix 7.1 NWA 2013_2014_eff_trap_nights.xls (accumulated trap nights by camera traps and sites)

Appendix 7.2 NWA_2013_14_Lynx_encounter_histories.xls (number of different individuals and cumulative encounters)

Appendix 7.3 Dates and times in R.R (R script used for the data preparation)

```
###############################################################################
######                         Section 7.4.2                          ######
######                         for Chapter 7                           ######
######                              ***                                ######
######           Scripting by Danilo Foresti   (August 2015)          ######
###############################################################################

as.POSIXlt("2015-03-29 01:30:00", format="%Y-%m-%d %H:%M:%S",
    tz="Europe/Berlin")
as.POSIXct("2015-03-29 01:30:00", format="%Y-%m-%d %H:%M:%S",
    tz="Europe/Berlin")
day<-"29.3.2015 00:00:00"
clocktime<-"30.12.1899 01:30:00"
strsplit(day, split=" ")
day<-strsplit(day, split=" ")[[1]][1]
clocktime<-strsplit(clocktime, split=" ")[[1]][2]
day; clocktime
x<-paste(day,clocktime)
x
xPOSIXlt<-as.POSIXlt(x, format="%d.%m.%Y %H:%M:%S", tz="Europe/Berlin")
xPOSIXlt
xPOSIXlt2<-as.POSIXlt("2015-03-29 03:30:00", tz="Europe/Berlin")
xPOSIXlt3<-as.POSIXlt("2015-03-29 03:30:00", tz="Australia/Melbourne")
xPOSIXlt; xPOSIXlt2; xPOSIXlt3
difftime(xPOSIXlt2,xPOSIXlt)
difftime(xPOSIXlt2,xPOSIXlt3)
xUTC<-format(as.POSIXct(xPOSIXlt),tz="UTC")
xUTC2<-format(as.POSIXct(xPOSIXlt2),tz="UTC")
xUTC;xUTC2
xUTClocal<-as.POSIXlt(xUTC,tz="UTC") + (60*60)
xUTClocal2<-as.POSIXlt(xUTC2,tz="UTC") + (60*60)
xUTClocal;xUTClocal2
```

Appendix 7.4 Lynx_data.txt (dataset containing all the photographs of lynx taken in our study area)

"Site"	"Time"	"Lynx_Name"	"Sex"	"Mother"	"Year_Born"
"E2"	2014-01-28 08:31:00	"B335"	"m"	"B208"	2012
"E2"	2014-01-28 08:30:00	"B335"	"m"	"B208"	2012
"C5"	2014-01-28 07:01:00	"B400"	""	"B185"	2012
"B8"	2014-01-27 21:36:00	"EYWA"	"f"	"MARI"	2011
"B8"	2014-01-27 21:36:00	"EYWA"	"f"	"MARI"	2011
"B3"	2014-01-26 03:34:00	"MISO"	"m"	""	NA
"C6"	2014-01-25 03:07:00	"LOKI"	"m"	""	NA
"C4"	2014-01-25 20:03:00	"LOKI"	"m"	""	NA
"C4"	2014-01-25 20:02:00	"LOKI"	"m"	""	NA
"B5"	2014-01-24 01:27:00	"B333"	"m"	""	NA

"A5"	2014-01-24 00:12:00	"GIRO"	"m"	""	NA
"B5"	2014-01-24 01:27:00	"B333"	"m"	""	NA
"A4"	2014-01-23 01:14:00	"GIRO"	"m"	""	NA
"F8"	2014-01-22 02:48:00	"B261"	"m"	"B202"	2010
"A5"	2014-01-22 04:51:00	"GIRO"	"m"	""	NA
"G8"	2014-01-21 15:34:00	"B258"	""	""	NA
"C4"	2014-01-21 00:52:00	"LOKI"	"m"	""	NA
"C4"	2014-01-21 00:51:00	"LOKI"	"m"	""	NA
"G8"	2014-01-21 15:35:00	"B258"	""	""	NA
"E1"	2014-01-20 17:48:00	"PIRO"	"m"	"B31"	2005
"F2"	2014-01-20 18:38:00	"B261"	"m"	"B202"	2010
"E1"	2014-01-20 17:50:00	"PIRO"	"m"	"B31"	2005
"F2"	2014-01-20 18:38:00	"B261"	"m"	"B202"	2010
"A1"	2014-01-19 23:43:00	"SILV"	"m"	""	NA
"B5"	2014-01-18 21:40:00	"EYWA"	"f"	"MARI"	2011
"B5"	2014-01-18 21:40:00	"EYWA"	"f"	"MARI"	2011
"F4"	2014-01-17 03:59:00	"B185"	"f"	""	NA
"F4"	2014-01-17 03:59:00	"B185"	"f"	""	NA
"A5"	2014-01-16 21:40:00	"B331"	""	"MARI"	2012
"A5"	2014-01-16 21:39:00	"B331"	""	"MARI"	2012
"A5"	2014-01-16 21:41:00	"B331"	""	"MARI"	2012
"B2"	2014-01-16 05:45:00	"B385"	""	"B239"	2011
"E5"	2014-01-16 18:05:00	"B335"	"m"	"B208"	2012
"E5"	2014-01-16 18:04:00	"B335"	"m"	"B208"	2012
"D5"	2014-01-15 23:24:00	"B261"	"m"	"B202"	2010
"C4"	2014-01-15 23:52:00	"LOKI"	"m"	""	NA
"C4"	2014-01-15 23:53:00	"LOKI"	"m"	""	NA
"D5"	2014-01-15 23:23:00	"B261"	"m"	"B202"	2010
"I1"	2014-01-15 04:31:00	"SILV"	"m"	""	NA
"F4"	2014-01-14 03:11:00	"PIRO"	"m"	"B31"	2005
"F8"	2014-01-14 01:17:00	"B256"	"m"	""	NA
"C4"	2014-01-14 22:16:00	"LOKI"	"m"	""	NA
"D4"	2014-01-14 06:06:00	"B261"	"m"	"B202"	2010
"D4"	2014-01-14 06:06:00	"B261"	"m"	"B202"	2010
"C4"	2014-01-14 22:16:00	"LOKI"	"m"	""	NA
"F4"	2014-01-14 03:11:00	"PIRO"	"m"	"B31"	2005
"E6"	2014-01-13 05:21:00	"PIRO"	"m"	"B31"	2005
"E6"	2014-01-13 00:04:00	"PIRO"	"m"	"B31"	2005
"E6"	2014-01-13 05:13:00	"PIRO"	"m"	"B31"	2005
"C6"	2014-01-13 04:51:00	"B335"	"m"	"B208"	2012
"E6"	2014-01-13 00:11:00	"PIRO"	"m"	"B31"	2005
"C6"	2014-01-13 04:53:00	"B335"	"m"	"B208"	2012
"F6"	2014-01-13 20:34:00	"B294"	"m"	""	NA
"F6"	2014-01-13 20:34:00	"B294"	"m"	""	NA
"A3"	2014-01-13 19:44:00	"GIRO"	"m"	""	NA
"B4"	2014-01-12 03:44:00	"B331"	""	"MARI"	2012
"G1"	2014-01-11 17:53:00	"B256"	"m"	""	NA
"B3"	2014-01-10 08:47:00	"B279"	"f"	""	2010
"A4"	2014-01-10 00:09:00	"GIRO"	"m"	""	NA
"A4"	2014-01-10 00:08:00	"GIRO"	"m"	""	NA
"B8"	2014-01-10 20:16:00	"B333"	"m"	""	NA
"A5"	2014-01-10 03:38:00	"B331"	""	"MARI"	2012
"B3"	2014-01-10 08:47:00	"B279"	"f"	""	2010

```
"B8"   2014-01-10 20:15:00   "B333"   "m"   ""        NA
"D2"   2014-01-09 01:24:00   "B261"   "m"   "B202"    2010
"D2"   2014-01-09 01:24:00   "B261"   "m"   "B202"    2010
"D1"   2014-01-08 22:07:00   "LOKI"   "m"   ""        NA
"D1"   2014-01-08 22:07:00   "LOKI"   "m"   ""        NA
"F9"   2014-01-08 23:36:00   "B383"   ""    "B196"    2013
"F9"   2014-01-08 23:38:00   "B383"   ""    "B196"    2013
"C1"   2014-01-07 04:17:00   "B336"   ""    "B208"    2012
"E2"   2014-01-07 19:27:00   "B335"   "m"   "B208"    2012
"I2"   2014-01-07 17:33:00   "SILV"   "m"   ""        NA
"C1"   2014-01-07 04:17:00   "B336"   ""    "B208"    2012
"E2"   2014-01-07 19:26:00   "B335"   "m"   "B208"    2012
"B8"   2014-01-05 01:31:00   "B333"   "m"   ""        NA
"B8"   2014-01-05 01:31:00   "B333"   "m"   ""        NA
"F7"   2014-01-05 20:26:00   "B256"   "m"   ""        NA
"E6"   2014-01-04 05:44:00   "B335"   "m"   "B208"    2012
"E6"   2014-01-04 05:38:00   "B335"   "m"   "B208"    2012
"B8"   2014-01-03 04:58:00   "EYWA"   "f"   "MARI"    2011
"B8"   2014-01-03 04:58:00   "EYWA"   "f"   "MARI"    2011
"B8"   2014-01-02 03:21:00   "B333"   "m"   ""        NA
"A5"   2014-01-02 00:11:00   "GIRO"   "m"   ""        NA
"G7"   2014-01-02 00:40:00   "B258"   ""    ""        NA
"B8"   2014-01-02 03:20:00   "B333"   "m"   ""        NA
"B8"   2014-01-02 03:20:00   "B333"   "m"   ""        NA
"A5"   2014-01-02 00:11:00   "GIRO"   "m"   ""        NA
"E3"   2014-01-01 19:38:00   "B331"   ""    "MARI"    2012
"G7"   2014-01-01 21:13:00   "B256"   "m"   ""        NA
"G7"   2014-01-01 21:12:00   "B256"   "m"   ""        NA
"B5"   2014-01-01 21:15:00   "MISO"   "m"   ""        NA
"B5"   2014-01-01 21:14:00   "MISO"   "m"   ""        NA
"G8"   2013-12-31 21:43:00   "B256"   "m"   ""        NA
"G5"   2013-12-31 00:47:00   "B256"   "m"   ""        NA
"B5"   2013-12-31 20:18:00   "EYWA"   "f"   "MARI"    2011
"G8"   2013-12-31 21:43:00   "B256"   "m"   ""        NA
"B5"   2013-12-31 20:19:00   "EYWA"   "f"   "MARI"    2011
"F8"   2013-12-30 07:29:00   "B261"   "m"   "B202"    2010
"F8"   2013-12-30 07:30:00   "B261"   "m"   "B202"    2010
"A3"   2013-12-29 18:14:00   "B379"   "f"   ""        NA
"A3"   2013-12-29 18:14:00   "B379"   "f"   ""        NA
"F4"   2013-12-28 06:15:00   "PIRO"   "m"   "B31"     2005
"F4"   2013-12-28 06:14:00   "PIRO"   "m"   "B31"     2005
"B7"   2013-12-28 19:59:00   "B385"   ""    "B239"    2011
"B7"   2013-12-28 19:58:00   "B385"   ""    "B239"    2011
"D8"   2013-12-28 23:15:00   "B185"   "f"   ""        NA
"D8"   2013-12-28 23:15:00   "B185"   "f"   ""        NA
"B2"   2013-12-27 18:07:00   "B385"   ""    "B239"    2011
"B2"   2013-12-27 18:07:00   "B385"   ""    "B239"    2011
"B8"   2013-12-26 18:45:00   "B333"   "m"   ""        NA
"B8"   2013-12-26 18:45:00   "B333"   "m"   ""        NA
"A4"   2013-12-25 16:21:00   "B381"   ""    "B379"    2013
"D8"   2013-12-25 01:47:00   "PIRO"   "m"   "B31"     2005
"D8"   2013-12-25 01:47:00   "PIRO"   "m"   "B31"     2005
"B3"   2013-12-25 07:57:00   "MISO"   "m"   ""        NA
```

"E6"	2013-12-24 08:03:00	"PIRO"	"m"	"B31"	2005
"E5"	2013-12-24 00:36:00	"B335"	"m"	"B208"	2012
"E5"	2013-12-24 00:36:00	"B335"	"m"	"B208"	2012
"E6"	2013-12-24 07:52:00	"PIRO"	"m"	"B31"	2005
"E2"	2013-12-24 17:40:00	"MARI"	"f"	"MILA"	2009
"G6"	2013-12-24 00:30:00	"B258"	""	""	NA
"G6"	2013-12-24 00:29:00	"B258"	""	""	NA
"E2"	2013-12-24 17:45:00	"MARI"	"f"	"MILA"	2009
"A3"	2013-12-23 22:44:00	"B379"	"f"	""	NA
"F7"	2013-12-23 05:22:00	"B256"	"m"	""	NA
"A3"	2013-12-23 22:45:00	"B380"	""	"B379"	2013
"F7"	2013-12-23 05:22:00	"B256"	"m"	""	NA
"A3"	2013-12-23 22:44:00	"B380"	""	"B379"	2013
"B3"	2013-12-22 07:33:00	"MISO"	"m"	""	NA
"E6"	2013-12-22 22:59:00	"B335"	"m"	"B208"	2012
"B3"	2013-12-22 07:33:00	"MISO"	"m"	""	NA
"E6"	2013-12-22 22:49:00	"B335"	"m"	"B208"	2012
"B8"	2013-12-21 04:08:00	"EYWA"	"f"	"MARI"	2011
"B8"	2013-12-21 04:09:00	"EYWA"	"f"	"MARI"	2011
"B8"	2013-12-21 22:12:00	"B335"	"m"	"B208"	2012
"A2"	2013-12-21 02:55:00	"B385"	""	"B239"	2011
"B8"	2013-12-21 22:11:00	"B335"	"m"	"B208"	2012
"B8"	2013-12-20 19:24:00	"EYWA"	"f"	"MARI"	2011
"D1"	2013-12-20 04:36:00	"B261"	"m"	"B202"	2010
"D1"	2013-12-20 04:37:00	"B261"	"m"	"B202"	2010
"B8"	2013-12-20 19:23:00	"EYWA"	"f"	"MARI"	2011
"A5"	2013-12-20 05:18:00	"B381"	""	"B379"	2013
"A5"	2013-12-20 05:14:00	"B381"	""	"B379"	2013
"G9"	2013-12-20 22:19:00	"PIRO"	"m"	"B31"	2005
"A6"	2013-12-19 02:05:00	"SILV"	"m"	""	NA
"A5"	2013-12-18 17:24:00	"B379"	"f"	""	NA
"A5"	2013-12-18 18:24:00	"B381"	""	"B379"	2013
"A1"	2013-12-18 02:58:00	"B318"	""	"B319?"	2012
"A6"	2013-12-18 01:09:00	"B318"	""	"B319?"	2012
"A5"	2013-12-18 17:23:00	"B379"	"f"	""	NA
"A5"	2013-12-18 17:36:00	"B379"	"f"	""	NA
"A5"	2013-12-18 17:38:00	"B379"	"f"	""	NA
"A5"	2013-12-17 06:19:00	"B381"	""	"B379"	2013
"A5"	2013-12-17 17:21:00	"B381"	""	"B379"	2013
"A5"	2013-12-17 06:26:00	"B381"	""	"B379"	2013
"A5"	2013-12-17 01:58:00	"B379"	"f"	""	NA
"A5"	2013-12-17 05:17:00	"B379"	"f"	""	NA
"A5"	2013-12-17 06:21:00	"B381"	""	"B379"	2013
"A5"	2013-12-17 06:23:00	"B381"	""	"B379"	2013
"A5"	2013-12-17 06:24:00	"B381"	""	"B379"	2013
"A5"	2013-12-17 06:27:00	"B381"	""	"B379"	2013
"A5"	2013-12-17 17:22:00	"B381"	""	"B379"	2013
"A5"	2013-12-17 01:56:00	"B379"	"f"	""	NA
"A5"	2013-12-17 05:16:00	"B379"	"f"	""	NA
"A4"	2013-12-16 18:50:00	"B379"	"f"	""	NA
"B5"	2013-12-16 06:53:00	"EYWA"	"f"	"MARI"	2011
"B5"	2013-12-16 17:40:00	"MISO"	"m"	""	NA
"A4"	2013-12-16 18:51:00	"B379"	"f"	""	NA

"B5"	2013-12-16 06:53:00	"EYWA"	"f"	"MARI"	2011
"E2"	2013-12-16 19:50:00	"B335"	"m"	"B208"	2012
"E2"	2013-12-16 19:49:00	"B335"	"m"	"B208"	2012
"F3"	2013-12-15 21:54:00	"B256"	"m"	""	NA
"G1"	2013-12-15 01:11:00	"B294"	"m"	""	NA
"F8"	2013-12-15 01:45:00	"B196"	"f"	"B53"	2009
"F8"	2013-12-15 19:26:00	"B196"	"f"	"B53"	2009
"F8"	2013-12-15 02:19:00	"B383"	""	"B196"	2013
"F8"	2013-12-15 01:45:00	"B383"	""	"B196"	2013
"F5"	2013-12-14 16:33:00	"B196"	"f"	"B53"	2009
"F8"	2013-12-14 20:40:00	"B196"	"f"	"B53"	2009
"B1"	2013-12-14 19:32:00	"B318"	""	"B319?"	2012
"B1"	2013-12-14 19:31:00	"B318"	""	"B319?"	2012
"F5"	2013-12-14 16:32:00	"B383"	""	"B196"	2013
"F3"	2013-12-14 03:36:00	"B256"	"m"	""	NA
"A2"	2013-12-14 01:52:00	"GIRO"	"m"	""	NA
"F5"	2013-12-14 16:32:00	"B196"	"f"	"B53"	2009
"A2"	2013-12-14 01:50:00	"GIRO"	"m"	""	NA
"D5"	2013-12-13 22:17:00	"B336"	""	"B208"	2012
"D5"	2013-12-13 22:16:00	"B336"	""	"B208"	2012
"D1"	2013-12-12 17:54:00	"B336"	""	"B208"	2012
"E2"	2013-12-12 17:31:00	"B335"	"m"	"B208"	2012
"D1"	2013-12-12 17:54:00	"B336"	""	"B208"	2012
"A2"	2013-12-11 01:52:00	"GIRO"	"m"	""	NA
"B5"	2013-12-10 22:02:00	"EYWA"	"f"	"MARI"	2011
"B5"	2013-12-10 22:01:00	"EYWA"	"f"	"MARI"	2011
"F4"	2013-12-10 05:40:00	"B185"	"f"	""	NA
"E5"	2013-12-10 19:41:00	"B335"	"m"	"B208"	2012
"F4"	2013-12-10 05:40:00	"B185"	"f"	""	NA
"B5"	2013-12-10 22:47:00	"EYWA"	"f"	"MARI"	2011
"A3"	2013-12-09 22:30:00	"B379"	"f"	""	NA
"F1"	2013-12-09 21:40:00	"B196"	"f"	"B53"	2009
"F1"	2013-12-09 21:50:00	"B383"	""	"B196"	2013
"F1"	2013-12-09 21:41:00	"B383"	""	"B196"	2013
"E7"	2013-12-08 19:48:00	"B335"	"m"	"B208"	2012
"A5"	2013-12-08 07:05:00	"B382"	""	"B379"	2013
"A5"	2013-12-08 07:04:00	"B382"	""	"B379"	2013
"D8"	2013-12-08 00:06:00	"B335"	"m"	"B208"	2012
"D8"	2013-12-08 00:06:00	"B335"	"m"	"B208"	2012
"A7"	2013-12-07 23:03:00	"MISO"	"m"	""	NA
"G6"	2013-12-07 03:35:00	"B256"	"m"	""	NA
"G6"	2013-12-07 03:35:00	"B256"	"m"	""	NA
"A4"	2013-12-05 17:13:00	"B379"	"f"	""	NA
"A5"	2013-12-05 07:01:00	"B382"	""	"B379"	2013
"A4"	2013-12-05 17:13:00	"B379"	"f"	""	NA
"D1"	2013-12-05 20:47:00	"B261"	"m"	"B202"	2010
"D1"	2013-12-05 20:45:00	"B261"	"m"	"B202"	2010
"A4"	2013-12-05 17:14:00	"B380"	""	"B379"	2013
"B5"	2013-12-05 23:07:00	"MISO"	"m"	""	NA
"B5"	2013-12-05 23:07:00	"MISO"	"m"	""	NA
"A5"	2013-12-05 07:00:00	"B382"	""	"B379"	2013
"A4"	2013-12-04 03:36:00	"B385"	""	"B239"	2011
"F3"	2013-12-04 19:14:00	"B256"	"m"	""	NA

"A4"	2013-12-04 03:36:00	"B385"	""	"B239"	2011
"F3"	2013-12-04 19:14:00	"B256"	"m"	""	NA
"B4"	2013-12-04 06:43:00	"GIRO"	"m"	""	NA
"C1"	2013-12-03 06:20:00	"LARY"	"m"	"B239"	2011
"B2"	2013-12-03 03:39:00	"B331"	""	"MARI"	2012
"A5"	2013-12-03 02:13:00	"B382"	""	"B379"	2013
"C1"	2013-12-03 06:20:00	"LARY"	"m"	"B239"	2011
"A5"	2013-12-03 02:13:00	"B382"	""	"B379"	2013
"A5"	2013-12-01 22:31:00	"B385"	""	"B239"	2011
"A5"	2013-12-01 22:31:00	"B385"	""	"B239"	2011
"A5"	2013-11-30 01:47:00	"B379"	"f"	""	NA
"E6"	2013-11-30 03:10:00	"PIRO"	"m"	"B31"	2005
"E6"	2013-11-30 03:05:00	"PIRO"	"m"	"B31"	2005
"E2"	2013-11-30 20:24:00	"PIRO"	"m"	"B31"	2005
"E2"	2013-11-30 20:24:00	"PIRO"	"m"	"B31"	2005
"D2"	2013-11-30 05:20:00	"B261"	"m"	"B202"	2010
"D2"	2013-11-30 05:16:00	"B261"	"m"	"B202"	2010
"A5"	2013-11-30 01:47:00	"B382"	""	"B379"	2013
"A5"	2013-11-30 17:02:00	"B381"	""	"B379"	2013
"A5"	2013-11-30 01:48:00	"B381"	""	"B379"	2013
"A5"	2013-11-30 01:47:00	"B381"	""	"B379"	2013
"A5"	2013-11-30 17:01:00	"B380"	""	"B379"	2013
"D2"	2013-11-30 05:16:00	"B261"	"m"	"B202"	2010
"D2"	2013-11-30 05:21:00	"B261"	"m"	"B202"	2010
"A5"	2013-11-30 17:01:00	"B380"	""	"B379"	2013
"D2"	2013-11-30 04:58:00	"B261"	"m"	"B202"	2010
"A5"	2013-11-30 01:46:00	"B379"	"f"	""	NA
"D2"	2013-11-30 04:58:00	"B261"	"m"	"B202"	2010
"C4"	2013-11-29 20:42:00	"LOKI"	"m"	""	NA
"A6"	2013-11-29 21:53:00	"MISO"	"m"	""	NA
"A5"	2013-11-29 19:12:00	"B379"	"f"	""	NA
"C4"	2013-11-29 20:42:00	"LOKI"	"m"	""	NA
"D2"	2013-11-29 17:05:00	"B261"	"m"	"B202"	2010
"I1"	2013-11-29 18:06:00	"LARY"	"m"	"B239"	2011
"A5"	2013-11-29 19:12:00	"B379"	"f"	""	NA
"D2"	2013-11-29 17:05:00	"B261"	"m"	"B202"	2010

Appendix 7.5 Sites.txt (table with the coordinates of all sites)

"Site"	"x"	"y"
"A1"	615262	167863
"A2"	608598	162329
"A3"	605040	159709
"A4"	604423	161485
"A5"	606097	162555
"A6"	614553	169920
"A7"	608951	173237
"B1"	611084	168717
"B2"	606990	166147
"B3"	602803	168903
"B4"	604002	166265

"B5"	600892	168566
"B6"	596506	166133
"B7"	597546	164213
"B8"	594233	163750
"C1"	603518	142013
"C2"	600502	139908
"C3"	601732	146044
"C4"	598633	145829
"C5"	598868	150021
"C6"	595876	149578
"C7"	596174	155056
"D1"	588062	137586
"D2"	588194	142569
"D3"	592059	138910
"D4"	590024	144381
"D5"	591250	142871
"D6"	591528	147205
"D7"	590244	147319
"D8"	587003	149422
"D9"	586680	137932
"E1"	590255	160646
"E2"	594331	156863
"E3"	595902	159821
"E4"	596772	157353
"E5"	595590	153627
"E6"	592454	153577
"E7"	590045	152065
"F1"	586294	144427
"F2"	585420	147987
"F3"	576320	148569
"F4"	580169	149671
"F5"	580790	146655
"F6"	573790	146837
"F7"	569629	146086
"F8"	575891	143932
"F9"	580664	138492
"F11"	575424	138175
"G1"	567321	145304
"G2"	571088	149865
"G3"	569678	152129
"G4"	571109	154340
"G5"	573070	153268
"G6"	574001	155325
"G7"	574150	158850
"G8"	578442	161266
"G9"	582952	160267
"I1"	618502	165767
"I2"	615877	161516
"I3"	611882	153758
"I4"	608447	148458

Appendix 7.6 Trapnights.txt (table about the trap deployment details) – see online resources.

Appendix 7.7 suitable_habitat_secr.zip (shapefile of the suitable lynx habitat)– see online resources.

Appendix 7.8 Chapter 7.R (R script for running all the analyses with the package `secr`)

```
###########################################################################
######                        Chapter 7                             ######
######        Spatially explicit capture-recapture with secr        ######
######                            ***                                ######
######      Scripting by Danilo Foresti and Fridolin Zimmermann     ######
######                      (November 2015)                         ######
###########################################################################

###########################################################################
## Preparation
###########################################################################

## Define working directory
setwd(choose.dir())

## Load secr package
library(secr)

###########################################################################
## Read dataset & prepare for analysis
###########################################################################

## Read Lynx_data.txt: All lynx photos of the session of interest:
lynx_data <- read.delim("Lynx_data.txt", header=T, stringsAsFactors=F)
lynx_data[,"Time"]<-as.POSIXct(lynx_data$Time) # Adopt a workable format for
# Time column
head(lynx_data)
dim(lynx_data)

## Import Sites.txt table:
sites<-read.delim("Sites.txt",stringsAsFactors=F);head(sites);dim(sites)
sites<-data.frame(LOC_ID=1:dim(sites)[1],sites) # Add a column with a single
# numeric identifier for each site
head(sites)

## Import Trapnights.txt calendar:
trap_nights<-read.delim("Trapnights.txt",header=T,
    stringsAsFactors=F);head(trap_nights)

###########################################################################
## Convert the juveniles' detections in mother's detections
## If they have to be considered, otherwise delete them before

for (i in 1:dim(lynx_data)[1]){
    if(lynx_data$Mother[i]!="" & lynx_data$Year_Born[i]==2013){      # If
# known mother and lynx is defined as juvenile for the specified year
        lynx_data[i,"Lynx_Name"]<-lynx_data$Mother[i]               # Replace
# juvenile's name with the mother's name
        lynx_data[i,"Sex"]<-"f"                                     # and
# insert "f" as the corresponding sex
    }};rm(i)

## Delete column with descendance information, since no more consistent
```

```
lynx_data<-lynx_data[,-which(names(lynx_data)=="Mother")]
lynx_data<-lynx_data[,-which(names(lynx_data)=="Year_Born")]
head(lynx_data)

############################################################################
## Define period:

## Start and stop of the sampling period:
start_date <- as.POSIXlt("2013-11-29 12:00:00", format="%Y-%m-%d %H:%M:%S",
    tz="Europe/Berlin")
end_date <- as.POSIXlt("2014-01-28 12:00:00", format="%Y-%m-%d %H:%M:%S",
    tz="Europe/Berlin")
## Length of sampling occasion IN DAYS:
length_occasion<-5
## Calculate number of sampling occasions in the defined sampling period
max_occasions<-as.numeric(difftime(end_date,start_date,
    unit='days')/length_occasion)
max_occasions

############################################################################
## Compute the trap nights (method is fraction):

traps_table<-matrix(nrow=dim(sites)[1], ncol=max_occasions)
for (i in 1:dim(traps_table)[1]){
    for (j in 1:max_occasions){
        traps_table[i,j]<-sum(trap_nights[i,
        (2+length_occasion*(j-1)):(1+length_occasion*j)])/length_occasion
        }
    };rm(i,j)
head(traps_table)

############################################################################
## Calculate capture events for all lynx detections

captures<-data.frame(SESSION=integer(), ANIMAL_ID=integer(),SO=integer(),
    LOC_ID=integer(), SEX=integer())
for (i in 1:dim(lynx_data)[1]){
    # For every detection...
    captures[i,"SESSION"]<-1
    # ...assign a constant value for session name, then...
    captures[i,"LOC_ID"]<-sites[sites[,"Site"]==lynx_data$Site[i],"LOC_ID"]
    # ...find the LOC_ID...
    captures[i,"ANIMAL_ID"]<-lynx_data$Lynx_Name[i]
    # ...the lynx ID...
    captures[i,"SO"]<-floor(difftime(lynx_data$Time[i],
    start_date,units='days')/length_occasion)+1        # ...and assign
    # detections to a specific sampling occasion
    captures[i,"SEX"]<-lynx_data$Sex[i]
        # Assign the sex of the animal
    if (captures[i,"SEX"]=="") captures[i,"SEX"]<-NA
    # If sex not known specify NA
    };rm(i)
head(captures)
dim(captures)[1]

## Remove repeated observations from captures
# (from "count" to "proximity" dataset)
captures_prox<-unique(captures)
```

```
rownames(captures_prox)<-1:length(rownames(captures_prox))

head(captures_prox)
dim(captures)[1]                     # Amount of detections before computation
dim(captures_prox)[1]                # Amount of detections after compression
head(captures_prox)
dim(captures_prox)[1]

##########################################################################
## Create SECR 'proximity' objects:

## Create SECR traps "proximity" object
traps_analysis_nousage<-read.traps(data=sites[,c(1,3:4)],
    detector="proximity", binary.usage=FALSE)
summary(traps_analysis_nousage)
## Add usage info
traps_analysis<-traps_analysis_nousage
usage(traps_analysis)<-traps_table
summary(traps_analysis)

## Create SECR capthist "proximity" object
lynx_capthist<-make.capthist(captures_prox, traps_analysis, fmt="trapID",
    noccasions=max_occasions, covnames="SEX")
summary(lynx_capthist)

##########################################################################
## Analysis
##########################################################################

## Create masks for mask inspection
mask_1 <-make.mask(traps_analysis, buffer=1000, type="traprec", spacing=1000)
mask_3 <-make.mask(traps_analysis, buffer=3000, type="traprec", spacing=1000)
mask_5 <-make.mask(traps_analysis, buffer=5000, type="traprec", spacing=1000)
mask_7 <-make.mask(traps_analysis, buffer=7000, type="traprec", spacing=1000)
mask_9 <-make.mask(traps_analysis, buffer=9000, type="traprec", spacing=1000)
mask_11 <-make.mask(traps_analysis, buffer=11000, type="traprec",
    spacing=1000)
mask_13 <-make.mask(traps_analysis, buffer=13000, type="traprec",
    spacing=1000)
mask_15 <-make.mask(traps_analysis, buffer=15000, type="traprec",
    spacing=1000)
mask_17 <-make.mask(traps_analysis, buffer=17000, type="traprec",
    spacing=1000)
mask_20 <-make.mask(traps_analysis, buffer=20000, type="traprec",
    spacing=1000)
mask_25 <-make.mask(traps_analysis, buffer=25000, type="traprec",
    spacing=1000)
mask_30 <-make.mask(traps_analysis, buffer=30000, type="traprec",
    spacing=1000)

## Run SECR analysis for different masks - find correct buffer
M0_1 <-secr.fit(lynx_capthist, mask=mask_1, model = list(D~1, g0~1, sigma~1))
M0_3 <-secr.fit(lynx_capthist, mask=mask_3, model = list(D~1, g0~1, sigma~1))
M0_5 <-secr.fit(lynx_capthist, mask=mask_5, model = list(D~1, g0~1, sigma~1))
M0_7 <-secr.fit(lynx_capthist, mask=mask_7, model = list(D~1, g0~1, sigma~1))
M0_9 <-secr.fit(lynx_capthist, mask=mask_9, model = list(D~1, g0~1, sigma~1))
```

```
M0_11 <-secr.fit(lynx_capthist, mask=mask_11, model = list(D~1, g0~1,
    sigma~1))
M0_13 <-secr.fit(lynx_capthist, mask=mask_13, model = list(D~1, g0~1,
    sigma~1))
M0_15 <-secr.fit(lynx_capthist, mask=mask_15, model = list(D~1, g0~1,
    sigma~1))
M0_17 <-secr.fit(lynx_capthist, mask=mask_17, model = list(D~1, g0~1,
    sigma~1))
M0_20 <-secr.fit(lynx_capthist, mask=mask_20, model = list(D~1, g0~1,
    sigma~1))
M0_25 <-secr.fit(lynx_capthist, mask=mask_25, model = list(D~1, g0~1,
    sigma~1))
M0_30 <-secr.fit(lynx_capthist, mask=mask_30, model = list(D~1, g0~1,
    sigma~1))

densities<-c(1.347605e-04,1.203294e-04,1.111139e-04,1.061034e-04,
    1.039526e-04,1.032479e-04,1.030708e-04,1.030367e-04,1.030318e-04,
    1.030314e-04,1.030314e-04,1.030314e-04)
SE<-c(2.850448e-05,2.550388e-05,2.363025e-05,2.266154e-05,2.228379e-05,
    2.217866e-05,2.215876e-05,2.215678e-05,2.215694e-05,2.215712e-05,
    2.215713e-05,2.215714e-05)

library (Hmisc)
errbar(c(1,3,5,7,9,11,13,15,17,20,25,30),densities*10000,
    (densities+SE)*10000,(densities-SE)*10000,type='b',
    col='black',pch=19,xlab='Buffer size (km)',errbar.col='black',
    ylim=c(0,max(densities+SE)*10000),
    ylab='Fitted (real) parameter for D (individuals/100 km2)')

## Choose good buffer: 13km
mask_prox<-mask_13
summary(mask_prox)

############################################################################

## Run several predefined models (without mixture on sex)

M0 <-secr.fit(lynx_capthist, mask=mask_prox, model = list(D~1, g0~1,
    sigma~1))
Mb <-secr.fit(lynx_capthist, mask=mask_prox, model = list(D~1, g0~b,
    sigma~1))
Mt <-secr.fit(lynx_capthist, mask=mask_prox, model = list(D~1, g0~t,
    sigma~1))
Mbt <-secr.fit(lynx_capthist, mask=mask_prox, model = list(D~1, g0~b+t,
    sigma~1))
MT <-secr.fit(lynx_capthist, mask=mask_prox, model = list(D~1, g0~T,
    sigma~1))
MB <-secr.fit(lynx_capthist, mask=mask_prox, model = list(D~1, g0~B,
    sigma~1))
Mbk <-secr.fit(lynx_capthist, mask=mask_prox, model = list(D~1, g0~bk,
    sigma~1))
MBk <-secr.fit(lynx_capthist, mask=mask_prox, model = list(D~1, g0~Bk,
    sigma~1))
MK <-secr.fit(lynx_capthist, mask=mask_prox, model = list(D~1, g0~K,
    sigma~1))
MK_NM <-secr.fit(lynx_capthist, mask=mask_prox, model = list(D~1, g0~K,
    sigma~1),method="Nelder-Mead")
```

```
Mk <-secr.fit(lynx_capthist, mask=mask_prox, model = list(D~1, g0~k,
    sigma~1))
Mh2 <-secr.fit(lynx_capthist, mask=mask_prox, model = list(D~1, g0~h2,
    sigma~1))
Mh2_NM <-secr.fit(lynx_capthist, mask=mask_prox, model = list(D~1, g0~h2,
    sigma~1),method="Nelder-Mead")
Mh2_NM_SL <-secr.fit(lynx_capthist, mask=mask_prox, model = list(D~1, g0~h2,
    sigma~1),method="Nelder-Mead",start=list(D=0.00012,g0=0.24,sigma=3200))
Mh2_NM_SM0 <-secr.fit(lynx_capthist, mask=mask_prox, model = list(D~1, g0~h2,
    sigma~1),method="Nelder-Mead",start=M0)

# AIC analysis
AIC(M0,Mb,Mt,Mbt,MT,MB,Mbk,MBk,MK_NM,Mk,Mh2_NM_SM0, criterion="AIC")
# Best model is Mbk

################################################################################

# Compare spatial versus non-spatial models with SECR
# region.N to transform SECR model into Npop estimations
region.N(Mbk, region=mask_prox)

################################################################################

# Analysis of sex differences
M_g0bk_sigma<-secr.fit(lynx_capthist, mask=mask_prox, model = list(D~1,
    g0~bk, sigma~1), hcov="SEX")
M_g0_sigmasex<-secr.fit(lynx_capthist, mask=mask_prox, model = list(D~1,
    g0~1, sigma~h2), hcov="SEX")
M_g0sex_sigmasex<-secr.fit(lynx_capthist, mask=mask_prox, model = list(D~1,
    g0~h2, sigma~h2), hcov="SEX")
M_g0bk_sigmasex<-secr.fit(lynx_capthist, mask=mask_prox, model = list(D~1,
    g0~bk, sigma~h2), hcov="SEX")
M_g0bksex_sigma<-secr.fit(lynx_capthist, mask=mask_prox, model = list(D~1,
    g0~(bk+h2), sigma~1), hcov="SEX")
M_g0bksex_sigmasex<-secr.fit(lynx_capthist, mask=mask_prox, model = list(D~1,
    g0~(bk+h2), sigma~h2), hcov="SEX")

# AIC analysis
AIC(M_g0_sigmasex,M_g0sex_sigmasex,M_g0bk_sigma,M_g0bk_sigmasex,
    M_g0bksex_sigma,M_g0bksex_sigmasex, criterion="AIC")
# There is no outstanding model
# We thus apply model averaging to the two competing models (delta AIC < 2;
# Burnham and Anderson 2002) to get unbiased parameter estimates
model.average(M_g0bk_sigmasex,M_g0bksex_sigmasex,criterion="AIC")
################################################################################

## Including the habitat mask

## Write a text file with the mask_prox for further analysis in GIS
write.table(mask_prox,'mask_prox_GIS.txt',sep='\t',row.names=F)

## Load the library maptools
library (maptools)

## Create the polygon object in R
HabitatPol <- readShapePoly("suitable_habitat_secr")
```

```
## Create the habitat mask
habitat_mask <- make.mask(traps_analysis, spacing=1000, type="polygon",
    poly = HabitatPol)
summary(habitat_mask)

## Draw a map to see if the sites and the shapefile are aligned
# to the same area
plot(HabitatPol, axes=F)
plot(habitat_mask, pch=20, add=T)
points(traps_analysis[,"x"], traps_analysis[,"y"], pch=20, bg=grey(1),
    col='black')

## Run an analysis with a habitat mask on the previous models (with and
# without sex)
M_g0bk_sigma_habitat<-secr.fit(lynx_capthist, mask=habitat_mask,
    model = list(D~1, g0~bk, sigma~1), hcov="SEX")
M_g0sex_sigmasex_habitat<-secr.fit(lynx_capthist, mask=habitat_mask,
    model = list(D~1, g0~h2, sigma~h2), hcov="SEX")
M_g0_sigmasex_habitat<-secr.fit(lynx_capthist, mask=habitat_mask,
    model = list(D~1, g0~1, sigma~h2), hcov="SEX")
M_g0bk_sigmasex_habitat<-secr.fit(lynx_capthist, mask=habitat_mask,
    model = list(D~1, g0~bk, sigma~h2), hcov="SEX")
M_g0bksex_sigma_habitat<-secr.fit(lynx_capthist, mask=habitat_mask,
    model = list(D~1, g0~(bk+h2), sigma~1), hcov="SEX")
M_g0bksex_sigmasex_habitat<-secr.fit(lynx_capthist, mask=habitat_mask,
    model = list(D~1, g0~(bk+h2), sigma~h2), hcov="SEX")
# AIC analysis
AIC(M_g0bk_sigma_habitat, M_g0sex_sigmasex_habitat, M_g0_sigmasex_habitat,
    M_g0bk_sigmasex_habitat, M_g0bksex_sigma_habitat,
    M_g0bksex_sigmasex_habitat, criterion="AIC")
# There is no outstanding model as in the previous case
# without the habitat mask
# We thus apply model averaging to the two competing models (delta AIC < 2;
# Burnham and Anderson 2002) to get unbiased parameter estimates
model.average(M_g0bk_sigmasex_habitat,M_g0bksex_sigmasex_habitat,
    criterion="AIC")
save.image("Chapter_7.RData")
```

Appendix 7.9 Chapter_7.RData (R file containing the results) – see online resources.

Appendix 8.1 Case study comparison of activity patterns: 'true_events_NWA2013_14.csv' – see online resources.

Appendix 8.2 R script: 'R script_chapter 8.R'

```
###################################################################
# Chapter 8 - Comparison of activity patterns
#
# Adapted from Meredith and Ridout (2014)
#
# Scripting Fridolin Zimmermann and Danilo Foresti
#
# August 2015
###################################################################
# To set the working directory type the following command line
# This will open an explorer window for easy browsing
```

```
setwd(choose.dir())
# To get the current working directory and verify that it is correct
getwd()
# Import the .csv table into R when the data are separated by ","
events <- read.delim(file.choose(),header=TRUE,sep=',')
# Choose the file containing the data (true_events_NWA2013_14.csv)
# Display the header of the table
# to verify that the file has been correctly imported
# This will recall you the exact name of the columns in your dataset
# This is crucial to successfully run the functions presented hereafter
head(events)
# Before the analyses, it is good to explore the dataset
# To see the different study areas the data come from type
table(events$area)
# To see how many species and events per species are available type
summary(events$species)
# To check if the time format is correct (0-1 range) type
range(events$time)
# Package overlap works entirely in radian units
# The conversion is straightforward
timeRad<-events$time*2*pi

######################################################################
# Fitting the kernel density
# Load the package overlap (Meredith and Ridout 2014)
# Extract the data for the Eurasian lynx, plot a kernel density curve
library(overlap)
lynx<-timeRad[events$area==1 & events$species== 'Lynx lynx']
densityPlot(lynx, rug=T)
densityPlot(lynx, rug=T, adjust=2)
densityPlot(lynx, rug=T, adjust=0.5)

######################################################################
# Coefficient of overlap
# Practical example with the north-western Swiss Alps dataset
# Extract the data for the Eurasian lynx and its prey the roe deer
lynx<-timeRad[events$area==1 & events$species=='Lynx lynx']
roe<-timeRad[events$area==1 & events$species=='Capreolus capreolus']
# Get the size of the smaller of the two samples type
min(length(lynx), length(roe))
# Calculate the overlap with the three estimators
lynxroeest<-overlapEst(lynx,roe)
lynxroeest
# Plot the curves
overlapPlot(lynx,roe, rug=T)
legend('topright', c("Eurasian lynx", "Roe deer"), lty=c(1,2), col=c(1,4),
    bty='n')

######################################################################
# Bootstrap analysis to estimate the CI of the coefficient of overlapping
# Generate 10000 smoothed bootstrap for Eurasian lynx and roe deer
lynxboot<-resample(lynx,10000)
roeboot<-resample(roe, 10000)
dim(lynxboot)
dim(roeboot)
# To generate estimates of overlap from each pair of samples
# these two matrices are passed to the function bootEst()
lynxroe<-bootEst(lynxboot, roeboot, adjust=c(NA,1,NA))
```

```
dim(lynxroe)
BSmean<-colMeans(lynxroe)
BSmean
tmp<-lynxroe[,2]
bootCI(lynxroeest[2],tmp)
tmp<-lynxroe[,2]
bootCIlogit(lynxroeest[2],tmp)

####################################################################
# Overlap for lynx and chamois including estimation of the CI
# estimated following the same procedure
chamois<-timeRad[events$area==1 & events$species=='Rupicapra rupicapra']
# Get the size of the smaller of the two samples type
min(length(lynx), length(chamois))
lynxchamoisest<-overlapEst(lynx,chamois)
lynxchamoisest
overlapPlot(lynx,chamois, rug=T)
legend('topright', c("Eurasian lynx", "Chamois"), lty=c(1,2), col=c(1,4),
    bty='n')
# Bootstrap analysis to estimate the CI of the coefficient of overlapping
chamoisboot<-resample(chamois, 10000)
lynxchamois<-bootEst(lynxboot, chamoisboot, adjust=c(NA,1,NA))
BSMean<-colMeans(lynxchamois)
BSMean
tmp<-lynxchamois[,2]
bootCI(lynxchamoisest[2],tmp)
bootCIlogit(lynxchamoisest[2],tmp)

####################################################################
# Function compareCkern () of package activity (Rowcliffe 2015) to test
# that two sets of circular observations come from the same distribution

library(activity)
compareCkern(lynx, roe, reps = 10000)
compareCkern(lynx, chamois, reps = 10000)
compareCkern(roe, chamois, reps = 10000)

####################################################################
# Wald test using the function compareAct(fits) to estimate
# the significance of pairwise comparisons between overall activity levels
library(activity)
# A circular kernel density on the original dataset is fitted
# The coverage of the confidence interval seems to be better estimated
# with sample = "model" when the sample size is greater than 100-200,
# whereas smaller sample sizes should be investigated using sample = "data"
# The bootstrapping on a model basis for lynx and roe deer was chosen
# given their sample size (> 100)
lynxactmod<-fitact(lynx,adj=1, sample="model", reps=10000)
lynxactmod
roeactmod<-fitact(roe,adj=1, sample="model", reps=10000)
roeactmod
compareAct(list(lynxactmod,roeactmod))

# Same analysis for the chamois
# As the sample size for chamois is less than 100,
# the argument sample of the function was set to data

chamoisactmod<-fitact(chamois,adj=1, sample="data", reps=10000)
```

```
chamoisactmod
compareAct(list(lynxactmod,chamoisactmod))
compareAct(list(roeactmod,chamoisactmod))
```

Appendix 9.1 'Chapter_9_script.R'

```
########################################
# Chapter 9 - R and JAGS model codes
# Simone Tenan
#
# last modified Wednesday 17 June 2015
########################################

###############################
# Extract the data
###############################

# set your working directory
setwd("/path/to/your/folder/")

### extract
source("TEAM library 1.7.R")
library(chron)
library(reshape)

#load the data, add taxonomy and fix them (see Chapter 5)

team_data<-read.csv(file="teamexample.csv", sep=",",h=T,stringsAsFactors=F)
iucn.full<-read.csv("IUCN.csv", sep=",",h=T)
iucn<-iucn.full[,c("Class","Order","Family","Genus","Species")]
team<-merge(iucn, team_data, all.y=T)

data<-fix.dta(team)
data<- droplevels(data[data$bin!="Homo sapiens", ]) # remove Homo sapiens
    # from data set

# extract the mammals
mam<-data[data$Class=="MAMMALIA",]

# select year by year, extract events by species and camera trap
# (example for 2009)
ev2009<-event.sp(dtaframe=mam, year=2009.01, thresh=1440)
rownames(ev2009)<-ev2009[["Sampling.Unit.Name"]]

# transpose matrix and save it
sp<-t(ev2009)
write.table(sp,"spudz_2009.txt")
#write.csv(sp, "spudz_2009.csv")

# calculate camera days (as done in Chapter 5)
camera_days<-cam.days(data,2009.01)
summary(camera_days[,2:4]) # check the maximum number of days
write.table(camera_days, file="camera_days_2009.txt",quote=F,
    sep="\t",row.names = F)
```

```
################################
# Static multi-species occupancy model (Section 9.3.1)
################################
# set your working directory
setwd("/path/to/your/folder/")

# load detection data
Y <- as.matrix(read.table(file="spudz_2009.txt",header=T,sep=" "))
# load effort
effort <- read.table(file="camera_days_2009.txt",header=T,sep="\t")

# load libraries
library(snow)
library(rjags)
library(dclone)

# set seed
set.seed(1980)

# BUGS model
modelFilename = "smsom.txt"

cat("
model {

# Priors for community-level parameters
omega ~ dunif(0,1)
psi.mean ~ dunif(0,1)
beta <- log(psi.mean) - log(1-psi.mean)      # logit(psi.mean)
p.mean ~ dunif(0,1)
alpha <- log(p.mean) - log(1-p.mean)  # logit(p.mean)
sigma.psi ~ dunif(0,10)
sigma.p ~ dunif(0,10)
tau.psi <- pow(sigma.psi,-2)
tau.p <- pow(sigma.p,-2)

# Likelihood
for (i in 1:M) {
    w[i] ~ dbern(omega)

    # occupancy
    phi[i] ~ dnorm(beta, tau.psi)
    # detectability
    eta[i] ~ dnorm(alpha, tau.p)

    logit(psi[i]) <- phi[i]
    mu.psi[i] <- psi[i]*w[i]
    logit(p[i]) <- eta[i]

    for (j in 1:n.site) {
        Z[i,j] ~ dbern(mu.psi[i])

        mu.p[i,j] <- p[i]*Z[i,j]
        Y[i,j] ~ dbin(mu.p[i,j], K[j])
    }
}

# compute species richness
```

```
    N <- sum(w[])

}
", fill=TRUE, file=modelFilename)

# number of sampling occasions for each trap
K <- effort$ndays

# number of traps
nsites <- dim(Y)[2]

# number of observed species
nspecies <- dim(Y)[1]

# Augment data set
nzeros <- 100
Y_auq <- rbind(Y,matrix(0,nrow=nzeros,ncol=nsites))

# Latent states
w <- c(rep(1, nspecies), rep(NA, nzeros))

# Parameters monitored
parameters <- c("omega","psi.mean","sigma.psi","p.mean","sigma.p","N")

# data
bugs.data <  list(M=(nspecies+nzeros),n.site=nsites,K=K,Y=Y_aug,
    Z=(Y_aug>0)*1,w=w)

# initial values
inits <- function() { list(omega=runif(1),
                           psi.mean=runif(1), p.mean=runif(1),
                           sigma.psi=runif(1,0,4), sigma.p=runif(1,0,4))}

#mcmc settings
n.adapt <- 5000            #pre-burnin
n.update <- 10000          #burnin
n.iter <- 30000            #iterations post-burnin
thin <- 10
chains<-3

# run the model and record the run time
cl <- makeCluster(chains, type = "SOCK")
start.time = Sys.time()
out <- jags.parfit(cl, data = bugs.data,
                   params = parameters,
                   model = "smsom.txt",
                   inits = inits,
                   n.adapt = n.adapt,
                   n.update = n.update,
                   n.iter = n.iter,
                   thin = thin, n.chains = chains)

end.time = Sys.time()
elapsed.time = difftime(end.time, start.time, units='mins')
cat(paste(paste('Posterior computed in ', elapsed.time, sep=''),
    ' minutes\n', sep=''))
stopCluster(cl)
```

```
#Posterior computed in 3.37720005909602 minutes

# Summarize posteriors
summary(out)

# check output
xyplot(out[,c("omega","psi.mean","sigma.psi","p.mean","sigma.p"), drop=F])
densityplot(out[,c("omega","psi.mean","sigma.psi","p.mean","sigma.p"),
    drop=F])
acfplot(out[,c("omega","psi.mean","sigma.psi","p.mean","sigma.p"), drop=F])

### plot species richness (Fig. 9.1)

# bind chains for the plot
out2 <- mcmc(do.call(rbind, out))

# plot
par(mar = c(5,4.5,4,1.5)+.1, cex.axis=1.5, cex.lab=2, tcl = 0.25)
hist(out2[,"N"],breaks=seq(20,100,by=1),main="",xlab="Species
    richness",ylab="Posterior probability",freq=F)
abline(v=nspecies,col="red",lwd=3)

#################################
# Dynamic multi-species occupancy model (Section 9.4.1)
#################################
# set your working directory
setwd("/path/to/your/folder/")

# load detection data and effort for the period 2009-2013
# get files' names
filesY <- list.files(pattern="spudz_")
names_objY <- paste("Y_",substring(filesY, first=9, last=10),sep="")
fileseff <- list.files(pattern="camera_days_")
names_objeff <- paste("effort_",substring(fileseff, first=15, last=16),sep="")

# open files and assign them names
for(i in seq(along=filesY)) {
    assign(names_objY[i], as.matrix(read.table(filesY[i],header=T,sep=" ")))
    assign(names_objeff[i], read.table(fileseff[i],header=T,sep="\t"))
}

# check dimensions of each data set
dimcheck <- sapply(mget(names_objY),FUN=dim)
dimcheck
# the number of detected species ranges from 24 to 28
# the number of active cameras ranges from 58 to 60

### let's keep only sites active every year for at least two sampling
    occasions
# get trap names for each year
Yl <- list()
for (i in 1:length(names_objeff)){
    Yl[[i]] <- get(names_objeff[i])[,1]
}

# homogenize trap names between detection matricies and effort data sets
Yl2 <- lapply(Yl,function(x) gsub("-",".",x))
```

```
for (i in 1:length(names_objeff)){
    tmp <- get(names_objeff[i])
    tmp[,1] <- Yl2[[i]]
    assign(paste(names_objeff[i],"b",sep=""),tmp)
}

# check which traps in a specific year (Yl2[[n]]) were not active in
# other years (unlist(Yl2[-n]))
traptodel <- lapply(1:length(Yl2), function(n) setdiff(unlist(Yl2[-n]),
    Yl2[[n]]))
traptodel2 <- unlist(traptodel)
traptodel3 <- traptodel2[-duplicated(unlist(traptodel2))]
traptodel3

# delete traps not active every year
names_objeff_b <- objects(pattern="b$")

for(i in 1:length(names_objeff_b)){
    col_todel_Y <- which(colnames(get(names_objY[i])) %in% traptodel3)
    row_todel_eff <- which(Yl2[[i]] %in% traptodel3)
    assign(paste("Y",i,sep=""),get(names_objY[i])[,-col_todel_Y])
    assign(paste("effort",i,sep=""),get(names_objeff_b[i])[-row_todel_eff,])
}

### insert all-zeros rows for species not detected in a certain year
names_objY_b <- objects(pattern="^Y[1-5]")

# get species names for each year-specific dataset and a list of species
# names detected at least once
colnamesYs <- data.frame(matrix(nrow=28, ncol=5))
allnames <- NULL
for(i in 1:(length(names_objY_b))){
    tmp <- rownames(get(names_objY_b[i]))
    colnamesYs[(1:length(rownames(get(names_objY_b[i])))),i] <- tmp
    allnames <- c(allnames,tmp)
}
allnames2 <- allnames[-(which(duplicated(allnames)==T))]
allnames3 <- allnames2[order(allnames2)]

# total number of observed species during the period 2009-2013
allnames3

# see which species are not present in the different years
for(i in 1:(length(names_objY_b))){
    print(which(sapply(allnames3,"%in%",colnamesYs[,i])==FALSE))
    print("--------------------------")
}

# edit the detection matrices in order to incorporate undetected species
not_detected <- rep(0,dim(Y1)[2])
Y1b <- rbind(Y1[1:9,],not_detected,Y1[10:12,],not_detected,Y1[13:26,],not_
    detected,not_detected)
Y2b <- rbind(Y2[1:6,],not_detected,Y2[7:12,],not_detected,Y2[13:18,],not_
    detected,Y2[19:25,],not_detected,Y2[26,])
Y3b <- rbind(Y3[1:6,],not_detected,Y3[7:11,],not_detected,Y3[12:28,])
```

```
Y4b <- rbind(Y4[1:6,],not_detected,Y4[7:8,],not_detected,Y4[9:11,],
    not_detected,Y4[12:13,],not_detected,Y4[14:16,],
    not_detected,Y4[17:20,],not_detected,Y4[21:24,])
Y5b <- rbind(Y5[1:6,],not_detected,Y5[7:8,],not_detected,Y5[9:10,],
    not_detected,not_detected,Y5[11:26,])

#### augment detection data
names_objY_c <- objects(pattern="^Y[1-5]b")
nzeros <- 100
for(i in 1:(length(names_objY_c))){
    nc <- dim(get(names_objY_c[i]))[2]
    assign(paste(names_objY_c[i],"_aug",sep=""),
           rbind(get(names_objY_c[i]), matrix(0, nrow=nzeros, ncol=nc))
           )
}

# bind augmeted matricies
library(abind)
Yaug_tot <- abind(Y1b_aug,Y2b_aug,Y3b_aug,Y4b_aug,Y5b_aug, along=3)
attr(Yaug_tot, "dimnames") <- NULL

# number of sampling occasions for each camera in each year
names_objeff_c <- objects(pattern="^effort[1-5]")
K_tot <- matrix(NA, nrow=dim(Yaug_tot)[2], ncol=length(names_objeff_c))
for(i in 1:length(names_objeff_c)){
    K_tot[,i] <- get(names_objeff_c[i])[,"ndays"]
}

# Target species for the WPI
speciesWPI <- c("Atilax paludinosus",
"Bdeogale crassicauda",
"Cephalophus harveyi",
"Cephalophus spadix",
"Genetta servalina",
"Loxodonta africana",
"Mellivora capensis",
"Nandinia binotata",
"Nesotragus moschatus",
"Panthera pardus")

nspeciesWPI <- length(speciesWPI)

# find out to which rows of the detection matrix these target
# species correspond
id_speciesWPI <- which(allnames3 %in% speciesWPI)

# load libraries
library(snow)
library(rjags)
library(dclone)

# set seed
set.seed(1980)
```

```
# BUGS model
modelFilename = "dmsom.txt"

cat("
model {
# priors
omega ~ dunif(0,1)
psiMean ~ dunif(0,1)
for (t in 1:T) {
    pMean[t] ~ dunif(0,1)
}
for (t in 1:(T-1)) {
    phiMean[t] ~ dunif(0,1)
    gamMean[t] ~ dunif(0,1)
}
lpsiMean <- log(psiMean) - log(1-psiMean)
for (t in 1:T) {
    lpMean[t] <- log(pMean[t]) - log(1-pMean[t])
}
for (t in 1:(T-1)) {
    lphiMean[t] <- log(phiMean[t]) - log(1-phiMean[t])
    lgamMean[t] <- log(gamMean[t]) - log(1-gamMean[t])
}
lpsiSD ~ dunif(0,10)
lpsiPrec <- pow(lpsiSD,-2)
lpSD ~ dunif(0,10)
lphiSD ~ dunif(0,10)
lgamSD ~ dunif(0,10)
for (t in 1:T) {
    lpPrec[t] <- pow(lpSD,-2)
}
for (t in 1:(T-1)) {
    lphiPrec[t] <- pow(lphiSD,-2)
    lgamPrec[t] <- pow(lgamSD,-2)
}

# likelihood
for (i in 1:M) {
    # initial occupancy state at t=1
    w[i] ~ dbern(omega)
    b0[i] ~ dnorm(lpsiMean, lpsiPrec)T(-12,12)
    lp[i,1] ~ dnorm(lpMean[1], lpPrec[1])T(-12,12)
    p[i,1] <- 1/(1+exp(-lp[i,1]))
    for (j in 1:n.site) {
        lpsi[i,j,1] <- b0[i]
        psi[i,j,1] <- 1/(1 + exp(-lpsi[i,j,1]))
        mu.z[i,j,1] <- w[i] * psi[i,j,1]
        Z[i,j,1] ~ dbern(mu.z[i,j,1])
        mu.y[i,j,1] <- p[i,1]*Z[i,j,1]
        Y[i,j,1] ~ dbin(mu.y[i,j,1], K_tot[j,1])
    }
    # model of changes in occupancy state for t=2, ..., T
    for (t in 1:(T-1)) {
        lp[i,t+1] ~ dnorm(lpMean[t+1], lpPrec[t+1])T(-12,12)
        p[i,t+1] <- 1/(1+exp(-lp[i,t+1]))
        c0[i,t] ~ dnorm(lgamMean[t], lgamPrec[t])T(-12,12)
        d0[i,t] ~ dnorm(lphiMean[t], lphiPrec[t])T(-12,12)
        for (j in 1:n.site) {
```

```
                    lgam[i,j,t] <- c0[i,t]
                    gam[i,j,t] <- 1/(1+exp(-lgam[i,j,t]))
                    lphi[i,j,t] <- d0[i,t]
                    phi[i,j,t] <- 1/(1+exp(-lphi[i,j,t]))
                    psi[i,j,t+1] <- phi[i,j,t]*psi[i,j,t] +
                            gam[i,j,t]*(1-psi[i,j,t])
                    mu.z[i,j,t+1] <- w[i] * (phi[i,j,t]*Z[i,j,t] +
                            gam[i,j,t]*(1-Z[i,j,t]))
                    Z[i,j,t+1] ~ dbern(mu.z[i,j,t+1])
                    mu.y[i,j,t+1] <- p[i,t+1]*Z[i,j,t+1]
                    Y[i,j,t+1] ~ dbin(mu.y[i,j,t+1], K_tot[j,t+1])
            }
        }
}

# Derive total species richness for the metacommunity
N_tot <- sum(w[])

# Derive yearly species richness
for (i in 1:M) {
    for (t in 1:T) {
        tmp[i,t] <- sum(Z[i,,t])
        tmp2[i,t] <- ifelse(tmp[i,t]==0,0,1)
    }
}
for (t in 1:T) {
    N[t] <- sum(tmp2[,t])
}

# Derive WPI
for (i in 1:nspeciesWPI) {
    for (t in 1:T) {
        psi_ratio[i,t] <- psi[id_speciesWPI[i],1,t]/psi[id_speciesWPI[i],1,1]
        log_psi_ratio[i,t] <- log(psi_ratio[i,t])
    }
}
for (t in 1:T) {
    WPI[t] <-  exp((1/(nspeciesWPI))*sum(log_psi_ratio[1:nspeciesWPI,t]))
}

# rate of change in WPI
for (t in 1:(T-1)) {
    lambda_WPI[t] <- WPI[t+1]/WPI[t]
}

}
", fill=TRUE, file=modelFilename)

# number of traps
nsites <- dim(Yaug_tot)[2]

# number of primary periods (years)
T <- dim(Yaug_tot)[3]

# latent states
w <- c(rep(1,length(allnames3)),rep(NA,nzeros))
```

```
# Parameters monitored
parameters <- c("omega","psiMean","pMean","phiMean","gamMean",
    "lpsiSD","lpSD","lphiSD","lgamSD",
    "N","N_tot","WPI","lambda_WPI")

# data
bugs.data <- list(M=dim(Yaug_tot)[1],n.site=nsites,K_tot=K_tot,
    Y=Yaug_tot,T=T,
                  nspeciesWPI=nspeciesWPI,id_speciesWPI=id_speciesWPI)

# Initial values
inits <- function() { list(omega=runif(1),Z=(Yaug_tot>0)*1,w=w,
    psiMean=runif(1),pMean=runif(T),
    phiMean=runif(T-1),gamMean=runif(T-1),
    lpsiSD=runif(1,0,4),lpSD=runif(1,0,4),lphiSD=runif(1,0,4),
    lgamSD=runif(1,0,4))}

#mcmc settings
n.adapt <- 5000              #pre-burnin
n.update <- 10000            #burnin
n.iter <- 50000              #iterations post-burnin
thin <- 10
chains<-3

# run the model and record the run time
cl <- makeCluster(chains, type = "SOCK")
start.time = Sys.time()
out <- jags.parfit(cl, data = bugs.data,
                   params = parameters,
                   model = "dmsom.txt",
                   inits = inits,
                   n.adapt = n.adapt,
                   n.update = n.update,
                   n.iter = n.iter,
                   thin = thin, n.chains = chains)

end.time = Sys.time()
elapsed.time = difftime(end.time, start.time, units='mins')
cat(paste(paste('Posterior computed in ', elapsed.time, sep=''),
    ' minutes\n', sep=''))
stopCluster(cl)

#Posterior computed in 137.004419155916 minutes

# Summarize posteriors
summary(out)

# check output
xyplot(out[,c("omega","psiMean","lpsiSD","lpSD","lphiSD","lgamSD"), drop=F])
xyplot(out[,c("pMean[1]","pMean[2]","pMean[3]","pMean[4]","pMean[5]"),
    drop=F])
xyplot(out[,c("gamMean[1]","gamMean[2]","gamMean[3]","gamMean[4]"), drop=F])
xyplot(out[,c("phiMean[1]","phiMean[2]","phiMean[3]","phiMean[4]"), drop=F])

### plot year-specific species richness
# bind chains for the plot
```

```
out2 <- mcmc(do.call(rbind, out))

median_N <- lower_N <- upper_N <- NULL
for (i in 1:T){
    lab <- paste("N[",i,"]", sep="")
    median_N[i] <- quantile(out2[,lab], 0.500)
    lower_N[i] <- quantile(out2[,lab], 0.025)
    upper_N[i] <- quantile(out2[,lab], 0.975)
}

par(mar = c(5,4.5,4,1.5)+.1, cex.axis=1.5, cex.lab=2, tcl = 0.25)
    # Note: many setting here... (tcl is for thick marks inside)
plot(x=1:T, y=median_N, type = "b", pch = 16, ylab = "Number of species",
    xlab = "", bty = "n", ylim=c(20,35),
    cex = 1.5, axes = FALSE, main="", lwd=2, cex.axis=1.5, cex.lab=1.5)
axis(1, las = 1, at = 1:5, labels = seq(2009,2013,1), cex = 1.5,
    lwd=2, cex.axis=1.5, cex.lab=1.5)
axis(2, cex = 1.5, lwd=2, cex.axis=1.5, cex.lab=1.5)
segments((1:T), lower_N, (1:T), upper_N, lwd=2)
points((1:T),dimcheck[1,])

### plot WPI
median_WPI <- lower_WPI <- upper_WPI <- NULL
for (i in 1:T){
    lab <- paste("WPI[",i,"]", sep="")
    median_WPI[i] <- quantile(out2[,lab], 0.500)
    lower_WPI[i] <- quantile(out2[,lab], 0.025)
    upper_WPI[i] <- quantile(out2[,lab], 0.975)
}

par(mar = c(5,4.5,4,1.5)+.1, cex.axis=1.5, cex.lab=2, tcl = 0.25)
    # Note: many setting here... (tcl is for thick marks inside)
plot(0, 0, ylim=c(0,2), xlim = c(1,T), ylab = "WPI", xlab = " ",
col = "red", type = "l", lty = 5, lwd = 2, axes = F)
axis(2, las = 1)
axis(1, at = 1:T, labels = c("2009","2010","2011","2012","2013"))
polygon(x = c(1:T, T:1), y = c(lower_WPI, upper_WPI[T:1]), col = "grey90",
border = "grey90")
points(median_WPI,type = "l",lwd = 2.5)
abline(h=1,lty=2,col="red")
```

Glossary

accelerometer a spring-like piezoelectric sensor. When deformed, the sensor generates a wave-like voltage signal that is proportional to the acceleration (change in velocity) it experiences. The sensor is deformed both by gravitational acceleration as well as inertial acceleration due to movement. From one to three of these sensors are aligned orthogonally to one another and affixed to an animal so that each sensor measures acceleration in a single plane, or dimension, of movement. All three sensors collecting simultaneous measurements can represent three-dimensional movement realistically.

active infrared (AIR) sensor an IR emitter sends a beam of IR which will be received by an IR receiver, and when the beam is interrupted a motion is detected.

activity centre (or home range centre) the centroid of the space that an individual occupied (or used) during the period camera traps were active. These can be the centroid of individual's home ranges or the centroid of an individual's activities during the time of sampling or even its average location. The collection of these points is thought to define the spatial distribution of individuals in the population. Whether or not individuals of a species establish home ranges is irrelevant because once a precise time period is defined, this defines a distinct region of space that an individual must have occupied.

activity pattern how animals allocate time to different behaviours, e.g. feeding, moving, resting.

Aichi Targets (2020) global targets towards reversing trends of biodiversity and habitat loss; they are included in the Strategic Plan for Biodiversity 2011–2020 as set at the meeting of the Conference of the Parties held in Nagoya, Japan, in 2010.

animal-borne video and environmental data collection system (AVED) an advanced form of biotelemetry that can combine video with variety of sensors including GPS, audio and accelerometer.

application programming interface a system of tools and resources in an operating system that enables developers to create software applications.

area effectively sampled area to which the abundance estimation refers. In ordinary capture–recapture models, the area truly sampled by a trapping array is unknown; hence, it is estimated in an ad hoc approach by adding a buffer of some width to the polygon encompassing all camera trap sites..

baseline encounter rate the expected number of captures of an individual at a camera trap site during a sampling occasion given its activity centre is located precisely at the site.

BUGS acronym for Bayesian inference Using Gibbs Sampling, reflecting the computational technique originally adopted. The BUGS language includes syntax for functions and distributions, which allows the expression of logical or stochastic relationships between variables. Different programs (e.g. WinBUGS, OpenBUGS, JAGS) make use of the BUGS language for specifying Bayesian models.

camera trap array (array) the number of camera traps set in a predetermined spatial pattern and location in the study area. A complete study may include multiple arrays sampled sequentially per study season.

cloud database a database that runs on a cloud computing platform (i.e. using a network of remote servers) and is usually accessed through a third-party provider, such as Amazon Web Services.

cloud storage a service model in which data is maintained, managed and backed up on remotely hosted servers and made available to users over a network or through the internet.

cyber-infrastructure information technology systems (e.g. the computing systems, data storage systems, advanced instruments and data repositories and visualisation environments), linked by high-speed networks, that create powerful and advanced capabilities including analytical engines and data dashboards.

data translation the process of converting data from the form used by one system into the form required by another.

detectability see detection probability.

detection event see event.

detection function relates the probability of detection or the expected number of detections for an animal to the distance of a detector from a point usually thought of as its activity or home range centre.

detection probability (detectability, encounter probability) a parameter estimated in abundance or occupancy models that varies between 0 and 1. In occupancy studies, it corresponds to the probability of detecting the species at a site, given it is present. In capture–recapture studies, it corresponds to the (average) encounter probability per sampling occasion.

detection zone the area, conical in shape, in which a camera trap is able to detect the heat signature and motion of a target.

detector in the analytical package secr, it refers to (camera) traps, searching polygons or transects. The polygon detector type is used for data from searches of one or more areas (polygons). Transect detectors are the linear equivalent of polygons. Both detector types are very similar in theory and implementation. Area and linear searches differ from other modes of detection in that each detection may have different coordinates, and the coordinates are random rather than fixed by the field design. The methods may be used with individually identifiable cues (e.g. faeces) as well as for direct observations of individuals.

encounter probability see detection probability.

event (detection event, photographic event) an instance of capture of a target species by the camera trap, obtained by screening the original images acquired by a set interval of time between subsequent images (typically 1 hour or 1 day); events are considered independent instances of capture as repeated images of an animal pausing in front of the camera traps are discarded.

field of view the area captured in an image, usually between 35° and 45°.

firmware a type of software that provides control, monitoring and data manipulation of engineered products and systems, including camera traps. Most camera trap manufacturers propose firmware updates, which allow the camera to be improved with enhanced performance and new features.

Fresnel lens a lens used by camera traps to direct infrared energy onto the passive infrared (PIR) sensor. These lenses are commonly seen in lighthouses and cause refraction of light.

Global Positioning System (GPS) GPS consists of three elements: the satellites that transmit the position information, the ground stations that are used to control the satellites and update the information, and the GPS receiver. The receiver collects data from the satellites and computes its location anywhere on or near the Earth based on the information from the satellites. The receiver measures its distance from the satellites and uses this information to compute a fix.

habitat mask in `secr` the habit mask serves four main purposes in spatially explicit capture–recapture. First, it defines an outer limit to the area of integration or state space; habitat beyond the mask may be occupied, but animals there should have negligible chance of being detected by the camera trap array. Second, it distinguishes sites in the vicinity of the detector array that are 'habitat' (i.e. have the potential to be occupied) from 'non-habitat'. Third, it discretises continuous habitat as a list of points. Each point is notionally associated with a cell (pixel) of uniform density. Discretisation allows the SECR likelihood to be evaluated by summing over grid cells. Fourth, the $x–y$ coordinates of the mask and any habitat covariates may be used to build spatial models of density.

half mean maximum distance moved 1/2MMDM see mean maximum distance moved MMDM.

hierarchical model multi-level or state-space models that allow an explicit and formal representation of the data into model components for the observation process and for the underlying ecological process. They are relevant to ecological inference as they express the nested, hierarchical organisation of ecological systems.

image bank a collection of images that is usually stored in an electronic format for retrieval by a computer.

imperfect detection in population ecology it refers to the observation process occurring when detecting individuals or species during surveys; invariably, the detection will not be perfect and therefore a number of animals or species will go undetected; this bias is accounted for in modern statistical approaches, whereby both the observation and state (e.g. abundance, species richness, occupancy) processes are modelled.

infrared (IR) flash illuminates the subject in night vision conditions with IR light. IR is invisible radiant energy, electromagnetic radiation with longer wavelengths than those of visible light, extending from the nominal red edge of the visible spectrum at 700 nm to 1 mm.

infrared sensor see passive or active infrared sensor.

legacy data information stored in an old or obsolete format or computer system that is difficult to access or process. Usually data translation is needed to get the information into a useful form.

likelihood-based inference the statistical approach adopted for making inference from the data, also called frequentist inference (as opposed to Bayesian inference). If we consider a model which gives the probability density function of observable random variable X as a function of a parameter θ, then the likelihood function gives a measure of how 'likely' any particular value of θ is if we know that X has the value x.

local environmental knowledge (LEK) see traditional environmental knowledge (TEK).

mark–resight model used to estimate population size and density by combining data from marked and unmarked individuals in cases where a portion of the population is tagged or otherwise marked (and thus individuals can be identified upon recapture), while the unmarked portion remains unidentifiable.

Markov chain Monte Carlo (MCMC) simulation procedures, or in other words algorithms, which result in samples from a probability distribution, i.e. the marginal posterior distribution of the parameter of interest. The sequence of values of a Markov chain can be used to obtain empirical estimates of any posterior summary of interest, such as the marginal mean, median or standard deviation of the parameter.

mask see habitat mask.

mean maximum distance moved between photo-encounters for each individual caught at least at two different camera trap sites (MMDM) and half MMDM in ordinary capture–recapture models the area sampled by a trapping array is unknown, and it is estimated by adding a buffer of some width to account for the additional area from which trapped individuals are taken. The buffer width has traditionally been estimated as either the mean maximum distance moved (MMDM) or half the mean maximum distance moved (1/2MMDM) between photo-captures, for each individual encountered at ≥2 camera trapping sites.

motion detector see passive or active infrared sensor.

movement (or scale) parameter sigma many encounter probability models have some scale parameter sigma, which describes the spatial scale over which an individual is detected. It is important to note that sigma is not comparable under the different encounter probability models available in `secr` and should not be regarded as home range radius in general. While there is often a relationship between sigma and home range size, that relationship varies depending on the model.

naïve occupancy the ratio between the number of sites where a species has been detected and the total number of sites surveyed. It varies between 0 and 1. It is called 'naïve' to distinguish it from 'true' occupancy, which accounts for imperfect detection and is estimated through modelling approaches.

nickel–metal hydride battery (NiMH or Ni–MH) a type of rechargeable battery (also called storage battery, secondary cell, or accumulator), which can be charged, discharged into a load, and recharged many times. The chemical reaction at the positive electrode is similar to that of the nickel–cadmium cell (NiCd), with both using nickel oxyhydroxide (NiOOH).

no-glow (or black) flash camera traps with a no-glow flash are invisible to the human eye as they can capture night-time images without the burst of visible light or the glowing red blob of white-flash and standard infrared models. They may produce

darker, grainier night photos but eliminate the potential disturbance of flash producing glows, and offer advantages in security surveillance or to avoid theft.

passive infrared sensor PIR (or pyroelectric IR detector) the type of sensor used by most commercial traps today. It reacts to heat and motion in front of the system where there is a differential between ambient and animal body temperature. A lens is placed in front of the detector to focus the IR rays onto the sensor. These are usually Fresnel lenses and may be a single lens or a lens array.

photographic event see event.

posterior distribution the probability distribution on which statistical inference in Bayesian analysis is based, derived after the collection of data by combining the prior distribution and the likelihood for the data. The posterior distribution for a parameter of interest is typically summarised by the mean, median, standard deviation and quantiles.

prior distribution the probability distribution that in Bayesian analysis describes the variation in the parameters before data are collected. Conceptually, the prior distribution defines the 'prior beliefs' about a parameter. Prior distribution is a peculiarity of Bayesian inference and can have substantial effects on the posterior distribution.

random encounter model (REM) first proposed in 2008, this adapts the gas model to the estimation of the density of (unmarked) animals using camera trapping events, based on the likelihood that animals encounter the detection zone of the camera traps.

sampling design in strictly statistical terms, sampling is the selection of a subset of units from a statistical population to estimate characteristics of the whole population; in population ecology sampling design is the spatial and temporal arrangement with which the study population is sampled (systematic, random, stratified, etc.).

sampling event in Wild.ID software, camera trap arrays can be grouped into sampling 'events' (not to be confused with 'events' of animal detection by camera traps). There are many possible uses for an event: seasons (wet and dry), months, years or other types of logical groupings when sampling occurs.

sampling occasion in analytical frameworks such as occupancy and capture–recapture, this is the temporal interval in which the overall survey effort is parted to build matrices of repeated species detections at a given site (occupancy), or repeated detection of individuals across sites (capture–recapture). The discretisation of effort in sampling occasions influences the estimation of detection probability.

sensitivity a setting, often adjustable, that reflects the camera's response to heat in motion for PIR sensors. Higher sensitivity is associated with more images, and lower sensitivity with fewer images. Increased sensitivity, however, does not guarantee detection of a target.

state space (or mask in secr terminology) defines the potential locations for any activity or home range centre. For example, a polygon defining available habitat or range of the species under study (see also habitat mask).

state variable (system state variable) in broad terms, one of the set of variables that are used to describe the mathematical 'state' of a dynamic system. In ecology it refers to the parameter(s) of a population being studied, the typical state variable being abundance or any proxy of it, such as occupancy.

survey effort (sampling effort) measured as camera days or nights and calculated as the total number of days (or nights) the camera traps effectively worked during a survey. When camera traps are paired per each site, one survey day should not be counted as two trap days but only as one trap day, since under these settings both camera traps together make up one sampling unit and do not accumulate effort independently.

system state variable see state variable.

time lapse a function that allows programming of the camera trap to capture images at prescribed times or intervals.

traditional environmental knowledge (TEK) and local environmental knowledge (LEK) TEK is a cumulative body of knowledge and beliefs, handed down through generations by cultural transmission, about the relationship of living beings (including humans) with one another and with their environment. Further, TEK is an attribute of societies with historical continuity in resource- use practices; these are non-industrial or less technologically advanced societies, many of them indigenous or tribal. LEK differs from TEK in that it does not require an ancient or even a multigenerational accumulation of knowledge, it does not require that the population be indigenous, and it does not require embedding in a broader shared culture.

trigger (or capture) speed the time difference between detecting heat in motion and capturing an image. Also known as response time. Slower trigger speed (i.e. more time elapsing between trigger and image capture) may decrease the likelihood of capturing a target.

walk test the function of a camera trap that allows for checking when the sensor detects heat-in-motion (i.e. a moving target) in front of the camera trap, through a blinking LED. This function helps positioning the camera optimally in the field.

xenon white flash an incandescent or white flash that illuminates the subject in night vision conditions in full colour.

Index

Page numbers in *italic* indicate figures and tables, and in **bold** indicate glossary terms.